Minimal Art
The Critical Perspective

Minimal Art
The Critical Perspective

by
Frances Colpitt

University of Washington Press

Seattle

Copyright © 1990 by Frances Jean Colpitt
Originally published by UMI Research Press, 1990
First paperback edition published by the University of Washington Press,
 1993
Third printing, 1997
Reprinted by arrangement with the author
Printed in the United States of America

Library of Congress Cataloging-in-Publication Data
Colpitt, Frances
 Minimal art : the critical perspective / Frances Colpitt
 p. cm.
 Originally published: Ann Arbor, Mich.: UMI Research Press, 1990.
 Includes bibliographical references and index.
 ISBN 0-295-97236-X
 1. Minimal art. I. Title
N6494.M5C65 1993 92-23902
709'.73'09046—dc20 CIP

The paper used in this publication meets the minimum requirements of
American National Standard for Information Sciences—Permanence of Pa-
per for Printed Library Materials,ANSI Z39.48-1984. ∞

To Jean and Charlie

Contents

Plates

Acknowledgments

Signe Jones provided invaluable assistance with every aspect of this book. My teachers and colleagues, Susan Larsen, Eunice Howe, Lynn Matteson, John Hospers and Richard Lind were inspirational. The past and present librarians and my sympathetic graduate students at the University of Southern California were helpful in many ways. I am especially grateful for the support of Donald Kuspit and the staff at UMI Research Press. Special thanks for advice and photographs to Robert Rowan, Daniel Weinberg, Lynn Sharpless at the Margo Leavin Gallery, Fred Hoffman and his assistant Bruce Allen, Shelly Lee at V.A.G.A., Susanna Singer, Ellie Meyer, Lois Rodin, Robert Rauschenberg, Cathy Gudis at the Museum of Contemporary Art, Natasha Sigmund at the Paula Cooper Gallery, Elizabeth Shepard at U.C.L.A., Dagny Corcoran, and Steve Stoltz. Many artists and critics who were active in the 1960s have shared their knowledge and recollections with me. Those who granted me interviews and in many cases conversations and letters of clarification, and whose kindness and generosity I will always cherish, are Carl Andre, Mel Bochner, Michael Fried, Clement Greenberg, Donald Judd, Sol LeWitt, Robert Mangold, Brice Marden, Robert Murray, Kenneth Noland, Anne Truitt, and William Tucker. I have enjoyed many discussions with David Novros and John McCracken over the years. This book, from its inception ten years ago to its present form, would have been impossible without the help and encouragement of Don Walton.

Introduction

Minimal art describes abstract, geometric painting and sculpture executed in the United States in the 1960s. Its predominant organizing principles include the right angle, the square, and the cube, rendered with a minimum of incident or compositional maneuvering. Historically a reaction to what young artists saw as the autobiographical, gestural excesses of Abstract Expressionism, Minimal art, at the same time, pursues the formal innovations of Abstract Expressionism, particularly as laid out by the paintings of Jackson Pollock and Barnett Newman. Although Minimalism shares with Pop art anonymous design, deadpan flatness, and unadulterated or industrial color, and was in fact described as "Imageless Pop" in 1966, the Minimalists eschewed any form of comment, representation, or reference.[1]

Frank Stella's Black Paintings, which were shown as early as 1959 in the Museum of Modern Art's Sixteen Americans, inaugurate the period, while Robert Morris's process-oriented work and Michael Heizer's earthworks of the late sixties signal its demise. The bulk of contemporary critical literature appeared between 1963 and 1968, the period to which this survey is predominantly restricted, although several sculptors, including Donald Judd and John McCracken, continue, in the 1980s, to make Minimal art. Minimalism is not used here with a lowercase *m*. It is restricted to those artists who shared a philosophical commitment to the abstract, anticompositional, material *object* in the 1960s.

Anne Truitt's exhibition in February of 1963 at André Emmerich's gallery was the first identifiably Minimal show, and was reviewed by both Judd and the imminently influential critic Michael Fried.[2] The first exhibition to attract significant critical attention was Robert Morris's at the pace-setting Green Gallery run by Richard Bellamy.[3] During the fall of 1963, the gallery was occupied by Morris's two distinct types of art objects. Among the smaller, Neo-Dada works were interspersed huge, gray, plywood constructions such as *Slab* (1962) and *Wheels* (1963). The future of Minimal-

ism was confidently announced by Judd's first solo exhibition of red wooden reliefs and floor structures at the Green Gallery in December.

A number of artists eventually known as Minimalists exhibited together for the first time in Black, White and Gray at the Wadsworth Atheneum in Hartford, Connecticut.[4] Sol LeWitt recalled that the first true group show of Minimal art was Eleven Artists, organized by Dan Flavin for the Kaymar Gallery in New York.[5] Henry Geldzahler included Morris, Judd, Robert Murray, Carl Andre, Charles Hinman, Will Insley, Neil Williams, Larry Bell, Darby Bannard, and Larry Zox in Shape and Structure at the Tibor de Nagy Gallery in 1965. Although certain artists, such as Bannard, would henceforth differentiate themselves from Minimalism, the cool and austere appearance of Shape and Structure characterized shows of the next few years. Andre, LeWitt, and the Californians Bell and McCracken had their first solo exhibitions in New York later in that year.

The most sensational New York exhibition of Minimal art was Primary Structures, organized by Kynaston McShine at the Jewish Museum in 1966. Forty-two British and American sculptors were represented. Every major art magazine devoted at least one article to the event; there were three reviews in the *New York Times*. Critic Barbara Rose, Judd, Morris, and Mark di Suvero participated in a well-attended symposium in May. McShine's catalogue included a general essay (undoubtedly aimed at familiarizing the public with such austere and antiexpressionistic work) and statements by most of the artists. Later that year, Lawrence Alloway organized what might be considered a sister show to McShine's.[6] Systemic Painting covered American geometric, hard-edge, and Minimal painting. Jo Baer, Robert Mangold, Kenneth Noland, David Novros, Robert Ryman, and Stella, among others, exhibited. Only Brice Marden, who was having his first show at the Bykert Gallery, was omitted.[7] On a smaller scale than the museum shows, but culling the best of both painters and sculptors was the Dwan Gallery's "10," in October of 1966. One work each by Andre, Flavin, Judd, LeWitt, Morris, Robert Smithson, Baer, Agnes Martin, Ad Reinhardt, and Michael Steiner was shown.

The following spring, Maurice Tuchman organized American Sculpture of the Sixties, a monumental extravaganza of eighty artists, at the Los Angeles County Museum of Art. Work was exhibited indoors and out, in the newly constructed buildings and plaza (which received their share of criticism from reviewers). Concurrently, on the East Coast, Barbara Rose organized A New Aesthetic in Washington, D.C. Of the six artists she chose, four were Californians.[8] Enno Develing's 1968 Minimal Art was the second major survey (following A Romantic Minimalism in Philadelphia) to use the word *Minimal* in its title. Organized for the Gemeentemuseum in The Hague, the show traveled to Düsseldorf and Berlin but received little cover-

age in the American art press.[9] Only two years before, the freshness of Primary Structures seemed to predict a trend of the future; Minimal Art was a retrospective to cap off the decade. By 1968, this kind of art had become mainstream.[10] Minimal art lay dormant through the 1970s, rejected, by the end of that decade, as hardline, authoritarian modernism by younger, pluralist artists. It has come to symbolize the final stage of the linear progress and reduction associated with the avant-garde. Although more recent criticism has attributed to Minimal art an initiation of the postmodern critique of modernism, specifically as it was constructed by Clement Greenberg and Michael Fried,[11] it is, according to Kim Levin, "the last of the modernist styles."[12]

The designation "Minimal art" cannot be credited to any certain individual. In the late 1920s, John Graham named a movement Minimalism, which, according to David Burliuk "derives its name from the minimum of operating means."[13] Most references in the sixties are to aesthetician Richard Wollheim's "Minimal Art," published in January of 1965. He was not, however, concerned with the artists who would be known as the Minimalists, but with Ad Reinhardt and Marcel Duchamp.[14] Judd used the adjective "minimal" as early as 1960, in a review of Paul Feeley's work, and later to describe Morris's constructions.[15] Although there continued to be reaction to such a seemingly negative term, a few critics used it without hesitation in reviews of Primary Structures.[16] In 1968, John Perreault, the critic for the *Village Voice*, announced that Minimal art was "a label that will stick."[17]

It is a rare artist who accepts a critic's or historian's label. Judd, Flavin, and LeWitt disapproved of the term. Morris referred to the style as "socalled Minimal" art.[18] Only Andre and McCracken felt that it had any redeeming qualities. Perreault's favorable analysis in 1967 characterizes what Minimal art meant then and now:

> Minimal art, although it has strong negative connotations (no more negative, however, than the term Fauvism) seems to be the term most commonly used. The term "minimal" seems to imply that what is minimal in Minimal art is the art. This is far from the case. There is nothing minimal about the "art" (craft, inspiration or aesthetic stimulation) in Minimal art. If anything, in the best works being done, it is maximal. What is minimal about Minimal art, or appears to be when contrasted with Abstract Expressionism or Pop art, is the *means*, not the ends.[19]

The artists in this study never considered themselves a group. Noland and Truitt, for example, are uncomfortable being associated with Minimalism's theoretical motives, although their work in the early 1960s was very much a part of the critical dialogue. Judd recalled that artists then rarely agreed on anything theoretical.[20] As Novros observed recently, "There may be schools but the only people who do anything, do it for very personal reasons, sometimes hidden from even the scholar. Often the best thing is

inexplicable."[21] There were many close friendships though: Marden, Novros, and Paul Mogensen; Judd and Flavin; Stella and Andre shared ideas. LeWitt, Ryman, and Lucy Lippard were associated by, among other things, having worked at the Museum of Modern Art.

The Minimalists' concerns were more aesthetic than social, although their art was as hip and cool, as aloof and metallic, as the sixties were in general. Bold fashions and rock-and-roll music were everywhere as Minimal art was hitting the galleries. "Now everything is happening with the intense action of jukebox noise, Rock-art-time, the artists are uninhibited, extroverted, turned on, wild in their dancing, their merrymaking, but the art itself has become silent. Art is silent—but the jukebox rocks like thunder with beat-rhythm—'Everything's Alright.'"[22] The Minimalists, more prone to discussion and theoretical arguments than the Abstract Expressionists, frequented Max's Kansas City bar instead of the Cedar Street Tavern. They were joined by Pop artists, rock musicians and fashion models, mostly in the company of Andy Warhol. There, according to one chronicler, a certain row of tables, "almost every night from 11 or 12 o'clock until closing . . . was Robert Smithson's territory. Carl Andre, Richard Serra, Mel Bochner, Don Judd, Larry Weiner, Joseph Kosuth, Ted Castle, Michael Heizer, Keith Sonnier, Dan Graham, and Dorothea Rockburne were often there, and occasionally Sol LeWitt." The first artists to occupy Max's, after it opened in December of 1965, were from Park Place and the Green Galleries.[23] Flavin and Judd, among others, traded works of art, which were then hung at Max's, for food and drink.

In the sixties, a great number of artists took on the critical responsibility for explaining their work in print. Judd wrote for *Arts Magazine* what has been referred to as "Scientific American criticism," because of his flat-footed, descriptive style, as well as more theoretical articles, such as "Specific Objects." Morris's "Notes on Sculpture," which appeared in *Artforum* between 1966 and 1969, were extraordinarily clear explications of his own program. LeWitt, Smithson, and Bochner wrote about their own and their contemporaries' work. Flavin wrote a series of quarrelsome articles, published in the December issues of *Artforum*, defending his own work and condemning critics and curators. Andre wrote poetry and occasional statements such as "Form, Structure, Place."

There are many explanations for this unprecedented phenomenon of artists' contributions to the critical literature. It has been proposed that this first generation of artists to be university-educated was accustomed to dealing with ideas. Others have suggested that primarily conceptual works require verbal explication, or that the artists expressed themselves verbally because their work was so nonexpressive. Both Judd and Bochner reviewed shows for *Arts Magazine* solely, they claim, to earn money. A popular

justification was the art critic's inability to deal with the radical new work. The artists, then, assumed the role previously occupied by critics.[24] One writer claimed that the artists were forced to defend their own work since no great critics like Clement Greenberg (who responded negatively to Minimalism, but was respected by these artists for his earlier opinions) or Fried came forward on their behalf.[25]

Although at first critics had difficulty in dealing with the new art (as it was so often called), there was little hesitation once the work had been around for a year or so. The triumvirate of Fried, Rose, and Lippard shared the majority of the responsibility, although rarely, if ever, were they in agreement. Lippard was the most perceptive and supportive. Rose never approached the work close-mindedly, but later expressed disappointment in the materialist bias of Minimalism.[26] Fried, like Greenberg, disliked Minimal art since it did not pursue the same goals as the work of which he approved (i.e., Stella's, Noland's, Jules Olitski's, and Anthony Caro's). His descriptive analyses of Minimalist art can hardly be disputed, although his conclusions and evaluations are controversial.

Each manifestation of modernism has had its interpreters: Roger Fry for the Post-Impressionists, Guillaume Apollinaire for the Cubists, Greenberg and Harold Rosenberg for the Abstract Expressionists. Writers have also been forced to either invent a new vocabulary, redefine an existing terminology, or transpose ordinary words into an art context. Perhaps more than any other generation, critics and theoreticians of the sixties were guilty of devising, on the surface of it, an impenetrable jargon. Besides "Minimal art," the work was labeled "primary structures," "structurist art," "cool art," "literalist art," "ABC art"—even "Dragnet art" ("Just the facts, ma'am").[27] It was described as nonrelational, nonhierarchical, reductive, serial, literal, unitary, and specific. There were theories of deductive structure and objecthood. Terms such as "presence," "Gestalt," "nonanthropomorphic" and "environmental" proliferated. Minimal objects were described as more "real" than previous art, although no writer defined reality. Minimalist criticism must have been thoroughly incomprehensible to the uninitiated reader.

It is my contention that the theories of Minimal art, whether relevant to artistic production (process) or the spectator/critic's apprehension of the object (product), are central to an understanding of that object.[28] In some sense, Minimalism is dependent on these issues, presented here from the least to the most abstract. Criticism provides a circuitous path to the object—the work of art—the real goal of this study. The focus is on the 1960s, with an attempt to remain as true as possible to the original moment. That moment, we can be assured, produced some of the most radical and provocative art of our century.

1

Process Issues

The most important decisions an artist makes are in the studio. Issues of process determine how and of what the work of art is to be made. The radicalness of Minimal art is partially due to a complete rethinking of process issues, which Robert Mangold characterized as "loss of identification with the process of making art, rather a stronger emphasis on the piece; frustration with painting as a medium for advanced art; adaption of industrial-commercial techniques and materials."[1] Minimal sculptors rejected the traditional concepts of "truth to material" and artistic facture in favor of industrial, non-art materials and the manufacturing process. Sculptors of the 1960s reexplored the possibilities of color, while many painters turned to monochrome. The traditional pedestal and base were dispensed with in order to affirm the reality of the sculptural object. The process of creation through the manipulation of materials in which the Abstract Expressionist invested did not provide the point of generation for the Minimal work of art.

New Materials and Techniques

The modernist concept of "truth to material" maintains that the form of a sculpture is found in its material, that the sculptor aids in its birth through an awareness and consideration of the potentiality of the material, and that the form and the material coincide. It is an inherently moralistic proposition, held to not so much for aesthetic reasons as for ethical ones, something like the ecologist's respect for nature. (Aesthetic issues are not normative—one ought to do such and such; ethical issues are.) Consequently, the overt rejection of the concept is also ethical; it proclaims the mastery of the artist. As Jack Burnham explained, it is as if the sculptor "has declared, I can make materials mean anything I want them to mean; after all, who is to be the master?"[2] Distinct from Henry Moore's Vitalist program, the new sculptor allows the form of the work of art to spring entirely from him or herself.

Emphasizing the conceptual origin of a work of art, Anne Truitt described her early experience with sculpture: "I thought that the impetus for a work of art had its origin in the material.... [This approach] was of no use to me whatsoever when it came to these things I saw in my head.... I would just make a reversal, turn and move from the inside out.... I would make things that I cared the most about."[3] The primacy of conception was maintained by Clement Greenberg in reference to Clyfford Still, Mark Rothko, and Barnett Newman. He suggested that a judgment of quality in art is based on "not skill, training, or anything else having to do with execution or performance, but conception alone."[4] Minimal art, however, was subsequently condemned by Greenberg as "too much a feat of ideation, and not enough anything else. Its idea remains an idea, something deduced instead of felt and discovered."[5] Greenberg later clarified the apparent contradiction by distinguishing between idea and conception:

> The conception of a work of art is not an idea.... An idea is something you can put into words, though I'm disagreeing with Kant's use of the word here. Newman could lay out the picture in his mind. He's not the only one; and I said that was conception. Now, I didn't say that Newman *ideated*. I did think the Minimalists ... made this decision to reduce art and so forth.

Even paintings that are laid out beforehand, like Newman's, are generally modified as they are brought into existence.[6] Similarly, James Monte remarked that while the sculptures of the Minimalists' contemporary Mark di Suvero are constantly restructured during the creative process, "the final execution" of the Minimal object is dictated by "the first conception," a fact that he found to be of questionable merit.[7] The artist's conception, rather than the materials, is the determining factor. This is not to suggest, however, that this art is Conceptual. Carl Andre has justifiably complained that "it is most appalling to be cast incessantly as a conceptualist when my sculpture has nothing to do with ideas-in-the-head & everything to do with matter-in-the-world."[8]

The substitution of originating concept for direct hands-on manipulation of materials can be traced to Marcel Duchamp, although the sculptural implications were not really evident until the 1960s. One paradoxical consequence of the artist's exercise of complete control over the material was that sculpture, instead of expressing the individuality of its creator, actually began to look more and more anonymous.[9] A wrestling or grappling with materials, out of which emerged a uniquely transformed (from nature to art) object, gave way to a work of art that seemed to have sprung full grown from the artist's mind. Carving and construction were replaced by conceiving and placing or presenting. Like Pop art, whose raw material was the

media image, the Minimal work of art exhibits no evidences of facture. It is more a case of transference than transformance.

Moore's practice of deducing the work of art from the given material is irrelevant to sculptors who make their work from whatever is best suited to the primary concept. Anonymous and nonnatural, industrial materials were generally preferred to suggestively organic materials, which "give" under the artist's touch. With industrial materials, there is virtually no way to achieve the sort of vitality that Moore desired. While stone, wood and bronze appear to be in essence "living" (partly because of their traditional uses in mimetic sculpture), galvanized iron and Plexiglas do not. A primary goal for artists such as Hans Arp, Barbara Hepworth, and Moore was to activate the sculpture internally so it would be more suggestive of a human being. The substitution of industrial materials for natural ones, and the rejection of "truth to material," divested sculpture of organic vitality. As Rosalind Krauss explained, "It will be difficult, that is, to read [the materials] illusionistically or to see them as alluding to an inner life of form (the way eroded or chiseled rock in a sculptural context might allude to inner biological forces)."[10] This partially accounts for the obdurate inertia of much Minimal sculpture. With the exception of Russian Constructivist sculptures which are politically motivated demonstrations of material, plywood, concrete, aluminum, galvanized iron and steel, brick, and plastics, including Plexiglas, polyester resin, and Styrofoam, had, up until the sixties, remained in the province of the practical building arts.

Donald Judd's earliest three-dimensional works are made of painted plywood. Some include elements of aluminum or galvanized iron, which he began to use extensively after his first one-man show in 1963. The first metal structure, a box of wood covered with galvanized iron and now owned by Frank Stella, was fabricated in March of 1964. As John Coplans has noted, sheet metal "speeds construction, overcomes structural and weight problems inherent to wood . . . and finally achieves durability to the extent that the sculptures can be displayed outside."[11] Judd's use of industrial material is not only practical, but aesthetic. When the stainless steel, aluminum, and galvanized iron pieces were exhibited in February of 1966, Rosalind Krauss was struck by the sensuousness of the objects. This effect was later emphasized by two reviewers of Judd's exhibition at the Whitney Museum in 1968.[12] The fact that these were made of heretofore non-art materials was only remarked upon cursorily. In the late sixties, Judd began to fabricate objects that were, in size and shape, duplicates of earlier pieces, but made of different materials or colored differently. There are three examples of a hemicylindrical progression of 1965 made of galvanized iron with red lacquer. The same form was subsequently made in stainless steel, plain galvanized iron, galvanized iron lacquered with blue, purple, or green,

brass and copper, many in editions of three. The vertical wall pieces, particularly those of metal and Plexiglas, have also been produced in various combinations of materials. However, as the artist and critics have stressed, different materials result in absolutely different works of art.[13] A structure made in gleaming brass and one made in nonreflective galvanized iron bear only remote similarities to one another, because, as Judd has said, the materials are "specific."[14] Where veined marble, grained wood, and patinated bronze allude to nature through the suggestion of growth, the crystalline inflection of a galvanized iron box is quite uninteresting in itself. It merely contributes to the brittle homogeneity of the surface and specifically identifies the material. Judd uses industrial materials, then, primarily for their surface qualities and their planarity. If they mean anything, it is function or utility: their reason for being.

Plywood, though of natural origin, has an industrial appearance because of its conventional uses and the process of planing and laminating the wood. Like Judd, Tony Smith and Anne Truitt used it primarily for formal and practical purposes. However, the surface and thickness or thinness of the individual planes were of little interest to Truitt and Smith. Judd, Truitt has said, "uses his copper or his steel as copper and steel *per se*, and then he arranges it.... That's entirely different from me." The surface of the wood itself is only important for her in that it is more receptive to applied color, that "it serves essentially as an armature which sets the color free into three dimensions, materializing it even as it dematerializes the form."[15] Smith's painted plywood and cardboard sculptures are actually mock-ups for steel versions. His interests lay in shape and scale; material is nearly irrelevant. "I wanted *form* to be form made of 'space and light and not material."[16] For Smith and Truitt, plywood is a convenience.

Sol LeWitt's materials are, according to Robert Rosenblum, "as free of worldly association and specific identity as possible."[17] Reviewing the artist's first one-man exhibition of large, lacquered, wooden structures, Lucy Lippard noticed that the material of the sculpture was revealed by the grain that was apparent beneath the monochromatic surface of the paint.[18] This criticism was taken to heart by LeWitt, who had wanted "the surface to look hard and industrial," whereupon he decided to "remove the skin altogether and reveal the structure."[19] The following year, his trademark skeletal cubes were exhibited at the Dwan Gallery. LeWitt continued to use wood for the more complex structures, although steel was used as early as 1965 in the *Cubic Modular Floor Piece*, and aluminum in the *47 Three-Part Variations on Three Different Kinds of Cubes* of 1967. Many of his earlier wooden pieces have been remade in steel. Because of his concern with the idea behind the work of art, the physical nature of the materials that embodies the idea is less important to LeWitt than form and content. He has

written that "new materials are one of the great afflictions of contemporary art. Some artists confuse new materials with new ideas.... The danger is, I think, in making the physicality of the materials so important that it becomes the idea of the work (another kind of expressionism)."[20] Although LeWitt's initial decision to use steel and aluminum was primarily an aesthetic one, his continued use of industrial material is almost completely practical. Steel is more durable and retains its sharp edges longer, while aluminum is lighter than wood.

Industrial materials also contribute to the sheer abstractness or nonreferential quality of the objects. Aside from the materials' obvious origin in the practical arts, they do not seem to have a history outside of the works of art themselves. They are plainly the stuff of which the object is made. This is their ultimately aesthetic nature. Krauss alludes to the difference between Judd and those artists for whom material *qua* material is of more importance: Judd's sculptures "are not developed from 'assertations' about materials or shapes, assertations, that is, which are given a priori and convert the objects into examples of a theorem or a more general case, but are obviously meant as objects of perception, objects that are to be grasped in the experience of looking at them."[21]

Then, there are a number of artists whose decisions to use nontraditional materials derive from the very fact that the materials had not previously been associated with art. This constitutes a Dadaist sensibility, although the Minimalists, unlike Pop artists, transformed non-art materials and objects into formal and ultimately abstract elements of art. Duchamp's *Bicycle Wheel* of 1913 is the first example of the use of non-art materials primarily for idea-oriented, anaesthetic purposes. The wheel and the stool retain their identities as wheel and stool, just as Truitt asserted that Judd does not transform his materials, but uses them as they are. However, Judd's copper and steel were nothing before they were sculpture. They were not real in the sense of previously being things in the world. The Dadaists' use of nontraditional materials results in a transformation of sorts: the object employed can now be granted the status of art, while its origin in the world *outside* of art cannot be overlooked without collapsing the concept of the work of art in question. Robert Rauschenberg's Neo-Dada combines also make use of non-art—though not necessarily industrial—materials, which are transformed by compositional juxtaposition and paint application. However, the materials themselves are not artistically legitimized by Rauschenberg's use of them. The goat and the tire of *Monogram* (1959), once used by Rauschenberg, cannot be used formally by other artists in the way that, say, stainless steel used by David Smith can. In the early sixties, John Chamberlain made a similar claim on the automobile. The origin and identity of his sculptures' materials remain evident, even after the painted metal has

been torn, crushed, and welded. Like Dan Flavin's fluorescent fixtures, Chamberlain's materials straddle the art/non-art boundary, while the sculptures they compose rest squarely in the art world. Rauschenberg's goat has not undergone this transformation.

Flavin and Robert Morris use nontraditional materials differently than Judd, but resemblances, linked to the tradition of assemblage, which these artists inherited, can be found in their early works. Judd inserted a baking pan in the center of a relief of 1961; Flavin affixed crushed tin cans to the surface of *Mira, Mira* in 1960. Morris built a monochrome, wooden structure in 1963 entitled *Wheels*, while Truitt's first mature sculpture, *First* (1961), resembles a section of a white picket fence. The meanings of the works, however, differ dramatically. While it does not lose its identity as a found object, Judd's baking pan functions formally. It punches a hole in the painting, denying traditional illusionistic space. Flavin's tin can sits on the surface of the picture with very unspecific formal, though specifically representational, qualities. Although it is debatable whether Morris ever rejects his Dadaist orientation, Flavin does escape his by 1964.

Morris's debt to Duchamp and Jasper Johns was acknowledged by most reviewers of his early shows at the Green Gallery in 1963 and 1965.[22] As late as 1969, William Wilson maintained that Morris's work was "implicitly opposed to formalist criticism, and closer to Dada and Surrealism."[23] Critics responded to the Dada implications of his early nonabstract sculpture, which remains distinct from his more purely Minimalist objects, the gray polyhedrons.[24] The works utilizing rulers and those with impressions of body parts in lead make specific references to Duchamp, as does *Fountain*, which consists of a bucket rather than a urinal. Judd believes that Morris's sensibility was and remains that of a Dadaist. He explained that when Morris titled his suspended rectangular sculpture *Cloud*, he *meant* cloud.[25] Morris's "cloud"—solid, planar and rectilinear—is an absurd object reminiscent of Man Ray's *Cadeau* of 1921, an iron that has a pressing surface studded with tacks, rendering it humorously—and threateningly—nonfunctional. Morris is indeed producing real objects, but not "specifically."[26] Comprehension of this art depends on recognition of the identity and functions of its materials and references in the world outside of art.

By the mid-sixties, Morris seemingly severed his ties to the representational art of Johns and Duchamp by substituting plywood and steel for found objects. He did recognize, however, the new sculpture's "referential connections . . . to manufactured objects." His structures of bland, industrial materials are decidedly different from what he called "candy box art—new containers for an industrial sensuality reminiscent of the Bauhaus sensibility for refined objects of clean order and high finish," the kind of art that predominated in the Primary Structures exhibition of 1966.[27] For his first

completely Minimal show, at the Green Gallery in December of 1964, seven plywood structures were colored with a brand of paint known as Merkin Pilgrim gray. These, the fiberglass pieces of 1965–67, and more recent versions attest to Morris's rejection of "industrial sensuality" in favor of industrial solemnity. They lack the beauty and grace of Judd's and Truitt's sculptures, and for this reason are even more resistant to formal analysis and criticism. Fiberglass provided Morris with a more unified object. Where David Antin found the joints at the corners of the plywood constructions to be somewhat distracting, the new fiberglass pieces seemed "sudden manifestations of some indefinable grey substance that has congealed under unknown conditions into these massive volumes."[28] It makes little difference whether a piece is wood or fiberglass; it is the mass and shape that counts. This is closer to LeWitt's work and very different from Judd's "variations" of the same form in different materials.

Morris began to use more obviously industrial materials in the later sixties. I-beams, steel plate, and steel mesh were left exposed in affirmation of their physicality. Martin Friedman described the artist's approach: "Morris believes that industrial materials have their own aesthetic possibilities, which can be revealed by letting them wholly retain their identity."[29] Morris's concerns shifted from materialist demonstrations of shape to material in the later work, which is recorded in his "Notes on Sculpture." Parts 1 and 2 deal with form and the perception of form, while parts 3 and 4 concentrate on materials and production.[30] In his monumental painting-reliefs of the 1980s, Morris continued to explore the emotive possibilities of materials, having abandoned Minimalism entirely.

The Duchampian nature of Flavin's fluorescent light objects was hotly debated. From the beginning, Lippard denied their Dada ancestry, calling their installation "more reminiscent of theatrically illuminated classical architecture than of a Duchamp readymade." She persisted in this attitude in her reviews of Flavin's exhibits in 1965 and 1966.[31] Philip Leider described the experience of Flavin's work as so pleasurable that the viewer tends to overlook the more mundane notion of the "store-bought" material.[32] Barbara Rose, on the other hand, called Flavin's tubes "a variation on Duchamp's readymades," though she too found that their *significance* was perceptual.[33] His unmistakably Dada *Barbara Roses* (1962–66), a light bulb enclosing a terra-cotta flower and mounted in the socket of a fixture, was named for her. When Elizabeth Baker claimed, in reference to Flavin, that light art's "major catalyst was Pop," Flavin angrily replied that painting, not Pop, was responsible.[34] In 1961, shortly after completing the paintings with attached crushed cans, he began making notes for "electric light art."[35] By thinking in terms of materials first, and the form they ought to take secondly, he differs from artists like Judd who were primarily concerned with

formal issues. Flavin's Icons of 1962 follow from the reliefs, with electric lights replacing the tin cans. The elimination of the support for the fluorescent tubes in 1963 freed the light from its Dada ground, and the *fact* of the material is taken for granted. It is the initial choice of an industrial product, not what he does with it, that distinguishes him from Judd and LeWitt.[36] By the time of Flavin's Green Gallery show late in 1964, sculptural issues of placement and especially color take precedence. Just as Morris deemphasized his Johnsian connections, Flavin moved closer to Judd in his preoccupation with more formal aspects, although Flavin uses a *product* rather than transforms raw materials into new objects. Judd's insightful statement that Flavin "appropriated the results of industrial production," also reveals the Dada/Constructivist gesture of taking things from one realm and putting them to use in another.[37]

Distinct from formal or Dada inspirations is a certain attitude reminiscent of "truth to material" in artists who find motivation in the material itself. Although a few writers associated Andre's materials with found objects, it was always obvious that the properties of the materials themselves were more important.[38] His first two exhibited works, *Cedar Piece* and *Well*, were made of beams of uncarved wood. For practical purposes (the gallery floor threatened to collapse under the weight of the large beams), he switched to Styrofoam for *Crib, Coin and Compound* in 1965. Lippard praised his choice of material on aesthetic grounds: "They do not evoke nature by rough wooden surfaces nor industry by pristine mechanical surfaces."[39] The materials were neither disguised nor referential. Andre was later critical of viewers who saw the soiled white Styrofoam planks as stand-ins for Pentelic marble.[40] To those who interpreted the firebrick *Lever* of 1966 as a Duchampian gesture, David Bourdon explained: "The major difference is that Duchamp chose and put into an art context individual manufactured objects, the shapes of which had been determined by their use. By contrast, Andre's units are the basic materials of construction and manufacturing."[41] As in Judd's work, industrial materials are transformed into works of art, a feat that Andre accomplishes through placement alone. The actual elements, or as Andre calls them, "particles," remain themselves unchanged and undisguised, much like Flavin's. Andre's most characteristic works are the metallic plates begun in 1967. Although the configurations (square, row, or triangular corner) change from piece to piece, the most conspicuous feature of each sculpture is its material. Not only are the visual qualities of surface immediately apparent, but the tactile qualities of mass, weight, and gravity are experienced by the spectator. As Andre has correctly surmised, the spectator experiences bodily a sense of the sculpture's material mass by walking or standing on the piece.

When questioned about the notion of "truth to material," Andre re-

plied, "I just like matter a great deal and the different properties of matter, the different forms of matter, different elements, different materials." He added, "We should use materials in art which are really appropriate to our ends. Not marble for the sake of marble or bronze for the sake of bronze, but marble where marble is appropriate and dirt where dirt is appropriate."[42] This is clearly reminiscent of Henry Moore and traditional modern sculptors. While Andre does not physically manipulate his materials to the extent that Moore did, he sees himself in contrast to an artist like LeWitt, who starts with the concept and works it out in sculpture. Andre begins with the materials, "which, in the end, are the subject and content of his work."[43] He is attempting to remain "true" to industrial materials.

In 1967, Kurt von Meier speculated that while Andre and other New York artists rely essentially on nineteenth-century materials and techniques, their Los Angeles counterparts look to the twenty-first century through the use of the synthetic medium of plastic.[44] The attraction to plastics, their transparency, sheen and opulent color, and what was called "finish fetish"—an obsession with high refinement—was often linked to the environment of urban Los Angeles. Held accountable were "aircraft, plastics, chemical and film industries," and "the automobile, the boat and the surfboard."[45] "Sunsets, neon, flowers, ocean, desert landscapes, and wide boulevards" were evoked in reference to the use of plastics, whose "preciousness (when polished) rival[s] bronze or marble."[46] Although Minimal sculpture might take the same form on both coasts, materials were used in distinctly different ways. Judd's use of Plexiglas was described as "pragmatic and restrained," in comparison to Craig Kauffman's use of the same material.[47] For Kauffman, Larry Bell, Ron Davis, and McCracken, the material, and particularly the technology involved in its manipulation, was of more than formalist importance.

There was disagreement (albeit never explicitly spelled out) over the issue of "truth to material" with respect to California artists. In John Coplans's view, these artists were totally indifferent to "truth to material," in which "the finished sculpture should clearly reveal the intrinsic nature of the material used and the form and manner of working this material should coincide."[48] Coplans's rejection of the notion may be rooted in its association with the now-conservative tradition of Moore. Plastics, what they can or cannot do, and what look one can or cannot get, were in fact the basis of the West Coast Minimalist sensibility. At odds with Coplans, Carol Lindsley astutely assessed the artists' relationship to their materials: "The materials themselves are often the direct inspiration for the artist to find new ways to put plastic into art; the motivation to make art may come directly from a fascination with the potential of material."[49] In discovering the generating concept of the work of art in the material, these artists are

closest to Andre. None of them adhere to all that is implied in "truth to material," yet they all respect the nature of their materials, whether it has the density and weight of metal or the translucency and lightness of plastic.

The relationship between materials and techniques was explored by E. C. Goossen and Morris in a 1970 interview. Goossen suggested that standard, four-by-eight-foot sheets of plywood are "related to arm length, what a man can carry, what a carpenter can handle," while truly industrial materials are heavier (and larger) and "geared for fork lifts and cranes." Morris agreed. He required only a Skil saw for the plywood pieces; the heavier steel objects necessitated the use of a fork lift.[50] The workmanlike image of the artist, as one who wields common, industrial material, was further enhanced by turning to industrial fabrication to deal with the technical problems engendered by the use of the new materials. Most artists in the 1960s (except Mark di Suvero) and most critics (except Hilton Kramer) saw nothing drastically detrimental or negative in this innovation. In fact, in two of the most ambitious surveys of modern sculpture, Burnham's *Beyond Modern Sculpture* and Krauss's *Passages in Modern Sculpture*, manufactured works of art are not treated at all differently from those manipulated by the artist's hand. Nevertheless, factory production was a radical method of artistic creation, particularly in light of the fact that an artist might simply send blueprints or unsupervised graphic plans to a fabricating plant that specialized not in art production, but whose purpose was industry. More often than not, no three-dimensional model accompanied the instructions. Most Minimal sculpture was considerably more simple in terms of shape than work produced in the preceding or following decades, and could be specified in verbal or mathematical terms. The artist functioned as conceptualizer; the factory as the actualizer.

Employing machinery and assistants in sculpture was not uncommon, particularly in a foundry or casting situation. Earlier monumental sculpture was rarely executed singlehandedly. Much has been made of the fact that Rodin's marbles were carved by assistants: the debate centers on whether or not to accept the marbles as significant evidence of Rodin's style. However, since his participation included "conceiving for stone, overseeing their making and finishing them," according to Albert Elsen, these sculptures must not be denied to Rodin, particularly "today, when so many artists don't even touch their works, not even making models, but are only giving verbal directions."[51] Perhaps the most radical example of manufactured works of art is Moholy-Nagy's project for the Telephone Paintings, exhibited in 1922 in Germany. According to his wife, these were ordered from a sign factory (others have said an enameling workshop), by using a color chart and graph paper "to specify the location of form elements and their exact hue." The three pictures were to prove "the existence of objective

visual values."[52] Although Minimal artists did not set out to "prove" any particular theory through fabrication, Moholy-Nagy's experiment is a direct antecedent to "post-studio" art as it developed in the 1960s.

In reaction to the physical labor involved in Abstract Expressionist painting, Pop artists also rejected personal facture, with Andy Warhol's Factory representing the zenith of industrialized art. Younger artists felt no compulsion toward personal involvement. Roy Lichtenstein declared, "I think the meaning of my work is that it's industrial."[53] This remark suggests the difference in intention between Pop and Minimal artists. The look of anonymity was desired by Pop artists; they employed commercial techniques to achieve it. For Minimal artists, anonymity was the consequence of fabrication, not the primary motivation.[54] Manufacturing techniques were used for efficiency. A comparison of Lichtenstein's remark above with Judd's, "Technology is merely to suit one's purposes," makes the difference clear.[55] Fabrication, by which the new materials were most competently manipulated, is a consequence occasioned by the decision to employ the materials in the first place.

Robert Murray's first public sculpture, a civic commission for the city of Saskatoon, was constructed at John East Iron Works in 1959. At the time, Murray was criticized for relying on industrial fabrication, and was a little uncomfortable about it himself, until his friend Barnett Newman heard the story and applauded the young artist's resourcefulness.[56] Murray began dealing with the firm of Treitl Gratz in 1962, after moving to New York. He recalled that Alexander Liberman was then the only other sculptor using these facilities.[57] Murray wrote that he appreciates working "along side the fabricators because I like to be involved and to keep the process open to spontaneous change.... In some cases, union, company, or safety codes prevented sculptors from picking up a tool."[58] Although Truitt had been working since 1948, her first Minimal sculpture was made from boards cut to her specifications by the lumberyard in 1961. When they informed her that their mill could also build the objects for her, she was delighted. She saw nothing unusual in this; it was just "common sense."[59] Judd presented his plan for "the relief with the one thousand holes" to Bernstein Brothers Sheet Metal in New York in 1963, with hopes that they could complete the tedious process of drilling all the holes. (Judd ended up drilling them by hand because of the expense.) Following the box covered with galvanized iron, the first piece to be completely fabricated was a large, red square with rounded corners, which sat on the floor and was exhibited in Shape and Structure in January of 1965.[60] Judd continued to use Bernstein and his assistants throughout the sixties. Both Morris and LeWitt were also having some of their work manufactured by the mid-sixties.

Donald Lippincott and Roxanne Everett opened the first factory de-

voted entirely to the manufacture of sculpture in 1966, on ten acres in North Haven, Connecticut.[61] Murray has worked with Lippincott practically from its inception; and the factory has also hosted Newman, Tony Smith, and Morris. Lippincott, Inc., provided the opportunity of having large sculptures fabricated in industrial materials by shop workers who, while not artists themselves, were sensitive to artistic process. The sculptors were also encouraged to work closely with the engineers and fabricators. Lippincott was felt to be "more a communal studio than a factory," since it resembled the traditional studio workshop.[62] It was the answer to many sculptors' practical and economic problems.

Although industrial fabrication is not an exhibited or manifest characteristic, there are certain formal qualities typical of work made from industrial materials and by industrial methods of forming. Murray appreciates "the directness and clean finish" of fabricated pieces.[63] There is a definite sharpness and clarity of edge and surface, which results from the fact that many of the new materials begin in sheet form. Manipulation of sheet steel will differ from the casting of liquid bronze, a viscous material appropriate for lumps and curves. In 1967, Robert Morris noted that "the most accessible types of forming lend themselves to the planar and the linear," and that "rectangular objects and right angle placement [are] the most useful means of forming."[64] Partly in reaction to the biomorphic gesturalism of Abstract Expressionism, and partly the result of industrial processes and materials, fabricated art took on the look of fabricated commercial products.

A work of Minimal art is a physical object that embodies the visual idea. The process was merely the step in between the idea and the object: a means, not an end. Kramer pointed out that artists using industrial fabrication were giving "priority to clarity of conception over the niceties of craft."[65] Perhaps because of his own emphasis on conception, LeWitt is often taken to be the best example of one who thinks up things for other people to do.[66] Although his works are more conceptual than most Minimalists', LeWitt's ideas are visual, and must be physically realized. Rather than illustrating an idea in material, Judd's conception is of a particular form in a particular material. For Morris, materials and techniques were practical considerations; the prescriptive conception was in terms of shape. As Robert Murray had observed, "How you make a piece of sculpture in the end doesn't matter."[67]

Minimal artists tended to treat the process of making the work of art as logical and practical, pursuing the efficiency and innovations of science and technology, which were very much a part of the space-age sixties. Recognizing that the primacy of conception demanded clear formal articulation, the artists called upon fabricators for their ability to do a better job. In the construction of his new piece for the Whitney Annual of 1968, Judd

relied not only on his fabricators at Bernstein Brothers, but on the engineers at Reynolds Aluminum, who were able to calculate how much a half-inch sheet of aluminum would sag when forced to span a large area, thus saving Judd time and expense.[68] Judd depends primarily on fabrication for its neat and austere results, the same reason he employs industrial materials. Morris, like Judd, had constructed his early plywood pieces himself, and was forced also to make early fiberglass pieces, begun in 1965, because he could not find a fabricator who could produce them to his specifications without constant supervision.[69] By 1967, however, Morris was able to assert that reliance on fabrication was primarily for reasons of efficiency.[70] Another reason for deferring to manufacture was that the artists did not have the skills required to make the object. LeWitt explained that "it was a matter of getting it done in a factory with people who knew how to do it." Speaking of having one of his metal structures made by assistants, he said, "They do it much better than I. If I were going to build that, I'd have to learn how to weld and everything; and I'd take years and years." Truitt turned to fabricators since she was lacking "the knowledge to construct a beautifully constructed thing." Both artists emphasized the time factor involved, whether in learning the technique, or in the actual construction, another practical reason for turning to fabrication. Robert Murray found that "you could really get action working in industrial situations."[71] It was a way of speeding the laboriously slow process of making large sculpture.

The new methods, practical as they might be, were never completely legitimized. The notion of artistry continued to imply the individual's manipulation of his or her materials. In 1966, Lippard reported that, at a symposium connected with Primary Structures, di Suvero "said that Judd didn't qualify as an artist at all since he has been sending his work out for construction."[72] Many, indeed most, artists continued to prefer personal facture. Artists associated with the Park Place cooperative gallery (sculptors Forrest Myers, Anthony Magar, Peter Forakis, Robert Grosvenor, and di Suvero, and painters Ed Ruda, Leo Valledor, David Novros, Dean Fleming, and Tamara Melcher), whose forms were primarily planar and geometric configurations made from the new materials—seemingly suited to fabrication—for the most part did not take advantage of industrial production. The Park Place sculptors were more concerned with complicated constructions dealing with science, mathematics, and space, in contrast to Minimal sculptors who presented simple, unified forms. Only Myers seemed to be interested in fabrication. Like the Minimalists, he depended on the factory for efficiency: "The time-saving factor more than compensates for the cost—if the artist can get money."[73] Fortunately, a group of collectors was solicited to help pay for the members' large sculptures.

Expense was the principal deterrent to fabrication. The new materials and techniques made the cost of large sculpture exorbitant. While the Park Place group and those affiliated with Lippincott's fabricating plant were not forced to depend solely on their own income, most artists were. "Money," said Barbara Rose, " ... is the secret ingredient."[74] Judd continually complained of the lack of funds for artists. Though private and government support increased during the sixties, most sculptors were caught in a circular situation: no money to produce sculpture, no sculpture to sell to make money to produce sculpture. When American Sculpture of the Sixties opened at the Los Angeles County Museum in April of 1967, it was lauded and criticized in economic terms: tens of thousands of dollars were spent on shipping, assistants, and fabrication on location (the catalogue cost $35,000). Frederic Tuten called it "probably the most expensive single show of modern American art by an American museum."[75] The curator, Maurice Tuchman, gave Andre and McCracken a chance to construct pieces specifically for the museum. Others, like Tony Smith and Lucas Samaras, sent an assistant (Richard Tuttle came to Los Angeles to construct Smith's *Cigarette*; the young painter James Hayward worked on McCracken's blue column) or instructions for the on-site construction of their pieces. Smith's *Die II* was fabricated in California because it was less expensive than shipping the original from the East.

Not all Minimal sculptors had their work fabricated. Andre's work, its elements not requiring any forming (after the original pressing or rolling and cutting into plate) or joining, goes from the metal supplier to the gallery. Flavin's fluorescent works are not produced by a fabricator to the artist's specifications, but are comprised of standard lengths of tubes. Although he has occasionally employed assistants, McCracken prefers to make the plank-sculptures himself. Since he conceives each sculpture completely before creating it, the making of it is almost a mundane activity, consisting of building a plywood armature, covering it with fiberglass, pouring pigmented resin on the surface, and finally waxing and polishing. "I've often felt kind of breathless at the moment of final polish," he said. "It's like BANG! ... It's more than I had thought."[76] McCracken's immaculate craftsmanship gives the sculptures an aura of industrial production, a quality he appreciates. Jack Brogan, who has made work for California artists for many years, provides the technology for McCracken's newer stainless steel sculptures that is beyond the resources of the studio. Another Californian, Larry Bell, has extended technology further than its industrial applications, yet the optical effects of the coated glass boxes are so subtle that they do not immediately present themselves in technological terms.[77] Bell was forced to turn to industrial techniques out of necessity, although he manages the equipment himself, a somewhat less radical approach than that of artists

who order work from a tinsmith or plastics factory. Along with McCracken and Bell, Grosvenor and Ronald Bladen, in the sixties, used industrial techniques for preconceived results, and always directly participated in the actual construction of the work of art, while eschewing any evidence of handicraft.

Most critics carefully explained the structural make-up of each object when discussing an artist's work, and considered fabrication a practical innovation. Only a few feared that it signaled the perpetually predicted death of art. The 1964 Whitney Sculpture Annual was criticized in conventional terms. Only Max Kozloff noticed that "it resembled an industrial research lab brimful with energetic, bewildered scientists."[78] Aside from Murray, most of the artists included were of the older generation (such as Jacques Lipschitz, David Smith, Ibram Lassaw, Chamberlain, Lyman Kipp, and Louise Nevelson), to whom fabrication was not an issue. Concurrently, in Shape and Structure at the Tibor de Nagy Gallery, both Murray and Judd showed fabricated pieces. However, Barbara Rose was the only critic to remark upon this fact (and then probably from inside information since her husband, Frank Stella, and Henry Geldzahler organized the exhibition).[79] Lippard did not comment on the techniques of fabrication at that time, but a few months later was able to assert that a lot of "factory constructed" art is empty.[80]

By the time American Sculpture of the Sixties opened in 1967, nonstudio production had become acceptable. Nearly every critic acknowledged the issue, and none were overly critical of it. Tuten simply stated that "in some instances the artists did not even make the sculpture themselves—a common enough situation now."[81] Kramer predicted ultimate control by "technicians of industry," a situation legitimized by this exhibition's display of technologically influenced sculpture.[82] Not many apprehensions remained by mid-1967.

One of the results over which Kramer agonized was the lack of the artist's personal touch or the look of facture. This critical stance was not simply anti-Minimalist or retrogressive. He had taken the concept of Moholy-Nagy's Telephone Paintings very seriously in 1960, admitting that one might want to laugh or shake one's head, though the story really demonstrated "an optimism about the universal communicability of pictorial values."[83] Kramer also realized that the primacy of conception led to fabrication, which resulted in the appearance of anonymity, a nexus often confusing to other critics. His most outspoken attack on fabrication was in a review for the *New York Times* of Judd's 1966 Castelli Gallery exhibition. He recognized the forceful presence of the pieces, although he regretted the lack of Judd's touch or expression. He claimed that "so much that we prize ... is traceable to the subtle dialectical transformation that follows

from an artist's ideas being submitted to the energy and genius of his own hand," and was at a loss when confronted with these so-called works of art produced by hired technicians.[84]

Dore Ashton carried on a perpetual debate with Kramer (though refraining from mentioning him by name) over this issue in 1966 and 1967. She replied directly to the *New York Times* critic's review of Judd's Castelli show, and dismissed the issue of fabrication as insignificant, in comparison to aesthetic issues.[85] She subsequently gave definite shape to her position: "The whole argument about fabrication, which I always think somewhat foolish, is activated by Judd's peculiarly cold conception. For his statement, Judd simply doesn't need the touch of his hand, and I see no reason to make this either a negative or a positive value."[86] Finally, with regard to those critics who continued to mourn the demise of facture, she queried, "Where do such critics find the personal touch in the history of monumental sculpture which is always the manufacture of ateliers supervised by the artist?"[87]

The second, though less disconcerting, apprehension was the possibility of replication. If a factory were capable of making one work of art, it was certainly able to duplicate the process and produce editions of monumental sculpture. Lippincott, Inc., produced a number of multiple works, including Newman's *Broken Obelisk* in an edition of three, although Lippincott himself preferred unique objects, generally fabricating one piece at a time until more were sold. As was the case with Judd, it seems that replication was primarily stimulated by economic factors.[88] Earlier, Judd had commented that "art could be mass-produced, and possibilities otherwise unavailable, such as stamping, could be used."[89] McCracken was also interested in the notion of replication. "My works at present are not made with the idea of duplication in mind, but this possibility intrigues me. In fact, as I think about it, the idea of *quality* mass production becomes quite exciting."[90]

There were two outstanding instances, both of them in Primary Structures at the Jewish Museum, of identical objects exhibited simultaneously. Two of Morris's L's (planned as a set of nine, originally handmade in painted plywood and subsequently fabricated both in fiberglass and stainless steel) were shown only a few feet away from Judd's contribution: two sets of galvanized iron boxes, one hung on the wall, one set on the floor. The wall boxes were connected by a blue aluminum tube; the floor boxes by a plain aluminum tube. One of the L's sat upright; one assumed an upside down V position. In each of Judd's and Morris's sculptures, the shapes are identical. Corinne Robins, in a review of the exhibition, considered Morris's contribution to be a nonrepetitive single piece, since it involved variation of placement. On the other hand, Judd's two objects were "almost identical," but

"did not relate to each other."[91] Mel Bochner found Judd's sculptures to be existentially enigmatic (the presentation of two identical sets of shapes is taken, one assumes, as posing questions about uniqueness as it relates to works of art—therefore, they do relate to one another in Bochner's opinion). He also differed from Robins in his assessment of the L's as two identical but distinct pieces which did not "organize, divide or articulate 'space.'"[92] In the case of Primary Structures, the implications of mass production are formal as well as conceptual. The viewer is forced to attend more closely to the differences as well as the similarities of color, shape, placement, and displacement.

Minimalist painters of the sixties, sharing an interest with sculptors in the physicality of the medium, quickly turned to the new materials and techniques, a trend that Lippard saw as originating with sculptors and subsequently adopted by painters.[93] For a time, Marden and Novros preferred the fine weave of Dacron sailcloth to the rough, natural texture of canvas.[94] Novros used fiberglass supports; Mangold constructed panels of Masonite. Ryman has used cardboard, cold-rolled steel, fiberglass and waxed paper. Most of these materials are nonabsorptive, and lack the bounce and resilience of canvas. They are comparable to the industrial metals and plastics of the Minimal sculptors in their inert frankness.

Unlike sculpture, Minimal paintings were not fabricated outside the studio. Though Alexander Liberman had used workers to execute his paintings in the early fifties, and many relied on others to build the painting's support, paint application was the responsibility of the artist alone. Nevertheless, the "look" of fabrication was evident in most paintings. One of the most significant technical innovations was the spray gun, a device that prevented touch or gesture from inflecting the surface of the picture. Paintings could be fabricated (by the artist) with the same meticulous finish as a new automobile (an especially relevant comparison in California). Although Mangold was one of the few Minimalists to use the spray gun, evidence of labor or process was generally avoided.

Again, because of the primacy of conception, critics complained of the fact that the artist knew what the painting would look like before completing it. Thus, the process itself appeared trivial and, worst of all, facile. Lawrence Alloway's Systemic Painting exhibition and catalogue were repeatedly taken to task for glorifying the conceptual approach. His statement in this context had simply read: "The end-state of the painting is known prior to completion (unlike the theory of Abstract Expressionism)."[95] Monochromatic painting, in particular, is seldom arrived at by trial and error; if it is, it is generally considered to be an "error."[96] Ad Reinhardt's approach prefigures Minimal painting: "Everything, where to begin and where to end, should be worked out in the mind beforehand. 'In painting

the idea should exist in the mind before the brush is taken up.'"[97] Spontaneity and "happy accidents" were irrelevant and avoided. Precision, with respect to image, application of paint and color, required foreknowledge of the final state of the painting.

The recently developed acrylic paints were well suited to "'cool' painting, for ... reasons of brilliance, purity and impersonal functionalism borrowed from technological or industrial sources."[98] Noland had been using water-based plastic paints since the mid-fifties, when they were not yet readily available. In the Black Paintings, Stella used enamel on raw canvas, as had Pollock, taking advantage of its glossiness when thickly applied, and its matte qualities and tendency to bleed when allowed to soak into the canvas. Stella's next two series, the Aluminum and Copper pictures, were painted with metallic paints. Lacquer, particularly automobile paint, produced an ideal, brittle and reflective surface. Billy Al Bengston had been making sprayed lacquer paintings since 1960; Novros used acrylic lacquer with a pearlescent sheen on his shaped canvases in the mid-sixties. Although there was a preference for industrially generated materials, Marden's admixture of beeswax and oil paint produced a comparable opacity. Very little "straight" oil painting was done.

Color

The use of color in sculpture is to an extent responsible for the critical assessment of Minimal works of art as objects, rather than strictly paintings or sculptures. With few exceptions, early modern sculptors, from Rodin to Moore, had taken care to maintain the material's natural beauty, rather than disguise it with polychromy. Whether or not one ought to consider natural materials—marble, bronze, and wood—as inherently colored was frequently debated by critics of modern sculpture.[99] At stake was whether sculpture that is naturally colored, which exhibits what Judd calls "natural monochrome,"[100] is any different from the new, deliberately colored work. Lippard's response to this particular dilemma is worth considering.

> Naturally colored traditional materials such as wood, bronze, marble, stone, no matter how much color they may provide would not make colored sculpture in the strict sense, partially because of their long acceptance and consequent low level of visibility, but mainly because other characteristics of these materials, such as grain, reflectiveness, surface, texture, are likely to be more important than their color. Thus a sculpture *painted* gray is more "colored" than a gray stone sculpture.[101]

Color in sculpture results from either the application of paint or the use of inherently colored materials, such as Plexiglas or polyester resin. Andre's sculptures, which are composed of more than one metal or of plates that

have weathered or oxidized to different degrees, are exceptions. His most indulgent use of color is in *37 Pieces of Work*, a giant checkerboard of aluminum, copper, lead, magnesium, steel, and zinc plates placed next to one another to form a square, 432 inches to a side. On the other hand, the pale, chalky color of his firebrick sculptures is neutral to the point of near invisibility.

In the early 1960s, David Smith's reputation, like Pollock's, was considerable. The fact that a number of his later pieces were painted, and that younger artists were also coloring their sculpture, suggested that Smith was responsible for the renewed interest in color. Lippard went so far as to claim, "If modern polychrome is just coming into its own, it is due to Smith more than to any one else."[102] However, his problems were different from the Minimalists'. Smith's sculptures, like Ellsworth Kelly's, tend to be frontal and pictorial in the sense that they read like painting or drawing in three dimensions, an aspect to which color contributes. His rather haphazard (read fortuitous, not sloppy) application of color results in either the distinction of parts, when more than one color is used, or in monochromatic unity of disparate elements. The fusion of color and form is not an issue for Smith.[103] At the same time, Smith's use of color does relate to one aspect explored by Minimal sculptors: nonnatural color increases the abstractness and nonreferentiality of the work of art.

By the early sixties, many artists besides Smith and Kelly had begun to paint their sculpture. Judd considered the issue to be one of the "big fake challenges," one that did not much concern him.[104] For most Minimalists, the painting of sculpture was a natural result of having painted canvases. Trained in the fifties, they had learned the techniques of painting, since there was not then a vital sculptural tradition in the United States; even David Smith did not think of himself as a sculptor.[105] When it appeared that painting issues had been thoroughly exhausted, the move to three dimensions was made, with the artists retaining a few concerns, such as color, and dispensing with most, such as figure-ground relationships. Judd's, Morris's, McCracken's, and LeWitt's work progressed from paint on canvas to wall-mounted relief constructions. All arrived at freestanding painted sculpture before 1965. Flavin had also been a painter before turning to sculpture, though his use of color through light is extraneous to the issue at hand—he is making sculpture of light rather than colored sculpture.[106] The prominent exceptions to the generalization of painter turned object-maker are Andre and Truitt, who have always been sculptors. While not a major aspect of Andre's work, color is the central issue in Truitt's. Her study of painters, from the American Luminists to Reinhardt, inspired her sculpture.[107]

Color was an important issue for those more firmly rooted in the sculptural tradition, since it had not been a vital concern for previous

sculptors and was relatively unexplored in three dimensions. George Sugarman, David Weinrib, and Tom Doyle were especially bold colorists. Lippard characterized this faction of sculptors as emphasizing "gesture, immediacy, intuitive and highly personal form," in direct response to Abstract Expressionism.[108] Caro, who had been Moore's assistant, and his students were also more sculptural in orientation. "Their attitudes," according to Lippard, "are sculptural attitudes adapted to an era dominated by painting."[109] The Park Place artists, with whom the English sculptors were identified, were interested in color as a new option for the sculptor. This group, which was avant-garde by design, treated polychromy as a significantly contemporary issue. Many of the Park Place painters used similiarly brilliant colors in their paintings, which made their art appear nontraditional and up-to-date.

Painted sculpture preceded the extensive use of inherently colored industrial materials by a year or two. Applied color had one major drawback: it nearly always functioned as a skin covering the object beneath.[110] This was of considerable importance, since any formal or perceptual disjunction affected the unity of the piece. Judd was the most concerned; and it was he, on account of his unorthodox use of color, who was generally accused of this disparity of surface and shape.[111] In relating a conversation with the artist, Amy Goldin described the problem: "Judd's chief worry about color is to avoid having it act like a second surface, a skin lying on top of the form. 'Of course it is a skin physically,' he admits, 'but it shouldn't look like one.'"[112] Michael Fried also considered this distinction between color and shape by noting that the color of a sculpture, unlike color in (most) painting, is "identical with its surface."[113] At the same time, if the form of the object is complex, paint can provide unity. Using color in this manner was more characteristic of British than American sculptors, particularly Caro, who used color to unify disparate elements.[114] While the Americans struggled to overcome the "skin problem," Tim Scott appreciated color in sculpture as "a skin envelope of a unifying character."[115] The Minimalists had no use for this function of color, since the shapes they used were already simple, without disparate parts.

Judd credits Chamberlain for introducing the issue of color into contemporary sculpture. He commented upon Chamberlain's unique use of color as an integral aspect of sculpture as early as 1960, and continued to stress the use of color as structure in subsequent reviews of the artist's work.[116] Judd's colors were influenced by Chamberlain, who suggested the use of Harley-Davidson "Hi-Fi" lacquer.[117] In all of Chamberlain's work, whether it retains the original automobile paint or is repainted by the artist, color is as important as shape. The colored planes are crushed and conjoined to the extent that each piece seems inevitably colored, unimaginable without its particular hue. Because color is used structurally, it seems less

like an added skin or covering. Judd achieved a more taut and brittle surface in his own work by applying enamel or lacquer on metal, in place of oil paint on absorbent plywood.[118] When the surface of the metal is allowed to show through the paint, such as in the Museum of Modern Art's purple hemicylindrical progression of galvanized iron, the form and its color are inextricably fused.

The absorbency of wood is a feature Truitt likes and believes is instrumental in unifying color and material. Color, she has found, will not "marry" metal. She is concerned with color more than most Minimalist sculptors, and has stressed the fact that colored sculpture was a natural evolution rather than a radically theoretical maneuver: "I realized that I was interested in counterpointing color and form. I never thought of painted sculpture.... I thought entirely of solid blocks of color ... units of color which changed in the center of them, not on the outside. I never thought of applied color."[119] Color appears to radiate from within, rather than to function as a skin over the object.

Where Truitt's color is somewhat disembodied, McCracken's plywood planks are as much shaped as colored, although the specific nature of the wood support is disguised. Color and form are fused so that the lacquered and fiberglass-coated boards read as solid bars of color.[120] Variously described as "vehicles for color" and "container[s] for color,"[121] the simplicity of his shapes and the complexity of hue and surface result in a complete unity of form and color. The artist himself seems to understand this best: "I think of color as being the structural material I use to build the forms I am interested in."[122] Other artists, such as Kauffman and Robert Irwin, applied color to their forms by spraying clear Plexiglas with acrylic or lacquer paint. Regardless of its shape, Plexiglas tends to retain its sheetlike appearance, and its transparency allows the applied color to seem inherent, not added.

Colored plastics, with their bright commercial hues, were the most obvious solution to unifying color and shape. In Claes Oldenburg's soft vinyl sculptures, for example, color is literally inseparable from shape. Judd inserted a plane of purple Plexiglas in a floor sculpture in 1963; the boxes of steel and Plexiglas were begun the following year. Aside from the transparency of Plexiglas, Judd appreciated that "it has a hard, single surface and the color is embedded in the material."[123] Larry Bell achieved a similar effect with the mirroring of plate glass. A related process is anodization, through which color is electrolytically fused to metal. Judd prefers this process to painting, but the expense and technical requirements are prohibitive.[124] Although few sculptors used this technique in the sixties, it was an effective solution to the fusion of color and form.

The choice of a particular color was made because of its capacity to

articulate form. Judd painted his wooden structures cadmium red light, a color that best defined the shape's edges.[125] While Judd rejected white, LeWitt preferred it to black, explaining that "white was the best because it showed all the planes most clearly."[126] Both artists discovered that black blurred rather than articulated the edges and shape of the form. To some extent, Morris's use of light gray functions similarly. He argued against "the use of color that emphasizes the optical and in so doing subverts the physical," maintaining that neutral colors were more consistent with the nature of sculpture.[127] Although Judd and Lippard disagreed with his contention that gray was colorless,[128] Morris's choice of a color that distinguishes shape aligns him with Judd and LeWitt.

In Judd's work, a single color always identifies a single shape, element, or surface, a self-imposed restriction that promotes the articulation of form.[129] The division of a surface by two colors disrupts the unity of the object and fractures the form. Judd was particularly critical of Truitt's coloristic violation of the singularity of surface, an observation concurrently made by Fried.[130] Around 1965, in transition from painting to sculpture, McCracken produced a series of slotted boxes, frontally oriented and placed on bases. These are technically executed in the same manner as the early planks, although the boxes are multicolored with two or three internal divisions. Upon seeing these, Lippard was bothered by "the apparent lack of connection between the color and the forms; the combinations seem arbitrary, as does the division of the forms."[131] In these sculptures, the color did not inform the shape so much as divide and decorate it.

Highly polished surfaces, enhanced by sensuous color, provide an antidote to the conceptualized form of Minimal art. Gleaming metal and fluorescent Plexiglas seem luxurious and opulent, often to the extent of overwhelming the spectator. Knute Stiles parenthetically related an anecdote concerning Judd's untitled steel and Plexiglas box of 1968 in the San Francisco Art Institute show Untitled 68. Stiles asked a visitor to the exhibition "if he felt the 'Do Not Touch' sign was almost a challenge to touch. He replied, 'No, I wouldn't touch it anyway. It's too blue.'"[132]

Morris's gray plywood and fiberglass structures have the opposite effect: their color, as Judd detected early on, is "inconspicuous."[133] LeWitt's white is also neutral and nonexpressive. There is none of the color-derived sensuousness so obvious in Judd's and McCracken's sculptures. Tony Smith justified his use of black by claiming that it was the least arbitrary of colors.[134] Here, by turning the issue of polychromy back onto itself, Smith's black appears to effectively rule out the option of color in sculpture.

Most painters tended to leave exceptionally brilliant colors to the sculptors. More prominent were neutral or industrial colors that had no

natural or emotional associations, but were rich in their reductive subtlety. The use of neutral colors, especially black, white, and gray, in the 1950s and 1960s was prompted by their resistance to interpretation. Reinhardt thought of black as the "absence of 'color'" and "non-color," empty and nonassociative.[135] To some extent, Minimal artists were also influenced by Johns's use of gray and by Rauschenberg's white and black paintings.[136] Stella's metallic paintings, described by Robert Smithson as "impure-purist," appear anonymous and almost incidentally colored.[137] Industrial colors, particularly metallic ones, parallel the sculptors' new materials, by connoting a certain functionalism. Such surfaces reflect light, rather than absorb it, and affirm the flatness of the picture plane and the actuality of the object.

Although influenced by Stella's Aluminum Paintings, Mangold did not use metallic paints.[138] The industrial quality of his colors was the result of an urban reference in his paintings. He explained that the Walls and Areas (exhibited at the Fischbach Gallery in 1965) were always *some* color, whether it was brick-red, cement-gray or the color of subway walls.[139] The associations were like inspirations, so vague that the colors, instead of recalling brick or cement, appeared neutral to the point of nothingness. More than most painters, Mangold has received harsh criticism for being almost too "minimal." Shape, size, and color are so carefully balanced that no one element overwhelms. Although the Walls and Areas were modified from edge to edge by subtle coloristic gradations, even this variation was seen to be ascetic. Michael Benedikt complained that the gradation of color denied to the spectator the pleasure of enjoying "near blocks of flat color."[140]

Stella's Black Paintings of 1959–60 were generally criticized as black and white stripe paintings, although he thought of them as purely black, "what he felt to be a neutral, non-color."[141] Neutrality was also the central issue of Baer's and Ryman's work.[142] Ryman has worked with a multitude of whites over the years, but always white. The colors of Marden's early gray paintings were described as "unnameable."[143] "A color," Marden has said, "should turn back into itself. It should reveal itself to you while at the same time it evades you."[144] In the 1970s, Marden made specific coloristic references to nature and landscape. Like Mangold's allusions to the man-made environment, Marden's inspirations come from his surroundings. Paul Mogensen preferred understated, less referential color. His rectangular canvas panels, arranged separately from one another across the wall to form a single image, "are intended strictly as color supports."[145] For Novros, color was "synonomous with, or inseparable from the form."[146] Color was not decorative, expressive, or symbolic, but an integral aspect of formal definition.

Monochromatic Painting

Not all abstract painting in the 1960s was strictly monochromatic. It could be said, however, to be generally composed of close-valued hues or single color panels in a multipanel configuration. As a category, monochromatic painting encompasses the purely monochrome of Yves Klein, the apparent monochrome of Ad Reinhardt and the predominantly monochrome of Jo Baer. These artists and Stella, Ryman, Mangold, Novros, Marden, and Mogensen most fully explored the issues of one-color painting, a phenomenon that was nearly unprecedented and continues to be viable thirty years later.

Historians of monochrome painting inevitably begin their discussion with Kasimir Malevich and Alexander Rodchenko.[147] Their conception of space, however radically it rejects gravity, is implicity pictorial. In contrast, Yves Klein's blue paintings were comparable, in their simplicity and objecthood, to the new American work, according to Judd, by being completely "unspatial."[148] Purely monochromatic, with rounded corners, Klein's work dispensed with the illusion of painting as window. As a critic in the early sixties reported, Klein's process originated in the experience of "a void; then a profound void, then a very deep blue."[149] By the time of his 1967 retrospective at the Jewish Museum, which immediately followed Reinhardt's, most critics considered Klein to be more interested in the Dada gesture, the act of creating or presenting, as opposed to the form, particularly in comparison to Reinhardt. Judd, of course, had not been incorrect in his assessment. Klein's paintings, which were conceived in the mid-forties, were one of the few European precedents—formally at least, if not in intention—of Minimal art. Klein exhibited at the Castelli Gallery in 1961 and 1962, seminal years for the young Minimalists.

One of the earliest American experiments in monochrome was Robert Rauschenberg's *White Painting* of 1951, a seven-panel painting exhibited at the Stable Gallery in 1953. Most of the controversy surrounding *White Painting* had to do with interpretation, although Greenberg later recalled that the white and black paintings in this exhibition were, far from appearing radical, in fact quite easy to "get."[150] Many critics saw the painting as a blank or empty stage, an environmental work of art upon whose surface lights and shadows were reflected. Quoting Rauschenberg, Calvin Tomkins took this to be the function of the painting, as did Carter Ratcliff as recently as 1981.[151] In the sixties, when nonillusionism and matter-of-fact objectness occupied the minds of critics, Lippard denied the random temporality of the white paintings, and claimed, also quoting the artist, that the paintings were generated by a desire to make paintings, and that their meaning rests in a silent, blank nothingness.[152] In light of Rauschenberg's *Erased de Kooning Drawing* of 1953, the implication of Dadaist gesture cannot be denied.

This does not preclude the painting's environmental quality, an issue raised by all monochromatic work, in which the focus is outer- rather than inner-directed. Rauschenberg's importance for later monochrome painters resides in his having done it, in presenting one-color painting as a viable option.[153]

In her 1966 catalogue for Reinhardt's retrospective at the Jewish Museum, Lippard noted that ten years earlier, his monochrome paintings were seen as "empty stages upon which the observer could act out his own interpretive fancies."[154] It was clear by the sixties that the formal purity of painting was at stake, and not a theatrical proposition or anti-art gesture. Beyond Klein and Rauschenberg, Reinhardt represents conscious reductionism: the deliberate elimination of detail and relationships in affirmation of the art of painting. The symmetrical composition and close-valued hues of the black paintings, though contemporaneous with early Minimal painting, were influential in their purity. The paintings lack the impenetrable stubbornness of Minimal art, but the artist's astringent polemics in the name of unity, illustrated by "the one painting ... monochrome, one linear division in each direction, one symmetry, one texture ... " that he produced over and over again from 1960 until his death in 1967, parallel Minimal theory of that decade.[155]

In general, monochrome had become a legitimate, if not widely practiced, approach to painting in the 1950s. Fully or nearly monochrome canvases were exhibited by Rollin Crampton, Ralph Humphrey, Sally Hazelet-Drummond, Yayoi Kusama, Agnes Martin, Milton Resnick, and Paul Brach. Certain artists of the sixties, including James Bishop and Dan Christensen, continued to explore the possibilities of monochrome in the direction charted by Still, Newman, and Rothko by increasingly suppressing value contrasts.[156]

For many young artists, Abstract Expressionism appeared to have exhausted all the relevant painting issues. The alternatives were now the rejection of two-dimensionality altogether for the "primary structure," "specific object," or "unitary form," or the monochromatic canvas, which substituted nonillusionism, clarity, and singularity for traditional composition and pictorial space.[157] Greenberg, unhappily convinced that advancements in art (at least in the sixties) seemed to be made by continuous striving for the "look of non-art," proposed that since monochrome painting was already acceptable, sculpture was the only option.[158] Some critics viewed painting as a limited enterprise. It was necessarily restricted to the two-dimensional plane, upon which color or colors were laid. Sculpture presented the opportunity to escape from these limitations, according to Lippard.[159] In "Specific Objects," Judd voiced his discontent: "The main thing wrong with painting is that it is a rectangular plane placed flat against

the wall." While Judd had even more complaints about the nature of sculpture, particularly with respect to its part-to-part composition, he preferred to make three-dimensional objects.[160] For Rose, "Judd's position is the most extreme: he believes that 'sculpture is finished,' although painting is still lively."[161]

For artists who began to show around 1965, painting seemed again viable because of the great proliferation of sculpture in the preceding two years. These painters, Lippard wrote, were "occupied with a further progression of painting, despite the contention of some critics and artists that painting is obsolete."[162] Mangold was aware of the critical objections to painting, but he countered that "one of the reasons people gave for saying that painting was dead [its capacity to be immediately and wholly perceived] seemed like the very thing that made it extremely unique and important."[163] Marden was particularly concerned with the tradition of painting.[164] Aware of and influenced to some extent by the work of Judd and Morris, he saw himself as pursuing the line established by painters like Newman, Kelly, and Stella. While it was common to hear "Painting is dead," in the early sixties, Marden said he never believed it.[165] Novros, also impressed by Judd's early work, chose to continue painting and to deal with color and the right angle as painting rather than sculptural issues.[166] Like Marden's, his work is grounded in history, as his frescoes of the seventies and eighties have demonstrated.[167] Along with Ryman, these artists are emphatically *painters*. Nearly two decades earlier Reinhardt had said, "The content [of abstract painting] is not in a subject matter or study, but in the actual painting activity."[168] Painters of this persuasion were more concerned with the application of paint on a surface and making pictures (implicitly two-dimensional) than with making objects of any sort. According to Grégoire Müller, "The colored uniform surface presents itself as a 'fact,' an entity referring to nothing else but itself.... One of the pitfalls that these painters avoid by different means is that of making of the canvas a 'specifc object' or a sculpture."[169] It is a tenuous position to maintain: the insistence on surface while denying the three-dimensional object-nature of the support.

Although neither Robert Irwin nor Jo Baer stressed the objectness of their paintings, there is at the same time a de-emphasis on the opacity of surface.[170] The resulting transparent space is not the same as the "optical" space of Abstract Expressionist painting, through which, according to Greenberg and Fried, one travels with the eye, the kind of space, Rosalind Krauss suggests, exists before the viewer like a mirage.[171] Instead of nontactile space, in the work of Baer and Irwin one is presented with a sort of two-dimensional void, if transparency can be described as flat.

Once painting becomes totally flat, it necessarily begins to relate to the

wall. By eliminating relationships within the picture itself, relationships are (must be) established between the painting and its surroundings. Thus, painting appears to deal with sculptural issues, like shape and placement. Stella's paintings were the first to propose this, although like Reinhardt, he was also concerned with the actual process of painting.[172] In a review of the Copper Paintings, Judd remarked that they looked like reliefs; Fried has dealt with Stella's work almost completely in terms of shape.[173] Beyond the fact that the paintings are literally shaped, flatness and the avoidance of coloristic relationships force the spectator to deal with the pictures of 1960–61 as objects in an environment.

The boundaries of painting and sculpture were often crossed. Sculptors dealt with issues of color, previously confined to painting, while painters were forced to take into account, because of their rejection of pictorial illusion, issues of three-dimensional work. There was an element of cross-breeding between the arts, with the shaped canvas being the most obvious result. (Painted reliefs and wall-oriented sculptures were also prevalent.) Charles Hinman and Sven Lukin in the United States and Richard Smith in England practiced this hybrid form. There was a residual illusionism in most of their works, although the forms contributing to it projected outward into the viewer's space rather than inward into pictorial space. Michael Heizer's shaped paintings, which were shown at Park Place in 1967, are in fact more sculptural than pictorial. McCracken's plank-sculptures, which lean against the wall, were often associated with shaped paintings. One critic found them to be the closest of all efforts to occupying an intermediate position between painting and sculpture.[174] E. C. Goossen was severely criticized by Philip Leider for maintaining that "as for John McCracken's slabs of sheer color, it is hard to tell whether one is confronting a painting or sculpture."[175]

At this point, the danger for painters was the possibility of losing sight of pictorial issues for the sake of wholly sculptural ones. Some semblance of "picture" was maintained by not departing too dramatically from painting's rectangularity. Mangold and Stella, by adhering to a two-dimensional, rectilinear format, remained painters, not sculptors: Hinman's reliefs, on the other hand, propose sculptural issues.[176] An alternative to the shaped canvas was the multipaneled picture. In Kelly's and Marden's work, the physicality of the support is emphasized by real, as opposed to drawn, lines at the junction of two panels.

Shaped or not, monochromatic painting always appears to have a shape. The eye, not satisfied with an imageless picture plane, travels quickly to the framing edge. Some sort of internal variation, surface texture or figuration, is necessary for de-emphasis of shape. Müller's analysis of Reinhardt's trisected image is a case in point.

The bands of a Reinhardt act as edges which prevent us from falling into all that he does not wish pure painting to be. . . . Within the limits of the painting, all that Reinhardt could have otherwise done would have permitted the eye—and the spirit—of the spectator to "go out" toward something else.

. . . When the eye arrives at the border limits of the canvas, it circumscribes this intensity within the space and recreates the sculpture or the object (as in the case of the monochromes of Yves Klein which, as opposed to those of Reinhardt, are "symbolic objects").[177]

Ryman's gestural paint application and Baer's black "frames" call attention to the interior of the painting; Stella stands somewhat in the middle with internal striping as well as irregular shaping. The Aluminum Paintings are more surface-oriented, the Copper Paintings, which are less rectangular, more shaped.

In painting, a two-dimensional unity of the picture plane results from the use of a single color, at the expense of figure-ground relationships. Reinhardt persistently sought unity or "oneness" through monochrome, a process eventually so refined that, in the black paintings, the picture plane seems spatially indivisible, although the trisection is evident. Stella was also aware of this effect: "The uniformity was simply that of, say, a monochromatic color rather than the way it was actually painted."[178] In multipart paintings, monochrome results in what James R. Mellow called "color coding, identifying individual units in a set."[179] As in sculpture, a single color unifies at the same time that it articulates.

In the case of painted sculpture, applied color had a tendency to function as a skin. Painters had not previously confronted this issue, since the physical surface of the picture was presented as if it did not exist, opened up to expose a unified set of images behind the window of the painting. The painting was not read in terms of a coat of paint on a panel of canvas. Once illusionistic pictorial space was replaced by flatness, the surface itself became a critical aspect of the painting. Separate identification of the physical support and a skin on top affected the unity of the painting. With reference to the narrow strip of unpainted canvas at the lower edge of Marden's paintings, Sheldon Nodelman observed that the "surface [of the paint] defines itself as a separate entity; a sheet which has been drawn down over the underlying object."[180]

Stain painting, like Helen Frankenthaler's or Morris Louis's, was one solution to the problem of unifying color and surface. Raw canvas, which functions as nonapplied color, absorbs color to the extent that it appears inextricably fused to the surface. The overall texture of the canvas remains visible, whether painted or not, to assert the lateral unity of the painting as well. When thicker paint or a less absorbent material is used, other solutions are sought. Ryman's *Standards*, of enamelac on cold-rolled steel, over-

come the appearance of painted objects by the thinness of the support. Materials generally associated with sculpture become, in Ryman's hands, those of a painter. Mangold neutralized his colors to prevent the dominance of any one aspect.[181] The result was an absolute unity of color, shape, and surface. Like McCracken's planks, Mangold's Areas simply are that color.

Sculptors and painters of the sixties shared a commitment to the single, unified image. Color created as many problems as it solved. Although any color could blanket the support and unify the surface and its elements, it often appeared arbitrary or facile. Color was forced into a completely structural role; the work of art had to appear to be built of its color. Just as hierarchies were avoided within the limits of the picture plane or the three-dimensional structure (the rectangle and the box being the most satisfactorally neutral), neither shape nor color predominated.

"The Vanishing Base"

The frame of painting, which sets it off and distinguishes it from ordinary objects at the same time that it underscores the window-quality of painting, disappeared a generation before the sculptural base. Traditional sculptors had not been unconcerned with issues raised by the convention of the base, yet a full-scale rejection had somehow never occurred. Before the early 1960s, most sculptors assumed the givenness of the base. An exception was Yves Klein, who dealt specifically with the "liberation of sculpture from the pedestal," in works such as his 1957 "aerostatic 'sculpture' composed of one thousand and one blue balloons" released into the sky.[182] By the mid-sixties, three-dimensional work without a base was common. The rejection of the base was made on the basis of formal and theoretical notions about the ontological status of the work of art.

According to Jack Burnham, the base functions primarily to support, to distance and dignify, and to isolate the work above it.[183] It physically elevates the sculpture, thereby severing the work of art's contact with the ground. Thus, sculpture becomes a thing apart, not sharing the spectator's space, but creating its own space, often delimited by the circumference of the plinth. The experience of sculpture which stands on the floor without the interference of a base is more direct and immediate.[184] Here, confrontation takes place between spectator and object on equal terms.

The spatial separation of the sculpture from the spectator also results in a metaphysical disjunction. Like the frame of a painting, the base signals the illusionistic quality of the mounted work of art. According to Nodelman, the frame and the base are agents "separating the fictive world of the reperesentation from the life-space of the spectator and thus defending the ideality of the work."[185] Freestanding, nonabstract sculpture has always

dealt with the human (or animal) figure, rather than landscape or still life, which exist in a *given* space. The base functioned to emphasize the unreal status of the object it supported—that is, as a clue to the mimetic nature of the work of art. According to Judd, it is directly related to the fact that sculpture is figurative: a "statue" always has a base.[186] Anthropomorphic sculpture is also oriented by its base, "a tacit acknowledgment that all mammals have a top and bottom or head and feet, plus a ventral and dorsal side. The base is a biological reaffirmation that man is constructed to walk the ground, to gain his mobility through successive contacts with the earth."[187] The base is no longer necessary for sculpture freed of the task of representing or even alluding to the human figure. The proliferation of horizontally oriented, as opposed to vertical and therefore anthropomorphic sculpture, also denied the base its practical function of support. In these cases, the ground makes a more reasonable platform.

The base distinguishes the object it supports from other things in the world. It informs the spectator that he or she is confronting a member of a special class—sculpture—and signals the preciousness and uniqueness of the object. Samuel Wagstaff noted that the two-by-fours underneath Tony Smith's *Black Box* "keep it from appearing like architecture or a monument, and set it off as sculpture."[188] Truitt relinquished the base early in the sixties, but was often surprised by the remarks of visitors to her exhibitions at the Emmerich Gallery. "Where's the sculpture?" they would ask, unwittingly acknowledging that the base serves as an immediate signifier of art.[189] Burnham deduced the rejection of the base from this one traditional function. As anything placed on a base (since Duchamp) automatically became sculpture, any meaning the base might have had is negated. Once conventional notions of uniqueness and illusionism were surpassed in favor of anonymity and reality, the base was rendered ineffectual and meaningless.

The propensity for literalness—that is, the complete consideration of all that is presented to perception—prompted critcs and spectators in the sixties to question the function of the support. No element could be overlooked that was apparent to the eye. Larry Bell's exhibition of mirrored glass boxes on clear plastic pedestals and white plinths at the Pace Gallery in 1965 was especially controversial. LeWitt remembered: "We wondered if the base was something you're not supposed to look at. . . . Maybe it's like the Emperor's clothing. But there it is, just as physical, perhaps more physical than the object on top of it." Lippard saw the total work as adding "up to a sculpture of three parts, detracting from what starkness the box might have on its own."[190] LeWitt concluded that unless the base had a specific function, "it seemed absurd."[191] Coplans, always the insightful defender of West Coast artists, explained that "Bell's glass constructions demand the entry of light through the bottom to gain maximum luminosity and the

desired quality of spatial intangibility."[192] The "problem" was resolved later in the decade, when Bell presented his series of Walls, large glass sheets that stood directly on the floor.[193]

Burnham traces the elimination of the base through the history of modern sculpture. Both he and Dore Ashton point to Rodin's *Burghers of Calais* as an early instance of a sculptor's conscious desire to eliminate the base and place the work of art directly on the ground.[194] By interrelating the pedestal and the sculpture, Brancusi did not do away with the support, but moved toward the eventual incorporation of the base into the work of art. The Constructivists' nonanthropomorphic sculpture continues to rely on a support, but not gravity, as in the wall-attached wires of Tatlin's *Corner Relief*. The brothers Georgii and Vladimir Stenberg pared down the support so radically in their "KPS" constructions (*Kostruktsiia prostannogo sooruzheniia*) that the device, even if functional, seems to be part of the sculpture itself. (That the "KPS" constructions are now exhibited in museums atop low wooden plinths underscores the base's educational function.) The issues of the pedestal began to be of some widespread interest about the time the sculptures of David Smith and Chamberlain attracted critical attention. Their sculptures appear rooted to the ground, rather than set off from it, to begin at the earth's or floor's surface, and to rise upward.[195] In 1964, Judd noticed that younger sculptors were, like Smith, integrating the base with the sculpture by making it part of the whole.[196]

Caro is generally considered to be the first contemporary sculptor to eliminate the base.[197] *Twenty-Four Hours* of 1960 is completely self-supporting. Di Suvero's *Hankchampion* of the same year also stands on the ground with no interference. However, the elements of *Hankchampion* that touch the ground function somewhat like legs. Caro's works relate to the ground and essentially incorporate it into the sculpture. In a symposium published in *Studio International* in 1969, four younger British sculptors pointed this out: Caro uses the ground as an "active element of the sculpture." It is "like painting in that the ground is like a canvas, and [the parts of the sculpture] are like elements in a canvas." Furthermore, Caro is "articulating the spaces on the ground as shape."[198] In Caro's and di Suvero's work the ground is substituted for and functions as an integrally related base. Although the conventional base is rejected, the work of art maintains a relationship with a support. A similar approach can be seen in Robert Smithson's *Mirror Displacements* of the later sixties.[199] The ground is literally part of the work. On the other hand, the relationship of Minimal sculpture to the floor is not emphatic. The base disappeared, as Burnham suggests, by being incorporated into the work of art, in the pursuit of unity and singularity of form.[200] At the same time, he maintained that this affirms the truly sculptural nature of Minimal art. However, the inspiration came not

from sculpture, but from considerations of two-dimensional painting issues.[201] The use of the base was simply not presupposed by artists who were painters before object makers. Abstract Expressionist paintings without frames, such as Rothko's, were particularly influential in the development of sculpture without a base, as many artists and critics have pointed out.[202] Large size and scale induced the sense of a picture's independence. Artists of the sixties attempted to produce a smiliar effect in three dimensions.

Judd's objects of 1962 are especially relevant. According to the artist, "the absence of a base" was completely his own idea. His first freestanding, albeit frontal, object was originally intended to be hung on the wall like a relief, before he decided to leave it on the floor.[203] A wooden corner with a black projecting pipe followed. Unlike the sculpture of Caro and di Suvero, these works had few elements and did not relate to the floor through appendages or leglike supports. By 1963, Judd had developed the box format, a shape in no need of a base and which continues to serve him well. The boxes are the best example of what Burnham calls "floor-bound sculpture," although he uses the term to refer to the work of Caro and others besides the Minimalists.[204] Judd's works do not lift off or expand upward from the floor, but sit there inertly.

Truitt's early vertical boxes and slabs, as well as an aluminum piece of 1964, were exhibited on the floor. Although she eventually added shallow invisible supports beneath the columns to give the illusion of an upward lift, she feels she should not be credited with the innovation of sculpture without a base, since it was not a theoretical decision on her part.[205] Morris's *Column* of 1961 might be considered the first Minimal sculpture without a base. An eight-foot beam, it was originally a stage prop, subsequently exhibited in a gallery situation, and not really a piece of sculpture. *Column* has the appearance of a base itself, a larger version of the pedestal on which *Box with the Sound of Its Own Making* (1961) has been displayed.[206] This is not to denigrate Morris's influential contribution to the issue. By 1962, he too was presenting sculpture without the base, although it was not until 1965 that the objects ceased to rise up from the ground, lean or be suspended in some manner. Many of his early structures have specifically to do with the notions of gravity and support.

Other sculptors relied on the walls or ceiling for support. Flavin began attaching his fluorescent tubes to the wall in 1963. Although the metal housing could possibly be construed as a surrogate base, no critic chose that interpretation. Once illuminated, the pans behind the tubes are fairly inconspicuous. Also using the wall are Judd's progressions and vertical stacks of boxes. When questioned about these, Judd replied, "The wall goes through the piece and that's all."[207] If there is any relationship set up

between the expanse of the wall and the boxes (similar to the relationship of Caro's sculpture to the floor), it is less of a pictorial one; they are merely dependent on it for support. Like Flavin's light fixtures, McCracken's planks cannot stand vertically without the wall, but lean anthropomorphically like people without feet. A number of artists suspended their work from the ceiling in reaction to the traditional acknowledgment of gravity. Alexander Calder's mobiles are prototypical; and Morris's *Cloud* predates most efforts. Grosvenor's achievements were the most ambitious, although Weinrib, Michael Todd, and Oldenburg made important contributions. Unlike floor- or wall-supported sculptures, ceiling-bound work tends to be disorienting. Most Minimalists preferred sedentary balance and quietude.

There is no work more placid or unobtrusive than Andre's. Nor is there any work more intimately floor-bound to the point of being generally described as "floor-hugging." Many of his 1959–60 sculptures, inspired by Brancusi, were carved in such a way as to suggest a supporting pedestal. The beams of his Element Series (proposed in 1960, but not made until the seventies) rise directly from the ground. None of the works that follow make any reference to the sculptural base. His decision to make works of art that "hug the ground" resulted in the *Equivalents* which were exhibited at the Tibor de Nagy Gallery in 1966.[208] The magnet pieces were created this same year, prefiguring his signature metallic plates. Andre succeeded in squeezing out sculptural space to the point of near two-dimensionality. The complete horizontality of his pieces effectively eradicated the issue of the base. The object is transformed into a place marker.[209] In contrast to the distinction and dignity of an object mounted on a base, the floor pieces may, as Andre wishes, go completely unnoticed by the casual spectator.

By the middle of the decade the use of the base had all but vanished in advanced sculpture. In Shape and Structure, in January of 1965, only Bell and Robert Murray still relied on the base for support. The base was a rare phenomenon in Primary Structures. It was nowhere to be seen in the Dwan Gallery's "10," in October 1966.

2

Internal Issues: Composition

Where process issues concern the work of art as a *physical object*, internal and external aesthetic issues pertain to the *perceptual object* as it is experienced by the spectator.[1] In Minimalism, such terms are presented comparatively, in juxtaposition or opposition: the relationship of parts (figure to ground, image to shape of the support in painting, unit to unit in sculpture) is internal; external relationships are on the other hand set up between the object and spectator. The issues, which an unprecedented amount of critical literature assumed the task of clarifying, are complex and intricate, especially in light of the formal simplicity of the works of art in question. Few critics saw them then, as William C. Agee did a decade later, as "foolish 'issues' of the mid-sixties."[2]

Nonrelational Composition

American artists of the 1960s described the composition of European paintings as "relational." This was succinctly characterized by Frank Stella: "The basis of their whole idea is balance. You do something in one corner and you balance it with something in the other corner."[3] Both relational and nonrelational composition specify the ordering of pictorial or sculptural parts, although in Minimal works, the parts are relatively few in number.

While relational juxtaposition underlies a good portion of traditional art, it is with Synthetic Cubism that this method of ordering was codified for modernism. In Cubist painting, an image is built up through the juxtaposition of flat planes parallel to the picture plane. Every angle is countered by an opposing line, setting up a dynamic tension in the center of the painting or collage that extends to the corners of the canvas. Mondrian extended the tenets of Cubism through perpendicular oppositions that produce a similarly active balance. This type of relational composition is even at work in the "checkerboard" paintings of 1918–19. As William Rubin writes, "Though the 'relational' aspects of such compositions were reduced

to minimal differences of accent—slight asymmetries in color placement, or discrepancies in the width of the black lines—these aspects still constituted the essential visual dynamics of the picture."[4] The perceptual movement generated by relational composition was especially attractive to Mondrian's followers, the American Abstract Artists, most of whom leaned toward the dynamic end of Mondrian's equation of "dynamic equilibrium." Fritz Glarner, for example, named his patterns of skewed rectangles "relational paintings." These and other A.A.A. paintings (which represent, with the exception of John McLaughlin in Los Angeles, the state of geometric painting in this country prior to the development of Minimalism) are non-statically balanced; and balance, as Stella pointed out, is a matter of relations.

Modern formalist criticism depends on relational composition for its evaluation of balance, harmony, and unified ordering of parts. The modernist viewer's aesthetic vision derives from Kant:

> What Kant terms the "free play of the imagination" thus can be viewed as the spatial and temporal ordering in the imagination of perceptions, the relating of parts (elements and complexes of elements) to each other in a variety of ways to determine whether a relatedness, a purposiveness of form, can be apprehended. "All appearances are consequently intuited as aggregates, as complexes of previously given parts."[5]

For the admittedly Kantian Greenberg, "The quality of art depends on inspired, felt relations or proportions as on nothing else."[6] An analysis of Greenberg's critical writing shows that he depends, for his judgments, on the unity arising from the manner in which formal elements have been combined—that is, according to Hilton Kramer, "the relations that obtain among abstract forms arranged in a decorative pattern."[7] Michael Fried championed Anthony Caro's work because of its relational nature. In contrast to Minimal sculpture, he wrote, "A characteristic sculpture by Caro consists, I want to say, in the mutual and naked *juxtaposition* of the I-beams, girders, cylinders, lengths of piping, sheet metal and grill which it comprises rather than in the compound *object* which they compose."[8] Pollock's paintings, equally appreciated, but for varying reasons by Fried, Greenberg, and the Minimalists, provided a model of nonrelational composition. His breakthrough, ultimately realized in *Number 1, 1948*, was to displace Cubist juxtaposition by equalizing all segments of the canvas. Parts and relations remain, but their formal significance as such is less interesting than the overall texture.

Brancusi's sculpture was also relevant in this context. Rosalind Krauss explained: "Given the unified quality of the single shapes, whether ovoid or finlike or voluted, there is no way to read them formally, no way to

decode the set of their internal relationships, for to put it simply, no relations exist."[9] Burnham and Judd also recognized the precedence of Brancusi, with Judd acknowledging Arp, Duchamp, and the Dadaists whose "objects are also seen at once and not part by part."[10]

In nonrelational composition, individual parts and elements play a subordinate role to the overall form of the work. It is not that elements are necessarily eliminated, but rather that the idiosyncratic or dynamic relationships between them are expended. Robert Morris observed that "art objects have clearly divisible parts which set up relationships," but that "certain forms ... do not present clearly separated parts for these kinds of relations to be established in terms of shapes. Such are the simpler forms which create strong gestalt sensations. Their parts are bound together in such a way that they offer a maximum resistance to perceptual separation."[11] Judd, also thinking of a simple shape such as a box, remarked that "it does have an order, but it's not so ordered that that's the dominant quality."[12] Balanced or equilibratory relationships between elements are no longer the source of composition. Instead, symmetry appeared to be the most obvious solution to achieving nonrelational composition.

By 1959–60, both Stella and Noland had developed symmetrical composition to the point that conventional Cubist balance was relegated to the art-historical past. Stella explained the new approach:

> Ken Noland has put things in the center and I'll use a symmetrical pattern, but we use symmetry in a different way. It's non-relational. In the newer American paintings we strive to get the thing in the middle, and symmetrical but just to get a kind of force, just to get the thing on the canvas. The balance factor isn't important. We're not trying to jockey everything around.[13]

Noland's circle paintings of 1960–62 (which do remain hierarchical in that the center of the canvas outweighs the corners) are apprehended by the spectator at once.[14] Concentric circles repeat one another, so that there's no question of how one part of the painting relates to another. Stella's Black Paintings, many of whose sides, but not top and bottom, might plausibly be reversed, are also oriented around the center of the canvas rather than from left to right. Corners mirror each other rather than counter one another as in Mondrian's work.

Symmetry tends to have what Rudolf Arnheim calls a "fossilizing effect," since the eye's propensity for directional scanning is essentially thwarted.[15] The whole notion of balance derives from the left-to-right reading promoted by Renaissance paintings, a convention most likely generated from reading of written text. Traditional painting is composed asymmetrically to compensate for this disposition, as well as to affirm the illusion of life and movement. Stella's symmetry, by contrast, made for "a sense of

unremitting stasis, and a configuration that could be instantly grasped."[16] Lateral symmetry (across the picture plane, as opposed to through it in depth) forces the spectator to change his or her viewing habits: no left to right scanning is encouraged. Reading is adirectional, and so relationships between one area of the canvas and another do not occur. Lateral symmetry implies imaginary quadrants of left and right, top and bottom. An axis, either centrally vertical or horizontal, is created to which the eye gravitates but tends not to cross.[17] Although Stella equated symmetry with the decision to "make it the same all over,"[18] one part cannot be substituted for any other part (except along divisional axes) because of the varying lengths of the stripes.

Pictorial depth was also treated symmetrically. In traditional painting with deep space, forms were strategically located so that the eye was guided through the painting in depth. Depicted objects were thus in an asymmetrical relationship to the picture plane. Such a painting cannot be sensibly switched from back to front. In contrast, nonrelational, symmetrical balance induces flatness. As evidence, Arnheim pointed out that, seen from straight ahead, the space of a theatre stage appears symmetrical and therefore flatter than it does when viewed from an angle, which skews the rectangle of the stage.[19] The effect of symmetry in depth was also described by Stella: "A symmetrical image or configuration placed on an open ground is not balanced out in the illusionistic space. The solution I arrived at—and there are probably others although I know of only one, color density— forces illusionistic space out of the painting at a constant rate by using a regulated pattern."[20] Like a laterally symmetrical painting without top and bottom, foreground and background no longer have any meaning. A view from behind the "scene" would be the same as from the front.

Symmetry in sculpture requires that the object look virtually the same from any viewpoint. Unlike earlier sculpture, which maintains vertical, front, and back anthropomorphic references, many Minimal sculptures could ideally be exhibited upside down, and approached from any vantage point.[21] Andre's early wooden pieces, though vertical, plainly deal with this notion, through implicit divisional axes. *Lever*, which instigates his rejection of compositional arrangement, is made up of one hundred thirty-seven bricks in order to avoid the possibility of relational or part-to-part reading by the spectator.[22] Andre's concern with "anaxial symmetry," in which "any part can replace any other part," is made manifest in the metal floor plates. Not only may the entire sculpture be read from any direction, but the particles themselves may be interchanged or inverted. The artist's refusal to permanently affix the elements reinforces their ultimately nonrelational character.[23]

Judd's attitude toward symmetry differs from Andre's. He has in fact

never made a single, regular cube that would read "anaxially." In an interview with Stella, who was extolling the virtues of symmetrical composition, Judd revealed that his work, although it might at times be symmetrical, was not predicated on that *per se*. It was *composition* (by which he means relational balance) that he was trying to avoid. Although he complained of Victor Vasarely's overindulgence in the "juggling" of structure, he later explained to John Coplans the process by which he arrived at the red box of 1963. "I did a great deal of juggling to make it uncomposed. I spent a lot of time determining where the trough should be on top of the box, having to do with it not being in any particular or obvious spot."[24] The spaces between the wooden slats visible in the trough also do not decrease in a regular order. Judd set himself the task of achieving nonrelational composition through asymmetry rather than symmetry. The progressions, which derive from the red box, are based on neutral mathematics, rather than idiosyncratic order, a method that precluded traditional balancing and distinguished Judd's work from Newman's, as Greenberg has pointed out.[25] Judd attempts to retain the wholeness of the piece above all and not to allow the disparity of the parts to interfere. For that reason, identical units are often used in structuring a piece. No comparison or counterbalancing is suggested, only "order, like that of continuity, one thing after another."[26]

By constructing a piece with only a few essential parts, the number of relations is automatically limited. Judd's desire to make works of art with a limited number of elements runs counter to the traditional method of additive or constructive composition: "When you start relating parts, in the first place, you're assuming you have a vague whole—the rectangle of the canvas—and definite parts, which is all screwed up because you should have a definite *whole* and maybe no parts, or very few."[27] Although, as Morris pointed out, there is no work that can have only one property, and therefore relationships are inevitable, simplicity can defeat the domination of formal relations.[28] The popularity of the box or cube format was based on this restriction. (A sphere would have done as well, yet was fraught with biomorphic associations.) Although ideal forms, boxes made by different artists are readily distinguishable. Judd's, in the sixties, were low-slung and industrialized; Morris's dull and space-consuming; McCracken's bright and slick; Tony Smith's dense and silent; Bell's airy and ephemeral. All of these constructions had six sides (or five, lacking a hidden bottom) and, except for Bell's, rested on the floor.

Because of the object's limited number of internal relationships, attention was turned to external relationships of scale and placement. The increasingly emphasized relationship between the spectator and the work of art was also a result of nonhierarchical organization of form, as Coplans pointed out: "All of Judd's floor sculptures are without any fixed sense of

front, back or sides, and the identification of any part as such is dependent on the position of the viewer in relationship to the sculpture at a given moment."[29] Hierarchical order has been the accepted method of composition since the Renaissance—and even earlier, in Gothic tympana where narrative elements were arranged according to importance. As Arnheim explained, the "hierarchical gradient," which depends on the number of elements within the field, "approaches zero when a pattern is composed of many units of equal weight.... Such works present a world in which one finds oneself in the same place wherever one goes. They may also be termed atonal, in that any relation to an underlying structural key is abandoned and replaced by a network of connections among the elements of the composition." In this sense, Pollock's paintings provide the best example of nonhierarchical organization.[30] The spatters of paint, repeated from one end of the canvas to the other, equalize the composition by making no part more attractive than any other part. There are not fewer parts with which to contend; only more similar ones. In Newman's work, nonrelational composition is achieved through a reduction of parts as well as through nonhierarchical organization. The "zips," by virtue of their strident tautness, and the highly saturated fields work together to produce the peculiar quality of wholeness so admired in his work. Both Judd and Walter Hopps wrote approvingly of Newman's structure in these terms.[31] In a different way, Stella's repeated stripes prevent the domination of one element over another, or the prevailing of the center over the edges. Noland's circle paintings, on the other hand, are less homogeneous since the raw canvas surrounding the image appears as ground or support for the motif. This is less evident in the chevron paintings begun in 1963. Here, since the image comes in contact with the upper corner, the field plays a more significant role and is less like empty space. The diamond-shaped paintings are organized nonhierarchically with each band seeming to be of equal weight.

Sculptors began using this method of composition in the early sixties, following Stella's example. Judd contrasted the new approach with traditional sculpture which is "made part by part, by addition, composed. The main parts remain fairly discrete. They and the small parts are a collection of variations, slight through great. There are hierarchies of clarity and strength and of proximity to one or two main ideas."[32] The new three-dimensional work, such as Andre's and LeWitt's, relied on repetition of the module rather than on thematic variation. Flavin's *the nominal three (to William of Ockham)* and Smithson's serial structures such as *Plunge*, dependent as they are on a basic unit (the tube or cube), owe a great deal to the repetitive patterning of Stella's Black Paintings.

The consequences of nonrelational organization were threefold: structures appeared increasingly anonymous as compositional decisions de-

creased; the impact on the spectator was more immediate as fewer details were presented for scrutiny; and most important of all, there was a resultant unity and wholeness of the work of art. Comparing Stella's work to Mondrian's, Fried noticed that "the different elements in Mondrian's pictures seem to have been *placed* in one relation or another to the framing edge by the painter himself," while the internal elements of Stella's paintings were determined by the whole, implying that his artistic decisions were severely limited.[33] While Stella was actually free to do whatever he pleased within the confines of the framing edge of the picture, nonrelational composition does tend to appear immutable, *as if* the artist had no choice. The givenness of the box-form is similarly static, although variations in coloration and proportion are still possible. The box must conform to certain requirements in order to remain a box. In reference to Morris's polyhedrons, Compton and Sylvester remarked that "the relationships between [the sides of a box] may not require the personal taste of the artist to create them."[34] This puts Minimalism directly at odds with Abstract Expressionism, in which individual sensibility at the moment of creation is all-important.

At the same time, the immediacy sought by Minimalists directly reflects the influence of Abstract Expressionism. Like the paintings of Pollock, work that cannot be read directionally hits the spectator wholly and at once, requiring no Kantian "spatial and temporal ordering in the imagination." Both Fried and Rubin have discussed the immediacy with which Stella's paintings strike the viewer. The motif "stamps" itself out as shape.[35] Morris also felt that noncompositional symmetry induced immediacy, directness, and unity.[36]

Unity and wholeness were obsessive concerns in the sixties. Although unity has traditionally been a positive aesthetic value (in contrast, generally, to chaos), many Minimalists worked and wrote as if it were the one and only criterion for a successful work of art. Most compositional devices were developed in accordance with this notion. If variously shaped and composed parts could not be differentiated in perception, the unity of the piece was assured. Without explicitly naming Pollock's method nonrelational, Judd explained that it was a new and different way of unifying a painting, and that it had to do with decreasing the disparity between parts.[37] Stella relied on "regulated pattern;" Judd on "one thing after another;" and Morris on "standardization and repetition."[38] Chaos simply did not stand a chance.

Figure-Ground

Hierarchical organization and the illusion of depth, which Minimalist symmetry denies, are the result of figure-ground relationships. The spectator

perceives and knows that the figure is more significant than the ground in a given painting. Although artists have always attended to such relationships, the phenomenon of figure-ground was not named and explored by perceptual psychology until this century. Edgar Rubin, in his *Visuell wahrgenommene Figuren* of 1921, discovered the spatial relationship between figure and ground, in which the figure area appears more solid than the environmentally loose ground on which it rests.[39] Gestalt psychology, developed by Wolfgang Köhler, relies on Rubin's distinction and is the basis for Arnheim's discussion of figure-ground relationships in painting. The figure is characterized as smaller and bounded or "confined by a rim," as opposed to the larger ground, which lies *behind* the figure. The figural area tends to appear denser and brighter than the ground, consistent with hierarchical organization. Arnheim explained that a balance between figures and ground areas must obtain, although the latter, or "negative spaces," are "subdominant" to the figure in order to avoid ambiguity.[40]

The elimination of figure-ground relationships satisfies the Minimalist predisposition toward nonrelational, and therefore more unified, compositions. Since it is impossible not to do so, figure and ground are always seen as two things. In order to prevent perceptual subdivision from hampering the wholeness of the work of art, Minimal painters eliminated the ground by extending the figure to the edges of the painting, as had Jasper Johns in his Flag paintings. Whereas a painting by Hans Hofmann presents the viewer with a series of figural rectangles poised on a continuous ground, a painting by Mangold is seen all of a piece, at once.

Fried attributes this radical reorganization of pictorial space to Pollock. In the drip paintings, line is read neither as a contour nor a shape in itself. It does not produce positive figural areas and negative ground areas. In fact, Fried notes, "We tend to read the raw canvas as if it were not there."[41] Figure-ground relationships do not occur because there seems to be no ground for them to occur *on*. One of the reasons for Fried's support for nonfigurative composition is its utter abstractness. Greenberg had observed that since all things exist in three-dimensional space, "the barest suggestion of a recognizable entity suffices to call up associations of that kind of space."[42] In other words, anything recognizable as a figure implies the space in which that figure exists. Fried described Wassily Kandinsky's line either as the "last trace of a natural object that has been dissolved," or as "a kind of thing, like a branch or bolt of lightning, seen in a more or less illusionistic space." Pollock's line, on the other hand, is completely "non-figurative," and results in the description of an optical field "devoid both of recognizable objects and abstract shapes."[43] Fried sees Pollock's nonfigurative paintings as the basis of subsequent modernist painting, in which image and ground are more closely identified than ever before.

Figure-ground relationship accounts for depth perception, in art as in everyday experience. The fact that a figure lies on top of or in front of its ground produces the illusion, in two-dimensional art, of some intervening space. As Greenberg put it, "The first mark made on a canvas destroys its literal and utter flatness."[44] Judd concurred: "Two colors on the same surface almost always lie on different depths."[45] One way to eliminate the illusion of pictorial space and thereby emphasize the wholeness of the object was to dispense with internal figure-ground relationships. According to Kurt von Meier, "The three-dimensional objecthood of the painting is most fully and consciously achieved by the artist when he sheds the last attempts to deal in illusionary space; in the history of twentieth century painting, this means when the figure-ground problem is finally resolved."[46] Mangold's work is probably the most boldly object-oriented. He preferred not to call his work "painting," since that term placed more "emphasis on the old idea of process, or applying paint."[47] Color and shape of the support are emphasized over surface quality, while the lack of discrete forms precludes spatial relationships. Subverting conventional figure-ground expectations, the series Walls was inspired by rows of buildings and the spaces between their silhouettes seen while riding the train.[48] The earlier, billboard-derived images were also commended for dispensing with figure-ground, although it is *composition* that they really reject.[49] Mangold's work is consistent in its pursuit of immediate impact at the expense of relational painting and illusionistic space.

Novros's early paintings are comprised of individual shapes spread laterally across the wall, wholly figural against the ground of the wall behind. Harris Rosenstein concurred with this reading of the paintings by noting the movement of the spectator's eye "along the axis of a shape and into implied complementary images of the wall space."[50] Positive and negative space function together to create the image. Novros, however, disagrees with the figure-ground reading, claiming that the empty space between the units is not part of the painting. He was making images, he said, not shapes.[51]

Stella's Black Paintings can be read alternately as thin white lines on a black field or as black bands on a white ground. However, either figure-ground reading is more forced than natural because of the repetitive configuration of the pattern. The painting appears first of all as a flat, incised rectangle. The image is single and runs from edge to edge. Unlike Pollock's paintings, there is no ground to be read away. Stella's and Noland's paintings are without figure-ground relationships, "contained or superposed forms," because, according to Nodelman, "no contrast [is] set up between the image-content and the picture-object."[52] Stella's Aluminum Paintings, in which there is less value contrast between the color of the bands and the

raw canvas lines, even more forcefully exhibit the nonfigurative by subverting the traditional rectangle as container of images.

Marden, Ryman, and Baer made some concessions either to surface beneath (as in Marden's margins at the bottom of the paintings, and Ryman's paintings on metal) or edge (Baer's "frame" paintings, and Ryman's paintings framed with waxed paper), although the centers of the paintings were sufficiently expansive to defeat obvious figure-ground readings. Responding to the antipictorial stance of Morris and Judd, Baer explained: "The last radical paintings to attend figure-ground problems were Noland's circle paintings of about 1960. Painters discarded ground altogether, and paintings became objects altogether. This happened some time before they were inflated into wall objects, up-to-ceiling objects and out-to-floor objects."[53] Internal figure-ground relationships were studiously avoided by painters. Although this was never an obvious problem for sculptors, the painters' strategy affected the priorities of sculpture in the sixties.

The Hegemony of Shape

Once the painted image was made to stretch across the length and height of the picture-support, the concern with the figure's relation to the ground was replaced by an attention to the relationship of pictured image to the framing edge of the support. Greenberg saw this as a fairly consistent modernist concern, of which the Cubists had been aware. "*Depicted* flatness— that is, the facet planes—had to be kept separate enough from *literal* flatness to permit a minimal illusion of three-dimensional space to survive between the two."[54] Fried subsequently appropriated the terms *literal* and *depicted*, which he defined respectively as "the silhouette of the support" and "the outline of elements in a given picture."[55] Although Fried was to parlay the relationship between the two aspects into "deductive structure," the simpler coincidence of image and shape appeared first in the critical literature and was infinitely more verifiable than was deductive structure.

Judd was the first to discuss the implications of such coincidence for sculpture. In Lee Bontecou's three-dimensional work, the shape and image are the same thing, he explained. "The reliefs are a single image. The structure and the total shape are coincident with the image."[56] The following year, 1965, he claimed that "Bontecou was one of the first to make the structure of a three-dimensional work co-extensive with its total shape."[57] There is nothing left over that is part of the total shape but not part of the image. In part, his analysis is due to the hollow appearance of her reliefs. The protruding shape, which is the skin of the structure, is also the image. The visibility of the armature, to which the skin is attached, also accounts

for Judd's conclusion. The armature spatially identifies the shape and structures the image.

Sculpture is the obvious medium for artists concerned that image and shape coincide—and it did ultimately attract many of the advanced artists in the sixties. Monochrome painting can also be said to solve the problem of figure-ground by making the image coextensive with the shape. Barbara Rose described Ellsworth Kelly's monochrome panels as "a way out of the figure-ground relationships that characterized the compositions of his earlier work." She continued: "In the sense that both the monochromatic rectangular panels and the freestanding sculptures are literal shapes in themselves and not depicted shapes, one can see them as alternative and equally viable solutions to the problem of eliminating figure-ground relationships."[58] This would extend to the shaped canvas as well, although there is a tendency for the actual shape to overpower all that is within, as in the radically shaped work of Peter Tangen and Charles Hinman. In discussing the implications of the shaped canvas, William Rubin explained that "Stella's solution to the problem lay in his *identification* of the field-shape with that of the pattern of the surface. Seen as the edge of that pattern, the shape of the irregular picture support was deprived of the autonomy—the separate identity—possessed by the outer contour of earlier shaped picture supports or reliefs."[59] As the spatial relationship of figure-ground was replaced by image-shape—relationships that occur literally "in the flat"—Fried developed his provocative theory of deductive structure. This causal relationship assumed that the depicted shape was not simply coincident with the literal shape, but was actually *deduced from* it. The Cubist attention to the framing edge of the support by making each line and shape conform to the edge was a tendency Greenberg saw turn into a modernist "habit."[60] For Fried, deductive structure was "a return to and reaffirmation of Cubism's implicit but decisive interpretation of the half-century of painting between Manet's first great seminal pictures of the early 1860s and the late works of Cézanne in terms of a growing consciousness of the literal character of the picture-support and a draining of conviction in traditional illusionism."[61] Fried's theory of deductive structure seems to derive from Greenberg's analysis of Newman's paintings. In "'American-Type' Painting," Greenberg suggested that the straight lines in Newman's paintings "do not echo those of the frame, but parody it. Newman's picture becomes all frame in itself.... With Newman, the picture edge is repeated inside, and *makes* the picture, instead of merely being *echoed*."[62] In his first article to outline deductive structure, Fried disagreed with Greenberg's analysis insofar as the verticals in Newman's paintings appeared to be based on "geometrical relationships" rather than to repeat

the framing edge. It was up to Stella to eliminate relational composition and replace it with an "internal logic."[63] When Fried wrote his definitive essay on deductive structure, in *Three American Painters*, he expressed a slightly different view:

> The bands [in Newman's paintings] amount to echoes within the painting of the two side framing edges; they relate primarily to these edges, and in so doing make explicit acknowledgement of the shape of the canvas. They demand to be seen as deriving from the framing edge—as having been "deduced" from it—though their exact placement within the colored field has been determined by the painter, with regard to coloristic effect rather than to relations that could be termed geometrical.[64]

Newman is thus honored as one of the greatest influences on painters of the sixties, artists who were "confront[ing] one of the most crucial formal problems thrown up by the development of advanced painting over the past decade."[65] Fried's crusade for deductive structure characterized most of his essays in the 1960s. Eventually, it was turned against Minimal sculptors, whose works, he felt, were wholly literal, in contrast to Noland, Olitski and Stella, who were dealing logically with the relations between literal and depicted shape.[66] Noland's breakthrough, he explained, occurred when the artist "discovered the center" of the canvas and began to deductively relate the image to the shape. In the chevrons of 1962, "all zones of color [were] related to the shape of the picture-support." Finally, Fried felt that Noland's suspension of the chevron-image from the upper two corners, and the freeing of its point from the bottom edge, was one of Noland's "most profound" decisions and one that made deductive structure explicit.[67]

Stella's Aluminum Paintings provided the most obvious illustration of deductive structure. In them, the "stripes begin at the framing-edge and reiterate the shape of that edge until the entire picture is filled; [the notches] make the fact that the literal shape determines the structure of the entire painting completely perspicuous. That is, in each painting the stripes appear to have been generated by the framing-edge." Deductive structure, as "the need to acknowledge the literal character of the picture support," resulted in the primacy of literal shape, Fried claimed. This assessment forced him to qualitatively differentiate between the literal character of Minimal sculpture, which he disliked, and the paintings of Stella, which he admired. Here Fried came up with one of the most provocative arguments of his career: he determined that Stella's shaped polygonal canvases of 1966 "are *not shaped*," due to the irregularity of the support and the geometric configurations within the works, complexities that prevent their being grasped as simple shapes.[68] About shaped canvases that are not shaped, Carter Ratcliff politely countered: "At the very least, then, a fictional realm has been presented."[69]

This most radical of assumptions was not the only one of Fried's theories to spark controversy. Deductive structure received its share of criticism. However, a few critics essentially agreed with Fried. Judd, probably on account of his own preference for coincidental image and shape, claimed that "the notches in [Stella's] aluminum paintings determine the pattern of the stripes within."[70] Nodelman expanded on deductive structure, citing what he called "paratactic ordering and frequently tautologous composition, with consequent complete absence of formal contrast and therefore of internally-focussed formal relationships," in which the internal parts are at once deduced from and dictative of the external shape.[71] Mangold explained his own approach to composition in terms of deductive structure: "Whatever goes on inside of any of my paintings is always kind of dictated by the perimeter. It always draws upon the shape of the work for what goes on inside." He did, however, differentiate his own work from Stella's. "In Stella's work there's always, even now, a pictorial relationship between what happens inside and the edge.... It's overly clear, in terms of the relationship." In Mangold's paintings, the relationship is less obvious, and less pictorial.[72]

Philip Leider and David Antin argued against the concept of deductive structure from a metacritical standpoint, but neither offered any reasons why deductive structure might actually be a false reading. Leider, in a review of the catalogue essay for the Fogg exhibit, termed the significance of deductive structure "unconvincing—and trivial," an idea that "teeters on the brink of the absurd."[73] Antin expressed doubts about the critic's invention of "art historical 'problems.'"[74] Fried's criticism, however, is so carefully structured and concretely demonstrated by the works of art he chooses as examples that arguments against its specifics, on its own formalist grounds, have little chance of success.

The most sensible critique of the theory is William Rubin's. In many of Stella's stripe paintings, "the patterns and lines [appear to] radiate out from the center of the canvas toward the edge."[75] As Coplans also observed, the organization of many paintings "begins at the center, and spreads outward by his use of various kinds of symmetry."[76] The effect described by Rubin and Coplans conflicts with Fried's implication that the stripes ask to be read from the framing edge inward. Fried attributes to Stella (and implicitly to Noland) what Rubin calls "deductive thought."[77] At one point, Fried noted that the configurations of Stella's shaped panels were influenced by the artist's "*prior* decision to achieve deductive structure,"[78] thus rendering the entire argument vulnerable to intentionalist attacks based on knowledge of how the pictures were actually made. Rubin cites Stella's process of cutting out the notches in the aluminum pictures after the pattern of the stripes had been determined, noting that "the framing edge was, in fact,

deduced from the surface pattern rather than vice versa."[79] Barbara Rose also claimed that the Aluminum, as well as the Black, Paintings were generated from the inside toward the edge,[80] not as Fried maintained on three separate occasions, "generated *in toto,* as it were, by the different shapes of the framing edges."[81]

Noland also disagreed with Fried's reading of his own painting in *Three American Painters* and the catalogue for his Jewish Museum show. Noland has always worked on unstretched canvas, whose framing edges are determined after the image is laid down, although, of course, he knows from the start what shape the painting will take. He sees his work as being different from Stella's. "It's as if Frank works from the outside of the picture in. I'd always myself felt like I was working from the inside of the picture out, and that the shape was a resulting factor rather than a determining factor."[82] Whether through his own observations, or Noland's convincing argument, in 1966 Fried conceded that in Noland's paintings "the literal shape of the support is made to seem the *outcome,* or *result,* of the depicted shapes," an analysis different from the one offered the year before.[83]

Fried further amended his theory the following year, substituting for deductive structure the acknowledgment of shape by structure.

> The concept of acknowledgment is meant to displace the notion of "deductive structure," which I have used in the past to describe the structural mode of Noland's and Stella's paintings and which now seems to be inadequate. One trouble with that notion was that it could be taken to imply that *any* structure in which elements are aligned with the framing-edge is as "deductive" (more or less) as any other. Whereas by emphasizing the need to *acknowledge* the shape of the support I mean to call attention to the fact that what, in a given instance, *will count* as acknowledgment remains to be discovered, to be made out.[84]

Fried's notion of "acknowledgment" was first outlined in reference to Newman in 1965. The following year, he claimed that "no single issue has been as continuously fundamental to the development of modernist painting as the need to acknowledge the literal character of the picture-support."[85] Deductive structure was in fact derived from this "need to acknowledge" in the first place. The revocation corrects the implicit causal relationship (that is, that the frame causes what happens inside to happen) and the emphasis on real process or the order of steps taken in constructing the work.

William Tucker suggested that young sculptors in the 1960s were attempting to accomplish similar goals. They were struck by "the idea of the raw materiality of a painting and the image being completely identified with the painting and not being *in* the painting. I think that in a general sense, you could say that that was what we were trying to do."[86] Positive

and negative space, rather than figure and ground, more appropriately de-
scribe internal relationships in sculpture. Mass, or in the case of linear wire
sculpture, line, is the positive element. Negative space, equal to a picture's
ground, denotes the empty areas circumscribed by the solid ones. Active
relationships, similar to figure-ground, are set up between solids and voids,
in a hierarchical manner. Negative space is a modernist concept, originating
perhaps with the Constructivists, but a most important concern for Henry
Moore and Barbara Hepworth. Three-dimensional art of the sixties returns,
in a manner of speaking, to making literal and depicted shape identical, as
it is in most premodern freestanding sculpture. Minimal sculptors used
negative space nonrelationally, or not at all. If empty areas do enter into
perception of the object, such as in Judd's vertical wall-bound pieces, it is
in external, rather than internal, terms. The empty spaces are not a part of
the objects, an assessment with which Novros would agree. In Minimal
sculpture, as Fried pointed out, (literal) shape is wholly predominant,
which accords with the notion of nonreferential abstraction, as well as with
the rejection of figure-ground relationships. The works are all figure; and
only figures, according to Gestalt psychologists, have shape. Thus, shape is
elevated to the "single most important sculptural value."[87] For Morris,
shape is a single thing, unified and immediately graspable. Judd's descrip-
tion of his 1964 horizontal wall piece from which five bars are suspended
also expresses the quality of unity afforded by shape: "To me the piece with
the brass and the five verticals is above all *that shape.*"[88] On the other hand,
di Suvero's *Hankchampion* does not appear to have a shape. "A beam
thrusts, a piece of iron follows a gesture.... The space corresponds."[89]
Minimal sculpture's lack of dynamic interaction with space derives from its
appearing neither convex nor concave (exerting or responding to pres-
sure), and from its emphasis on wholistic shape. A "shapeless" di Suvero
jabs the air. A cube sits inertly on the ground.

The appearance of Minimal objects as hollow shells depends, according
to Fried, on the emphasis on shape.[90] Traditional sculpture, because of its
figurative (in the sense of figure-ground as well as anthropomorphic) qual-
ity, is perceived as being solid. The "sculptural invention," as Burnham calls
it, of "the hollow, fully enclosed box form" originated with David Smith's
Cubis, but was fully explored by the Minimalists.[91] Smith's hollow struc-
tures differ from the Minimalists' because they are "used as planes and
lines," instead of shapes.[92] Chamberlain approaches the Minimalist sensibil-
ity by dealing with hollow volumes, although it is nearly impossible for the
spectator to conceive of his objects in terms of shape.

Hollowness assures that attention will be focused on surface. Unlike
Moore's work, there is no organic core or armature bound in an intricate
relationship to the surface of the sculpture. The sixties' penchant for literal-

ness, for unambiguous structure, was expressed by Stella's famous quip: "My painting is based on the fact that only what can be seen *is* there.... What you see is what you see."[93] Of all sculptors working with hollow volumes, Judd is the most concerned with clarity of structure, to prevent the objects from appearing mysterious or ambiguous.[94] Only Morris's fiberglass volumes (1965–66), split to expose fluorescent light inside, were interpreted in terms of secrecy, although Lippard noted that the division of volumes "specifically allud[es] to the hollowness of the shell."[95] In the work of Judd, Truitt, and especially Bell, the appearance of the exterior surface assures the viewer that nothing is hidden, that surface is all there is.

Hollowness prompted a debate about the monolithic nature of Minimal sculptures. According to Rose: "One knows that the monolith is solid, but what one knows or senses about the new sculpture is that it is hollow. (In Larry Bell's glass boxes and certain of Don Judd's works, this hollowness is made explicit.) This awareness of the interior space which [is] contained within the hollow volume does not allow us to treat the new sculpture as a monolith."[96]

Lippard disagreed: "They are monolithic, in that they are single shapes.... The shell idea seems invalid. There is no way of telling which structures are hollow and which are just made out of light materials."[97] Morris dealt with the argument in a practical and less aesthetic manner: "The objection to current work of large volume as monolithic is a false issue. It is false not because identifiable hollow material is used ... but because no one is dealing with obdurate solid masses and everyone knows this."[98] Although single in shape, Minimal sculpture is not truly monolithic because it is clearly hollow.

As Morris implied, the spectator, aware of the planar format of sheet steel, aluminum, Plexiglas, and plywood, knows that an object made of those materials is most likely hollow. Compton and Sylvester observed that Morris's gray polyhedrons "are perceptibly made of plywood (typically) by techniques familiar to any amateur carpenter. The objects are therefore clearly hollow."[99] Even the fiberglass pieces, in which the method of forming is less obvious, appear hollow due to the materials and the bulk of the volume. Judd switched from plywood to metal to ensure a hollow reading of the form, often recessing the lids of boxes to clearly expose the thickness of the material.[100] Judd, Rose explained, "takes advantage of the fact that the viewer knows the thickness or rather the thinness of sheet metal, and therefore surmises his volumes are hollow."[101] Anyone familiar with Plexiglas knows it originates in sheet form (unlike polyester resin), and will identify a Plexiglas construction as hollow. Kauffman's "washboards" of 1966, though opaque, are clearly hollow.

The transparency of glass and Plexiglas provides visual access to inner

structure. In many of Kauffman's transparent reliefs, the spectator sees the wall behind the object, whose shell-like appearance is thus reinforced. Judd turned to Plexiglas since it "exposes the interior, so the volume is opened up."[102] It also reveals the structure of the object, as in *Untitled* of 1968–88, in which the guy wires holding the two end plates in place are visible. Although Bell's boxes often seem to contain tinted air, there is no doubt about their hollowness. The surface of glass or Plexiglas is readily apparent, and assures the spectator that nothing is being hidden. It functions as both surface and structure.

Not all Minimal sculpture is hollow. Several artists define space without enclosing it. Andre has "always had a very primitive, infantile love of solids and the mass, the thing that was the same all the way through" as opposed to Judd, who claims to "dislike sculptural bulk, weight and massiveness."[103] Andre's pieces are never closed and hollow. Instead, one feels along with Krauss, "that internal space is literally being squeezed out of the sculptural object." She compares Andre's sculptures to Stella's paintings in the sense "that Andre's works exist completely at their surface, that depth or interior has been expelled." Barely describable as objects, Andre's floor-bound work exhibits his passion for mass and solidity, without volumetric spatial displacement. Since no internal space comes into play, no space is displaced. Krauss describes the floor plates as having "no appearance of inside or center. Rather they seem to be coextensive with the very floor on which the viewer stands."[104] They define a block of air above somewhat like that enclosed by others' shell like sculptures. One does not feel that pressure is being exerted on the surroundings. He simply prefers inert mass as opposed to inert volume. LeWitt's grids equally refrain from displacing space, and although not properly described as hollow, the effect is similar in that no hidden core or armature determines the shape of the exterior.

In a discussion of sculptural space Arnheim suggested that "the empty volume as a legitimate element of sculpture has led to works in which the material block is reduced to a shell surrounding a central body of air."[105] The planes do not push in on themselves toward the core implying the space of a vacuum, nor do they exert pressure. The core of air that the planes surround has the same character as the air outside the piece. The planes, in LeWitt's case imaginary, divide and define but do not displace, just as shells cover but do not take up much space. Even the bulkiness of Morris's shapes does not produce the illusion of displacement. There is obviously space inside of them. Compton and Sylvester explained the polyhedrons' appearance: "The sense one has of the sculpture being shells is also linked to the way they occupy space. That is, they fence it off rather than fill it absolutely."[106] The inertia of Minimal art is the result of an

instantly graspable shape. No work before or since evinces such bald immediacy.

Systematic Order

Only Stella continued to describe his arrangements of form as compositions: "I still have to compose a picture, and if you make an object you have to organize the structure. I don't think our work is that radical in any sense because you don't find any really new compositional or structural element."[107] A number of artists, such as LeWitt, Judd, and Andre, found modular and serial systems, as opposed to composition, more appropriate methods for structural intelligibility. As Mel Bochner, the primary commentator and exponent of the systematic approach, explained, "The fascination with seriality and modular form (which continues, disguised, in the work of many artists) made it possible at one point to clarify and distinguish the processes involved in the realization of the work of art."[108] Three distinct categories comprise the systems of the sixties: modularity, seriality in a single work of art, and the extended series encompassing a group of works. The systematic was appropriated from science and mathematics, fields that are based on rigorous order.

Artists of the sixties emphasized the distinction between what they thought were logical as opposed to rational procedures in art making. Paintings such as Mondrian's, models of relational balance, appeared to be determined by a process of reasoning whose steps are not known in advance. Each compositional decision is contingent upon the decision preceding it. On the other hand, systematic thinking, which was identified as logical, permits no such decisions once the pattern or system is chosen. As Ludwig Wittgenstein, whose influence was widespread in the sixties, explained, "There can never be surprises in logic.... Process and result are equivalent."[109] Accordingly, LeWitt described the difference between reason and logic: "In a logical thing, each part is dependent on the last. It follows in a certain sequence as part of the logic. But, a rational thing is something you have to make a rational decision on each time.... You have to think about it. In a logical sequence, you don't think about it. It's a way of not thinking. It's *irrational*." Although he considers some Minimal art to be rational, certain things, like Judd's progressions, "are logical. They can't be changed."[110] Judd is opposed to rationalism, "which is pretty much discredited now as a way of finding out what the world's like." In "unrelational" composition, decisions about how one part ought to relate to another are foregone.[111] Fried's notion of deductive structure is also based on the "logical relation between the image and framing edge."[112] Such compositional decisions are necessary and deterministic rather than idiosyncratic.

Logical thinking for the artist is methodical and mechanical. James R. Mellow found a similar conceptual basis in the "eminently logical approach" to industrial design that "free[s] the designer from any over-dependence upon flashes of intuition or inspiration in arriving at his solutions."[113] Because of the decreased emphasis on self-expression, according to Bochner, "systematic thinking has generally been considered the antithesis of artistic thinking. "Systems," he continued, "are characterized by regularity, thoroughness, and repetition in execution. They are methodical."[114] Although the choice of a specific system is personal, its deployment is anonymous and self-contained. No veiled allusions, covert references or subjective content are accommodated within the strict confines of the logical system. The spectator is able to discern whether or not systematic structure is at work, even if the fundamentals of the particular system are not decipherable, by analyzing the relative size and order of the individual elements of a given work of art. All information is as available to the spectator as it is to the artist.

The regularity of the parts, whether identical or incrementally altered, prevents hierarchical distinction of one element over another. In Judd's work, "Intervals are an important aspect of his sculpture, but these are sufficiently regular and rhythmic to present a total unified effect in a piece whose simple components are not in active interrelationship or opposition to each other."[115] The whole rather than the parts is primary. Of course, not all Minimal art is systematic—single pieces, such as the cube or box-form, have no disparate parts, aside from their five or six planar faces. The unity of the whole is thus more obvious.

Certain systems are immutable. In any of Judd's progressions, in which units and intervals are numerically determined, no adjustments can be made. Broader systems permit digression and function as support structures. Flavin explained the variable in his system: "I know that I can reiterate any part of my fluorescent light system as adequate. Elements of parts of that system simply alter in situation installation."[116] Tony Smith, unlike LeWitt "who prefers closed systems to open or infinite ones," had to make decisions about "when to change direction and when to stop," once the pattern was established.[117] This results in "unpredictable constructions with an animistic soul and emotive powers."[118] The less rigid the system, the more personal and expressive the result. Larry Poons, who undertook a systematic approach early in the sixties before most Minimalists, served as a critical model for the fusion of sensibility and *a priori* structure."[119] The grid system chosen by Poons and Smith permitted them a certain amount of freedom in composition, whereas Judd and LeWitt were virtually locked in, subsequent to the establishment of the system.

Although there was a great deal of terminological confusion with re-

spect to modularity and seriality, modular composition describes organizations of interchangeable units. Minimal painting and sculpture are geometric rather than fluidly organic, but Greenberg's definition of the "all-over" picture (an acknowledged precedent in terms of composition) is close to Minimal modularity: "The all-over, 'decentralized,' 'polyphonic' picture ... relies on a surface knit together of identical or closely similar elements which repeat themselves without marked variation from one edge of the picture to the other."[120] Furthermore, the more neutral the module, the better the chances are for unified structure. In his analysis of modular composition, LeWitt prescribed, "It is best that the basic unit be deliberately uninteresting so that it may more easily become an intrinsic part of the entire work. Using complex basic forms only disrupts the unity of the whole."[121] In effect, this amounts to the conjunction of Mondrian's or Vasarely's simple geometric unit and Pollock's textural composition.

For each Minimal artist employing modular composition, a signature module evolved: Andre's square metal plates, LeWitt's open cubes, Tucker's tubular elements in the sixties, and Smith's tetrahedra and octahedra.[122] Any part, as Andre specified, can replace any other part. Stella's stripes, Judd's boxes and Flavin's tubes function as basic units although they are not strictly modular in terms of isomorphic identity and placement. The exceptions are the ten boxes of Judd's vertical pieces and Flavin's works in which the tubes are the same color and of equal length.

The reliance on fabricated and standardized units played a significant role in determining modular structure. Krauss observed that "mass production insures that each object will have an identical size and shape, allowing no hierarchical relationships among them. Therefore, the compositional orders that seemed to be called for by these units are those of repetition or serial progression."[123] An example is Morris's 1969 exhibit at the Corcoran Gallery, for which he ordered identical steel plates from the fabricator and joined them in various configurations by clips and screws.[124] Repetition of the standardized unit and the resulting nonhierarchical, modular arrangement is also illustrated by Andre's *Lever*. Not only does it satisfy the requirements for nonrelational composition, but the neutrality of the individual firebricks, their relative lack of inherent interest, is conducive to apprehension of the object as a single shape.

No organizational format is as dominant in modern painting as the grid,[125] which structures and unifies the picture plane by creating a network of identical and contiguous modules. As LeWitt pointed out, the Minimalist grid comes from painting.[126] Reinhardt, Kelly, and especially Agnes Martin made early use of the format as a divisional and unifying device. In many of Martin's paintings, the grid stands alone as the only image. In others from the early sixties (1960–62), the grid provides a framework for painted

dots and dashes, bits of canvas, or nails. Poons also used an underlying grid to structure his compositions. Dots or ellipses were then located along the grid lines, the grid structuring the pattern of the dots so that it did not appear random, chaotic, or directional. Ryman relies on the grid to give substance as well as structure to his paintings. In his early work, the grid is superimposed on the surface. Later, as in the Classico Series, it is formed by individual units of paper and redoubled by tape marks in the corners of each sheet.[127] In two-dimensional work, the grid provides a basic nonrelational structure for the arrangement of identical modules.

In 1968, Robert Smithson described the situation that he and the Minimalists created:

> A cartography of uninhabitable places seems to be developing—complete with decoy diagrams, abstract grid systems made of stone and tape (Carl Andre and Sol LeWitt), and electronic "mosaic" photomaps from NASA. Gallery floors are being turned into collections of parallels and meridians. Andre in a show in the Spring of '67 at Dwan Gallery in California covered an entire floor with a "map" that people walked on—rectangular sunken "islands" were arranged in a regular order.[128]

The concept of mapping applies particularly to artists using the three-dimensional grid structure, which was often described by critics as a space-lattice.[129] In painting, a flat, undivided plane is given, whereas sculpture begins in amorphous and structureless space. By assuming the space-lattice—a three-dimensional map—modular elements may be located according to the regular division of space. The space grid is outlined by LeWitt's open white cubes, which often decrease in number but never vary in size or shape in a single work of art. The struts modularly chart out the geometric division of space.

Tony Smith's three-dimensional grid is crystalline rather than rectilinear, but like LeWitt's, his structures geometrically map the space of the gallery. Chandler described Smith's octahedral-tetrahedral grid: "Some of Smith's pieces have been so symmetrical that they can reproduce themselves by rotation.... Based on a continuous space grid, itself generated by the rotation of the basic modules, these structures can be seen as holes punched in a solid space constructed of these modules."[130] The space-lattice, like the two-dimensional grid, produces a pattern for the location of interchangeable isomorphic modules. Just as in Andre's floor pieces, any element can be exchanged for any other due to the morphological similarity of the modules.

Stella's paintings were often classified as modular because of the repetition of the painted band, itself derived from the 2½-inch width of the stretcher bars.[131] Although constant in terms of width, the bands vary in length and configuration as they move across the canvas. The early paint-

ings of Stella are actually serial rather than modular, since the units are not identical. Bochner explained the difference between the two approaches: "Modular ideas differ considerably from serial ideas although both are types of order. Modular works are based on the repetition of a standard unit. The unit, which may be anything (Andre's bricks, Morris's truncated volumes, Warhol's soup cans) does not alter its basic form, although it may appear to vary by the way in which the units are adjoined."[132] The artist David Lee compared Andre's modular work to Smithson's serial approach. "Andre repeats one thing in each piece; Smithson repeats one thing but increases its size."[133] For a single work of art to partake of seriality, there must be an incremental variation of units. The variation is regular and systematic, however. "Seriality is premised on the idea that the succession of terms (divisions) within a single work is based on a numerical or otherwise predetermined derivation (progression, permutation, rotation, reversal) from one or more of the preceding terms in that piece. Furthermore the idea is carried out to its logical conclusion."[134] Smithson's *Plunge* is a prime example of serial order. Ten units of painted black steel are each comprised of four cubes. As the size of the cubes decreases in half-inch increments, the units are compacted. The progression is made to seem complex by optical distortions of perspective, but its form is the result of simple addition. Neither the individual cubes nor any of the ten units they comprise may be interchanged. The established order dictates the variations.

One of the confusions with respect to numerical progressions involved the existence of a first and last element in the series, and the use of finite versus infinite (or closed versus open) progressions.[135] What this suggests is the problem of knowing when to stop or where to start. One of the reasons for systematic ordering was the resulting mechanical—as opposed to idiosyncratic or expressionistic—appearance. The linear extension of a progression implies that it could be continued *ad infinitum*. Limiting the number of units in a progression seems to be a purely aesthetic decision. Permutations, on the other hand, used especially by LeWitt, produce only a certain number of possibilities from the given variables. In *47 Three-Part Variations on Three Different Kinds of Cubes* of 1967, LeWitt proposed what he thought was every possible variation of open, closed, and half-closed cubes arranged in stacks of three. Subsequently, he discovered nine further variations possible, and added them in 1974. Other permutations, such as *Serial Project No. 1 (ABCD)* and the Incomplete Open Cubes Series, are fully played out, sometimes with verification by a mathematician, within the closed system selected by the artist.[136] Morris's fiberglass elements, shown in various combinations at Castelli's in 1967, are also examples of permuting a system with a limited number of variables.[137] Andre's most

complex work, although exceptional in its highly systematic basis, is permutational in David Bourdon's outline:

> Taken as a whole 37 *Pieces of Work* consists of 1,296 plates, 216 each of aluminum, copper, steel, magnesium, lead and zinc. Each metal appears alone in individual six-foot square Plains, then alternates with another, checkerboard fashion, in every possible permutation. Since each of the six metals in the large piece was laid out in the alphabetical order of its chemical symbol, alternating successively with the others, there are two versions of each combination. Consequently, there are six monometal and 30 bimetal Plains. The 37th "piece" is the whole ensemble, as exhibited at the Guggenheim.[138]

The key to seriality in individual works of art lies in numerical systems or simple mathematics, somewhat in the way that modular composition relies on the grid. For Judd, mathematical progressions provided asymmetrical order without composition in the traditional, i.e., relational, manner. He added that "the series doesn't mean anything to me as mathematics."[139] LeWitt, whose serial work is based on addition and rotation, does not believe "that anyone uses mathematics *per se*. They use *numbers*. It's just like Jasper Johns using, 1, 2, 3, 4, 5, 6, 7, 8, 9, 0. I use numbers only as a way of drawing something.... I'm thinking of it in numerical terms, but that's not mathematical.... Numbers are used in mathematics. Numbers are used in numbers too."[140] Although Donald Kuspit described LeWitt's mathematics as naive because they are "inconsistent" and "obsolete,"[141] no artist actually pretended to be a mathematician. According to Lippard, "sculptor Tony Magar's anti-programmatic attitude is probably the most common one among artists who study but do not imitate science: 'When I read math books, I find myself reinterpreting most of the things, and that, to a mathematician, I'm sure, is outrageous.'"[142] What the serial artist does have in common with the mathematician is the appreciation of the crystalline clarity and beauty of numerical relations. Early in the century, Roger Fry had observed the similarity between the aesthetic response and "the responses made by us to certain abstract mental constructions such as those of pure mathematics."[143] Both endeavors have been generally construed as purposeless, pursued for their own sake alone. For the Minimalist, mathematics enhanced aesthetics. Joseph Masheck replied to Kuspit's criticism of LeWitt: "LeWitt's work stylistically shares a late-Constructivist faith that even the simplest mathematics (perhaps most of all the simplest mathematics) generates pure beauty."[144]

Although the numerical progressions used by Minimal sculptors ranged from the very simple to the exceedingly complex, the size of each successive unit in a given progression is always derived from the unit preceding it. Bochner distinguished two types of series: "(a) *Arithmetic Progression*—

A series of numbers in which succeeding terms are derived by the addition of a constant number (2, 4, 6, 8, 10 ...). (b) *Geometric Progression*—A series of numbers in which succeeding terms are derived by the multiplication by a constant factor (2, 4, 8, 16, 32 ...)."[145] Flavin's *the nominal three (to William of Ockham)* is an arithmetic progression based on Ockham's Razor: "('Posit no more entities than are necessary.'—William of Ockham). The simple series involved can be graphically visualized as (1 + [1 + 1] + [1 + 1 + 1])."[146] Smithson's *Plunge* is an example of the arithmetic progression, which was also favored by Judd. His hemicylindrical progression is based on the series 3, 3½, 4, 4½ for the projections and the inverse (4, 3½, 3) for the intervals.[147] The actual object is 76½ inches wide, so that each unit in the series stands for three inches. A geometric progression is illustrated in a sketch done by Judd in 1963.[148] Here, the solid members of the progression remain constant at one-half (inch?), while the intervals begin at one-half and are successively multiplied by 1½ (½, ¾, 1⅛, $^{27}/_{16}$, $^{81}/_{32}$...).

Judd also employed Fibonacci and inverse natural number systems.[149] In Fibonacci, each unit is the sum of the two immediately preceding terms. The inverse natural number system is less regular. From the original unit (one) a half is subtracted. The third element is one-third more than the second, and so on.[150] According to Judd, "No one other than a mathematician is going to know what that series really is ... but I think you do understand that there is a scheme there."[151] "What was important," Barbara Haskell wrote, "was that viewers intuitively realized that something other than personal choice was operative."[152] The more complex the progression, the more difficulty the spectator will have in deciphering the system. Unlike Conceptualists, Minimalists relied on the system to order and unify, rather than to function as the subject matter of the work of art (though this is less true of LeWitt than of Judd). As Roberta Smith wrote of Judd's work: "A system unifies the piece, but it is the perception of that unity, not the system which is prominent."[153]

The prior existence of the system as a thing separate from the work of art—as something applied to art-making—forced the form and content dichotomy. Sometimes the system was taken to be the meaning of the work and the conceptual nature of systematic ordering was often stressed. In LeWitt's work, the form of the piece "suggests, implies or points to the central idea of the whole series," which is the system.[154] Seriality does more than simply unify; it is the generating force behind the object. For the spectator, then, the object clarifies the idea. The object is much less important than the system in Mel Bochner's serial work. In the Dwan Gallery's Scale Models and Drawings in January of 1967, he showed photographs and drawings of a series of twelve sets of stacked cubes. The series was not

physically constructed since the artist had only one set of cubes. The graphic information, however, satisfactorily explained the placement of the cubes.[155] Bochner preferred arrangement rather than composition to describe Andre's "strict, self-imposed modular system," because "'arrangement' implies the fixed nature of the parts and a preconceived notion of the whole."[156] Although Andre would disagree, Lippard noted in 1965 that his *Crib, Coin and Compound* would, upon dismantlement, cease "to exist as anything but ideas—which is their prime role in any case."[157] After Morris's Corcoran exhibit in 1969, the steel plates were bought back by the distributor. Although the original art objects no longer exist, the systematic motivation of the modular work of art remains.[158]

Although a number of Minimal artists, including Bochner and Smithson, utilized more than one discrete object in their serial works, the set of objects comprised a single work of art. An alternative serial approach was the more traditional one, in which the series is made up of separate, related works of art. Monet's Haystacks and Rouen Cathedral paintings are often cited as modernist prototypes, and the concept is tracked through de Kooning, Warhol, and Lichtenstein to Stella and Noland. Instead of the object informing the spectator of the particular system, knowledge of the system or series serves to clarify the individual works of art. Fried explained that seriality "arose during Impressionism in concomitance with the exploration throughout a number of pictures of a single motif, but which has come increasingly to have the function of providing a context of mutual elucidation for the individual paintings comprising a given series."[159] In its emphasis on repetition and variation, this type of series is related to the serial structure. It is not, however, finite, regular, or linear, having no given unalterable progression once established.

Three major exhibitions examined the serial impulse. Alloway showed only hard-edge abstractionists in his Systemic Painting at the Guggenheim in 1966. Art in Series at Finch College in 1967 ranged from Rauschenberg to Hanne Darboven, while Coplans's 1968 Serial Imagery at the Pasadena Art Museum consisted of a variety of modernists including Monet, Mondrian, and Stella. One faction of systemic painting discerned by Alloway was "One Image" art, defined as "the repeated use of a configuration." Representatives were Noland, Thomas Downing, Paul Feeley, and Reinhardt.[160] "One Image" painting supports Coplans's definition of serial imagery as "a type of repeated form or structure shared equally by each work in a group of related works made by one artist."[161] Art in Series, on the other hand, was restricted to seriality as explored in a single work of art along with related diagrams and literary matter.

Mellow noted that de Kooning's Women and Monet's Haystacks were not included in the Finch College exhibition since they are variations on a

theme rather than serial.[162] Most critics agreed that serial art was more than mere thematic variation, due to the explicative nature of the individual works of art within the series. Because of the nonhierarchical situation of the serial works, no one work could be classified as the theme and subsequent works as variations.[163] Coplans observed that in the use of serial imagery, "the Masterpiece concept is abandoned." The critic is prevented from asserting the superiority of any piece in a given series, and can only say if it is consistent within the series.[164] Although there can actually be value judgments within a series (certain works represent more clear and unified explorations of the motif than others), decreasing emphasis was placed on originality and invention, criteria upon which judgments had often been made.

According to Alloway, "Here form becomes meaningful, not because of ingenuity or surprise, but because of repetition and extension."[165] Novelty is de-emphasized while the artist investigates the possibilities of a single form. In this context, all Minimal artists are involved with seriality. Each produced numerous examples of a single, basic idea. Judd's vertical sculptures and progressions, Morris's gray polyhedrons, Flavin's lights, Bell's glass boxes, McCracken's planks, Andre's plates, and LeWitt's cubes represent a consistent interest in a single form. Painters as well were serial: Ryman's Standards, Marden's Back Series and Mangold's Walls and Areas follow Stella's Black and Aluminum stripe paintings and Noland's circles and chevrons.

Seriality, in which individual works of art appeared structurally similar, led in many cases to an emphasis on the gallery environment, as did so many consequences of nonrelational composition. Lippard, one of the first to discuss the extrapictorial issues of Minimal art, noticed this aspect of Baer's work. "In view of this serial premise, the installation by the artist, is noteworthy. The paintings themselves may be wholly non-relational, but the gallery space was 'composed' for the occasion."[166] With the elimination of internal figure-ground relationships and the increasing interest in shape and systematic structure, external relationships were more thoroughly investigated.

Abstract artists in the 1960s placed a higher premium on unity and wholistic structure than on composition, at least as it had been previously practiced. Formal elements of the work of art were balanced by symmetry, or by serial or modular arrangement. Thus, the work itself demanded less perceptual discrimination on the part of the spectator. It was actually easier to appreciate, since relationships were limited. However, the spectator's role became, in direct proportion, more dramatic and complex.

3

External Issues: The Spectator

With the reduction or systematization of internal relations came a new focus on relationships struck up across and within the space between the spectator and the object of perception. The nature of spectator *confrontation*, beyond the traditionally passive aesthetic *experience*, encompasses the actual space in which such confrontation takes place, as the spectator responds to nonexhibited features such as presence, scale and architectural implications. Minimal art, as Fried recognized, *"depends on* the beholder [and] is *incomplete* without him."[1] The meaning of these works of art is discovered not through formal analysis of internal relationships, but through the experience of them by the spectator.

The Concept of Presence

Traditional sculpture depends on anthropomorphism to strike a bond between the spectator and the object, which accounts for the nonabstractness of most sculpture prior to the sixties. Sculpture has tended to imitate certain aspects of the human figure in terms of gesture, shape or orientation. Consequently, the spectator recognizes or senses a kindred form when faced with the statue and attributes to it certain emotional or psychological human qualities, which, though having root in the spectator's person, account for what is known as expression. Judd defined anthropomorphism as "the appearance of human feelings in things that are inanimate or not human, usually as if those feelings are the essential nature of the thing described."[2] For example, Newman's early fifties series of Here sculptures, consisting of tall vertical strips of cast bronze, display the uprightness of bipedal creatures, just as the vertical "zips" in his paintings face the spectator and echo his or her orientation.

Certain critics maintain that *all* sculpture is anthropomorphic, thereby expanding the definition of anthropomorphism to a meaningless extent. Burnham conflated anthropomorphism with humanism in the following statement:

Most modern abstractionist movements have rejected their predecessors on the grounds of anthropomorphism. This has consistently undercut the humanistic intention of figurative work; and it has provided new abstraction with the appearance of greater detachment and objectivity. Yet the absurdity of who is less anthropomorphic soon ends in its own logical *cul-de-sac*. The more obvious truth is that all art is anthropomorphic—that is, if it is interpreted not solely through appearance but as one of many extensions of human need and thought. In reality, the argument over anthropomorphism is one concerned with the priorities of different sign and symbol systems, not over limits of mimetic imagery.[3]

However, anthropomorphism *is* recognized through mimesis, either of shape or orientation or both. If a work of art has no formal human attributes, it is not anthropomorphic. Krauss's view that, to some extent, "sculpture is constantly forming an analogy with the human body," sounds at first like an anthropomorphic view of sculpture.[4] However, she does not identify the kinesthetic or bodily response with figuration.

Biomorphic form is the most obvious mimetic device. With few exceptions, such as Egyptian and Archaic Greek sculpture, and de Stijl and Constructivist work in this century, a lumpy biomorphism establishes an analogy with the curves of the human body. Arnheim points out that practically all sculpture is convex, since "the statue is conceived as an agglomeration of spherical or cylindrical shapes that bulge outward." This is particularly true of the semiabstract sculptures of Arp and Hepworth. Concavity is a twentieth-century innovation—creditable especially to Henry Moore—which, with convexity, promotes dynamic interaction with surrounding space, Arnheim maintains, as bulges and depressions appear to react to pressuring forces of the environment.[5] According to Morris, "Surfaces under tension are anthropomorphic: they are under the stresses of work much as the body is in standing. Objects which do not project tensions state most clearly their separateness from the human."[6]

Until the 1960s, sculpture was implicitly if not explicitly figurative. Alloway's explanation of this phenomenon is convincing: "One reason that 20th century sculptors rely so heavily, and placidly, on the human image, is that if they don't their work may look like furniture or hardware," as sculpture is "more prone to object-status" than painting.[7] Indeed, this characterized Hilton Kramer's response to Judd's completely nonanthropomorphic sculptures of 1963. He compared them to record cabinets and Kleenex boxes. The caption of the illustration accompanying Kramer's review referred to "a harp piece" and a "bleachers floor piece."[8] Without the presence of the human figure, critics attempted to locate the subject matter of abstract sculpture in other familiar objects. The rigid and planar surfaces of most industrial materials also contributed to this reading. As Judd pointed out, "In earlier work the structure and the imagery were executed in some

neutral and homogeneous material. Since not many things are lumps, there are problems in combining the different surfaces and colors and in relating the parts so as not to weaken the unity."⁹ The formal dissimilarity to previous sculpture, to the extent that most Minimal artists claimed not to be making sculpture at all, accounted for the unique nonanthropomorphism of abstract three-dimensional art.

Geometry, rather than biomorphism, was the chosen language of the mid-sixties. Just as a decade earlier Pollock's work had signaled the end of geometric art as begun by Mondrian, young artists rejected the figurative traces of Abstract Expressionism, and reinstated geometry, now, however, without "purist" composition. Judd explained that Stella's method of composition provided a new and viable way of using geometry, since it was both nonrelational and nonanthropomorphic.¹⁰ The substitution of systematic order for relational composition effectively diminished anthropomorphic gesture. Grids, permutations and serial progressions are distinctively nonbiomorphic. The regularity of systematic structure was, for Robert Smithson, a way of "overcom[ing] this lurking pagan religious anthropomorphism. I was able to get into crystalline structures in terms of structures of matter and that sort of thing."¹¹ Nothing is so inanimate as the crystal's inert, faceted modularity.

Figurative sculpture is primarily vertical, echoing the uprightness of the spectator, and establishing bodily empathy with him or her. David Smith's Cubis present themselves as reductive stick-figures, with suggestions of head, arms, torso, and legs. There are definite backs and fronts, tops and bottoms. The sculptural base reinforces this by acknowledging "that all mammals have a top and a bottom or head and feet."¹² Horizontal sculpture, which does not require a base for support, is looked down upon rather than met face to face. Andre's bricks and metal plates, and Judd's floor boxes make no concession to human uprightness. Minimal horizontality also dispensed with vertical hierarchy, in which head is more important than feet. By avoiding biomorphic shape, gesture, or relational composition and verticality, the traditional anthropomorphic connotations were avoided. The issue, however, was not.

Fried plainly admonished the Minimalists for a "latent or hidden naturalism, indeed anthropomorphism." The qualities he established as anthropomorphic were not those typical of earlier sculpture, but a new set altogether: symmetry, hollowness, and, most justifiably, size.¹³ Approximation to human size, i.e., between about four and seven feet high, and at least as tall as wide, did characterize some Minimal painting and sculpture. Fried quoted Tony Smith's comments about *Die*, to the effect that he was making neither a monument nor an object, to justify the fact that Smith was making "a surrogate person." Smith's cube is precisely six feet square and appears

neither to be a large monument nor a small object.[14] McCracken echoed Smith's concerns when he explained, "I think of [my sculptures] as being relative to human size. If they are too tall, then they get monumental. If they're not tall enough, they're not presence-full enough."[15] The loose restriction to human size, however, has less to do with anthropomorphism than it does with scale. By presenting an object about the same size as the spectator, a more active relationship is established between the two. Smith's *Die*, like Reinhardt's five-foot black paintings, has little in common with a human being, aside from dimension. Judd's and Morris's works, although the latter's are more monumental than the former's, are unfairly interpreted as anthropomorphic. McCracken's planks, on the other hand, share verticality with the spectator, inducing a more human presence.

Fried held, against Judd, that nonrelational sculpture *is* anthropomorphic, based on his interpretation of the human body as nonrelational. "The entities ... that most closely approximate the literalist ideals of nonrelational, the unitary and the holistic are *other persons*." Symmetry is natural, in the sense of imitating nature, he claims. Morris agreed with the association, but maintained that the forms are nevertheless nonanthropomorphic, referring to the kinesthetic responses evoked rather than to mimetic identification.[16] While it is true that human beings are outwardly symmetrical, the essentially gestural nature of sentient beings, their capacity and tendency for movement, distinguishes them from inanimate objects. Stance and gesture are suggested in both Caro's and di Suvero's compositions of linear and directional elements. The stretch and thrust of beams are inherently anthropomorphic. A delicate and tense balance of parts structures such compositions, just as it does Richard Serra's work later in the decade. The elimination of tensions by Minimal sculptors resulted in static, nongestural objects. Boxes, planks, and plaques exhibit no potential kinetic energy.

"And third," Fried wrote, "the apparent hollowness of most literalist work—the quality of having an inside—is almost blatantly anthropomorphic."[17] Is this really the case? One has only to turn awareness to one's own body: limbs and torso feel solid through and through. The Vitalists' attention to core and armature is many times more anthropomorphic than are hollow Minimal structures.

Anthropomorphic associations were displaced in this art by the nonanthropomorphic quality of "presence." There are no exhibited, formal clues to signal the existence of presence, since it is felt, *responded to*, rather than *recognized*. Even Fried admitted that "the vital presence of Stella's paintings cannot be understood solely in terms of their physical and formal characteristics."[18] Some writers went so far as to speculate about the metaphysical or mystical nature of presence and the totemic power it connotes.[19] Both Rubin and Fried emphasized the significance of spectator response in at-

tempts to come to grips with this elusive concept. According to Rubin, "It refers to the way in which the work of art imposes itself on the perception and experience of the viewer ... *the ability of a configuration to command its own space.*" "Something is said to have presence when it demands that the beholder take it into account, that he take it *seriously*—and when the fulfillment of that demand consists simply in being *aware* of it and, so to speak, in acting accordingly.[20]

It is primarily its objecthood, its status as object rather than surrogate person, that gives an abstract work of art presence. "The picture-object stands," Nodelman wrote of the art of the sixties, "unconcealed before the spectator in its quality as a *thing*, and thus asserts its immediate presence in his life-space on the same terms as the other things which populate it, and which engage him on the primary existential plane."[21] Presence evokes a bodily, nonspecific response in the spectator. For Morris, "The specific art object of the '60s is not so much a metaphor for the figure as it is an existence parallel to it. It shares the perceptual response we have toward figures. This is undoubtedly why subliminal, generalized kinesthetic responses are strong in confronting object art."[22] Because all sculpture is, in one sense, real rather than illusory, it evokes a physical response. Presence is the obdurate force of Minimal art, which links the spectator to the object, in lieu of anthropomorphic gesture or the multiplicity of viewpoints of traditional sculpture.

Critically, presence was seen as a positive feature of works of art. Writers and artists used the word without hesitation, assuming that it was universally understood. When questioned about his use of the term, Greenberg cursorily replied that it signified "plentitude, a fullness—describing your reaction to art," but that the term itself, like other metaphors, was not worth worrying about.[23] In 1966, Stella also saw it as "a matter of terminology.... It's just another way of describing."[24] If the derivation and definition of the term were insignificant, the fact that the quality was characteristic of this art was not. Peter Plagens capsulized the new American sculpture: "Simple geometric volumes imposing in size, static qualities and physical presence."[25]

For many sculptors, the quality of presence was essential. Chamberlain's experience of Alberto Giacometti's sculpture in contrast to de Kooning's paintings inspired him to make sculpture rather than painting, since "there's a larger presence in sculpture than there would be in painting."[26] Tony Smith called his sculptures "presences," as does McCracken: "A strong work of art is, amongst the world of objects, like a star, a film star, say, in the world of film actors. A star is one who has strong presence and focus, and is a strong individual."[27] Truitt has insisted on the nonanthropomorphic presence of her own work. She also described in terms of presence the

powerful impression made by Noland's painting *Mandarin*, which she once owned. She missed it "like a person when it left."[28]

According to Fried, Greenberg's "Recentness of Sculpture" was the first analysis of presence in Minimal art. Minimal art was seen to derive its presence from "the look of non-art" and from size. By "non-art," Greenberg means something that does not look like past art, exhibiting what Fried calls "objecthood."[29] Greenberg's condemnation was of sculptures that "hide behind presence," that rely on a strong and forcefully projected presence instead of more traditional aesthetic qualities for their success. The work of Judd, Morris, Andre, and Steiner, he thought, was guilty of this; Smithson's and LeWitt's less so. Truitt's work exhibited presence, but did not hide behind it.[30] With respect to Greenberg's comments, presence may arise from the nonillusionistic, nonmimetic reality of the object—a thing as real and present as another person or piece of furniture. Of Andre's works, Bochner noted that it is their "persistent slightness that is essentially unavoidable and their bald matter-of-factness that makes them in a multiple sense *present*."[31] The confrontational response elicited by objects with presence derives in part from the recognition of self-contained otherness. The Minimalist sculpture is a thing apart from the spectator, but equally palpable and spatial.

The analysis of presence in certain works of art avoids the pitfalls of intentionalistic criticism. Attention is paid to what the work of art actually does rather than what it communicates about its creator—that is, what its creator "put" into it or intended it to do. "There is an attempt to suggest the presence of paint rather than the presence of the painter," in the art of the 1960s.[32] What is present, what is given, is the work of art; and a work exhibiting presence, being in some sense separate from the spectator, is an autonomous being. Its presence is ever so much more powerful than the presence of its creator. Ratcliff's description of Fried's critical method, of which he is less than appreciative, is to the point: "Fried addresses himself to paintings as autonomous entities, not as painters' vehicles for intention and meaning."[33]

The fact of the total abstractness of Minimal art resulted in a personification of its objects. The objects are not formally similar to human beings, yet their complete self-sufficiency encouraged the critic and spectator to treat them as other beings. Both Greenberg and Fried were found guilty by Ratcliff of personification.[34] One of Fried's descriptions of Olitski's paintings exemplifies this approach: "The narrow vertical format" makes the painting "self-sufficient, a presence, like that of a human figure, instead of a void waiting to be filled."[35] Likewise, Minimal paintings and sculptures are not peered into but are confronted and "looked at." The nonreferential nature of these objects stimulates external interaction between object and

viewer. Morris responded to a question about the relationship of the human body to his sculpture: "The fact of the body, fact of the work reflecting back to the body, its scale, and that in turn reflecting the scale of the work to the person is very much, I think, a feature of seeing it, experiencing it. But this is not in terms of any specific anthropomorphic kinds of equivalents in the work for the body in any way."[36] The substitution of presence for anthropomorphic associations and intimate textural relationships between parts of the work of art brought about a new concern for external scale: the manner in which the spectator's body takes possession of the object.

Significance of Scale

One of the most seriously discussed issues of the sixties was scale. The tendency of Pop artists to enlarge and exaggerate commercial images paralleled the Minimalists' attention to correctness of scale, although few in the latter group found large size attractive in itself. One critic claimed that of all the issues raised by the exhibition American Sculpture of the Sixties, "what is most strikingly apparent is the issue of scale." The same critic noticed the intricate relationship between presence and scale, and suggested that perhaps the concept of monumentality is "more appropriate to anthropomorphic forms . . . and 'scale,' more to abstract work whose 'presence' is achieved through a certain dimension."[37] In fact, Lippard's remark that "a sculpture's scale is successful in direct proportion to the degree in which it succeeds in holding its own space," is almost identical to Rubin's definition of presence.[38]

Like presence, scale is felt rather than empirically measured. In an insightful discussion of scale, "one of the most profound qualities of sculpture," Barbara Hepworth explained that "it can only be perceived intuitively because it is entirely a quality of thought and vision."[39] Although there are physical bases for scale in size, the spectator's experience of the object determines scale. A piece of furniture may exhibit great scale to a child, and moderate scale to an adult. According to Lippard, "Most discussions of scale consider it a strictly optical experience. . . . But a sense of scale is also a *sense* proper. Scale is *felt* and cannot be communicated either by photographic reproduction or by description."[40] Minimal art is as much kinesthetic as it is visual.

Some artists consider scale to be the essential ingredient of successful art.[41] Morris told an interviewer that he unhesitatingly rejects a piece of sculpture if the scale is not right. The object must be constructed, however, for him to judge the scale. It cannot be visualized, only experienced directly.[42] For an exercise in scale, Robert Mangold constructed the same painting in ten different sizes in order to learn if a perfect scale could be

achieved.[43] Secondary reproductions, including maquettes and models, can never impart information as to specific scale.

Abstract Expressionist scale was particularly influential.[44] Not only were these paintings large in size, but depth was compressed, and surface emphasized. The result was more of an object, whose literal dimensions, over and above pictorial incident, took on significance. Pollock's paintings, the size and shape of which were determined after the image had been laid down, differ from the traditional canvas filled in by the painter. The relationships of the internal elements to the shape of the canvas, and that shape to the spectator were judiciously conceived. The impact of scale in Newman's paintings, particularly, was often discussed, although critically analyzed less often. Hopps's catalogue essay on Newman, from which the following passage is excerpted, was especially admired for its insightfulness.[45]

> A sense of vast scale exists in his smallest paintings as well as in his largest, such as *Vir Heroicus Sublimis*. The vast scale would seem to result from the hypothetical extendibility of his areas and bands of color which continue without interruption to the very edge of the canvas. More specifically, the vastness of scale is a result of the extremely great contrast established between the overall physical format of the work and the smallest effective element within the format.[46]

Inspired by but not specifically mimicking the scale of Newman's paintings, Minimalists strove to achieve a similarly impressive presence.

Sculptors were the first to assimilate Abstract Expressionist scale. Although Robert Murray's work is compositionally more conventional than most Minimalists', his opinion was shared by those sculptors: "The idea that a piece of sculpture should stand on its own and have the kind of scale that the large painting of Newman and Rothko and Pollock and others had, seemed to me an important thing to attempt."[47] In their first one-man shows at the Green Gallery, Morris and Judd exhibited broadly scaled structures (Morris's Neo-Dada objects were smaller—and more precious), which by their expansive planes were much more imposing than the gestural, welded sculpture of the fifties.

Comparable paintings by artists such as Mangold, Marden, Novros, and Baer were rarely as monumental as Abstract Expressionist painting, and by far less explosively dramatic, possessing a more human scale. Mangold recalled being impressed by Judd's sense of scale. While Morris's work often seemed too big, Judd's structures were like desks or chairs—suited to human beings.[48] With the exception of completely monochrome canvases, which in fact fall closer to sculpture in their undifferentiated objectness, the scale of a particular painting generally derives from relationships of internal elements. Paintings based on a grid pattern, for example, achieve scale through the size of the unit in relation to the framing dimensions.

Agnes Martin's paintings are smaller-scaled, though not necessarily smaller in size, than Reinhardt's. This sort of part to whole reading is promoted by the tendency to look into the painting rather than at its periphery. The spectator is more likely to judge the scale of sculpture in terms of external relationships—that is, how his or her body relates to the object. Both internal and external scale were of considerable importance, as in Marden's double-paneled paintings, which are scaled by the central division as well as by overall dimensions. Andre's floor plates depend largely on the size of the components. The 1966 magnet pieces, constructed from one- to two-inch units, are more intimate than the larger-scaled steel plaques. The relationship of the spectator to the object, particularly when standing on the sculpture (an exercise not recommended for the magnet pieces), determines external scale.

Internal scale is gauged by the relationship of individual elements, such as figure to ground or module to module. The fewer and larger the parts, the greater the scale. As Rubin pointed out with respect to Stella's stripe paintings of the early sixties, "The new scale was equally a matter of suppressing very small units." Noland's circle paintings, he continued, also exhibited this broad scale. The width of the bands "created—as a minimal unit of measurement set against the size of the field—a comparable sense of breadth."[49] Large scale can also result from a vast field sparsely populated by small elements, as Hopps showed in Newman's work. Barbara Rose noted that both seventeenth-century landscape painting and Olitski's canvases are examples of this kind of scale.[50] Internal scale is very similar to the notion of proportion.[51] Proportion, as a relational phenomenon, is derived from the comparative sizes of constituent elements. "Good" proportion denotes a lack of awkwardness. Lippard described Newman's *Broken Obelisk* as "a clear example of the use of scale in the classical sense, as harmony, or balance."[52] It is well proportioned. When the parts of a sculpture are identical, however, proportion is irrelevant (there is nothing to balance), and scale becomes a matter of the number of elements and the overall size of the object. Large scale is a matter of the reduction of textural detail and incident, as well as the number of elements. A box has only five visible faces, only a few of which can be seen at once.

Most sculptors and monochrome painters in the sixties were concerned with external scale, the relationship of the size of the object to the size of the spectator and the environment. Because most sculptures are hollow and most paintings flat, relations are forced out of internal structure to surface and shape. Stella described the effect this has on scale: "Spanning the entire surface produced an effect of change of scale—the painting is more on the surface, there is less in depth. And the picture seems bigger because it doesn't recede in certain ways or fade away at the edge."[53]

External scale is not a new issue. The gigantic, exaggerated heads topping monumental Renaissance sculpture to compensate for perspectival diminution, and Northern Renaissance painters' predilection for small, refined pictures of intimate interiors are examples of scale in which image, size, and viewer are considered. The scale of any given object, as Lippard pointed out, is "dependent not only on its internal proportions, but on those of the space in which it is placed, the distance from which it is seen."[54] Relating it more directly to the human body, Barbara Reise explained: "Our direct understanding of *scale* is based on perceived relations with the various size of ourselves (both as whole physical bodies and relations of parts such as fingers to hands to arm to whole)."[55] Morris's explanation of the fact that external scale is determined by the relationship of the object to the spectator in terms of size is the most succinct: "The awareness of scale is a function of the comparison made between that constant, one's body size, and the object. Space between the subject and the object is implied in such a comparison."[56] The work elicits physical comparisons to the human body, the constant by which scale is judged. Andre also explained this phenomenon: "In sculpture, there's quite a concrete relationship between one's size as a person and/or mass as a person and the mass of a piece of sculpture.... And we are just absolutely conditioned by the sizes of our bodies and our own pretentions to measure things off, especially material things in the world, by our own size."[57]

Each sculptor, or painter, can make assessments of scale *only* in terms of his or her *own* body. Although recognized by most artists, this was rarely acknowledged in print, perhaps because it seems so obvious. Judd and LeWitt, among others, admitted the necessity of relying on their own dimensions to determine appropriate scale. A shorter or taller viewer can be imagined but never catered to without losing control of the object. Just as the spectator judges scale on a private, physical level, so must the artist.[58]

Scale was sometimes confused with mere size in less careful writing in the sixties. Where scale is relational, size is objectively measurable in inches or feet. Artists as well as critics were guilty of substituting the more critically potent term *large scale* for *large size*. Mangold was puzzled by the fact that many artists who claimed to be concerned with scale made very large objects. "And I kept saying, 'Well, you're really talking about size aren't you?' And they'd say, 'No, I'm not talking about size, I'm talking about scale.' I found it difficult—you see, if they were talking about scale why did they *always* work large?"[59] The more environmental, less object-oriented artists, such as Bladen and Grosvenor, were often cited as sculptors dealing with scale when the operative term should have been size. A very small piece, such as one of Judd's single projecting wall boxes, can possess great scale, while an immense nineteenth-century history painting, Rose sug-

gested, may not be in the least bit grand or significant.[60] Like presence, the ingredients of scale cannot be *prescribed*.

In an attempt to come to terms with appropriate scale, size was often discussed. Although no specific size was settled upon, there was a certain amount of agreement among Minimalists that monuments and *objets d'art* were to be rejected. Tony Smith's paradigmatic response to questions about *Die* was often quoted:

Q: Why didn't you make it larger so that it would loom over the observer?
A: I was not making a monument.
Q: Then why didn't you make it smaller so that the observer could see over the top?
A: I was not making an object.[61]

Patricia Johanson's paintings and sculptures composed of single lines, some more than twenty feet long, struck an interesting compromise between large and small. LeWitt suggested a middle ground as well: "If the thing were made gigantic then the size alone would be impressive and the idea may be lost entirely. Again, if it is too small it may become inconsequential."[62] In an essay on Andre, Kurt von Meier equated small sculpture, in fact most twentieth-century sculpture, with jewelry, and very large sculpture with architecture. He concluded that "it may just be this dimension of scale that comes to serve as a practical basis upon which to distinguish sculpture from architecture."[63] At the same time, since sculpture was freed from alluding to the human figure and its multitude of parts, its scale could increase. "Until recently abstract painting and sculpture retained the scale and the type of unification necessary for the representation of objects in space. The new work has a larger internal scale and has fewer parts."[64] The relatively large size of the new sculpture, one critic suggested, "once more belie[s] the rather absurd label 'Minimal art.'"[65] Because of their broad, regular planes, and lack of negative space and relational balance, Minimal objects often appeared larger than earlier work of comparable size. However, proclivity for the gigantic was tempered. Most Minimal artists did not let the size of their work dictate the overall effect. LeWitt explained: "If it's so big that you can't really comprehend it except by its emotive force then I don't want it." Morris held that "beyond a certain size the object can overwhelm and the gigantic scale becomes the loaded term."[66] In pursuit, of the wholly unified form, no one aspect, except to some extent shape, was allowed to predominate.

The appropriate size, then, was approximately that of a human being. Since scale was gauged through interaction of viewer and object, proximity of dimensions could only amplify that relationship. Many artists confessed

to restricting their work to the size of the human body, most particularly in terms of height. In one respect, this has to do with the observer's eyes being near the top of the body, thus assuring certain perspectives. It also promoted greater spectator involvement. Flavin's tubes and McCracken's planks are scaled in this manner. The dimensions of Marden's Back Paintings were derived from his wife's height and the width of her back.[67] Objects that were to be looked down upon, and therefore shorter than a person, such as Judd's and Morris's early boxes and Andre's plates, often expanded in width to just under what extended arms could grasp. Since scale, rather than size, was at stake, an object might have nothing in common with the actual size of a person, but appear to be physically manageable or graspable. The structure's size thus relates to the viewer's size without mimicking it.[68]

Certain critics found an analogy between Minimal art objects and children's play toys. According to this view, the artist manipulated the elements of a work of art much as a child would his or her building blocks, a notion presumably based on the limited number of internal parts, as well as large scale. Truitt's and Stella's works were described as constructions of children's blocks, Andre's early wooden structures as "a child's 'Build a Log Cabin' game." Often the works were characterized in playground terms, such as LeWitt's "Jungle Gyms," and as objects and environments providing children with crawl spaces and hiding places. The sculptures were interpreted by this handful of critics as large toys for large children lacking the dexterity of adults.[69]

It wasn't just the "human module" against which the Minimalists measured their works, but "in the greater context of interior or outdoor expanses."[70] Architectural sculpture has traditionally acknowledged this: scale is an effect, for example, of the size of the niche, its distance from the ground, and the proportions of the building. Judd always takes into account the place in which he is working or in which the object will appear. A human-sized sculpture can appear monumental in a tiny gallery. The same object can be dwarfed out-of-doors. In Scale as Content, Ronald Bladen and Tony Smith were each given half of the Corcoran Gallery's main gallery, which extends at least two stories upward, for a single work constructed on site. Bladen built his gigantic *The X.* Smith presented his environmental *Smoke.* Both sculptures are concerned with gigantic size and architectural context rather than with scale *per se.* The objects dominated and loomed. Unlike Flavin's or Morris's gallery installations, in which the objects articulated the space of the environment, the Corcoran was relatively insignificant—the giant sculptures created environments inside of and beneath themselves. Lippard reported that Robert Morris, upon hearing a description of *Smoke,* "called its obstreperousness 'being rude to the room.'"[71] The third work in the exhibition, Newman's *Broken Obelisk,* was seen to

successfully handle internal and external scale. Most critics were in agreement about the exhibition: scale was in no way identifiable with content.

Architecture and the Environment

In the early sixties, Alloway proposed that sculpture's anthropomorphism kept it from looking like furniture or hardware.[72] By 1966, the larger scale of sculpture was commonly interpreted as architectural, not only in terms of appearance, but because of interaction between spectator and object, and technical principles. Despite the popularity of the analogy, sculpture was never really confused with architecture. Although aesthetic, architecture is primarily functional. LeWitt made the distinction clear: "Architecture and three-dimensional art are of completely opposite natures. The former is concerned with making an area with a specific function. Architecture, whether it is a work of art or not, must be utilitarian or else fail completely. Art is not utilitarian."[73] Because of architecture's sheltering function, its inside is at least as important, if not more so, than its outside, whereas emphasis in most sculpture is on the exterior. "Even when a sculpture can be entered," Lippard observed, "it remains sculpture."[74] The manageable scale of Minimal sculpture, as opposed to architecture, was described by Morris as "haptic": "It has to do with dealing with objects in that kind of latent sense one has of being able to handle them and deal with them, move them. It's not a sense that I find applied to architecture, but objects that are in one's own body space."[75] The Russian avant-garde explored the amalgamation of architectural and sculptural ideas to a greater extent than the Minimalists, although one critic writing about Primary Structures offered Malevich's *Arkitektonics* (architectural models) of the twenties and Tatlin's *Monument to the Third International* of 1921 as prototypes.[76] Flavin's *Monument for V. Tatlin* pays direct homage to Tatlin's *Monument*, even in this case mimicking its shape, but it was Russian sculpture that was more generally influential, and according to Morris, precisely because of its *nonarchitectural* bias.

> [Tatlin], Rodchenko, and other Constructivists refuted Appollinaire's [*sic*] observation that "a structure becomes architecture, and not sculpture, when its elements no longer have their justification in nature." At least the earlier works of Tatlin and other Constructivists made references to neither the figure nor architecture. In subsequent years Gabo, and to a lesser extent Pevsner and Vantongerloo, perpetuated the Constructivist ideal of a nonimagistic sculpture which was independent of architecture.[77]

Lippard, more inclined toward an architectural interpretation, suggested that artists were influenced by sculptural monuments that had originated as architecture. She offered this example: "The pyramids started out as

architecture, but once the tombs were closed, they became sculpture." "What was inside of them," she had written earlier, "gradually became less important than their exterior shapes."[78] The tendency for architecture to "become" sculpture was not only a capacity of historical monuments. In the 1960s, the phenomenon that Kuspit later termed "dialectical conversion," worked in both directions.[79] Perreault explained: "Architecture as it tries more and more to be simply architecture becomes sculpture, and sculpture as it strives for 'sculptureness' becomes architecture or merely interior design."[80]

Some painters were directly inspired by architectural forms. As early as 1949, Ellsworth Kelly embarked on his Parisian Window Series, and subsequently, paintings based on bridges.[81] Mangold's Walls were also based on observations of the architectural environment. The glowing, rectilinear spaces between buildings prompted him to "think about a painting that would be atmospheric and architectural."[82] Fried noticed "doors" in Robert Huot's paintings at the Radich Gallery in 1964, positing the origin of the image in Robyn Denny's work of two years before.[83] When they were first exhibited, David Novros's right angle canvases of the mid-sixties suggested doorways to many observers. The architectural overtones, he recalled, most likely resulted from his frustration at the impossibility of utilizing actual architectural situations, circumstances remedied in the seventies. Novros feels that while Mangold's early work is correctly identified as architectural, his own and Marden's works, despite the latter's recent references to post and lintel construction, were mistakenly described as architectural.[84] For Marden, it was "more an interest in a man-made form, you know, like the rectangle is a man-made form. Post and lintel is man-made, just very basic."[85] Although one cannot see "through" Jo Baer's paintings, the rectangular bands that frame the blank centers are windowlike.

Sculptors less frequently drew inspiration from architecture, although their work, on account of its three-dimensionality, often more closely resembled real architecture than painting did. Morris's objects invite comparisons with doorways, columns, and altars, wrote Martin Friedman, but these analogies have nothing to do with his sculptures.[86] Judd's work in the 1966 Whitney Annual, a large, multipart turquoise structure now owned by the museum, was described as "ten metal elements which are very similar to prefabricated rectangular office window frames reclin[ing] on their long sides."[87] Certain of his other works were interpreted as adhering to or alluding to technical principles of building. The support and suspension of the units of his attenuated Whitney progression prompted Krauss to observe a parallel between the progression and the colonnades of classical and Renaissance architecture.[88] The structural and titular reference of Andre's *Crib, Coin and Compound* is architectural construction.[89] The

installation was described by Lippard as "even more architectural than the work of other structurists," because of the interior spaces of the three constructions. Lippard was especially prone to architectural comparisons. Larger sculptures, she remarked in reference to LeWitt's 1965 exhibition of planar, boothlike structures, "are patently architectural in their space-filling character; the smaller ones take on the dimensions of furniture rather than buildings."[90] Tony Smith, she maintained, "makes no pretense of making sculpture that has an architectural scale." Smith himself had previously explained, "I think of the piece as pretty much in a certain size and related to ordinary everyday measurements—doorways in buildings, beds, etc."[91] Smith's larger sculptures can be walked under, but of course are not functional in the way that architecture is.

Architectural references are appropriate to Smith, who was a practicing architect, and to LeWitt, who had worked for I. M. Pei in the fifties, designing such things as directory towers with numbers on them for parking lots. He feels that "the kind of structures that architects were doing was more of an influence on me than sculpture."[92] Bladen's and Grosvenor's complex monumental structures are clearly *built*. Grosvenor studied architecture and naval engineering (the latter, according to David Bourdon, having no influence on his work) in France.[93] Bladen, who had worked in the San Francisco shipyards and "built all kinds of semi-heavy steel structures," often had the impressive armatures of his sculptures photographed during construction.[94] While construction generally replaced traditional techniques such as carving and casting, Lippard made a distinction between sculpting and building: "Like [that of] Morris and LeWitt, [Bladen's] work is architectonic rather than sculptural though he is not as outrightly anti-sculptural as they."[95] In accordance with the pragmatism of the decade, the romantic associations of sculpting, from Michelangelo to Rodin to Moore, were rejected in favor of the concrete practicality of building.[96] The romantic artist is replaced by the worker. Rubin revealed such a sensibility in Stella's paintings:

> "They're architectonic," he observes, "in the sense of building—of making buildings. My whole way of thinking about painting has a lot to do with building—having foundations to build on. . . . I enjoy and find it more fruitful to think about many organizational or spatial concepts in architectural terms, because when you think about them strictly in design terms, they become flat and very boring problems."[97]

The architectural analogy illuminates the new concern for real space. As Kurt von Meier observed of Morris's Los Angeles show in 1966: "While the artist's intent may not have been to create 'architectural' sculpture, the effectiveness of this sculpture in transforming the space around it seems to be a major achievement."[98] Flavin's work is much less space consuming,

but has the same effect.[99] Relationships are established between pieces of sculpture and the walls and floor of the room. In a sense, sculpture becomes "decoration" for interior architecture, though not subservient to it.

Because of Minimal art's articulation of the actual space of the gallery, its objects were often described as "environmental." While most traditional sculpture and painting are inwardly directed and self-contained, Minimal objects activate, without actual or implicit movement, the space not enclosed by the pieces themselves—that is, the space inhabited by the viewer. Statements made by three artists of different generations illustrate the shift of emphasis in the 1960s. Robert Rauschenberg's famous quote provides a starting point: "Painting relates to both art and life. Neither can be made. I try to work in that gap between the two." In 1966, Grosvenor explained: "I don't want my work to be thought of as 'large sculpture,' they are ideas which operate between floor and ceiling. They bridge a gap." Finally, Mel Bochner reinterpreted Rauschenberg's statement to advocate the operative gap between the wall and the spectator.[100]

Lippard described a major distinction among Minimalists in their use of space. Judd, Morris, and Smithson, she noted, make works that occupy space. Bladen, Tony Smith, and Grosvenor conquer space. The installations of Andre and Flavin disperse space, while LeWitt's grids and Smith's *Smoke* incorporate it.[101] Earlier, in a 1964 review of Judd, Stella, and others, she initiated the custom of classifying certain objects as environmental.

> There is a growing tendency, even in "straight painting" exhibitions, to *surround* the spectator, whose increased physical participation, or immediate sensorial reaction to the work of art, often operate at the expense of the more profound emotional involvements demanded by New York School painting in the fifties. In the broadest sense, the five exhibitions discussed below could all be called "environmental."[102]

Later, another critic cautioned that "environmental sculpture" demands "that the observer get physically involved as if he were entering a serious space playground for adults."[103]

Like most Minimal concerns, the interest in real space evolved from a scrutiny of pictorial issues. Progressively flatter paintings forced the consideration of the space in front of rather than behind the surface, i.e., a concern with the environment in which the work itself existed. Russian sculpture was also a precedent, though less immediately influential. Tatlin's use of the corner is especially recalled by Flavin's lighted squares that dissolve the corner and by Morris's *Corner Piece* of 1964.[104] El Lissitzky's *Proun Room* of 1923 is an early example of manipulation of the total environment. Kurt Schwitters, Frederick Kiesler and Moholy-Nagy were also cited in this context.[105] Yves Klein's 1958 exhibition of an empty, white-walled room at the gallery of Iris Clert in Paris proposed the viability of the room as a work of art.

The Minimalists, however, were quick to deny that they were making environmental sculpture. The term, perhaps, carried associations of the Happenings and installations of Allan Kaprow, Claes Oldenburg, and George Segal, although Lippard distinguished this kind of work "which physically invades the exhibition space" and can provoke audience participation, from the more formal concerns of the Minimalists.[106] Alloway, too, noted the two variants of what he called environmental art: "(1) The expansion of works of art until they are big enough to surround and envelop the spectator; attention to such works is discussed in terms of drama and encounters. . . . (2) The incorporation in works of art of objects and signs for the man-made environment."[107] Warhol's 1966 environments of cow wallpaper and floating silver pillows at the Castelli Gallery were distinct from those of the Minimalists who denied the connection between their art and the more entertaining efforts of the Neo-Dada and Pop artists.

Morris was most often implicated in discussions of environmental work. For example, one critic wrote that "Morris has here accomplished an important break with past sculpture ... by creating a sculpture that serves to redirect the entire environmental experience."[108] Although Martin Friedman maintained that Morris did not make environments, he noted that the "environment is a critical factor" in the artist's work.[109] In his "Notes on Sculpture," Morris himself persistently denied that his work was environmental. "That the space of the room becomes of such importance does not mean that an environmental situation is being created." And later, "Such work which deals with more or less large chunks of space in these and other ways is misunderstood and misrepresented when it is termed 'environmental' or 'monumental.'"[110] Judd also described Morris's 1964 exhibition of seven plywood sculptures as *not* environmental. "If Morris made an environment it would certainly be one thing."[111] With veiled reference to Judd's subsequently published comment in "Specific Objects" that the difference in the new work "is between that which is something of an object, a single thing, and that which is open and extended, more or less environmental," Morris told David Sylvester: "But for me it doesn't go to the point of being an environment. You know, it's like these polarities. I just don't think that's the right kind of language to use: that it's either an object or it's an environment—that if you slip out of the compact introverted focus, then you're in an environment."[112] Many years later, Hal Foster revealed the contradiction in Morris's position, which held that significant relations are external (i.e., between the object and the viewer) while claiming that the work was not environmental.[113]

"Although in no way connected with environmental art," wrote Bochner, "both Andre and Flavin exhibit an acute awareness of the phenomenology of rooms."[114] Flavin was especially sensitive to the label of environ-

mental, yet more than most, he creates a situation involving the structure of the gallery itself. From his first all-fluorescent show at the Green Gallery in the winter of 1964 to his recent installations, Flavin seems specifically attentive to the space of the gallery. In his preliminary sketches, the gallery appears in plan as an open cubic block on whose interior the tubes are mounted.[115] Nevertheless, Flavin published a letter he wrote to Jan van der Marck with regard to his exhibition at the Museum of Contemporary Art in Chicago. "I do not like the term 'environment' associated with my pro- posal. It seems to me to imply living conditions and perhaps an invitation to comfortable residence. Such usage would deny a sense of direct and difficult visual artifice (in the same sense that to confront vibrating fluores- cent light for some time ought to be disturbing for most participants)."[116] In cursorily attempting to sort out this dispute, Burnham, whose dedication to a "systems esthetic" colored most of his later writing, claimed that "the best formalists" of the sixties (in which he included Flavin) have been "making more and more of the environment *their system*."[117] Despite the artists' distaste for the *term*, compositional concerns had expanded to the space shared by the object and the spectator.

Practically every Minimalist contrived new ways of dealing with floors, walls, ceilings, and corners. Andre, for example, laid his sculptures so low that they mimicked the floor's flatness, rising no more than a fraction of an inch above it. Judd cantilevered his stacked boxes from the wall, proposing a new support for nonrelief sculpture. Morris's *Cloud* was suspended from the ceiling, which it also echoed. Flavin's light fixtures frequently depend on the corner. Grosvenor's huge cantilevered sculptures are "structured in terms of the room," according to Corinne Robins, and clearly make an environmental statement.[118]

Walls and floors became part of the viewer's experience of externally oriented work. Novros recalled that several people questioned the viability of his shaped canvases if they were hung on colored wallpaper, suggesting the seriousness with which spectators took the environment, often at the expense of the work of art.[119] In a review of the Dwan Gallery's "10" show, which included the prominent Minimalists, Michael Benedikt observed with distress the interference by "the rug fuzz (truly: after placing all bets on things reductive and mainly black and white, it seems to me that no gray-brown textured rug should have been left around, as it did at the Dwan)."[120]

Morris's and Judd's works were frequently received in terms of their affiliation with the structure in which they were exhibited. Morris's work was described as actively utilizing the space of the room by forcing the spectator to take it into consideration.[121] Jane Harrison Cone observed that "one of the defining characteristics of Judd's art is that its limits are de-

clared by the inescapable factuality of the works he creates, a factuality which goes so far as to accept and use the walls and floor of a given room, and which accepts and uses the space of that room."[122] The exhibition space now took precedent over the isolated, "introverted" object (as Morris called it). Early in 1964, Rose noticed in group shows "a new and healthy trend toward assembling what looks good together rather than presenting captioned picture-stories of modern art movements and trends meant more to enlighten than delight, and which often fail to do either."[123] Most artists paid close attention to the way in which their works were exhibited. As Morris explained, "Placement becomes critical as it never was before in establishing the particular quality of the work."[124] For Judd and Andre, the placement of the object figured largely in the success of the exhibition. Andre's abbreviated history of modern sculpture emphasized the contemporary interest in placement: "Sculpture as form/Sculpture as structure/ Sculpture as place." His *Lever* was specifically designed for a room with two entrances so as to provide spectators with differing perspectives.[125] When he makes a work, he thinks in terms of "generic classes of spaces," such as homes, galleries, and museums.[126] Judd offered a detailed description of the ideal exhibition space: a high-ceilinged, rectangular space with plain walls and floors.[127] Installations of his own work attest to his concerns, from the specification that the height of the ceiling in a collector's home determines the number of boxes in the ten-part vertical pieces that can be exhibited with nine inches in between, to his Chinati Foundation in Marfa, Texas, a permanent installation of his and other artists' works. Judd was said to have redirected an entire installation of his work in 14 Sculptors: The Industrial Edge.[128] Of Truitt's first solo exhibition, he complained, "The arrangement of the boxes is as thoughtless as the tombstones which they resemble."[129]

Exhibitions were sometimes arranged by the artist, in a manner similar to the composition of a large sculpture. In a brief discussion of LeWitt's first one-man show of the booth structures, a reviewer pointed out that "LeWitt designed the pieces specifically for the gallery, so its negative areas are equally meaningful."[130] Baer's first show was also, as Lippard noted, "composed," with the result of "forcing the space of the room into personal proportions."[131] Lighting was a considerable concern as well. Shadows often seemed an integral aspect of an exhibition, particularly since critics and spectators were aware of the heightened significance of the gallery space. Lippard observed that LeWitt's grids "are subject to the most dramatic change and modulation because of the shadows cast by the bars, with or without dramatic lighting.... Because of this, the contour—corners, floor and ceiling lines—take on an added importance."[132] When questioned about the relevance of the shadows cast by his sculptures, Judd replied, "All of my pieces are meant to be seen in even or natural light. The shadows

are unimportant, they are just a by-product."[133] According to his distinction between object-oriented and environmental artists, Judd makes objects, not environments.

The environmental aspect of Minimal art led directly to what has come to be known as "site specific" work, which cannot be transported from exhibition to exhibition but is dependent for its existence on its particular location. Michael Heizer's *North*, for example, is the Minimalist cube turned inside out, allied in concept to the Sierra Nevada. Although Flavin designed certain installations for specific spaces, such as the exhibition at the Kornblee Gallery in the fall of 1967, most Minimal artists did not actually create site-specific work that functioned only in a single context. Individual works by Flavin are easily exhibited with varying groups of objects. Friedman's remark on Morris's sculpture applies equally to other Minimalists: "While some of his pieces function better in particular environments, he does not make work for a specific space."[134]

Exhibitions of the same piece in different environments may provide startlingly different experiences, and yet the work itself remains unchanged. In reference to Judd's vertical, galvanized iron plates, which lined the walls at Castelli's in 1970 and the following year at the Pasadena Art Museum, William Agee commented, "The difference in experiencing the two installations was equivalent to viewing two distinct pieces."[135] Although in Judd's case the metal units were identical from one installation to the next, other work has been refabricated for subsequent exhibitions. Unlike site-specific work, as long as the form is unchanged, the identity of the work remains the same. The replacement of burnt-out tubes in Flavin's work does not result in a different work of art.

Most discussions of environmental art pointed out the tendency of such work to surround the spectator. Because of the close relationship established by scale between the viewer and the object, Minimal exhibitions seemed to fill the gallery space, in a sense defining that space, making spectators acutely aware of their own "space." Several shows dealt specifically with this aspect, such as Andre's *Crib, Coin and Compound*, and McCracken's fourteen white plinths at the Robert Elkon Gallery in 1968. These objects took up so much space, and were never capable of being seen *in toto* by the spectator, so that the cubic space of the gallery essentially became a work of art through which the spectator moved. Often the works literally blocked the viewer's passage. In "ABC Art," Rose described Morris's plywood objects "which serve mostly to destroy the contour and space of a room by butting off the floor on to the wall, floating from the ceiling or appearing as pointless obstacles to circulation."[136] Flavin, the least object-oriented, was also interested in the idea of art as obstacle. Beneath a sketched proposal for an exhibition in 1966 he wrote, "A fluores-

cent room for the Kornblee Gallery which will inhibit and permit movement of an adult."[137] His barrier to the entrance of the gallery in the form of vertical, inward-facing tubes was constructed in 1968 and named *Untitled (to Dorothy and Roy Lichtenstein on not seeing anyone in the room)* (perhaps a response to Lichtenstein's early *I Can See the Whole Room* of 1961). Real three-dimensional space is one of the subjects of his work: "I know that the actual space of a room could be broken down and played with by planting illusions of real light (electric light) at crucial junctures in the room's composition."[138] As had not typically been the case, the unoccupied space of the gallery was part of the spectator's experience of sculpture in the 1960s. On Morris's show at the Dwan Gallery, Don Factor wrote, "The room, and the people in it, become important to the experience in an extension of the manner in which the wall becomes an important adjunct to the nonrectangular paintings of Frank Stella."[139] Stella's paintings, in particular, proposed the activation of the previously neutral buffer zone of the gallery. In installations of his shaped paintings, "The walls act like sound boxes echoing the interior shape and amplifying the exterior shape. The intervals between paintings, as the intervals in music, become positive elements," according to Coplans.[140] Morris was especially concerned with the shared space between the spectator and the work of art, which he found be "a structuring factor" itself affecting the "object-subject terms."[141] "I wish to emphasize," he says, "that things are in a space with oneself, rather than a situation where one is in a space surrounded by things." It is real space, belonging ultimately to the spectator, that Morris finds to be a plausible field of action.[142]

Minimal artists stood by the distinction between environments, which were inclusive, and their own objects, which depended on the space of the room, but were to be appreciated as separate things. In her review of Judd's first show, Lippard reflected, "Don Judd was probably not planning an environment, yet his exhibition casts a definite collective spell which to some extent overshadows the individual pieces, leaving one to wonder how well they stand up on their own."[143] For James Mellow, however, the pieces were capable of retaining their singularity: "But each of them seems to stake out and occupy its territory with absolute authority, without dependence upon or response to the pieces surrounding it."[144] As it turned out, Judd was far less interested in the space of the room than was Morris, who by the later sixties rejected the confines of the unitary form for more environmental work. His interest in the actual space between the spectator and the "extroverted inclusiveness" of the work of art led to his distinction between the public and private mode. The smaller an object is, the more intimate or private it is. Smaller objects force the spectator into a closer physical appreciation of detail or "surface incident." On the other hand, "A

larger object includes more of the space around itself than does a smaller one. It is necessary literally to keep one's distance from large objects in order to take the whole of any one view into one's field of vision."[145] By calling this work "non-personal" or "public," Morris illuminated an aspect of all the new art—that the essential anonymity of the artist extends to the observer as well. According to Krauss, "It staked everything on the accuracy of a model of meaning severed from the legitimizing claims of a private self."[146] For Rubin, the mode of "public address" is a result of external scale, in contrast to Abstract Expressionist painting, which is private in the sense that it was intended for "intimate contemplation" in private homes rather than museums.[147] Subsequent developments must surprise (or annoy) Barbara Rose who wrote of Morris's early polyhedrons, "One must conclude there is no private collector in existence disinterested enough to purchase this work for home installation."[148] While collectors such as Panza di Biumo have proved her wrong, the basic idea behind her statement corresponds to Morris's. Minimal art is ill-suited to the kind of formal analysis and aesthetic appreciation appropriate to modernist painting and sculpture.

Michael Fried's Theory of Theatricality

With the decreasing interest in internal formal relationships, new demands were placed on the spectator. Robert Morris explained this situation most clearly:

> One is more aware than before that he himself is establishing relationships as he apprehends the object from various positions and under varying conditions of light and spatial context. Every internal relationship, whether it be set up by a structural division, a rich surface, or what have you, reduces the public, external quality of the object and tends to eliminate the viewer to the degree that these details pull him into an intimate relation with the work and out of the space in which the object exists.[149]

Observers of Minimal art are, on the other hand, made superconscious, almost self-conscious. They compare their place and existence with that of the object, on equal footing with it. The opposite is true of much earlier art, specifically that of Newman and Rothko, "to the extent that the spectator, far from eventually maintaining his identity as separate from the painting, gets sucked into it."[150]

One of the reasons for the external orientation of Minimalism and subsequent emphasis on the spectator is the literal and metaphorical emptiness of the work. The objects are hollow. One does not, or cannot, focus on the relationship between interior and exterior structure. The lack of expressive content also induces the outer-directedness of the object, forcing the spectator to locate the meaning of the work within the experiencing

self rather than within the object. The British sculptor David Annesley distinguished Morris's work from that of Caro's on this basis.[151] Indeed, it was Morris's art and writings that emphasized the constitutive role played by the spectator and led to an unprecedented critical focus on the viewer's reactions.

Michael Fried's well-argued "Art and Objecthood" remains the most influential analysis of Minimal art.[152] Because of their obsession with the spectator, Morris's, Judd's, and Tony Smith's sculptures are negatively assessed as theatrical. The theatrical sensibility, evidenced in the previous decade's work by Kaprow, John Cage, and Rauschenberg, was never sanctioned by Greenbergian or formalist critics, and appears from the start to be a value-loaded term in Fried's vocabulary.[153]

Earlier references to theatre in Minimal criticism were confined to the appearance of the installation rather than the spectator's relationship to that installation. Lippard, who was later to refute Fried's theory, wrote of Judd's first show: "The effect is that of the scattered units of a stage set. Some of the pieces resemble the kind of podium upon which Greek drama is often enacted in the modern theatre."[154] Corinne Robins discussed the "non-schematic method of exhibiting" the works in Primary Structures. "And the show, in general, seemed arranged more along the lines of theatrical effect than aesthetic coherence."[155] The fact that the objects were presented like stage props was not, however, Fried's point. He treats the Minimal objects in question as *actors* rather than as inert stage props, which is characteristic of his tendency to personify works of art, to attribute to them autonomous progressiveness for the sake of (or counter to) modernism. While Fried does not draw on the example of Morris's eight-foot *Column* of 1961, Krauss's description of it substantiates Fried's point of view: "The 'performer' [Morris] chose and constructed was a hollow column which appeared alone on stage." During his performance, the column stood upright for three and one-half minutes, and was then made to lie horizontally for the remainder of the event.[156]

Fried's argument is based to a large extent on Morris's concern with the spectator. As he said, "The whole category of theatricality that I use is all about a problematic of the spectator." He continued to clarify his statement, "but it's not arguing for a criticism that has nothing to do with the spectator. My criticism is talking about the spectator but saying that art has to have the right relation ... to the spectator."[157] Secondly, Fried maintains Greenberg's distinction between the individual arts (derived from Gotthold Lessing), and assumes there are appropriate and inappropriate concerns for each one. Theatre, he holds, is "what lies *between* the arts."[158] While he has denied that Minimal art is *non-art*, he infers that its concerns are antithetical to those of art, especially since the Minimalists, and here the reference

is more to Judd than Morris, refuse to recognize the boundary between painting and sculpture.[159]

Finally, not only is theatre not art, in the sense of lying between rather than within the valid arts, but its appeal is literary.[160] In an early review of some nonMinimalist, "semi-abstract" wood sculpture, Fried confessed: "This is where I bridle: the sentimentality and literary imagination which I might be glad to find on the stage become intolerable in the gallery."[161] Minimal art was subsequently characterized as "ideological," having the capacity of being formulated in words.

Fried launches his argument by claiming that Minimal art is theatrical because "it is concerned with the actual circumstances in which the beholder encounters" it. The environment activated by the art is interpreted as a showcase or stage set for the objects displayed. The experience of objecthood, Fried notes, is the result of the entire perceived situation, including the spectator's body. Although for Fried, Caro's sculpture represents the nontheatrical, Caro explained his own work differently. "This sort of sculpture is entirely to do with the sort of space the onlooker, or the artist who's making it, inhabits."[162] Real space, to varying degrees, was a concern of all nonmimetic sculptors in this decade.

Minimal art also parallels theatre in that both have an audience, and in fact *"exist for* one.... That the beholder is confronted by literalist work within a situation which he experiences as *his* means that there is an important sense in which the work in question exists for him *alone*."[163] A theatrical spectacle without an audience would be pointless. Fried's analogy is again based on Morris's "Notes on Sculpture, Part 2," as Barbara Reise explained: "The dialogue between plastic concepts within one of Judd's works is de-emphasized [by Morris], replaced by a dialogue between the piece and the viewer. (Michael Fried's attempts to characterize the 'theatrical' presence of work by Morris, Judd and Smith is probably based on this aspect of Morris's work; it is certainly relevant only to it.)"[164] Greenberg's notion of presence prompted Fried to describe Minimal objects as possessing "a kind of *stage* presence," a quality he compared to "the silent presence of another *person*." Such anthropomorphism was "incurably theatrical."[165] Fried's support of Caro's work as nontheatrical is once again undercut by the artist, whose shift in sensibility in 1960, from Moore-inspired bronzes to abstract floor-bound sculpture was, he explained, "because I wanted to make something that was as important in a room as a person."[166]

Fried sees Minimal art as distancing the spectator and countered its theatrical effects with work that is absorbing or absorptive. In each case, the audience's relationship to the work is different. Fried reiterated this duality, now in the context of eighteenth-century painting, by contrasting

depictions of "absorptive activities" with theatrical work made expressly for and relating specifically to the spectator. The parallel is obvious:

> In several essays on recent abstract painting and sculpture published in the second half of the 1960s I argued that much seemingly difficult and mediocre work of those years sought to establish what I called a *theatrical* relation to the beholder, whereas the very best recent work—the paintings of Louis, Noland, Olitski, and Stella and the sculptures of Smith and Caro—were in essence *anti*-theatrical, which is to say that they treated the spectator as if he were not there.[167]

Finally, to the concern with the situation, the awareness of the audience, and the possession of an anthropomorphic stage presence, Fried adds the concept of temporality. "The literalist preoccupation with time—more precisely, with the *duration of the experience*—is, I suggest, paradigmatically theatrical."[168] Fried updates the standard distinction between the spatial arts (painting, sculpture, and architecture) and the temporal arts (literature, drama, music, and dance) by analyzing the spectator's response rather than the objective existence of the work of art. Although Minimal sculpture itself, unlike literature, takes up space rather than time, time is spent by the spectator in apprehending the object.

Krauss finds Fried's concept of time to be central to his theory of theatricality, and to explain why he must accept Caro's work and reject that of Morris and Judd. "Essential to the two-dimensionality of painting is the fact that its contents are available at any one time to a viewer with an immediacy and wholeness that no three-dimensional art can ever have. It is basically on these grounds that Caro and the sculptors who follow him defend the kind of pictorialism that came increasingly to the fore in their work."[169] According to Fried, Minimal work, like a drama, unfolds in time. On the other hand, "It is as though one's experience of [modernist painting and sculpture] *has no* duration."

Fried's biting indictment of Minimalism in "Art and Objecthood" elicited rapid response from the art community. Letters from Peter Plagens, Allan Kaprow, Lawrence Shaffer, and Robert Smithson appeared in the next two issues of *Artforum*. Barbara Reise attacked Fried's position in *Studio International*.[170] John Chandler attempted to discredit Fried's thesis based on the "fallacy of the converted middle." (After establishing the drama of Tony Smith's sculpture, according to Chandler, Fried proceeded to criticize it as theatrical.) Chandler also disputed the argument of temporality.[171] No one at the time, however, confronted Fried's position as directly and devastatingly as Lucy Lippard. Lippard's rebuttal, which appeared in 1972 in a book on Tony Smith, illuminates Fried's inability to deal with truly three-dimensional art.

Michael Fried's contention that all such art is "theatre" and therefore diametrically opposed to the "modernist tradition" from which all his own favorite art arises, does not take into consideration the fundamental differences between the experience of perceiving painting and sculpture. The sculpture he admires belongs to the *pictorial* tradition and therefore, as pictorial or graphic sculpture, it is indeed threatened by the encroachment of the "real space" and "real life" introduced by the minimalists, conceptualists, etc. Painting is not, however, threatened, unless one makes irrelevant claims for the continuing *domination* of painting's tradition.[172]

Fried's entire criticism rests on his distinction between pictorial-modernist art and literal-theatrical objecthood. As an example of the kind of sculpture he favors, i.e., modernist art of quality, he offers Olitski's *Bunga*, the surface of which he describes as "more like that of a painting than like that of an object."[173]

Greenberg aligned the pictorial with painting and the literal with sculpture. However, as Fried was to do later, he made an allowance, counter to his habit of maintaining the separateness of the arts, for pictorial sculpture. "It is significant, moreover, that modernist sensibility, though it rejects sculptural painting of any kind, allows sculpture to be as pictorial as it pleases. Here the prohibition against one art's entering the domain of another is suspended, thanks to the unique concreteness and literalness of sculpture's medium."[174]

The Minimalists' "anti-pictorial interpretation" of modernism is, according to Fried, one in which Stella does not participate.[175] In preparation for the arguments of "Art and Objecthood," he differentiated the works of Stella, Noland, and Olitski which acknowledge literalness, from those of Judd and Larry Bell which "simply are literal."[176] The modernist painting Fried champions must "defeat or suspend its own objecthood" through shape, but "shape which must belong to *painting*—it must be pictorial, not merely literal." Thus, Fried sets up the dichotomy of literal and pictorial (not in this instance depicted) shape and opts for the latter, literal shape being merely "a given property of objects."[177] Caro is acceptable because, as Krauss and Lippard acknowledged, he deals in the realm of the pictorial. Three-dimensional Minimal objects lack the presentness or immediate availability of pictorial art.

"It is," as Barbara Rose notes, "impossible to disagree with Fried's characterization of the new aesthetic as literalist. But it is not necessary to accept his conclusion that the new work lacks quality."[178] Nor for that matter is one required to abide by his characterization of the work as theatrical. The *reasons* he gives for the theatricality of the works are valid— that is, they are valid descriptions of the objects' features and functions. However, to link such work to the theatre is misleading. Drama is a literary, essentially narrative art. Events, not objects, are enacted (or participated

in in modern theatre). And although Fried maintains that "the theatricality of Morris's notion of the 'non-personal or public mode' seems obvious: the largeness of the piece, in conjunction with its non-relational, unitary character, *distances* the beholder—not just physically but psychically,"[179] theatre is the *least* distancing of all the arts.[180] Because of drama's depictions of real life, the spectator often finds him or herself lost in it, losing distance. Theatre cannot partake of the abstraction and inertia present in Minimal works of art.

The Spectator's Experience

Fried's notion of temporality—the duration of the spectator's experience—is central to his condemnation of Minimal art. The amount of time it takes the spectator to apprehend the object was also debated by other critics and artists. The relative simplicity and geometric regularity, or ideal form of cube, plane, etc., on the one hand, would seem to elicit immediate apprehension. Once a cube is recognized, no further discrimination is necessary or possible. On the other hand, because of the spectator's movement toward, away from or around the object, total comprehension does take place over a period of time.

Fried's own position in "Art and Objecthood," that apprehension of modernist painting is instantaneous while the experience of Minimalist objects persists in time, with the former experience being preferable to the latter, differed from his earlier explanation of Olitski's painting. Olitski's unique color sense, his combination of seemingly disparate colors, Fried remarked, could only be comprehended if the spectator were made to view the colors sequentially, one after another, without any prescribed order, but in time.

> Most of Olitski's paintings executed since 1963 that I have seen virtually demand to be experienced in what may be perhaps called visual time. . . . Putting aside for a moment their obvious differences, what the paintings of van Eyck and Olitski have in common is a mode of pictorial organization that does not present the beholder with an instantaneously apprehensible unity.[181]

Although the painting may be seen instantaneously, he continued, the result would be an incorrect impression of the work in question.

Subsequently, Fried claimed that the experience of a modernist painting is instantaneous, "as though if only one were infinitely more acute, a single infinitely brief instant would be long enough to see everything, to experience the work in all its depth and fullness, to be forever convinced by it." No mention was made of the previous description of Olitski's work,

only that modernist painting, as against literalist art, "*has* no duration," only "presentness and instantaneousness."[182]

Not only does the experience of a Minimal work of art take place in time, it has no beginning or end according to Fried. "It merely *stops*."[183] This notion led him to posit the compositional endlessness of the *object*, with his position losing some of its credibility in the transition from experience (of the spectator) to experienced (object). Either "there is nothing there to exhaust," as in the case of Smith's black cube, or the work seems to be a fragment of a much larger infinitely extendable object, such as Judd's progressions.[184] Judd, however, would probably not agree. His method of order, "one thing after another," which he appreciated in Stella's striped paintings, was founded on the desire for compositional unity and wholeness rather than extension.[185] Relational, hierarchical compositions emphasize the parts at the expense of the whole, as opposed to Judd's works, which are not intended to appear as fragments.

While Fried does venture into descriptions of the physical objects, his main interest is in the spectator's response to the objects. As Lippard surmised, Fried only has sympathy for works of art that are apprehensible from a single, stationary vantage point. Mangold's interpretation corresponds to Fried's: "What interests me about flat images is the fact that you receive all the information ... at once.... Somehow, in one snapshot you can get all the information that the painting has to give."[186] Nodelman also explored the immediacy of two-dimensionality. Beyond the simple flatness and smooth surfaces of Stella's and Noland's paintings, "a single, immediately graspable principle of arrangement" results from the coincidence of image and shape.[187] Stella himself preferred the unprolonged approach resulting from the minimization of detail. "One could stand in front of any Abstract-Expressionist work for a long time, and walk back and forth, and inspect the details of the pigment and the inflection and all the painterly brushwork for hours. But I wouldn't particularly want to do that and also I wouldn't ask anyone to do that in front of my paintings."[188]

For Lippard, the suppression of incident and singleness of image did not necessarily lead to instantaneous comprehension. In reference to the most formally simple work, she observed: "Monotone painting can be said to exist in time as well as in space, for it demands much more time and concentration than most viewers are accustomed or, in most cases, are willing to give."[189] Annette Michelson's description of Morris's sculpture is comparable: "Cognitive in its fullest effect, then, rather than 'meaningful,' its comprehension not only demands time; it elicits the acknowledgement of temporality as the condition or medium of human cognition and aesthetic experience."[190] The issue of duration appears to depend on what is to be obtained from the experience of the work of art. According to Flavin,

"Quick, available comprehension is intended for participants in my installations. (One should not have to pause over art any longer.)"[191] LeWitt, on the other hand, noted that one is inclined to look at his structures for an extended period of time in an attempt to decipher the original idea by working backward from the object to the concept.[192]

Confronted with one or more of Morris's polyhedrons, the spectator compares and adjusts each apprehensible relationship to the unchanging form of the object. "Only one aspect of the work is immediate: the apprehension of the Gestalt. The experience of the work necessarily exists in time."[193] That Morris's three L-beams are identically shaped is registered instantaneously. While this recognition structures subsequent experiences of the group, the configuration is perceptually altered as the spectator moves around and between the elements. As one moves, through space and time, relationships between spectator and object change. Uprightness, horizontality, and diagonality are recognized and reconciled with the conceptual basis of the work. The experiential component of Minimalist objects, whether Judd's, Andre's, or Morris's, can only be recognized through time. The awareness of the duration of the experience is especially pronounced since the spectator does not give him- or herself up to the object, but retains a persistent awareness of self as separate from the object of contemplation.

The spectator's circumnavigation of the object literally takes time. The larger the object, the longer the walk. As Andre pointed out with respect to small sculptures, "You don't have to walk around them. You can turn them with your hand or you can grasp the whole thing at once."[194] Making objects large means, according to Morris, "that one keeps moving around in looking at the piece, that you're constantly seeing something different."[195]

Most Minimal sculptors, especially those indifferent to Gestalt principles, advocate circumnavigation of their objects. Andre believes that from no single point are his sculptures fully revealed. Like roads, he said "They cause you to make your way along them or around them or to move . . . over them."[196] Judd sees his structures as objects that sit in real space to be looked at from all angles. He wants the observer to walk around the sculpture rather than stand in one place.[197] There are only a few exceptions to this rule. Smithson's *Gyrostasis*, a spiral series of stacked three-dimensional triangles, can be read only in profile. The other side of the object is an undivided, smooth white surface. The frontality of Flavin's corner pieces prohibits circumnavigation. Attachment to the wall does not necessarily rule out the spectator's movement. Judd's attenuated progressions, for example, are most clearly understood when one moves along in front of them. Many merit oblique and profile inspection as well.

The notion that sculpture ought to be viewed in the round is a modern idea, William Tucker explains: "It really came from Henry Moore in terms of *insisting* that his sculptures were seen as a series of successive views, none of which would be dominant. You had to get to know it by going around it and reading the views one after another."[198] This kind of sculpture was considered incomprehensible from a single, stationary position. According to Moore, in-the-round reading "can give to sculpture a continual, changing, never-ending surprise interest." Although both Moore's and Minimal sculpture are appreciated in the round, the difference between the two seems to have to do with the spectator's reaction. Moore's work "one explores with the eyes, but the body remains behind."[199] Minimal objects, on the other hand, evoke in the spectator an awareness of his or her body within the space shared by object and viewer.

Not all modern sculpture is like Moore's. Krauss links David Smith's reliance on frontality to the theories of Adolf von Hildebrand, who demanded that complete knowledge of shape and gesture be obtainable from a position directly opposite, i.e., in front of the sculpture. With Smith's Cubis, "the resolute frontality of the works makes it clear that no real knowledge of them will come from a change in the spectator's point of view; everything to be known is given, as in a drawing or painting, from the front." She notes Smith's own statement, "I don't consider always that sculpture should be conceived/viewed in the round," which justifies her description of his work in pictorial terms.[200] She subsequently developed "the principle of radical *discontinuity*," from the concept of frontality. This involves the "avoidance of a predictable relationship between front and profile view," as exemplified by Smith's *Blackburn: Song of an Irish Blacksmith* (1949–50).[201] Awareness of the two faces does not necessarily add up to an understanding of the shape as a whole, which circumnavigation of work by Moore, on the other hand, permits.

The simple polyhedron of the Minimalist presented a different problem. Since each face is identical or extremely similar, successive views cannot be said to sequentially reveal the form. Because there is no appreciable physical difference between the sides, discontinuity does not occur, nor can the sculpture be said to be frontal. Frontality depends completely on the position of the viewer, rather than on a hierarchical favoring of one side over another, as Coplans pointed out.[202] Perhaps this work doesn't require time-consuming circumnavigation at all. Taking her cue from Coplans's essay on Bell, Price, de Lap, McCracken, and David Gray ("Their sculptures are of such a nature that shape is delivered and grasped at once"), Rose claimed that the Minimalists dispensed with the concept of in-the-round reading, as they had done with "truth to material." "The all-at-once experience of a specific object can be had from any angle, but it does

not require the sequential examination of walking around the object. This, again, differentiates it from sculpture in the round."[203] Although Morris was the most outspoken advocate of circumnavigation, he did at one point explain that "in the simpler polyhedrons such as cubes and pyramids one need not move around the object for the sense of the whole, the gestalt, to occur."[204]

The instantaneousness of the Gestalt, as Morris knew, is a central thesis of Minimalism. The form is completely given at once. What unfolds in time is the experience: a series of changing perceptive states based on the relationship of the viewer's body to the object. Friedman described a typical encounter with one of Morris's polyhedrons: "With such a Gestalt one sees a form as a totality, not as a series of separate unrelated sequences. As the observer moves around the form and changes his distance from it, proportions vary; perspective is altered and constantly shifting relationships are set up between him, the object and the room."[205]

Minimal objects tend to be based on regular solids, ideal forms that one knows from geometry. The form of a cube for example—its Gestalt—is known before the particular box is encountered in the gallery. As the spectator moves around the object, which one *does* tend to do despite Coplans's and Rose's remarks to the contrary, he or she explores various physical relationships between the self and the object. Knowledge about the shape is not incrementally received. Gestalt psychologists discovered a parallel in the nature of perception itself, as Arnheim explained.

> It seemed no longer possible to think of vision as proceeding from the particular to the general. On the contrary, it became evident that overall structural features are the primary data of perception, so that triangularity [for example] is not a late product of intellectual abstraction, but a direct and more elementary experience than the recording of individual detail.[206]

With traditional sculpture in the round, such as Moore's, knowledge of the shape is arrived at after circumnavigation, due to the complexity and originality of the form.

Because of Morris's writings, particularly the first installment of "Notes on Sculpture," a popularized version of Gestalt theory was developed. Don Factor, for example, referred to the viewer's experience as "a kind of Gestalt showdown."[207] Although simplified by art writers, the basis of both Gestalt and Minimal theory is the same. Both seek to describe and render objects as unified wholes: "That a whole cannot be attained by the accretion of isolated parts was not something the artist had to be told. . . . At no time could a work of art have been made or understood by a mind unable to conceive the integrated structure of the whole." Gestalt theory is, Arnheim continued, "the active striving for unity and order."[208]

Morris delineated two principles with respect to the apprehension of the Gestalt, and these were demonstrated by his sculptures. The first is that the simpler the polyhedron, the stronger the Gestalt. In other words, basic and recognizable forms appear more whole and unified than complex ones. Morris also noted that the Gestalt is immediate, takes no time to decipher and, once established, does not break down or "disintegrate."[209]

An object, however, appears different from various perspectives. The spectator must walk around LeWitt's structures because "each view is completely different. . . . With the cube, the incomplete cube, you get more than a reaction [to the Gestalt], you get a mental message as well."[210] Morris explained that in moving around the object, "you are more aware that it's always different from each position, that you're always seeing something different each time."[211]

The notions of differing perspectives would seem to contradict the physical reality of a regular, symmetrical polyhedron. How can circumnavigation of a cube reveal various and contrasting points of view when all four faces and all eight corners are essentially identical? Even Judd's open-ended floor boxes are completely accessible from any oblique point of view. Alloway described traditional sculpture as "the extension of uniquely invented form into three dimensions. Thus the sculptors felt obliged to invent all-round entertainment for the prowling viewer."[212] Each view is literally different—that is, it is a view of a different shape or form. Although Minimal objects do not offer *actual* substantially different faces, presence and scale are noticed to varying degrees as the observer moves.

"There are two distinct terms: the known constant and the experienced variable," Morris maintained, touching on the philosophical dichotomy of knowing and seeing. "You see a shape—these kinds of shapes with the kind of symmetry they have—you see it, you believe you know it, but you never see what you know, because you always see the distortion and it seems that you know in the plan view."[213] Arnheim, however, suggested that the brain compensates for or corrects what the eyes see.

> It is pointed out, correctly, that if we saw physical objects the way they are projected on the retinas of the eyes, they would undergo dreadful amoebic transformations of shape and size every time the objects changed their position toward us or we changed our position toward them. Fortunately this does not happen. The percept produced by the brain from the retinal projection is such that we see the object as it *is* physically.[214]

It is the constancy of the Gestalt, discussed in the second part of "Notes on Sculpture," that maintains the sense of the whole and prohibits stupefying distortion.

Phenomenology, in particular, has investigated the difference between

what a thing is known to be and the way it appears. Maurice Merleau-Ponty, whose influential texts were translated into English in the early sixties, explained:

> Our perception ends in objects, and the object once constituted, appears as the reason for all experiences of it which we have had or could have. For example, I see the next-door house from a certain angle, but it would be seen differently from the right bank of the Seine, or from the inside, or again from an aeroplane: the house *itself* is none of these appearances; it is, as Leibnitz said, the flat projection of these perspectives and of all possible perspectives, that is, the perspectiveless position from which all can be derived, the house seen from nowhere.

After a short argument, he adjusted this statement. "The house itself is not the house seen from nowhere, but the house seen from everywhere."[215] Merleau-Ponty's recognition of the role played by the body in perception is appropriately Minimal: "From the point of view of my body I never see as equal six sides of the cube, even if it is made of glass, and yet the word 'cube' has a meaning; the cube itself, the cube in reality, beyond its sensible appearances, has *its* six equal sides."[216] What can be had from perception are various perspectives as the spectator moves toward, around, or backs away from the object. Knowledge is of the three-dimensional form: the cube seen from nowhere and everywhere.

4

Theoretical Issues

Many Minimal artists, sculptors in particular, devoted a good portion of their time and creative energies to explaining their ideas, examining broad, theoretical issues normally left to art historians and aestheticians. Materiality—an unparalleled commitment to matter—is an essential thesis. Literal, nonreferential objecthood took precedent over any form of reference, representation or illusionism. There was less agreement on the validity of reduction as a historical process, although most agreed to an interest in what was essential rather than inessential in art. Since their objects lack what were traditionally necessary conditions for being works of art, Minimal art appeared to many observers as not art at all. Because there was some doubt as to the status of the objects, the artists' and critics' interpretations of the theories were all the more significant.

Abstraction and the Subversion of Illusion

The most distinctive development of modernism is nonrepresentational art. Now commonly called abstract, this art eschews depictions and references to figures or objects. Although by definition it refers to art whose forms have a basis in the real world, i.e., by being "abstracted" from it, abstraction has come to replace such cumbersome adjectives as nonrepresentational, nonobjective, nonfigurative, and concrete.[1]

As Clement Greenberg pointed out, it was hard-edge and flatly colored painting, derived from Synthetic Cubism, that typified abstract art until the advent of Abstract Expressionism.[2] Groups such as the French Abstraction-Création and the American Abstract Artists argued for Cubist-based abstract painting, while the Constructivists were most instrumental in legitimizing abstract sculpture. This springs less from spiritual or other-worldly concerns than from a belief in the materiality of this world, as Tatlin's advocacy of "real materials in real space" illustrates. According to Robert Morris, "Tatlin was perhaps the first to free sculpture from representation and

establish it as an autonomous form both by the kind of image, or rather non-image, he employed and by his literal use of materials."[3] Gabo's voice is typically Constructivist: "The shapes we are creating are not abstract, they are absolute. They are released from any existing thing in nature and their context lies in themselves."[4] Both Constructivist and Minimal works of art are *nonreferential*. Released from representation, they further remove themselves from allusion by being in themselves new and unique objects, referring to nothing (except, some might argue, to the theories upon which they are based).

Annette Michelson found nonreferentiality to be characteristic of the work immediately preceding Minimalism: "It was in order to dispel or to attenuate the persistent implication of the 'referent,' the reality assumed as prior to the created reality of the work of art, that the term 'formal statement,' so consistently in use throughout the American criticism of the '40s and '50s, was devised." Since many modernist works do not refer to or picture things outside of themselves, formal qualities, which *are* in some sense pictured, essentially replaced representation as the subject of criticism. Beyond this, Morris's and other Minimalists' work is for Michelson "self-referring."[5] In his discussion of Andre, Flavin, and LeWitt, Mel Bochner proposed that "serial art in its highly abstract and ordered manipulation of thought is [like solipsism] self-contained and nonreferential."[6]

Abstraction implies not only the elimination of an identifiable image, but the repression of illusionistic space in which that image might plausibly exist. Flatter and more object-like paintings are necessarily more abstract. As Sheldon Nodelman sees it,

> Perhaps the most important and comprehensive—and certainly the most obvious— change in pictorial structure between the nineteen fifties and sixties has been the definitive renunciation of illusionist representation. This renunciation is the culmination of a long development toward the dissolution of the fictive world of space and objects "behind the picture plane."[7]

One might describe the space in Pollock's paintings as "optical," along with Greenberg, yet uninhabitable, while Stella's paintings, as Judd claimed, are "nearly unspatial." Only pure monochrome, such as Yves Klein's, escapes illusionism, since "anything placed in a rectangle and on a plane suggests something in and on something else, something in its surround, which suggests an object or figure in its space, in which these are clearer instances of a similar world—that's the main purpose of painting."[8] The question arises, then, as to the very possibility of painting without referential illusion. Because of the nature of the medium, its rectangular, boxlike format into or onto which shapes are placed, illusionism would seem unavoidable in painting.

Illusionism was subverted by stressing the real existence of the object. Rarely were the two states reconcilable—it was either one or the other— although many critical attempts to do so were undertaken. Robert Mangold may be more concerned with "optical illusion" than other Minimal artists, in the sense that the eye often has trouble resolving the ever-so-slight irregularities of the shape of the support. According to Diane Waldman, he "has always been concerned with illusionism, or a form of illusionism best expressed by stressing the reality of the painting as object."[9] Although Waldman offers the 1969–70 series of Frames as evidence of this position, the feasibility of a conjunction of real objecthood and illusion is extremely limited. They are, by definition, antithetical to one another.

For some critics, illusion was not only inescapable, but actually essential to good painting. Barbara Rose observed that "a new type of illusionism may well be the single common denominator linking the most advanced painting being done today." Grégoire Müller also maintained the value of illusion in Judd's work, which "is no exception to the best art that has been created: it is illusional."[10] Above all, Michael Fried seems to maintain that the contiguity of illusion and quality, as painting, to "compel conviction," must defeat its own objecthood.[11] According to Fried, Noland pursues this by appending the factor of literal shape to the "new, exclusively visual mode of illusionism" of Pollock, Newman, and Louis. In Noland's paintings, "the sheerly visual illusion generated by the interaction of the colored bands" all but dissolves the picture's literal shape. A dialectic of object and illusion is thus established, which is eventually synthesized by Stella's Irregular Polygons of 1966. Both Noland and Olitski continued to struggle with "the conflict between a sheerly visual or optical mode of illusionism and the literal character of the support."[12] The problem is this: illusionism is the result of either a transparent picture plane or the apparent continuation of a ground beneath an overlaid figure, while recognition of the physical existence of the support means that surface, as well as shape, must be viewed as a single palpable thing. The two perceptions are in conflict.

Willis Domingo explicated Fried's rather intricate argument nearly seven years later in *Arts Magazine*. By setting up "a chain of dualities ... shape/form, illusion/literalness, optical/tactile, etc.," Fried is able to establish certain analogies such as "shape is to form as literalness is to illusion," in Noland's work; and in Olitski's, "shape is to illusion as form is to literalness." Thus, according to Domingo, Fried can assert that "absolute illusion is the necessary result of the absolute primacy of literal shape." An analysis of Stella's shaped canvases provides Fried with the following equations (says Domingo): "Literalness equals illusion." Stella has solved the "contradiction in a spatial ambiguity whereby literal and illusionistic space become indistinguishable from one another."[13] Through his rhetorical prowess,

Fried is able to retain both seemingly contradictory states: opticality (illusion) and literalness (object).

Barbara Rose sets up a simpler situation without referring specifically to "Shape as Form," although she was undoubtedly familiar with its arguments. The work of Ron Davis, Darby Bannard, Stella, and Olitski, she claims, can be characterized as "abstract illusionism." While Fried rejects Greenberg's penchant for the flatness of modernist painting, Rose retains the importance of surface emphasis. The artificiality of the surface—plastic, metallic, sprayed, or juxtaposed matte and glossy—establishes the abstractness, or nonreality, of the picture. At the same time, truly optical illusion occurs because of the "contradictoriness of the visual information supplied," also artificial because it is perceptually irresolvable.[14] The result is flat paintings that are illusionistic.

Nodelman deals with the same artists as Fried and Rose, but comes to a different conclusion. Stella and Noland represent for him renunciations of illusionism. "The spectator is no longer invited to contemplate a proffered world of fictive contents which are deployed in front of him as on a stage, but is confronted with formal events which take place in his own life-space—his *Umwelt* as Husserl called it—on the same terms, claiming to affect his life with the same 'real' force as do the objects of that world."[15] Nodelman's is the more generally accepted interpretation. As painting appears more and more flat and objectlike, abstraction overtakes illusion.

The contradiction, prized though not resolved, according to Fried, by Noland and Olitski was entirely rejected by Minimalists. "There are certain younger artists to whose sensibilities *all* conflict between the literal character of the support and illusion of any kind is intolerable, and for whom, accordingly, the future of art lies in the creation of works that, more than anything else, are *wholly literal*—in this respect *going beyond* painting."[16] Sculpture, Greenberg declared, "remains tied inexorably to the third dimension and is therefore less illusionistic."[17] Of all the Minimalists, only Flavin perversely turned to three dimensions in order to promote illusion.[18] Although Lippard claimed that sculptural materials may contribute to a certain kind of illusionism, "Sculpture, existing in real space and physically autonomous is *realer* than painting."[19] Morris believed that painting was inherently illusionistic. "Sculpture, on the other hand, never having been involved with illusionism could not possibly have based the efforts of fifty years upon the rather pious, if somewhat contradictory, act of giving up this illusionism and approaching the object."[20] Judd agreed. "Three dimensions are real space. That gets rid of the problem of illusionism and of literal space, space in and around marks and colors—which is riddance of one of the salient and most objectionable relics of European art."[21]

In what seems an attempt to salvage illusion as an essential ingredient

of art, many critics believed, contrary to the artist's opinion, that Judd's sculptures are illusionistic. Krauss argued most forcefully through her description of the Whitney progression: from the front, the purple bars appear to be suspended from the continuous aluminum bar; from the side, the true structure is revealed. The aluminum bar is set into and supported by the purple boxes.[22] Shadows and reflections also seemed illusionistic to some observers. Rauschenberg, according to Rose, saw the shadows cast by Judd's wall boxes as illusionistic.[23] The shiny but opaque materials sometimes appeared to Robert Pincus-Witten "translucent rather than reflective." Instead of the floor being mirrored on a box's face, the floor looked as though it were being seen through the box.[24] Morris also considered reflections to be illusionistic, especially the mirrored surface that he had used since the early sixties. "In the beginning I was ambivalent about its fraudulent space, its blatant illusionism. Later its very speciousness seemed a virtue."[25] Now, in fact, illusion is central to his anti-Minimalist works. Phil Patton recounts: "'I always had an appetite for richness of illusion,' Morris says. 'It just didn't come out. It was there in other areas—in performance, say.' He points out that even while he was becoming known for his Minimalist work and exploring the gap between ideal geometry and actual object, he was concerned with the issues that have surfaced in his latest work."[26]

The inevitable perspectival distortion that occurred when one looked along one of Judd's rows of boxes was also considered illusionistic. Rose's analysis of the progressions was typical. "From any angle other than head on, illusionistic distortions occur. From one side or the other, the units at the opposite end appear to decrease in size." The new works, she added later, "because they are larger than the field of vision, cannot be seen without some type of illusionistic distortion."[27]

Is perspectival foreshortening an illusion? For something to qualify as illusionistic, the observer must in some sense and at some time be convinced of the illusion. If Rudolf Arnheim is correct, the viewer adjusts to size variations in depth. "In this case the more distant edges of the figure are shorter than the closer ones. Even so, we may be able to perceive a more or less convincing rectangle or cube. This ability of the sense of sight to straighten out the deformed projection and to perceive it as an obliquely oriented, rightangular object is commonly ascribed to the 'constancy of size and shape.'"[28] As Morris explained, "The presumption of constancy and consistency makes it possible to speak of 'illusionism' at all. It is considered the less than general condition. In fact, illusionism in the seeing of objects is suppressed to an incidental factor."[29] While one may not, from an oblique point of view, be certain of the precise length of the elements of Judd's serial progressions, one can be fairly sure that the continuous bar and the

shorter bars below do not actually narrow as they move away from the viewer.

Krauss contends that Judd's work deals with "lived illusion" rather than "pictorial illusion."[30] It is not the fictional illusion of painting, but somehow a "real" illusion, according to William Agee. For Rose, the illusion "is not depicted, it is actual." Grégoire Müller declares that "the illusion [is] *believable*, so much that it is no longer perceived as an illusion."[31] These critics have managed to arrive at, and accept without reservation, a contradiction analogous to Fried's "literalness equals illusion." By positing the reality of illusion, both terms are stripped of meaning. If, for example, objects seen in perspective are illusionistic, then all physical objects are illusionary.

Judd has had to come to his own defense. When questioned about reflections, he replied that they are not illusionistic. They are simply reflections.

> All I can say is that [the works] don't seem illusionistic in that sense to me. You are bound to have a certain amount of reflection, and you are changing position when you look at a three-dimensional thing. In a sense that is illusion just in the technical meaning of the term. I distinguish between that, and illusion which I think is a perfectly matter-of-fact illusion and has no connection to the other kind.[32]

Coplans confirmed Judd's "rejection of all forms of illusionism."[33]

If one must accept references to illusionism in the critical writing on Judd—which one must if only because of the frequency with which they occurred—Müller's interpretation is enlightening: "The specificity with which he has invested his best pieces makes them *look* literal, yet this specificity is illusional by nature in that it forces the viewer to distinguish the art object from its sole materiality, making it unique and giving it a scale of its own."[34] The illusion accounts for the work of art's appearance as more than a *mere object* in the world. Nevertheless, the firm belief in the reality of the material, in the cause of pure abstraction, and the rejection of illusionism incorrigibly structured the artists' approach to the work of art.

Reality and the Condition of Objecthood

References to "the real" and "reality," an artistic condition antonymous to illusion, were frequent in art discussions during the sixties. This was not a philosophical argument: what is "real" is what has material existence and does not pretend to be other than what it is. The belief that the material, apprehensible form of the object constituted its reality is generally characteristic of modernism. For the modernist, Richard Wollheim contends, "the identity of a work of fine art resides in the actual stuff in which it consists."

Later, he summarized, "For the mainstream of modern art, the appropriate theory is one that emphasizes the material character of art, a theory according to which a work is importantly or significantly, and not just peripherally, a physical object."[35] In 1960, Sonya Rudikoff suggested that "quite possibly, the art of our times is a witness to this, a witness to the irreducible nature of actuality. Out of experience itself come works of art which exist in themselves in the way natural objects exist, with no rationalized purpose or meaning, but, as is so often said, are simply *there*."[36] The object-oriented materialism of the period was also indicated by Nodelman: "The tactile sense is the ultimate criterion of reality for the organism; all other senses may deceive. What is not tangible cannot surely be said to exist."[37] This generation was perhaps more materialistic and literal than any before or since. Only the Russian Constructivists pursued their own notion of "the real" with an equivalent passion.[38]

There is a subtle contradiction, however, between the emphasis on tangibility and materiality—as indicators of the real—and the primarily conceptual basis of most Minimal objects. Unlike Moore's highly palpable sculptures, whose tactile sensuousness is formal and material, Minimal works are rigid and geometric, repellent and unresponsive to the touch. Their obdurate materiality (a popular phrase from the period) is intellectual in the sense that it is recognized more than literally experienced. As Dore Ashton observed, "Most of the artists here take [illusion] to be the opposite of reality. Illusionistic effects ... are the handmaidens of appearance, and not of reality."[39] The rejection of mimesis and reference, and a concomitant emphasis on materiality, led artists and critics to the notion of objecthood, a status preferable to that of either painting or sculpture, and more specific than "art." To refer to a work of art as an object, in the sixties, meant that it was a nonrepresentational, concrete, and real thing existing in the world, without illusion or formal prototype.

The Art of the Real: USA 1948–1968, organized by E. C. Goossen for the Museum of Modern Art, illustrated the urgency with which reality was sought. The pompousness of Goossen's assumptions about the real did not go unnoticed by critics. When the show traveled to London in 1969, R. C. Kenedy remarked on "the blissful certitudes" of the Americans, and the "evangelic zeal" and "dogmatic propositions" of Goossen's catalogue essay. "The extraordinary title" of the exhibition was criticized as well.[40] According to Goossen, "Today's 'real' ... offers itself ... in the form of the simple, irreducible, irrefutable object," a proposition most critics refused to accept.[41] However, Goossen's connection between reality and objecthood is illuminating. The pursuit of the real provided the philosophical foundation for the production of "objects" conceived as neither painting nor sculpture. Nonillusionistic three-dimensionality (i.e., objecthood) is more obviously

real than two-dimensionality, since it implies spatial, physical existence of the object. Alloway's article on sculpture, written before he could have had the opportunity to see much, if any, Minimal art, forecast the incipient movement. "Because sculpture has a more substantial and literal physical existence than paint on canvas (which has an inveterate sign-making capacity and an unquenchable potential for illusion—and these are the medium's main carriers of meaning) it is prone to object-status."[42] The new objects of the sixties were intended to rival, in their "realness," things in the world.

The problem, of course, with making art as real as things in the world was how to distinguish the former from the latter. Arthur Danto has pointed out this dilemma as one characteristic of modern art, that is, of art made subsequent to the renunciation of the "Imitation Theory." Replacing the "IT," as he calls it, is the "RT" (Reality Theory): "According to it, the artists in question were to be understood not as unsuccessfully imitating real forms but as successfully creating new ones, quite as real as the forms which the older art had been thought, in its best examples, to be creditably imitating." Specifically referring to sculptures of beds by Rauschenberg and Oldenburg, Danto noted the facility with which the mistaking of a work of art for a real object could be made. In a later article, Danto outlined Rauschenberg's solution, an approach that also characterizes Minimalism. The way to escape the dilemma "is to make non-imitations which are radically distinct from all heretofore existing real things."[43] Nonfunctional boxes, for example, exist without real-world prototypes.

Although objecthood was most descriptive of three-dimensional works, several painters discussed it. Both Stella and Mangold distinguished between the kind of object made by artists like Judd, and their own two-dimensional objects. Stella said at one point, "Any painting is an object and anyone who gets involved enough in this finally has to face up to the objectness of whatever it is that he is doing. He is making a thing." Later, he explained that his thicker stretcher bars (one-by-threes turned on their side), so remarked upon by critics, held the painting in front of the wall, with "just enough depth to emphasize the surface. In other words, it makes it more like a painting and less like an object, by stressing the surface."[44] Mangold's position is compatible: "If it's done right then the final object is really somehow much more important than the idea."[45] When asked whether his use of the term *object* derives from Judd's notion of the specific object, he replied: "What I meant was that I wasn't interested in the painting being an object, as a thing in the room, but I was very interested in it being a concrete surface, being a surface that was real, as opposed to something like a painting as a window.... It wasn't like an object on the wall.... I wanted it to be as flat as possible."[46]

Works of art were also often referred to as "things," and the popular

philosophical expression, "the thing in itself," was invoked by critics to stress the reality of new works of art.[47] William Tucker's notion of (artistic) thingness is insightful:

> Ideally, the individual piece would attain to a character of being a thing in the world like a table or chair. It wouldn't fit into the category of table or chair, or any other known thing, but it would in a way create a category of its own.... First of all, there was the problem of whether thingness could be disassociated from being a particular thing. In other words, if you talk about thingness as a characteristic of a thing—if that was possible—then individual thingness could be recovered, as it were, for an object, but it wouldn't belong to the kind of thingness that already existed in the world.[48]

Tucker here touches a basic theoretical problem: while most Minimalists stressed the ontological equality of art objects and things in the world, the objects they made were never dealt with in the same manner that one would deal with a non-art object. In a similar vein, Müller characterized Judd's approach as "a request for the work to exist, not 'merely' as one thing among other things, but as something having its own, specific, mode of existence."[49] Although the new work was often explained in terms of a "renunciation ... of the notion of the uniqueness of the art object and its differentiation from common objects,"[50] to call a work of art an object was, by convention, to elevate it to a more important position than that occupied by "mere" things in the world.

Object terminology was promoted in the sixties primarily by Judd, although the term had been applied to art before Minimalism (especially, and probably most influentially, by George Kubler in *The Shape of Time*).[51] The word *object* was used in criticism to describe Johns's and Rauschenberg's assemblages (with Johns himself encouraging such a use).[52] "We are given in many instances," Sidney Tillim wrote in 1959, "'objects' which seek to make a content of motives rather than visions."[53] The critical language developed to discuss Neo-Dada in the late fifties was extended to Minimalism in the sixties. This, it will be recalled, also occurred with the concept of the environmental. Judd distinguished between "that which is something of an object ... and that which is ... environmental."[54] Eventually, objecthood was wrested from Neo-Dada to become a definitive characteristic of Minimal art.

Judd often remarked on the object-quality of the works of art he reviewed for *Arts Magazine*. In 1962, one of Noland's paintings was described as "a single object without conspicuous parts." The following year he wrote of Bontecou's relief, "It is actual and specific and is experienced as an object," and about Klein's work, "They are simple and broadly scaled, they tend to become objects." An Aluminum Painting by Stella is also "something of an object, it is a single thing, not a field with something in it, and it has

almost no space."[55] It is clear from these favorable reviews that the quality of being an object was a significant characteristic of the kind of art that took shape in the early sixties. His position was, of course, fully explicated in "Specific Objects," which was written in 1964.[56] In it, he emphasizes the quality of three-dimensionality that characterizes the new work. He sees these specific objects, including paintings by Noland and Stella, and sculpture by Oldenburg and Chamberlain, as neither painting nor sculpture, but as occupying an intermediate (though superior) position. The qualifier "specific" denotes the use of actual rather than illusionistic space, and the use of new materials, which stand for themselves rather than imitate some other substance, such as flesh.[57] Although many examples of work by diverse artists are called specific objects, Judd's meaning is indeed quite specific.

The marriage of *specific* and *object* occurred in 1965. For example, Clair Wolfe referred to Craig Kauffman's work as "specific objects," and Rose used the term loosely in "ABC Art."[58] By the mid-sixties it was widely used to refer to wholistic, nonrepresentational work. According to Fried's interpretation of Minimalist theory, "The shape *is* the object: at any rate, what secures the wholeness of the object is the singleness of shape."[59] By definition, the term implies the rejection of internal relationships. As Judd explained, "The most unusual part of three-dimensional work is that which approaches 'being an object.' The singleness of objects is related to the singleness of the best paintings of the early fifties."[60]

Morris knew well enough what Judd's category implied. He believed that his own work was not implicated:

> I don't think I've ever made what have been called "specific objects," which are not so much involved with recognizing gravity—or they're painted, or they're very much involved in a kind of emphasis on surface properties, and I don't want my pieces to be objects in that sense. They're not specific objects at all. I mean, they are specific, and they're sometimes object-like, but the term specific object doesn't apply. It has come to mean a particular thing that my work is definitely not about."[61]

Morris preferred to call his objects *unitary forms,* a term that had fewer ontological implications than did *specific objects.* Unitary forms are "simple regular and irregular polygons." Cubes and pyramids are simple regular polygons. Irregular polygons include "beams, inclined planes, [and] truncated pyramids."[62] Shape (form) is much more crucial to Morris than it is to Judd.

The fact that three-dimensional Minimal work could be subsumed under the traditional category of sculpture was recognized by certain nonartist critics. To differentiate it from other concerns, however the term *object sculpture* was devised, and artists were described as "object makers"

as early as 1964.[63] In 1965, Rose defined object sculpture as "three-dimensional forms that are such simple uninflected volumes or structures that they appear to be functionless objects rather than sculpture as we know it."[64] Burnham elaborated on Rose's definition but concluded that the new objects are in fact *more sculptural* than their predecessors.

> It might be saying that sculpture, as we have known it, is only one kind of three-dimensional object, and that it conforms to its own particular standards of esthetic presence. As much as object sculpture seems to be a denial of past sculpture values, it reminds us uncategorically that sculpture is eminently three-dimensional. To desire sculpture which is solid, palpable and *real* may appear tautological, but in truth, these characteristics reaffirm those qualities which have been methodically removed from modern sculpture.[65]

Structure was also a popular term for abstract, three-dimensional work. The title of the 1966 exhibition Primary Structures encouraged the proliferation of the term, although Lippard claimed to have coined it for a more specific set of objects.[66] Although Kynaston McShine refrained from precisely defining the "primary structure" in his catalogue essay, he did note general characteristics. Three-dimensionality and the use of new materials, which Judd had stressed in his writing, physically identified a primary structure. The conceptual, theoretical basis of the work was also acknowledged. McShine dutifully reminded his readers that primary structures "are conceived as 'objects,' abstract, directly experienced, highly simplified and self-contained."[67] The exhibition itself, however, included a number of artists hardly classifiable as Minimal, such as Richard Artschwager, Anthony Caro, and Tom Doyle.

Lippard prefers the term *structurist* to Minimalist.[68] This designation might have been inspired by her friendship with LeWitt, who had worked for Pei and designed "a tower in a parking lot that had numbers on it. That was a real structure. That's what they called them, and that's just what I continued to call them." LeWitt's concerns are more conceptual—"I'm not interested in objects as an end"—in which case the structure or construction of the thing is more appropriate.[69] Structures, unlike "'object' sculptures," are for Lippard "non-sculptural and even anti-sculptural."

> Structures, or as Don Judd has called a broader grouping—"specific objects"—are ... simple, single or strictly repetitive, serial or modular with a quality of inertia and apparent (superficial) abdication of the transforming powers of art. In this context, the object or objectness is directly opposed to the additive premise on which most post-Cubist works are founded.[70]

Morris not only rejected *specific objects*, but the unmodified terms *object* and *structure*. "The word *structure* applies either to anything or how

a thing is put together." Structures, he wrote in a subsequent "Notes on Sculpture," tend to be didactic and to emphasize "'reasons' for parts, inflections." On the other hand, "Every rigid body is an object. A particular term for the new work is not as important as knowing what its values and standards are." He criticized the term *object* since it recalls the *objet d'art*, which is small and "handleable."[71] Morris eventually and completely rejected "object-type art" because in it, "process is not visible," confirming Fried's earlier recognition of his more sculptural interests.[72]

The terminological warfare of the sixties, which inspired artists to propose substitutions for plain *sculpture*, was best exemplified in a debate between the British sculptors William Tucker and Garth Evans. In "An Essay on Sculpture," published in January of 1969, Tucker explained that although pieces of sculpture have always been objects, this particular quality has been concealed by the assumption that works of art are "rare, special or superhuman." Recent innovations, however, have denied such transcendental attributes. Now, Tucker claims, "It is the matter-of-fact 'objectness' of sculpture that has become in recent years its prime feature." This was particularly true of American work in the 1960s. Evans's reply, however, is critical of object-theory.

> What happens to an object [a book, a table, etc.], its life in the world, is primarily determined by what, in a total sense, it is. Sculptures are different in this respect. An object classified as a sculpture thereby relinquishes much of its objecthood in terms of self-determination.
>
> What happens to a sculpture is determined largely by factors outside of itself. The fact of its being thought of as a sculpture is more critical to its existence, its life, than any other facts about it. This is a fundamental distinction between objects and sculpture. It has nothing to do with the physical nature of either.[73]

The designation of objecthood is theoretical rather than descriptive. While such work does differ formally from all previous sculpture, it is Minimalist theory (and the fact that the work in question does not resemble statuary) that provokes the *object* label. Minimal sculptures were never assumed to be *merely* objects, on a par with books and tables. They were always treated with the seriousness accorded to works of art.

The Concept of Reduction

Critics and historians generally assume that Minimal art is "reductionist," because of its anonymity and austerity. The term *Minimalism* was partly responsible for this generalization, because it implies something less than the norm. Its connotations were, at first, undoubtedly negative. Lacking features such as illusionistic space and relational composition, the works

were seen as the culmination (or dead end) of the modernist reduction which, according to convention, began with Manet. In fact, most critics accepted as fundamental to modernist theory the notion of reduction as codified by Greenberg, whose immense reputation and declaratively blunt writing style reinforced his views to the point that it was nearly impossible to dispute them, so convincing was his argument. In 1955, he described as "a law of modernism" the fact "that the conventions not essential to the viability of a medium be discarded as soon as they are recognized." Noting that painting possessed a great "number of expendable conventions," he explained that it, nevertheless, "has a relatively long way to go before being reduced to its viable essence."[74] By 1962, he was able to specify exactly to what "essence" painting was being reduced. "The irreducible essence of pictorial art consists in but two constitutive conventions or norms: flatness and the delimitation of flatness." The advancement of painting was explicitly named as "reduction."[75]

Michael Fried broke significantly with Greenberg on the issue of reduction (but then, only in footnotes), an instance all the more interesting since Fried respected Greenberg more than any other critic.[76] "Art and Objecthood," he later explained, was written in reaction to Greenberg's "notion that modernism in the arts involved a process of *reduction* according to which dispensable conventions were progressively discarded until in the end one arrived at a kind of timeless, irreducible core."[77] Fried's conviction that reduction does not account for the development of modernism is laid out in a footnote to "Shape as Form."

> This [reductionist conception] seems to me gravely mistaken, not on the grounds that all modernist painting is *not* a cognitive enterprise, but because it radically misconstrues the *kind* of cognitive enterprise modernist painting is. What the modernist painter can be said to discover in his work—what can be said to be revealed to him in it—is not the irreducible essence of *all* painting, but rather that which, at the present moment in painting's history, is capable of convincing him that it can stand comparison with the painting of both the modernist and pre-modernist past whose quality seems to him beyond question. (In this sense one might say that modernist painting discovers the essence of all painting to be quality.)[78]

For Fried, painting does have an essence, which is quality, but it is not something irreducible, since it changes with respect to past art.[79] He maintains the Greenbergian notions of historical comparison and essence, but rejects reduction as descriptive of the evolution of modernism.

Lippard favored the less negative term *rejective* to reductive. This process is characteristic of modern art, and definitive of "a phenomenon of the 1960s concerned primarily with the specificity of esthetic object and esthetic experience. Rejection does not, unlike reduction, suggest attrition,

but rather a strengthening process by which excess and redundancy are shed and essence retained."[80] Essence is an integral component in the scenario of reduction, since art is being reduced to or toward something. Lippard does not name the essence to which she refers, although she noted that the painter's process of elimination results in an "emphasis on two-dimensionality."[81] C. Blok contended that "in connection with Minimal art, 'the essential' may be taken to refer to a heightened sensibility of physical presence."[82]

The process of reduction to an essence was frequently held to be definitive of Minimal art. David Bourdon equated "minimalization" with "essentializing" to characterize the art of this period.[83] For John Perreault, the enterprise was "a reductionist effort to determine the essence of a particular medium. How much can an artist eliminate of the traditional ingredients and still produce art?"[84] Convinced of the viability of Greenberg's analysis, Rose also believed the artists were "involved with finding out how little one can do and still make art."[85] In this view, conventions are progressively stripped away to reveal the essence, the part that makes something art. Many Minimal painters and sculptors admitted that their goal was one of simplicity, and the process itself one of simplification as opposed to reduction. Stella explained that this occurs periodically, whenever a painting style, such as Abstract Expressionism, appears to younger artists highly complicated.[86] Andre described his forms as "essentially the simplest that I can arrive at, given a material and a place."[87] In reference to his gray polyhedrons, Morris axiomatized, "Simplicity of shape does not necessarily equate with simplicity of experience."[88] Simplicity was a virtue. According to Kozloff, "The idea that the *simple* is good in itself underlies all positive assessments of recent abstraction."[89]

While simplicity *implies* an intentionally reductive process—that is, one eliminating cumbersome or unnecessary components—it does not demand it. For many artists, there is an important difference between the conception of a work of art as simple and the process of reducing from complexity to arrive at that simplicity. One of Judd's most confident declarations reveals the value he places on simplicity: "There is one thing that I know how to do very well and that is to produce a plain, austere piece."[90] Complexity was avoided by using materials as they were, without adulteration. Stella "tried to keep the paint as good as it was in the can."[91] During a period when he was close to Stella, Andre realized about his carvings that "the wood was better before I cut it than after. I did not improve it in any way."[92] The uncarved beams of the Element Series recall the "zips" in Newman's paintings. As these developed, Newman recognized that "I had been emptying space instead of filling it, and that now my line made the whole area come to life."[93]

Simplification or reduction are conceptual, as opposed to literal descriptions of process, since physical labor or handicraft are beside the point. If elements were to be eliminated, they were done so in the artist's mind. Critics who saw Minimalist objects as exhibiting a reductive conception were noticing *less* of what Wollheim called "constructive work" and "manifest effort," in comparison to other works of art.[94] To say a work is reductionist—to say that it has *fewer* elements—requires comparison with painting or sculptures of the past, while no other work of art need be brought to mind to verify internal features of a particular work of art. Artists taking a strong stand against the concept preferred that the work be accepted on its own terms, not those conventionalized through art of the past. Judd pointed this out in one of his many statements disputing the importance of reductionism: "If changes in art are compared backwards, there always seems to be a reduction, since only old attributes are counted and these are [al]ways fewer.... If my work is reductionist it's because it doesn't have the elements that people thought should be there."[95]

Certain conventional features, such as internal formal relationships, illusionism, representation and narrative content, gesture, and inflection are indeed not present in work of the 1960s. In their place are a coolly forthright anonymity, frequently bright and opulent color in sculpture, and non-rectangular shape in painting. New, often dazzling or luxurious materials and the use of actual space, aspects that Judd called "specific," were seen for the first time in the art of the sixties. To determine if this work is reductive, an assessment of fewer features or elements must be registered, as Judd implied: "Prior work could be called reductive too; it would have less color, less scale and less clear form; compared to the new work it would mean even less, since then much of its own meaning would be irrelevant."[96]

Two different senses of reductionism, frequently confused, were at work: one sees modernism as historically reductive by contrasting new work with old, the other attributes reductive intentions to the Minimalists. Although intentions are dangerously unverifiable, most artists took a stand on this much-discussed topic. McCracken's planks, for example, "came out of thinking, well, what can I do that's more reduced or simple? The wood I used was leaning against the wall. So, I thought, that's it. You just go down to the planks or the boards. It seemed kind of daring to do that, but it was the only logical move.... It seemed distinctly reductive." The process, in alchemical terms, involved "distilling down the essence, trying to get at the true gold."[97] Robert Murray was more concerned with eliminating Cubist composition in sculpture than with reduction for its own sake. "What people did right off the bat was to kind of clean house; and instead of trying to juggle complex, complicated forms, a lot of us went back to work with

rather elemental forms." In order to make reductionism sound less negative, he suggested that it might be interpreted as an additive process, originating in the early sixties with the simple form, and proceeding toward more complicated ones.[98] LeWitt also admitted that he had been involved with reductionist notions: "There was always the idea of getting back to square one. For me, it just became a method to elaborate on. When I finally got to the simplest kind of thing—the cube or the solid cube . . . [I] naturally had to make elaborations. . . . Everybody reduces to what they think is the most pertinent thing and takes that and elaborates on that."[99] Intentional reduction to the simplest or most essential was for these artists followed by elaboration. The only other possibility was repetition *ad infinitum* (of which several artists, including Judd and McCracken, have been accused).

Because of the negative connotations of the term *reduction,* and despite Greenberg's apparent sanction of the process, a number of artists loudly protested. Noland was surprised when modernism was described as reductive. "I'd always conceived of abstract painting, art that was going on at that time, as an 'opening' concept, rather than a 'closing' one, or a diminishing one, or a reductive one."[100] Neither Stella nor Judd (who offered Noland's painting in defense of his theory that new art had different, not fewer, things than past art had) considered themselves to be, as Stella said, "motivated by reduction."[101] Morris, who claimed to be ordering, not reducing, relationships in his "unitary forms," also objected to the reductionist label.[102] Although in 1970 Andre told Phyllis Tuchman that it had been necessary for him to dispense with his own "cultural overburden," "and get down to something which . . . resembles some kind of blankness," he did not see Minimalism as being reductive or negative in any sense.[103] Rather, it is only what is necessary to producing works of art. Most Minimalists would concur with his advocacy of "the Rules of Parsimony and Sufficiency." in art-making.[104]

Although many artists hesitated to label their works reductive, the intellectually clearest, most practical, and formally economical means did tend to prevail. The number of conventions dispensed with, such as internal relationships and illusion, and the determination to present the pared-down thing itself—the object—suggest a self-conscious frugality, which frustrated formalist criticism. Theoretical discourse expanded in proportion to the diminishing amount of interesting formal differentiation.

"Boring" Art

Two simple statements sparked one of the most fascinating controversies and heated debates in the sixties:[105] Judd wrote, "A work needs only to be interesting"; and Rose despaired, "If, on seeing some of the new paintings,

sculpture, dances or films, you are bored, probably you were intended to be. Boring the public is one way of testing its commitment."[106] The essential conflict, that contradictory terms—*boring* and *interesting*—could both be used to describe the same art, was never resolved. Judd's position, in particular, was continually misinterpreted on account of the brevity of his statement in "Specific Objects." James Mellow observed that "some critics have claimed that Judd has raised boredom to an aesthetic principle."[107] Both boring and interesting were used as value-loaded terms, and the entire issue rests on the judgment of quality in works of art.

A boring object can be characterized as a thing tediously devoid of interest. Other adjectives such as wearying, dull, and irrelevant are nearly appropriate, but boring implies even more than merely uninteresting. To be bored by something means that the thing cannot hold one's interest, that it neither attracts nor repels. The familiar state of boredom generates yawns and inattentiveness; the mind becomes maddeningly inactive. The object responsible for this situation cannot be concentrated upon, and so tends to lose focus, with the inevitable result that the subject's awareness shifts to a topic more interesting. Frequently a boring object is decried because "there is nothing there." As Blok, writing on the exhibition of Minimal art at The Hague, explained, "Those who find this boring probably mean: devoid of human interest."[108] For Amy Goldin, "Boredom means that you are waiting for something and you don't know what it is. It means the messages you are getting are irrelevant to your existence."[109]

Earlier episodes of modernism were, on the whole, more interesting than boring, because of the originality of formal innovation or the uniqueness of personal expression. It might therefore be reasonable to imagine that boring works are unoriginal or in a style that critics had "seen before." However, as was so often stressed, Minimal art was new, even to the point of appearing "novel."[110]

The most boring exhibition of the decade seems to have been Stella's Purple Polygons, including *D*, at Castelli in 1964. Kozloff declared, "It has been said, quite rightly, that his art concerns itself with such problems as boredom, monotony, even hypnosis."[111] Reviewing the same exhibition, a critic for the *New York Times* called Stella "the Cézanne of nihilism, the master of *ennui*."[112] Rubin's retort was typical of writers who accepted the label "boring" and attempted to make of it a positive value: "Even ennui can be turned into the substance of major art, while 'noble' emotions can and have provided more than their share of failed paintings."[113] Few artists escaped being called boring at least once or twice. Besides Judd, Morris, Andre, Mangold, LeWitt, and Agnes Martin, the list of the accused includes John Cage, William Burroughs, Alain Robbe-Grillet, Jean-Luc Godard, Michelangelo Antonioni, Merce Cunningham, Yvonne Rainer, and, espe-

cially, Andy Warhol. The epithet did not vanish with the sixties. In 1981, Barbara Cavaliere bestowed the award: "Most Boring: Donald Judd, *Untitled* (1966)."[114]

A few critics interpreted boring works of art as symptomatic of a general cultural *ennui*. Goldin described the situation in the sixties in Existential terms more characteristic of the preceding decade: "The implausibility of being able to do anything significant, the sense of being trapped in inaction and impotence within a demonic world, is a characteristic contemporary experience. So is boredom."[115] Rose also proposed a sociological explanation. She found it not surprising that, since boredom was a "common experience," artists have chosen to deal with it in their work.[116]

The economy of formal relationships and the lack of expressive facture deprived the spectator and formalist critic of interesting incident and complex readings of composition. When asked why he supposed Minimal art was criticized for being boring, LeWitt replied, "Because they were looking at the formal qualities of it rather than trying to read it in terms of content.... They were only trained to 'what you got was what you saw,' not what you understood, but what you saw."[117] According to Morris, "Such work would undoubtedly be boring to those who long for access to an exclusive specialness, the experience of which reassures their superior perception."[118] Reviewing Morris's felt sculptures at Castelli in 1968, John Perreault wrote: "His works are only boring, as he himself has pointed out, if one expects traditional inflection and internal relations (i.e., composition) and/or, I might add at this point, evidences of the artist's impassioned handiwork, 'self-expression,' or globs and streaks of anguished autobiography."[119] To many viewers the work was boring, "especially after a period of excitement like the fifties."[120] Sandler saw it specifically in reaction to Abstract Expressionism. "Therefore, many have embraced a different method—the execution of simple, pre-determined ideas—and other values—calculation, impersonality, impassiveness and boredom."[121] Repetitiousness and simplicity were also considered contributing factors to the boredom experienced by viewers comfortable with the more traditional notion of theme and variation or who had "expectations structured by a Cubist esthetic."[122]

Susan Sontag has briefly dealt with the problem of the audience's incapacity to deal with the new art: "There is, in a sense, no such thing as boredom. Boredom is only another name for a certain species of frustration. And the new languages which the interesting art of our time speaks are frustrating to the sensibilities of educated people."[123] This is an important observation, for it lays the blame on the *audience* and their *sensibilities*, while it asserts that the new art is, in reality, *interesting*. Boredom is not a

state to which one would likely aspire. Perreault discerned that "a great deal of boredom is in the mind of the beholder."[124] Boredom necessarily describes the spectator's state of mind rather than any characteristic of the object. In fact, "Whether he experiences an object as boring or not depends upon the viewer's expectations," claimed Blok. Cage's musical performances, for example, will be boring to "those who came in the expectation of hearing music."[125] The root of the problem is the unpreparedness of the audience, most of whom were not familiar with the theoretical concerns of Minimal art. If, for example, one were unaware of the value placed on wholistic structure (e.g., Judd's "All I'm interested in is having a work interesting to me as a whole"), any attempt to read the work in terms of relational composition would be frustrating. Similarly, boredom must infect the spectator desirous of complex figure-ground relationships (or one used to reading work in such terms). Rose described what she called "ABC Art" as intentionally "vacant or vacuous.... In other words, the apparent simplicity of these artists' work was arrived at through a series of complicated, highly informed decisions."[126] She found it boring *because* it is basically theoretical. Minimalism's theoretical underpinnings, which expanded to fill the gap left by the absence of formal relationships, were seen by certain critics as theoretical dogmatism. They desired, and were denied, what Kant called "the free play of the imagination." Primary Structures was particularly criticized on this account, since "the work has all the answers prepared in advance."[127] Of the show, Kramer complained, "I cannot recall another exhibition of contemporary art that has, to the same extent, left me feeling so completely that I had not so much encountered works of art as taken a course in them."[128]

It was customary to refer directly to Rose's "ABC Art" when commending work thought to be intentionally boring and valuable as such. One critic, for example, searched (in vain) for "the much-conjured positive boredom" in Andre's work.[129] More frequently, critics denied Rose's thesis. Lippard explained that "without crutches of associative relationship to other objects of sights," the work is called boring,

> or, at the other extreme, it is said to "test the spectator's commitment." The fact is that the process of conquering boredom that makes the pleasure of art fully accessible is a time-consuming one. Most people prefer to stay with boredom, though it does seem in view of the deluge of recently published comment about boredom in the arts, to be a pretty fascinating boredom.[130]

Obviously, Lippard does not agree with Rose, nor does Kramer. After quoting a passage from "ABC Art," he continued:

> Now it is true that much of this art is boring, and one is at first relieved to hear that one's own boredom in confronting it is, after all, the correct response. But then one wonders. Clearly, Miss Rose herself does not find this art really boring, and in reading her essay one's own boredom is quickly dissipated, one's interests are aroused.[131]

Twelve years later, reflecting on the issues of the art world in 1966, he quoted Rose's statement again. "This was a wonderful ploy," he decided. "Boredom was endowed with a moral imperative, and it was left for the public—rather than the art—to acquit itself of indifference."[132] While Kramer never appreciated this sort of art, what is apparent in his responses to the contention that it is supposed to be boring, is that it really is not.

Although a few artists, like Warhol, Cage, and Ad Reinhardt ("I finally made a program out of boredom.... 'Interest is of no interest in art'")[133] made boredom an issue, no Minimal artist saw boredom as a positive effect of his or her art. The charge of boredom is a forceful one, devastating even it its implication of triviality and irrelevance. Only Bochner, parodying Judd's "A work needs only to be interesting," declared, "For me, all a work needs to be is uninteresting."[134] Critics who approved of Minimal art, aside from Rose, did not find it boring, while those who disliked it were quick to accuse it of being only that.

Interest as a Value

There was support in the critical literature of the 1960s for Lippard's statement that "good art is never boring no matter how spare it is."[135] Obviously reacting to Rose, Judd commented on critics' "sympathetic" use of the terms "'boring' and 'monotonous.'" For his statement in the catalogue for Primary Structures he wrote, "I can't see how any good work can be boring or monotonous in the usual sense of those words. And no one has developed an unusual sense of them."[136] It was clear to both Lippard and Judd that what came to be known as Minimal art was not only not boring, it was good art.

There were attempts to resolve the dichotomous relationship of boring and interesting. Lippard described the spectator's experience of monochrome painting as originally boring, eventually contemplative, and finally one motivated by interest.[137] More abrupt are the attempts to *equate* boringness with interestingness. Although the arguments were much less intricate, the maneuver recalls Fried's synthesis of literalness and illusion. In "An Art of Boredom?" Kramer noted that for Rose, "Boredom is simply one of the interesting theoretical elements that may or may not enter into the creation and experience of this art."[138] Of Mangold's show at the Fischbach Gallery in 1965, Benedikt claimed, "The issues that this work raises have

centrally to do with the interest of boredom."[139] Sandler declared that "in its boredom, Stella's painting has affinities to Reinhardt's, but ... Stella appears to have made it the content of his art—a content so novel and perverse as to be interesting."[140] Boring art is interesting art.

Critics like Judd and Lippard, who felt that good art cannot be boring, injected a variable: the question of quality, i.e., judgments of good and bad. The misunderstanding, both by critics who thought boring art was interesting and those who thought boring art was good, arose from a failure to acknowledge that "interest" can itself be a value. (As Judd pointed out, someone would have had to prove that boring was valuable—an "unusual sense" of the word; and no one has done so.) The term *interesting*, in a colloquial sense, typically implies a reluctance to make a value judgment. A viewer's description of a work of art as "interesting" means that he or she does not know if it is good or bad. That, however, was not Judd's intention when he wrote that "a work needs only to be interesting." When asked about the misunderstanding fueled by that remark, he responded rhetorically: would a bad work be interesting? A good work is always interesting. Who would (intentionally) make a boring work of art?[141]

Both Mangold and LeWitt spoke of the importance of "interest" in value judgments. Mangold explained his approach: "I certainly make evaluations when I go into shows. I don't do it formalistically ... but I certainly know whether I'm interested in the work, or whether I'm not interested in the work." LeWitt was more explicit: "I wouldn't say that I wanted to like uninteresting things or to dislike interesting things. I think that that's one way that you measure your response, if it interests you. 'Interests you' means that it somehow makes a bridge between you and it, you and the object, you and the art object. If it hits home, it means that it's of interest."[142] Clearly, interestingness is a valuable quality.

Fried's persistent concern with quality—more specifically the quality of form—led him to dismiss Judd's remark. Before "Specific Objects" was published in 1965, Fried reviewed Judd's first show and worried, "But what has not clearly emerged in [Judd's] criticism—at least to my reading of it—is how exactly Judd means to discriminate between the objects he admires and those he does not." After listing certain formal features he supposes that the artist likes, Fried continued, "But on the other hand it is not at all clear *why* Judd values these qualities."[143] Fried felt that the Minimalists avoided the issue of quality altogether. Taking interest to be of utmost relevance to these artists, Fried explained, "My own impulse is to say that interest is basic to art—but not to either the *making* or *judging* of it."[144] For Fried, interest has no bearing on quality. Rather, the "conviction that a particular painting or sculpture or poem or piece of music can

or cannot support comparison with past work within that art whose quality is not in doubt" makes for the judgment of value.[145]

For certain post-Greenbergian critics, it is *quality* that is irrelevant to art criticism. Two of these writers, Max Kozloff and Bruce Boice, have substituted interest for quality. In light of Fried's emphasis on value judgments, Kozloff's paper, which was delivered at a symposium on criticism in 1966, is particularly interesting.

> The regrettable tendency of art writers to rank works of art or even to judge them by words such as good and bad, major and minor, is, for instance, irrelevant to professionalism. What difference should it make to say that Rembrandt is a greater painter than Mark Rothko, if Rothko, for obvious reasons, "interests" us more? And if Larry Poons is thought by some not to exist on the same level as Rothko, is he not, in fact, more strikingly relevant to our situation than the older painter? By acknowledging the imperatives of art most pertinent to our immediate experience, we do not thereby dismiss the accomplishments of the past, but rather guarantee some further and more adventurous life for them, even if it is not fixed by a totally arbitrary hierarchy of values.[146]

By emphasizing the irrelevance of judging contemporary works of art against the past, Kozloff is probably reacting specifically to Fried (who was presenting a paper to the symposium the same day).

In 1972, Boice took on "The Quality Problem." Assuming that "a statement of value is not a statement of fact and thus can be neither true nor false," he proceeded to examine the concept of interest.

> It is only to show that when interest does describe the relationship between the speaker and an art work, that "quality" or evaluation is irrelevant to the relationship and to the experience. When Judd wrote, "All a work needs to be is interesting," what was meant is not so much that interest is enough, but that interest is all that is possible. But of course, words get used in different ways.[147]

Not only did Judd not write "*All* a work needs to be is interesting," he had no intention of denying the relevance of quality or value judgments. One of the things he claims is "essential to a good review, article or book is an estimate of how good the artist is."[148] In fact, he has stressed the importance of making value judgments (a position clearly supported by a survey of his art criticism).[149] Suggestive of Boice's interpretation of Judd's remark in "Specific Objects" is Fried's claim that "literalist work is often condemned—when it *is* condemned—for being boring. A tougher charge would be that it is merely interesting."[150] Judd complained: "I was especially irked by Fried's misinterpretation of my use of the word 'interesting.' I obviously use it in a particular way but Fried reduces it to the cliché 'merely interesting.' ... Fried is not careful and informed."[151] It is likely

that Fried transposed the "merely interesting" from Stanley Cavell's remark, which was quoted in "Shape as Form." According to Cavell, "But objects of art [do] not merely interest and absorb; they move us."[152] Like Fried, Noland interpreted Judd's statement to mean that interest has no bearing on aesthetic value: "Mr. Judd made a statement in the sixties that opened a flood-gate, that the difference between good and bad doesn't make any difference. 'All a work of art has to be is interesting.' That just opened the door."[153]

For Fried, "To experience painting as painting is inescapably to engage with the question of quality."[154] (Here he is in agreement with Greenberg, for whom "aesthetic experience is valuing experience.")[155] Interest, however basic it is to art, is not, according to Fried, relevant to the judging of art and so has nothing to do with experiencing art as it should be experienced.

"For Judd, as for literalist sensibility generally, all that matters is whether or not a given work is able to elicit and sustain (his) *interest*."[156] Fried apparently sees interest as a subjective phenomenon. Boice remarked that "'interest' generally acknowledges the presence of the speaker and indicates a subjective situation."[157] Like boring, "interesting," adjectivally applied to an object, implies that someone has experienced that object in those terms. However, unless the speaker specifies "*I* find the object interesting," he or she may mean that someone would find it interesting, not necessarily that the speaker himself does.

When Judd wrote, "I obviously use [the word *interesting*] in a particular way," he did not elaborate.[158] However, when asked what he meant by the term, he replied that he was using it in accordance with the ideas of the American philosopher Ralph Barton Perry.[159] Perry's book, *General Theory of Value*, was published in 1926. In it, his position is clear: an object is valuable if and when interest is taken in it. "That which is an object of interest is *eo ipso* invested with value. Any object, whatever it be, acquires value when any interest, whatever it be, is taken in it." The equation is formulated as follows: "x is valuable $=$ interest is taken in x."[160] Thus, Judd *cannot* be taken to mean "neither good nor bad, but 'merely interesting.'" If he is in league with Perry, he is attributing a value to an object of interest.

The act of being interested, or taking an interest in something, is a valuing experience. Interest is defined by Perry as "this all-pervasive characteristic of the motor-affective life, this *state, act, attitude or disposition of favor or disfavor*."[161] In a later book, he expanded the definition.

The word "interest" is the least misleading name for a certain class of acts or states which have the common characteristic of *being for or against*. The expressions "motor-affective attitudes" or "attitudes of favor and disfavor" serve as its best paraphrases. "Caring"

and "concern" are also convenient synonyms. The absence of interest is indifference, as when one says, "It makes no difference to me," "I do not care," or "It is of no concern to me."[162]

Perry acknowledges the relational quality of value, which is defined as "the peculiar relation between any interest and its object," but believes he has escaped the charge of relativism, what Boice would call "a subjective situation." As Perry explained,

> In the first place, although defining value as relative to interest, we have not defined value as exclusively relative to the present interest of the judge. . . .
> In the second place, having defined value as constituted by interests, such judgements have a content or object other than themselves. They may refer to the interest of the judge, or to any other interest, past or present, common or unique: but the interest that creates the value is always other than the judgement that cognizes it.[163]

It is possible to speak of interests other than one's own.

Philosophers commonly speak of the "disinterestedness" of the viewer during the aesthetic experience. This derives from Kant, who maintained that, in making aesthetic judgments, "we have no interest whatever in an object—i.e., its existence is indifferent to us." What one experiences disinterestedly is "the formal subjective purposiveness of the object."[164] Conversely, Kant defines interest as "pleasure in that thing's existence." This comes close, I think, to what Judd had in mind when he used the term: taking interest in a thing is to value that thing. In Jerome Stolnitz's often-quoted definition of the aesthetic attitude, "disinterested and sympathetic attention to and contemplation of any object of awareness whatever, of its own sake alone," disinterestedness means impartiality.[165] Because of his conflation of interest and value, Judd might be said to be *partial* to an interesting work of art. At the same time, Judd's notion is not in conflict with a traditional feature of disinterestedness, which prohibits the desire to possess the object. His is not a collector's mentality.

In recent years, Stolnitz's position has been rigorously challenged.[166] One aesthetician, Timothy Binkley, seems especially relevant because of his knowledge of contemporary artistic ideas. According to him, "Simply by making a piece, a person makes an artistic 'statement'; good art is distinguished by the interest or significance of what it says."[167] Richard Lind has also offered, even more boldly, a statement with which Judd would agree. "If there's one thing we know about aesthetic objects right off, it is that they are *interesting* in some way."[168] And, while Lind's theory of "micro-phenomenology" "holds that spontaneous perceptual interest is in all cases directed toward total clarification of whatever is given in the experience, whether simple or complex,"[169]

only when perceptual discrimination is of sufficient vivacity to arouse or satisfy a metain-
terest in experiencing the process itself (depending on whether it follows or precedes
the perceptual process) is an object deemed interesting to perception, hence aesthetic.

When all the data are unambiguously similar it does not take much comparison to
make that similarity apparent: running one's eye down a picket fence once is enough to
establish the equality of the boards or the spaces. Such quick satisfaction of the interest
in clarity fails to arouse or satisfy a practical interest in the process itself.[170]

What Lind suggests is that one's interest is aroused by the particular
formal arrangement of elements in a given work of art. It is not too great a
leap (although one Lind does not make) to suppose that judgments of good
and bad could be predicated on the success or failure of an object to arouse
interest through the complex formal arrangements of its elements. Un-
doubtedly implicated is the artist's skill in arranging (or painterly inscribing
of) those elements. This, it seems, is precisely how many formalist critics
operate. It also explains why certain of them find the work not only uninter-
esting (boring), but bad.

Despite the accusation, the insights of two major "formalists" have
illuminated the error of judging modern works of art in terms of the artist's
skill. In his catalogue essay for the second Post-Impressionist exhibition in
1912, Roger Fry wrote that "it is not the object of these artists to exhibit
their skill or proclaim their knowledge, but only to attempt to express by
pictorial and plastic form certain spiritual experiences; and in conveying
these, ostentation of skill is likely to be even more fatal than downright
incapacity."[171] Speaking directly to the issue of "value or quality in art,"
Greenberg observed that it depends on "not skill, training, or anything else
having to do with execution or performance, but conception alone."[172]

Finally, Wollheim has pointed out that a great deal of modern art, the
kind of art he calls "minimal," depends not in the least on "manifest effort."
There are two alternatives: Duchamp's "decision that the work has gone far
enough" and Reinhardt's "dismantling of [an] image which is fussier or
more cluttered than the artist requires."[173] Neither one of these activities
involves the skillful arrangement of forms.

What remains to be judged, and be interested in or bored by, is the
all-encompassing conception of the piece. It is by its wholeness that a
Minimal work succeeds or fails. Following "A work needs only to be inter-
esting," Judd wrote: "most works finally have one quality."[174]

Art or Non-Art: The Relevance of Theories

More than two decades have lapsed since Minimalism's inception. The
question as to whether it is art may no longer seem as pressing as it once

did. While certain Minimal artists denied an interest in making either paint-
ing or sculpture—and claimed to be making *objects*—they were all con-
vinced that these objects were *art* objects. Only Flavin saw this in terms of
non-art: "We are pressing downward toward no art—a mutual sense of
psychologically indifferent decoration—a neutral pleasure of seeing known
to everyone."[175] Artists who took the opportunity to define what they
meant by art, or work of art, utilized the classificatory sense of the word
rather than the evaluative. Not only good art, but all art, good or bad, was
included in the category. Their definitions tend to be extremely liberal, in
tune with the permissiveness of the decade. While a few conservative crit-
ics and the non-art public hesitated to call Minimal objects art, those con-
versant with artistic theory in the 1960s had no reservations. There was
simply no question about it.

Quoting Judd's "A work needs only to be interesting," Fried concluded
that the Minimalists "have shown considerable uncertainty as to whether
or not what they are making is art."[176] The refusal to label their works as
painting or sculpture prompted Fried to make this statement, since, for
him, what is neither painting nor sculpture lies between the arts, is theatre
and not (visual) art. Only Allan Kaprow, in a letter to the editor of *Artfo-
rum*, was supportive of his assumption. After denying the war between the
"literalists" and the "modernists" described in "Art and Objecthood," Kap-
row continued: "But I sure do dig his much better idea that all this mucky
stuff, from Tony Smith to John Cage, is out to get ART ITSELF. I haven't
checked to find out if they know what they're really doing, but they might
be thrilled to hear about it."[177] Unlike Kaprow and his Happenings, the
Minimalists were not "out to get" art. As Morris said, "I think they're all
pretty convinced that what they're making is art."[178] They persisted in
showing in art galleries, called themselves artists, and discussed their work
as art. While they may be said to have redefined the nature of art objects,
and in so doing broadened the category, there is no evidence that they
desired to eliminate the category.

Judd, in fact, maintained an almost traditional definition: "Art is some-
thing you look at."[179] His first critical opinion of Morris to appear in print
was on the occasion of a group show at Gordon's Gallery in 1963. "The
understatement of these boxes is clear enough and potentially interesting,
but there isn't, after all, much to look at."[180] The following year, two of
Morris's pieces shown at Gordon's were accompanied by *Column* and *Slab*
in the exhibition Black, White and Gray. While Judd called these "the most
forceful and the barest expression" of nonhierarchically ordered work, he
added, "I need more to think about and look at." However, of Rauschen-

berg's white paintings he wrote, "There isn't anything to look at. . . . Morris's pieces exist after all, as meager as they are. Things that exist exist and everything is on their side."[181] However, "It isn't necessary for a work to have a lot of things to look at, to compare, to analyze one by one, to contemplate. The thing as a whole, its quality as a whole, is what is interesting."[182] Although Judd never denies that the work he is discussing is art, he does make quality judgments based on what art is supposed to be—"something you look at."

McCracken looked up *art* in the dictionary. "The first meaning given is the archaic form of the verb 'to be,' or 'is,' rather. So it has in it the idea that what art is is 'is-ness' . . . or strong being."[183] LeWitt made this remark to Lippard: "All segments of society have their own art forms, art being everything in life in which an aesthetic choice is made."[184] According to Morris, "Anything that is used as art must be defined as art."[185] He also made it clear that the Minimalists were not involved with the Duchampian enterprise of destroying the boundaries of art. Theirs is "a conventional definition. And that's the way it's accepted, and so I think artists are aware of this, and that kind of protest art or questioning art is not relevant any more."[186] However, Minimalism was not always critically interpreted in those terms.

In retrospect, Krauss could write: "This assumption that minimalism stood for an attack on the very possibility of art's meaningfulness formed the basis of the initial response to minimalism—both by its supporters and detractors."[187] Certain critics assumed that the Minimalists were intentionally making deviate objects, that they were purposefully denying the validity of a certain special class known as art. For John Canaday, who reviewed Judd's first exhibition, such work was not only not art, but meaningless. "This show is merely an excellent example of 'avant-garde' non-art that tries to achieve meaning by a pretentious lack of meaning."[188] A less abusive approach, although one still assuming a destructive intention on the part of the Minimalists, was to interpret the works of art as "advancing on the frontiers of non-art."[189] Thus, the paintings and sculptures were seen to be art, alright, but only barely so, by existing dangerously close to the borderline between art and non-art.

Greenberg believed that Minimalism occupied that borderline for a specific reason. Mindful of the critical reception of artists from Manet to Pollock, he determined that when each modernist style originally appeared it always looked like non-art. Aware of this situation, the Minimalists have attempted to perpetuate it by making art that is as like non-art as possible. Since "a monochromatic flatness that could be seen as limited in extension

and different from a wall henceforth automatically declared itself to be a picture, to be art," the Minimalists were forced into the third dimension, which "is, among other things, a co-ordinate that art has to share with non-art."[190]

Fried translated Greenberg's "condition of non-art" into the state of objecthood, and seems to be maintaining the position that Minimal objects are not art. Objecthood is "antithetical to art," and is "at war today, not simply with modernist painting (or modernist painting and sculpture), but with art as such."[191] Fried, who cares exclusively for *good* art, admitted in 1981 that "art's anything that anyone wants it to be." His consistent references to "literalist works of art" make good his claim that he never felt that Minimal objects were anti-art or non-art: "Anti-modernist, sure," but not non-art.[192] Greenberg and Fried collapsed the distinction between art and good art: "The first disappears into the second."[193] Art becomes an evaluative term. The only conclusion one can possibly draw from their arguments, and one that both have confirmed in conversation, is that Minimal art is art, but very bad art.

Other critics had less value-loaded reasons for their suspicions. In an early assessment, Rose observed that "the new sculpture, like the new painting, seems involved with finding out how little one can do and still make art."[194] One of the things the artists could refrain from doing was building their own objects. Both Kramer and Mellow thought that Judd's show of fabricated sculpture in 1966 raised the question, "What is a work of art?"[195] While Ashton denied that fabrication *per se* was relevant to the determination of artistic status, she also expressed doubts about Judd's 1966 exhibition. "There is no opportunity in such highly stylized, totally conceptual art for the sensuous and imaginative responses traditionally associated with art."[196] There were in the sixties certain assumptions about the nature of art. The most aggressive deviation from these standards was the conceptual orientation of Minimal art. Both fabrication and systematic organization contributed to the "look of non-art." As Bochner noted, "Serial or systemic thinking has generally been considered the antithesis of artistic thinking."[197] Without idiosyncratic facture and expression—the definitive drip of the Abstract Expressionist—Minimalism at first appeared deficient.

It also looked completely unlike earlier art, whose objects were highly differentiated, made so, according to Wollheim, by "'constructive' work." Reviewing Morris's first completely Minimal show, Judd wrote:

> First, many aspects often thought essential to art are missing, such as imagery and composition. This is also true of the work of Flavin and Stella, for example; their work is obviously not like prior art. But theirs is plainly aesthetic in intention. Morris's work

nearly appears not to be art; perhaps he doesn't want it to be thought art at first, though of course it is finally.[198]

Bochner also remarked on the difference between old and new art.

Traditionally, what has been known as art has been a group of objects having to some degree the attributes of other previously made objects known as art. Stella's work neatly bypassed most of the traits common to the painting that preceded him. Subsequent art therefore, did not have to be the same as previous art.[199]

Fried distinguished two attitudes operative in this century. The first, exemplified by Reinhardt, is "profoundly a-historical." On the other hand, work such as Stella's and Newman's is "historically self-aware." "The historically self-aware attitude towards one's work, together with the acceptance of history as that which in the long run determines validity, are the hallmarks of *modernism*."[200] The artists of the sixties were perhaps more conscious of art history than any other modernist generation. Greenberg thought that they pursued certain innovations based on what they knew of the past: "By now we have all become aware that the far-out is what has paid off best in avant-garde art in the long run."[201] That art should look so unlike previous art is not surprising.

As Minimal objects became less like past art, the more they appeared to be real things. Although the same problem confronted Pop artists, it had a different source. Because Pop paintings and sculptures mimetically resemble real things, there is a danger that they will be indistinguishable from those real things. For the conservative critic, the fate of Pop was the same as that of Minimal art. It was not art. One writer discussed Warhol's *Brillo Boxes* at the Castelli Gallery in 1964, and concluded that Warhol "takes art into the non-art, into the un-esthetic, and leaves it there."[202] The conventional distinction between art objects and real objects was being breached. In the past, Kramer lamented, "the very concept of fine art signified a certain elevation from the common ground."[203]

It would seem that by their very abstractness, their nonreferential relationship to the world of things, Minimal objects would automatically be classifiable as art. However, this was not the case at all. It was precisely their objecthood that connected them to other (non-art) objects. As Danto sees the situation: "Non-imitativeness becomes the criterion of art, the more artificial and the less imitative in consequence, the purer the art in question. But ... the more purely art things become, the closer they verge on reality, and *pure* art collapses into pure *reality*."[204] One of the most crucial problems, if not *the* most crucial problem, confronting Minimalism

was how to distinguish these works from other things—that is, what made them different, better or more valuable than non-art? If their aim was to be as real and objectlike as possible, why were they exhibited and written about as if they were special?

A simple and frequently espoused explanation is that a work is something made, or in the case of readymades or fabricated works, conceived of, by an artist. Since not everything artists make, such as cups of coffee, the bed in the morning and a grand slam at bridge, can reasonably be called art, one would want to append to this definition, "with the intention of making a work of art." According to Kramer, in 1969,

> As our cultural assumptions are currently constituted, we are—insofar as we are part of the vast body of informed esthetic consumers—ready, if not always willing or happy, to accept as a work of art almost any object, arrangement of objects or sheer physical gesture that someone identifying himself as an artist asserts to be a work of art.[205]

Although Kramer admitted this with some reluctance, it is significant that he, a rather conservative critic, could recognize such a trend. What should be obvious, especially in art of the sixties, is that the fact of an artist's having made or presented something he calls art is not evident from the appearance of the object. Danto brings this intentionalistic definition full circle so that industrial fabricators (or forgers or junkmen) are prevented from being identified as artists. "It is analytically true that artworks can only be *by* artists, so that an object, however much (or exactly) it may resemble an artwork is not *by* whoever is responsible for its existence, unless he is an artist."[206]

At the same time, a work of art—by an artist—could sit unrevealed to the artworld in someone's attic and even if discovered might not be recognized, dislocated as it is from definitive context. Judd and Andre provided critics with pertinent examples of the dilemma.

> It is highly doubtful . . . if even the most enthusiastic partisans of Carl Andre's sculpture would have recognized this arrangement of *144 Pieces of Zinc* (1967) as a sculptural expression—or even a hypothetical sculptural idea—if they had found themselves traversing it on their way to the teller's window in their neighborhood bank, instead of on the floor of the Dwan Gallery.[207]

Another critic wrote of Judd's work that if it were placed in or near a building site, it "might well be mistaken for structural components or housing for equipment."[208] It is the studio, gallery or museum location that signals the artistic status of the object, although even this doesn't prevent

some handlers, shippers, and gallery-goers from carelessly defacing Judd's works.[209]

Judd himself saw certain objects connected with Pop art as dependent on context. Often, such work "doesn't appear to be art. Its only claim to be is that it is being exhibited. It is shown as art and becomes the equal of things that are obviously art."[210] Rose, reviewing the same exhibition and other related shows, described the situation perpetuated by Johns, Morris (in his Neo-Dada phase), Jim Dine, George Brecht, and other less reputable artists.

> It being a commonplace of modern analytic philosophy that meaning is contingent on context, we are left with little more than the assumption that if a thing is in a museum or gallery, then it is an art object. But some of these putative art objects have little art quality, and some, if I may risk a heresy, have none at all.[211]

It is precisely because of the absence of such "art qualities" that a contextual definition was formulated.

For George Dickie and other contemporary philosophers such as Danto and Maurice Mandelbaum, on whom Dickie draws, "nonexhibited properties are of great importance in constituting something as art." In other words, there is something other than that which can be directly perceived in the work of art that makes that thing a work of art. According to Dickie, "A work of art in the classificatory sense is (1) an artifact (2) a set of the aspects of which has had conferred upon it the status of candidate for appreciation by some person or persons acting on behalf of a certain social institution (the artworld)." Dickie's is an "institutional" definition in that artistic status is conferred upon an object by the institution of the artworld, which is made up of artists, presenters, and appreciators. (Dickie makes it very clear that "specified procedures and lines of authority are nowhere codified, and the artworld carries on its business at the level of customary practice." Still, the artworld is an institution.)[212] Dickie has explained precisely how it is that what might pass unnoticed and unappreciated in a bank or on a construction lot, may be respected and esteemed in an art gallery. It is identifiable as a work of art because of its context.

Beyond the simple conferring of artistic status lies the artworld's intimate knowledge of artistic theory. Contextual knowledge is essential to a valid assessment of Minimal art. Danto forecast such a conclusion in 1964.

> But telling artworks from other things is not so simple a matter, even for native speakers, and these days one might not be aware he was on artistic terrain without an artistic theory to tell him so. And part of the reason for this lies in the fact that terrain is

constituted artistic in virtue of artistic theories, so that one of these theories, in addition to helping us discriminate art from the rest, consists in making art possible....

To see something as art requires something the eye cannot decry—an atmosphere of artistic theory, a knowledge of the history of art: an artworld.[213]

It is the overwhelmingly significant role played by Minimalist theories that differentiates Minimalism from earlier art. As Danto observed, it is theory that provides the key to differentiating works of art from objects in the world.

There is no art without those who speak the language of the artworld, and who know enough of the difference between artworks and real things to recognize that calling an artwork a real thing *is* an interpretation of it, and one which depends for its point and appreciation on the contrast between the artworld and the real-world.[214]

Familiarity with the pervasive theoretical basis of Minimalism enhances and sustains a more rewarding experience of the art objects themselves. "There is no art without those who speak the language of the artworld."

Conclusion

Minimalism attempted, above all, the subversion of artistic "style." As Mel Bochner declared in 1966, "This is not an 'art-style.' It will not 'wither' with the passing season and go away."[1] Its objects were industrially produced in rigid materials without any trace of the artist's hand. Its forms were those of an idealistically conceived geometry, rather than intuitive self-expression. Since its dominant period (1963–68), however, it has come to *seem* a style so much so that critics use "minimalist" to categorize any painting or sculpture that is nonfigurative, nonreferential, and nonnarrative or is even remotely geometric.[2] What makes Minimal art special, though, is its philosophical underpinnings. It expresses beliefs about the self and the self's perception of the world that are based on material—objecthood—and space as occupied by that material and the artist/viewer's body. It is the condition of objecthood that elevates the work of art, theoretically, from *mere* things in the world.

Art history sees Minimal art as superseded by Process art, which Robert Morris had a hand in developing; and Conceptual art, which can be seen either as one more step in the reductive process to what Lucy Lippard called the "dematerialization of the object,"[3] or as a reaction to Minimalism's materialistic commitment to the object for which the Conceptualists substituted photographic and typescript documentation. Unlike Minimal art, Conceptualism placed no premium whatsoever on the object. Douglas Huebler summarized the Conceptualist enterprise when he stated: "The world is full of objects, more or less interesting; I do not wish to add any more."[4] Minimal and Conceptual art shared a commitment, however, to straightforward simplicity and austerity through a denial of figurative or formal elaboration. It was difficult art that placed strong demands on the spectator. This was anathema to the Neo-Expressionists, who returned to the hand-painted figure, apparently replete with emotive expression. Art in the late eighties has revived geometry and industrial production but put them at the service of political, rather than aesthetic, content.

There is a move afoot to reinterpret Minimal art along political lines. At a symposium held in 1987, Brian Wallis was reported to hold that "Minimalism was a response to the socio-political conditions of the Sixties—the Vietnam war and the civil-rights movement on the one hand, and such trends as the increasing geometrization of, say, fashion design on the other."[5] Hal Foster, who has shown an especially intelligent interest in the revision of Minimal art, believes that it (along with Pop art) "retooled the old device of the readymade to suit late-capitalist conditions," which results, in the case of Minimalism, in "the fetishism . . . of new materials (e.g., Plexiglas, aluminum and Formica) and techniques (e.g., industrial fabrication, serial production) that, though esthetically nontraditional, are hardly neutral."[6] Wallis, citing the popular French theoretician Jean Baudrillard, also links Minimalist seriality to "late capitalist mass production."[7] This sort of revisionist criticism, for which there is no evidence in the literature of the period, is nevertheless further justification for the extraordinary viability of the language of Minimal art.

Two things distinguish Minimalism from previous modernist art. First, the spectator is given a new role as contributor of meaning, the result of what Foster describes as Roland Barthes's notion of the "death of the author."[8] Linked to this is the proliferation of critical writing and analysis in the 1960s. In 1978, Hilton Kramer wrote that Minimal art "is a movement still very much with us, and the literature written on its behalf is now so immense that a complete bibliographical account of it would itself fill a fat book."[9] For Craig Owens, this "eruption of language into the aesthetic field . . . is coincident with, if not the definitive index of, the emergence of postmodernism."[10] Foster agrees, since Minimal art "initiates the postmodernist critique of its institutional and discursive conditions."[11] The historical position of Minimalism remains much debated, however, as less radical critics such as Peter Schjeldahl maintain that "Minimalism is more obviously the finish of modernist idealism than the commencement of a new era."[12]

Owens's insight into the relationship of critical literature and its art objects was articulated as early as 1966 by Darby Bannard, a Greenbergian opponent of Minimal art.

> As with Pop and Op, the "meaning" of a Minimal work exists outside the work itself. It is part of the nature of these works to act as *triggers* for thought and emotion pre-existing in the viewer and conditioned by the viewer's knowledge of the style in its several forms, as opposed to the more traditional concept of the work of art as a *source* of beauty, noble thought, or whatever. It may be fair to say that these styles have been nourished by the ubiquitous question: "but what does it mean?" These styles are made to be talked about. That is one good reason for their popularity.[13]

Minimal art, however, does not exist on theory alone. Since a great deal of its impact results from experiential factors such as presence and scale, face-to-face confrontation with the physical object is essential. The work cannot be appreciated merely through a discussion of the issues; neither can it be appreciated without such a discussion. While theories such as objecthood and all that it implies necessarily exist outside of the work of art, they are dependent on the work for their justification.

Although the Minimalists derived their compositional strategies from the Abstract Expressionists, many Abstract Expressionists, especially Pollock, were hesitant to comment critically on their work. The exception to the taciturn older generation was Ad Reinhardt. In numerous essays, written over many years, he attempted to explain and justify his own difficult art based on his commitment to abstraction. Finally, by 1963, critics began to question "to what degree his articulateness had obscured the way [his] paintings actually do operate."[14] The viewer, another critic noted, "tends to see the paintings through written filters."[15] Other artists such as Duchamp have positioned themselves as spokesmen for their own art. The difference, however, between Duchamp's advocacy of a "nonretinal," intellectual art and the theoretical nature of Minimalism is apparent in a comparison of their respective objects. Duchamp's art does not, and was not intended to, "look good." (In fact, the "look" of the object matters very little in Dada readymades.) Minimal art, on the other hand, if austere, is decidedly visual. It stimulates perceptually and kinesthetically, as well as conceptually.

The era of the 1960s, as epitomized by Minimal art, saw the future optimistically. It evidenced an unmatchable enthusiasm for progressive invention and a passionate commitment to intellectual inquiry. It was, then, a world without fragmentation, a world of seamless unity.

Plate 1. Vladimir Tatlin, *Corner Relief*, 1915
Wood and metal, 27″ × 32³/₄″ × 31″ (1980 reconstruction
by Martyn Chalk).
(*Annely Juda Fine Art, London*)

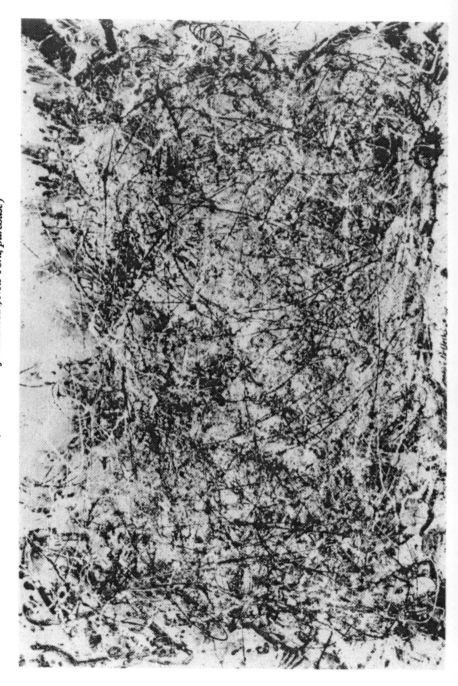

Plate 2. Jackson Pollock, *Number 1, 1948*, 1948
Oil on canvas, 68" × 8' 8".
(*The Museum of Modern Art, New York; purchase*)

Plate 3. Yves Klein, *Blue Monochrome*, 1961
Oil on cotton cloth over plywood, 6′ 4^7/$_8$″ × 55^1/$_8$″.
(*The Museum of Modern Art, New York; The Sidney and Harriet Janis Collection*)

Plate 4. Barnett Newman, *Vir Heroicus Sublimis*, 1950–51
Oil on canvas, 7' 11³/₈" × 17' 9¹/₄".
(*The Museum of Modern Art, New York; gift of Mr. and Mrs. Ben Heller*)

Plate 5. Ad Reinhardt, Black Paintings, 1966
Black Paintings Exhibition at the Jewish Museum, New York
City.
(*Photo courtesy The Pace Gallery, New York; photo by
Gretchen Lambert*)

Plate 6. Kenneth Noland, *Blue Veil*, 1963
 Synthetic polymer paint on canvas, 69⅞" × 69⅞".
 (*The Museum of Modern Art, New York; The Riklis
 Collection of McCrory Corporation; fractional gift*)

Plate 7. Robert Rauschenberg, *White Painting*, 1951
Oil on canvas, seven panels, 72" × 126".
(*Collection of the artist*)

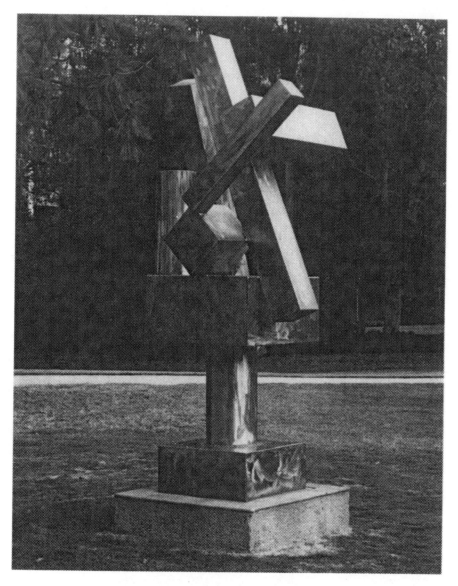

Plate 8. David Smith, *Cubi XX*, 1964
Welded stainless steel, 111″ × 55″ × 56½″.
(*Franklin D. Murphy Sculpture Garden, University of
California, Los Angeles; photo by Anthony Hernandez*)

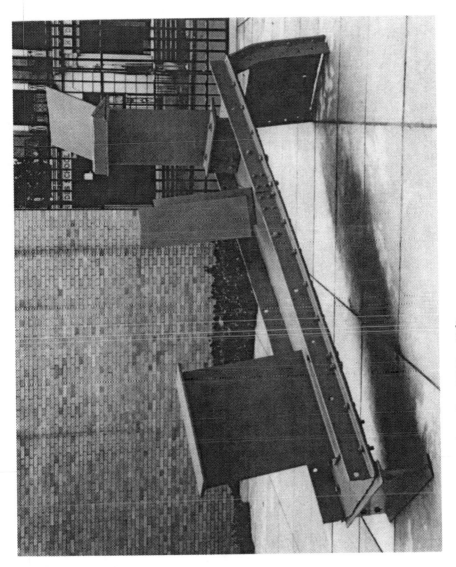

Plate 9. Anthony Caro, *Midday*, 1960
Steel, painted yellow, 7' 7³/₄" × 37³/₈" × 12' 1³/₄".
(The Museum of Modern Art, New York; Mr. and Mrs. Arthur Weisenberger Fund)

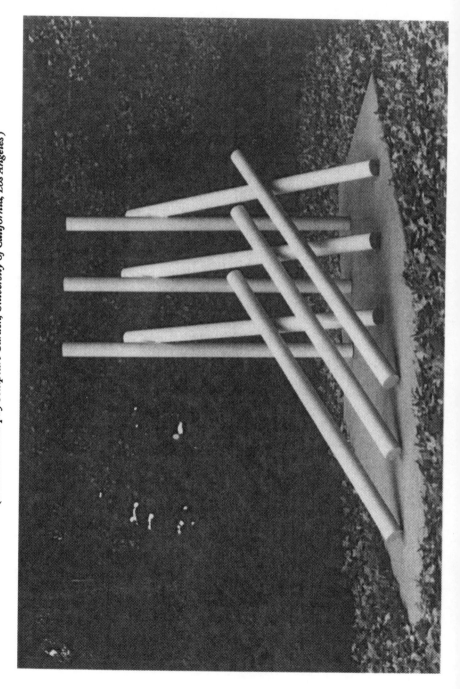

Plate 10. William Tucker, *Untitled*, 1967
Painted steel, 80".
(*Franklin D. Murphy Sculpture Garden, University of California, Los Angeles*)

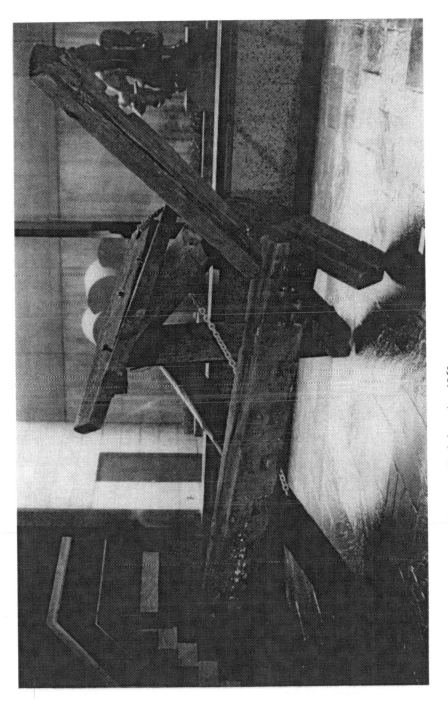

Plate 11. Mark di Suvero, *Hankchampion*, 1960
Wood and chains, 77¹/₂″ × 149″ × 105″.
(*Collection of Whitney Museum of American Art; gift of Mr. and Mrs. Robert C. Scull, 73.85;
photo by Geoffrey Clements*)

Plate 12. John Chamberlain, *Sweet William,* 1962
Welded and painted metal, 61" × 74" × 43".
*(Los Angeles County Museum of Art; gift of Mr. and Mrs. Abe Adler in memory of Mrs. Esther
Steif Rosen through the Contemporary Art Council)*

Plate 13. Lee Bontecou, *Untitled*, 1961
Relief construction of welded steel, wire, canvas, 6' 8¹/₄" × 7' 5" × 34³/₄".
(*The Museum of Modern Art, New York; Kay Sage Tanguy Fund*)

Plate 14. Frank Stella, *Tomlinson Court Park*, 1959
Enamel on canvas, 7' 1" × 9' 1¾".
(*Collection Robert Rowan, Pasadena, Calif.*)

Plate 15. Frank Stella, Installation View, 1959–60
Frank Stella (Black Paintings) section of exhibition, Sixteen Americans, The Museum of
Modern Art, New York City.
(*Courtesy The Museum of Modern Art, New York; photo by Rudolph Burckhardt*)

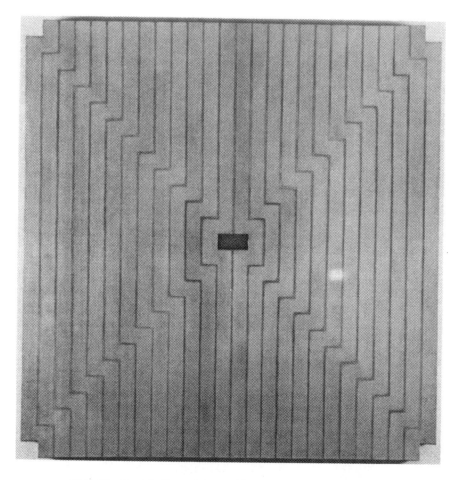

Plate 16. Frank Stella, *Avicenna*, 1960
Aluminum paint on canvas, 74½" × 72".
(*Courtesy of The Menil Collection, Houston, Texas; photo
by Hickey & Robertson, Houston*)

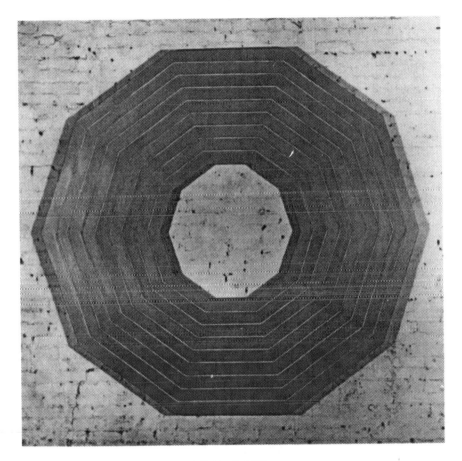

Plate 17. Frank Stella, *D*, 1963
Metallic paint on canvas, 6′ 9″ × 7′ 1″.
(*Collection Irving Blum*)

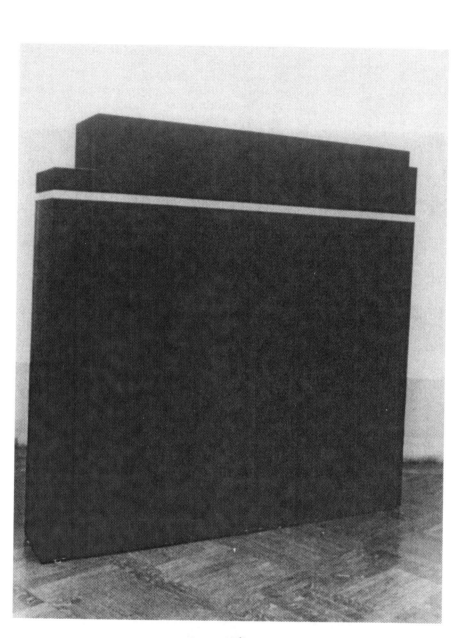

Plate 18. Anne Truitt, *Carson*, 1963
Acrylic on wood, 72¼″ × 72″ × 13″.
*(Baltimore Museum of Art: gift of Helen B. Stern,
Washington, D.C., BMA 1984.56; photo courtesy André
Emmerich Gallery)*

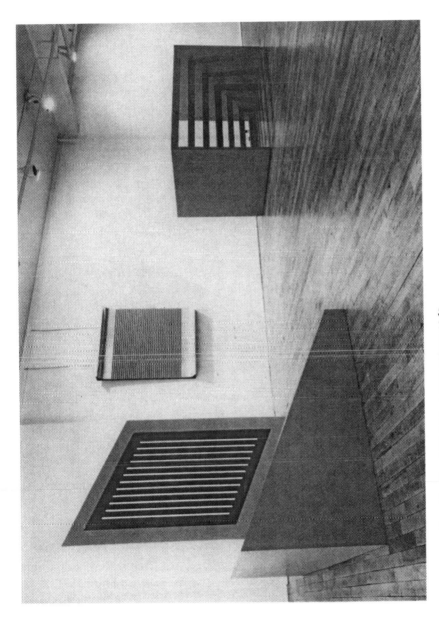

Plate 19. Donald Judd, Installation View, 1963
Exhibition at the Green Gallery. Painted wood and metal.
(*Photo courtesy Paula Cooper Gallery, New York; photo by Rudolph Burckhardt*)

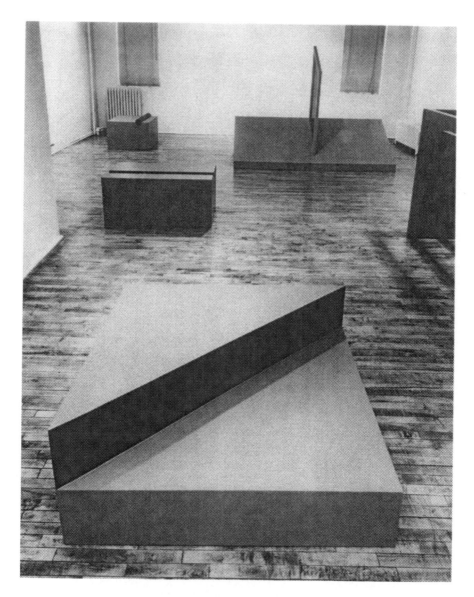

Plate 20. Donald Judd, Installation View, 1963
Exhibition at the Green Gallery. Painted wood and metal.
(*Photo courtesy Paula Cooper Gallery, New York; photo
by Rudolph Burckhardt*)

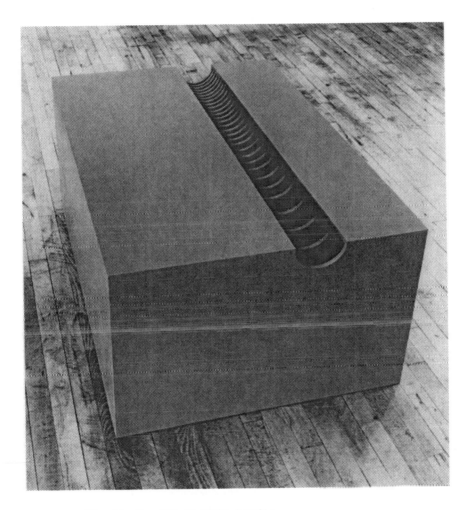

Plate 21. Donald Judd, *Untitled*, 1963
Painted wood, 19^{1}/$_{2}$" × 45" × 30^{1}/$_{2}$".
(*Photo courtesy Paula Cooper Gallery, New York; photo
by Rudolph Burckhardt*)

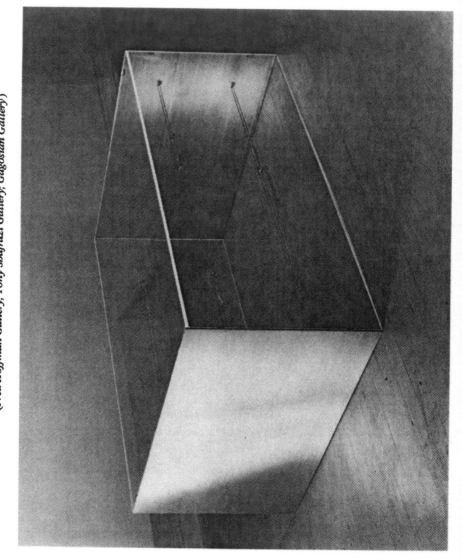

Plate 22. Donald Judd, *Untitled*, 1968–88
Green Plexiglas, steel cable, steel plate, 20" × 48¼" × 34".
(Fred Hoffman Gallery; Tony Shafrazi Gallery; Gagosian Gallery)

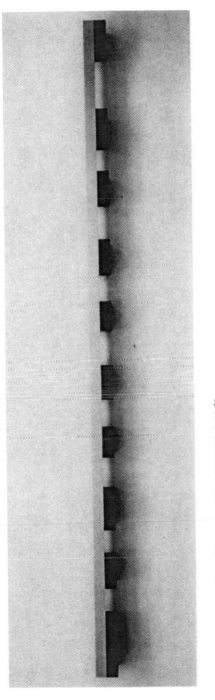

Plate 23. Donald Judd, *Untitled*, 1965
Aluminum, 8¹/₄" × 21'1" × 8¹/₄".
(*Collection of Whitney Museum of American Art, New York; purchase with funds from
Howard and Jean Lipman Foundation, Inc.; 66.53*)

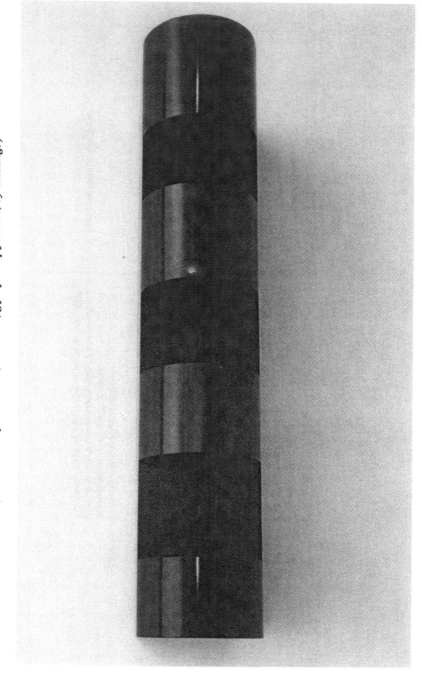

Plate 24. Donald Judd, *Untitled*, 1973–75
Refabricated after 1967 version. Painted galvanized iron, 25⅝" × 6' 4¾" × 14¾".
(*The Musuem of Modern Art, New York; gift of Philip Johnson, by exchange*)

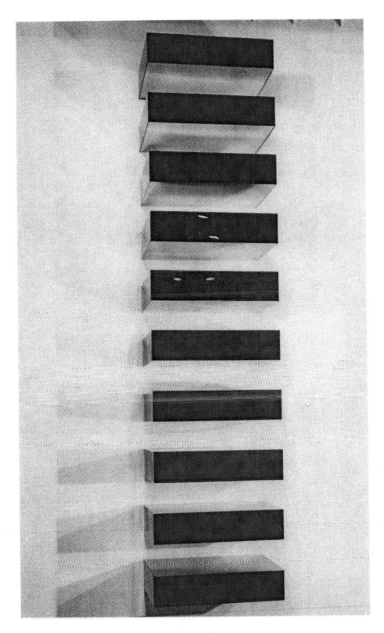

Plate 25. Donald Judd, *Untitled*, 1969
Stainless steel with blue Plexiglas, ten units, each 9″ ×
40¼″ × 31¼,″ at 9¼″ intervals.
(*Norton Simon Museum of Art, Pasadena; part purchase/
part gift of the artist, 1969*)

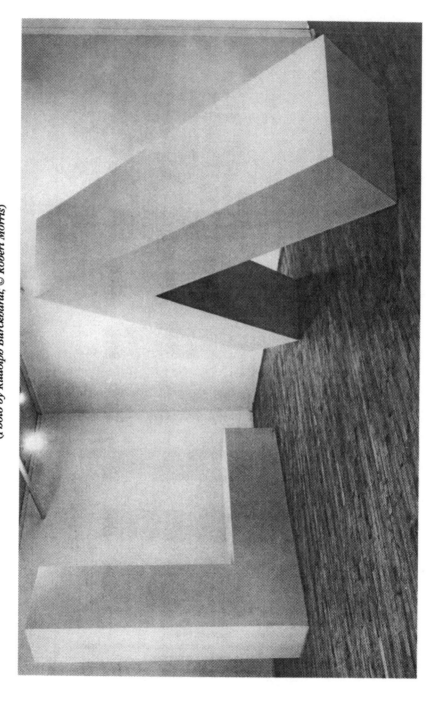

Plate 26. Robert Morris, *Untitled*, 1965
Painted plywood, each unit 8′ × 8′ × 2′ (destroyed).
(Photo by Rudolph Burckhardt; © Robert Morris)

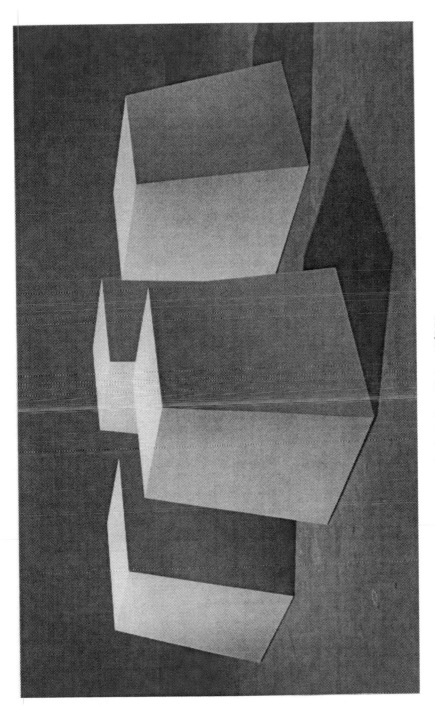

Plate 27. Robert Morris, *Battered Cubes*, 1965/88.
Painted steel, each unit 36" × 36" × 36".
(*Margo Leavin Gallery, Los Angeles; photo by Douglas M. Parker Studio*)

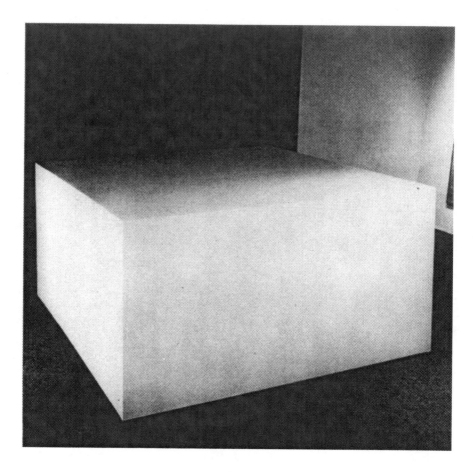

Plate 28. Robert Morris, *Untitled,* 1966
Painted plywood, 4′ × 8′ × 8′.
(© *Robert Morris*)

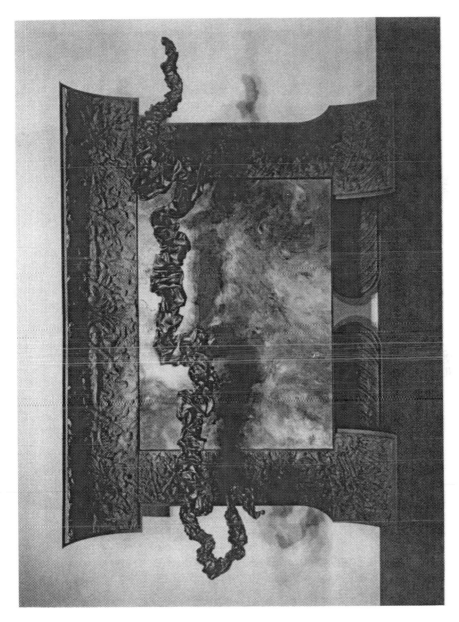

Plate 29. Robert Morris, *Order* (Burning Planet Series), 1985
Painted cast hydrocal, oil on canvas, and fiberglass, 112″ × 147″ × 24″.
(*Los Angeles County Museum of Art; gift of the collectors committee*)

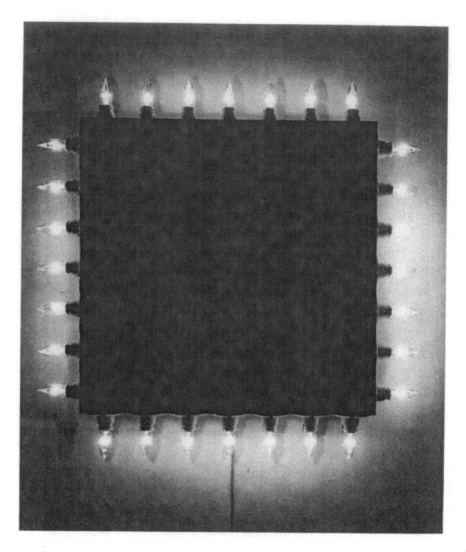

Plate 30. Dan Flavin, *Icon V (Coran's Broadway Flesh)*, 1962
Oil on Masonite, porcelain receptacles, clear incandescent
bulbs, 42⅛″ × 42⅛″ × 9½″.
(*Heiner Friedrich, New York; © Dan Flavin/ARS, New York, 1989*)

Plate 31. Dan Flavin, *the nominal three (to William of Ockham)*, 1963
Daylight fluorescent light, 72".
(*Giuseppe Panza di Biumo-Varese; photo by Giorgio Colombo, Milan*)

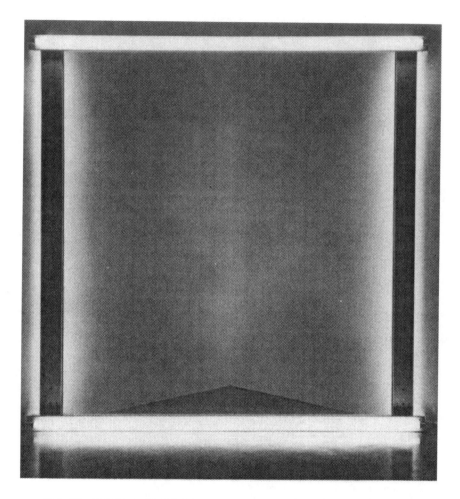

Plate 32. Dan Flavin, *Untitled (to the "innovator" of Wheeling Peachblow)*, 1968
Fluorescent lights and metal fixtures, 8 ½" × 8 ¼" × 5 ¾".
(*The Museum of Modern Art, New York; Helena Rubinstein Fund*)

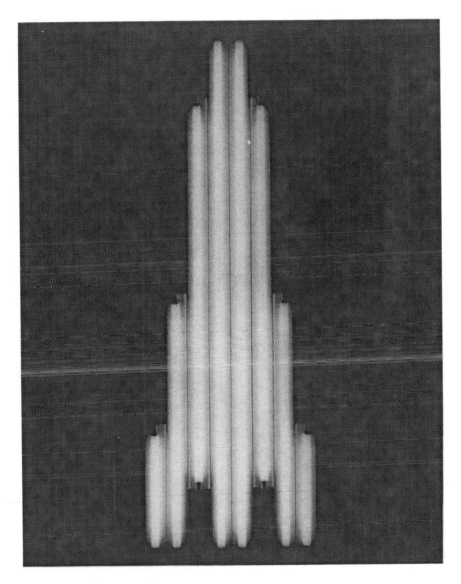

Plate 33. Dan Flavin, *Monument for V. Tatlin*, 1969
Cool white fluorescent light, 96" × 30¹/₂".
(*The Museum of Contemporary Art, Los Angeles; photo by Squidds & Nunns*)

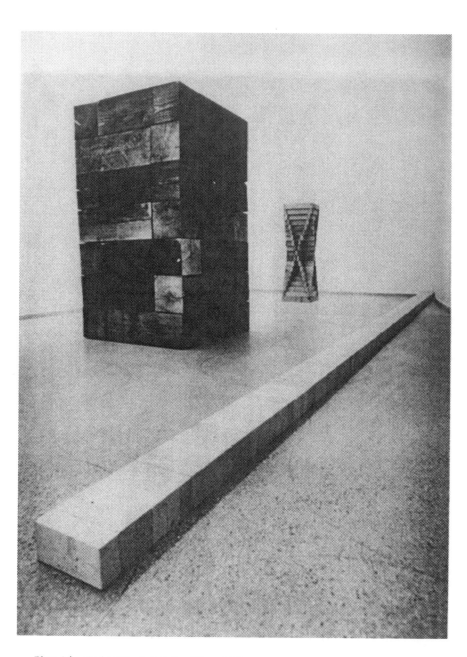

Plate 34. Carl Andre, Installation View, 1970
Exhibition of *Well*, 1964/70, wood; *Pyramid*, 1959/70, wood; *Lever*, 1966,
firebrick, at the Solomon R. Guggenheim Museum.
(*Photo courtesy Paula Cooper Gallery, New York;* © *Carl Andre/V.A.G.A.,
New York, 1989*)

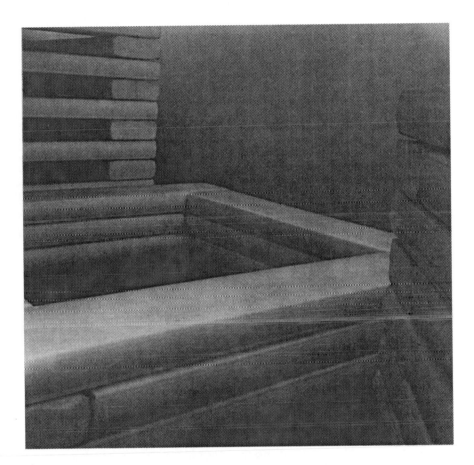

Plate 35. Carl Andre, *Crib, Coin and Compound*, 1965
Exhibition at the Tibor de Nagy Gallery. Styrofoam, each
plank 9' × 18" (destroyed).
(*Photo courtesy Paula Cooper Gallery, New York;* © *Carl
Andre/V.A.G.A., New York, 1989*)

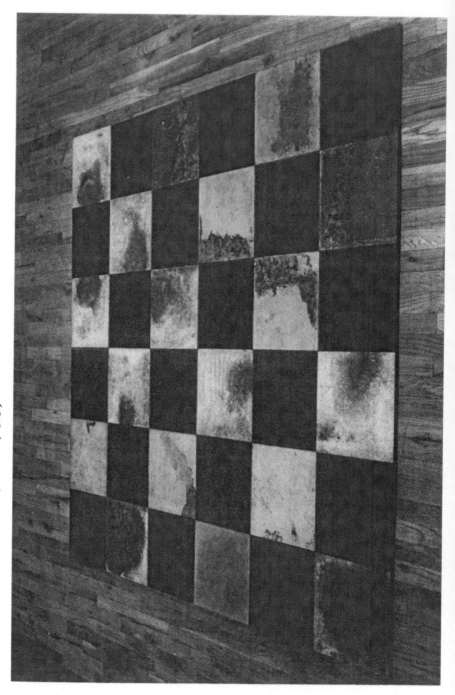

Plate 36. Carl Andre, *Steel-Magnesium Plain,* 1969
Steel and magnesium, ³/₈" × 72" × 72" overall.
(*Photo courtesy Paula Cooper Gallery, New York; photo by eeva-inkeri; © Carl Andre/
V.A.G.A., New York, 1989*)

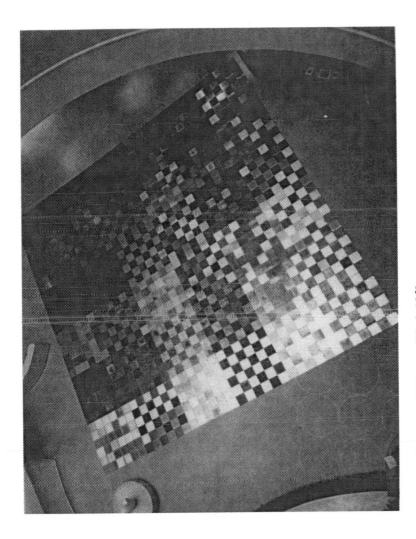

Plate 37. Carl Andre, *37 Pieces of Work*, 1969
Exhibition at the Solomon R. Guggenheim Museum, 1970. Aluminum, copper, steel,
magnesium, lead, zinc, $3/8'' \times 432'' \times 432''$ overall.
(*Grex Collection, Hallen für neue Kunst, Schaffhausen, Switzerland; photo courtesy Paula
Cooper Gallery, New York; © Carl Andre/V.A.G.A., New York, 1989*)

Plate 38. Sol LeWitt, *Double Floor Structure*, 1964
Painted wood (destroyed, remade in painted steel), 30″ × 48″ × 144″.
(*The Contemporary Museum, Honolulu; photo courtesy Margo Leavin Gallery, Los Angeles; photo by Douglas M. Parker Studio*)

Plate 39. Sol LeWitt, *47 Three-Part Variations on Three Different Kinds of Cubes*, 1967/74
Aluminum (destroyed, remade in steel, 1974), 45" × 300" × 195".
(*Allen Memorial Art Museum, Oberlin College; Rousb Fund for Contemporary Art, 1972;
pboto courtesy Sol LeWitt; pboto by Walter Russell*)

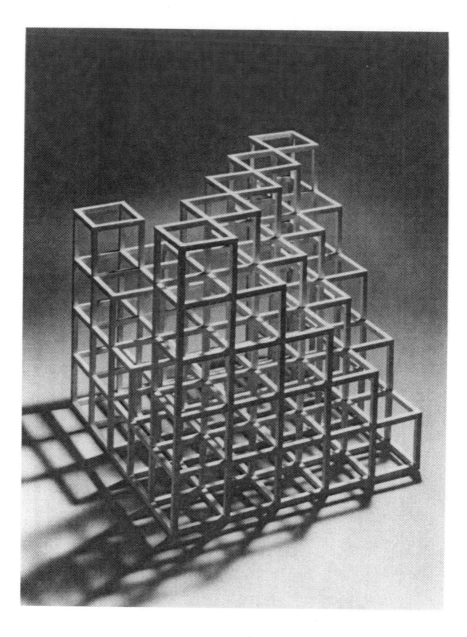

Plate 40. Sol LeWitt, *Cubic Construction: Diagonal 4, Opposite
Corners 1 and 4 Units,* 1971
White painted wood, 24½″ × 24¼″ × 24¼″.
(*The Museum of Modern Art, New York; The Riklis
Collection of McCrory Corporation; fractional gift*)

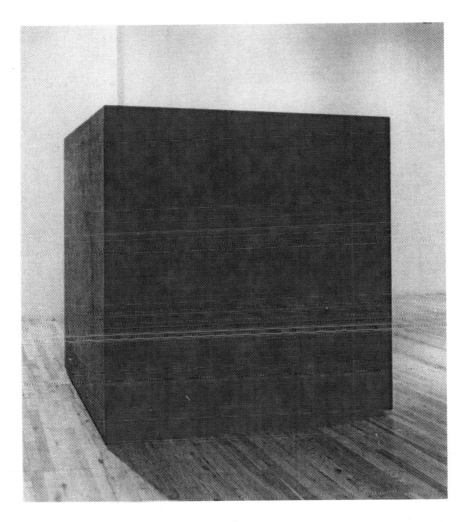

Plate 41. Tony Smith, *Die*, 1962
Steel, 72″ × 72″ × 72″.
(*Paula Cooper Gallery, New York; photo by Geoffrey
Clements*)

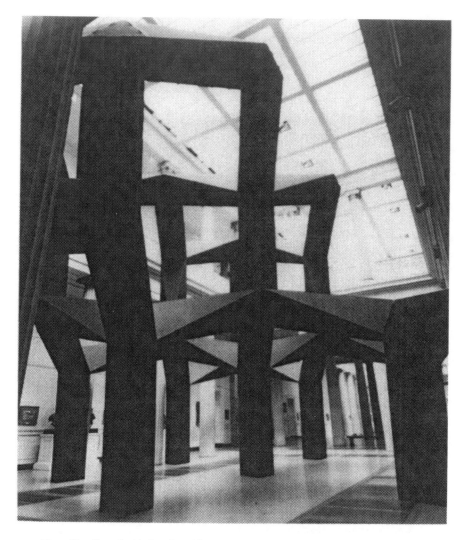

Plate 42. Tony Smith, *Smoke*, 1967
Exhibition at the Corcoran Gallery. Mock-up in wood, 24′ × 34′ × 48′.
(*Photo courtesy Paula Cooper Gallery, New York*)

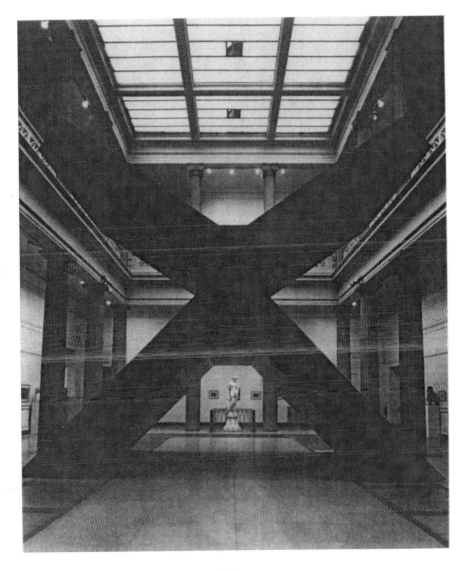

Plate 43. Ronald Bladen, *The X*, 1967
Exhibition at the Corcoran Gallery. Painted wood, 22′ × 24′ × 14′.
(*Photo courtesy Washburn Gallery*)

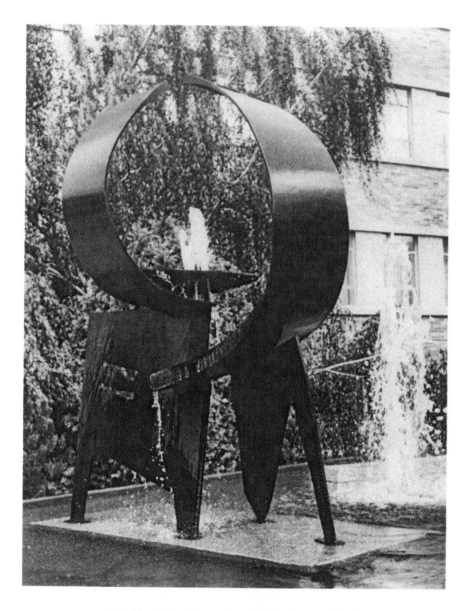

Plate 44. Robert Murray, *Fountain Sculpture*, 1959–60
Steel painted black-green, 8'.
(*City Hall, Saskatoon, Saskatchewan*)

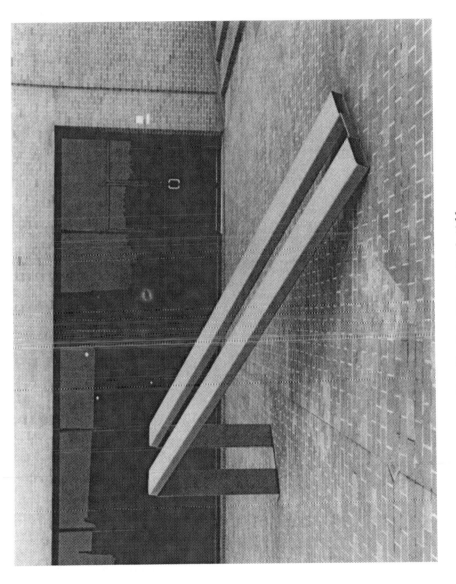

Plate 45. Robert Murray, *Track*, 1966
Steel and painted aluminum, 14'.
(*Walker Art Center, Minneapolis*)

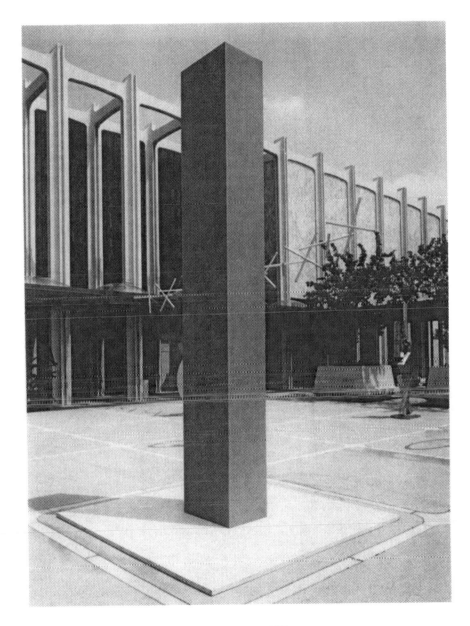

Plate 47. John McCracken, *Untitled*, 1966
Exhibition at the Los Angeles County Museum of Art.
Fiberglass, lacquer, plywood, 15′ × 27″ × 20″.
(*Los Angeles County Museum of Art; gift of Friends of
Leonard B. Hirsch, Jr., 1967*)

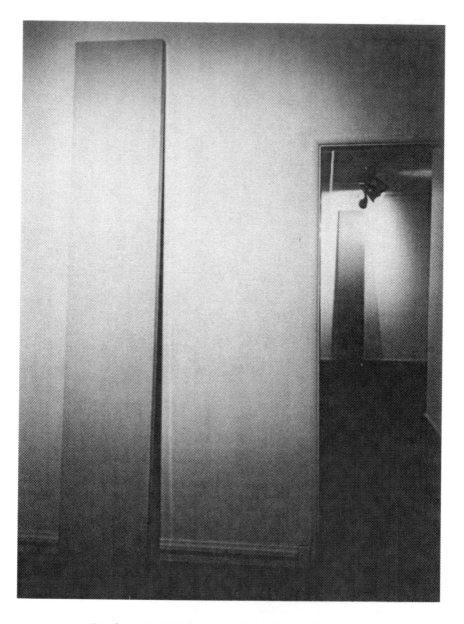

Plate 48. John McCracken, Installation View, 1967
Exhibition at Nicholas Wilder Gallery, Los Angeles.
(*Photo courtesy Fred Hoffman Gallery*)

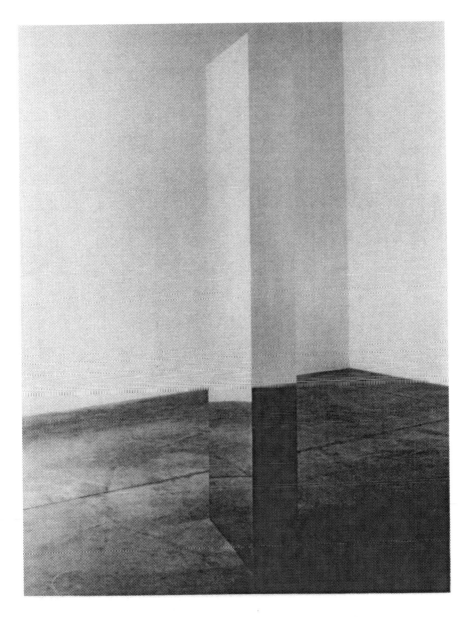

Plate 49. John McCracken, *Sagittarius*, 1988
Stainless steel, 92″ × 18″ × 28″.
(Photo courtesy Fred Hoffman Gallery)

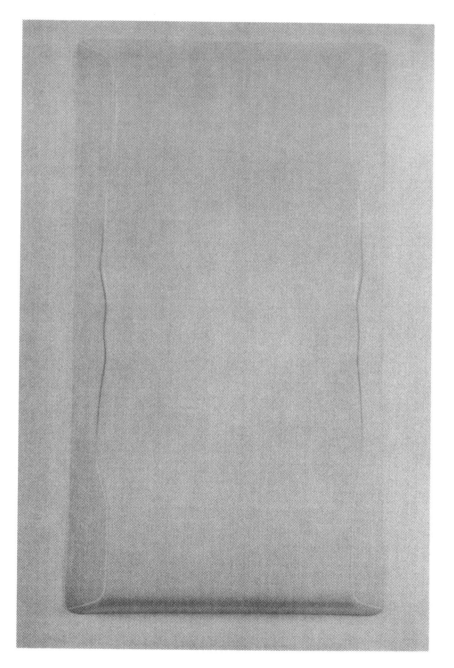

Plate 50. Craig Kauffman, *Untitled*, 1968–69
Vacuum formed Plexiglas, 22″ × 52″ × 12″.
(*Asher/Faure Gallery, Los Angeles; photo by James Franklin,* © *1989*)

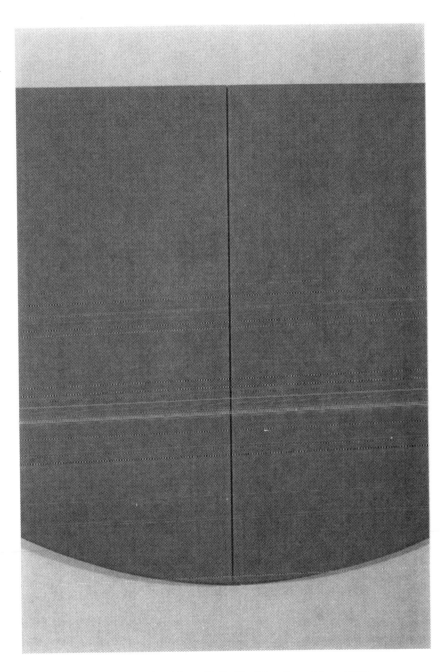

Plate 51. Robert Mangold, *1/2 Blue/Grey Curved Area*, 1967
Oil on Masonite, 72″ × 72″.
(*Collection Daniel Weinberg, Los Angeles*)

Plate 52. Brice Marden, *Choice* (Back Series), 1967
Oil and wax on canvas, 69″ × 45″.
(*Collection Robert Rauschenberg; photo by Geoffrey Clements*)

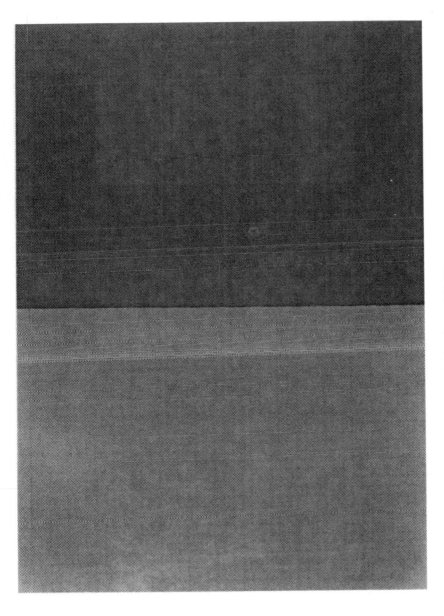

Plate 53. Brice Marden, *Fass*, 1969–73
Oil and wax on canvas, 53¹/₂″ × 70¹/₂″.
*(The Museum of Contemporary Art, Los Angeles; The
Barry Lowen Collection; photo by Squidds & Nunns)*

Plate 55. Jo Baer, *Untitled*, 1964–72
Oil on canvas, 48″ × 48″.
(*San Francisco Museum of Modern Art; gift of Rena Branston*)

Plate 56. Robert Ryman, *Twin*, 1966
Oil on cotton, 6' 3³/₄" × 6' 3⁷/₈".
(*The Museum of Modern Art, New York; Charles and Anita Blatt Fund and Purchase*)

Plate 57. Robert Ryman, *Classico I*, 1968
Acrylic on paper, 7′ 6″ × 7′ 9″.
(*Giuseppe Panza di Biumo-Varese; photo by Giorgio Colombo, Milan*)

Plate 58. Robert Smithson, *Gyrostasis*, 1968
Painted steel, 73⅝″ × 54⅛″ × 39¼″.
(*Hirshhorn Museum and Sculpture Garden, Smithsonian
Institution; gift of Joseph H. Hirshhorn, 1972*)

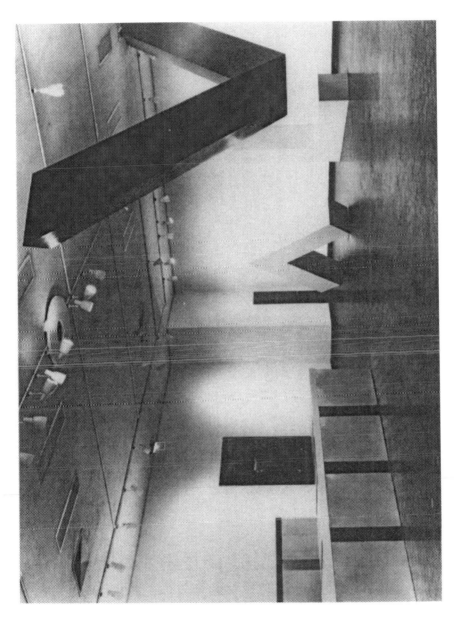

Plate 59. Primary Structures, Installation View, 1966
Works by Judd, Morris, and Grosvenor.
(*Jewish Museum, New York*)

Appendix

Exhibitions and Reviews, 1963–68

All exhibitions held in New York unless location is specified.

1963

New Work, Green Gallery, 8 January–2 February.
> Fried, Michael. "New York Letter." *Art International,* vol. 7, no. 2 (February 1963): 64.
> J[ohnson], J[ill]. "Reviews and Previews." *Art News,* vol. 62, no. 1 (March 1963): 50.
> Tillim, Sidney. "Month in Review." *Arts Magazine,* vol. 37, no. 6 (March 1963): 61–62.

Anne Truitt, André Emmerich Gallery, 12 February–2 March.
> Fried, Michael. "New York Letter." *Art International,* vol. 7, no. 4 (April 1963): 56.
> J[ohnson], J[ill]. "Reviews and Previews." *Art News,* vol. 62, no. 1 (March 1963): 16.
> J[udd], D[onald]. "In the Galleries." *Arts Magazine,* vol. 37, no. 7 (April 1963): 61.

Toward a New Abstraction, Jewish Museum, 19 May–15 September (catalogue).
> Hess, Thomas B. "The Phony Crisis in American Art." *Art News,* vol. 62, no. 4 (Summer 1963): 24–28.
> J[udd], D[onald]. "In the Galleries." *Arts Magazine,* vol. 37, no. 10 (September 1963): 55.
> O'Doherty, Brian. "Abstract Confusion." *New York Times,* 2 June 1963, sec. 2, p. 11.

Robert Morris, Green Gallery, 15 October–2 November.
> J[ohnson], J[ill]. "Reviews and Previews." *Art News,* vol. 62, no. 6 (October 1963): 14–15.
> Rose, Barbara. "New York Letter." *Art International,* vol. 7, no. 9 (December 1963): 63–64.
> T[illim], S[idney]. "In the Galleries." *Arts Magazine,* vol. 38, no. 3 (December 1963): 61–62.

The Hard Center, Thibaut Gallery, 3–28 December.
> C[ampbell], L[awrence]. "Reviews and Previews." *Art News,* vol. 62, no. 9 (January 1964): 10–11.
> Rose, Barbara. "New York Letter." *Art International,* vol. 8, no. 1 (February 1964): 41.

Donald Judd, Green Gallery, 17 December–11 January 1964.
> Fried, Michael. "New York Letter." *Art International,* vol. 8, no. 1 (February 1964): 26.
> Kramer, Hilton. "Art Centers: New York." *Art in America* 3 (1964): 112.
> Lippard, Lucy R. "New York." *Artforum,* vol. 2, no. 9 (March 1964): 18–19.
> Rose, Barbara. "New York Letter." *Art International,* vol. 8, no. 1 (February 1964): 41.
> S[wenson], G. R. "Reviews and Previews." *Art News,* vol. 62, no. 10 (February 1964): 20.
> Tillim, Sidney. "The New Avant-Garde." *Arts Magazine,* vol. 38, no. 5 (February 1964): 20–21.

1964

Robert Mangold, Thibaut Gallery, 4–25 January.
> C[ampbell], L[awrence]. "Reviews and Previews." *Art News,* vol. 62, no. 9 (January 1964): 19.
> Fried, Michael. "New York Letter." *Art International,* vol. 8, no. 3 (April 1964): 58.
> H[arrison], J[ane]. "In the Galleries." *Arts Magazine,* vol. 38, no. 6 (March 1964): 67.
> Lippard, Lucy R. "New York." *Artforum,* vol. 2, no. 9 (March 1964): 19.

Frank Stella, Castelli Gallery, 4 January–6 February.
> Kozloff, Max. "New York Letter." *Art International,* vol. 8, no. 3 (April 1964): 64.
> Lippard, Lucy R. "New York." *Artforum,* vol. 2, no. 9 (March 1964): 19.
> O'Doherty, Brian. "Frank Stella and a Crisis of Nothingness." *New York Times,* 19 January 1964, sec. 2, p. 21.
> S[wenson], G. R. "Reviews and Previews." *Art News,* vol. 62, no. 10 (February 1964): 11.
> Tillim, Sidney. "The New Avant-Garde." *Arts Magazine,* vol. 38, no. 5 (February 1964): 20–21.

Black, White and Gray, Wadsworth Atheneum, Hartford, Conn., 9 January–9 February.
> Judd, Donald. "Black, White and Gray." *Arts Magazine,* vol. 38, no. 6 (March 1964): 36–38.
> Rose, Barbara. "New York Letter." *Art International,* vol. 8, no. 1 (February 1964): 41.
> Wagstaff, Samuel J., Jr. "Paintings to Think About." *Art News,* vol. 62, no. 9 (January 1964): 38.

Dan Flavin, Kaymar Gallery, 5–29 March.
> J[udd], D[onald]. "In the Galleries." *Arts Magazine,* vol. 38, no. 7 (April 1964): 31.
> L[evin], K[im]. "Reviews and Previews." *Art News,* vol. 63, no. 1 (March 1964): 14.
> Lippard, Lucy R. "New York." *Artforum,* vol. 2, no. 11 (May 1964): 54.
> Rose, Barbara. "New York Letter." *Art International,* vol. 8, nos. 5–6 (Summer 1964): 80.

Eleven Artists, Kaymar Gallery, 31 March–14 April.
> J[ohnson], J[ill]. "Reviews and Previews." *Art News,* vol. 63, no. 3 (May 1964): 15.
> O'Doherty, Brian. "Art: Avant-Garde Deadpans on the Move." *New York Times,* 11 April 1964, p. 22.

Post Painterly Abstraction, Los Angeles County Museum of Art, 23 April–7 June (catalogue).
> Coplans, John. "Post-Painterly Abstraction." *Artforum,* vol. 2, no. 12 (Summer 1964): 4–9.
> Lynton, Norbert. "London Letter." *Art International,* vol. 9, no. 6 (September 1965): 49.

Dan Flavin, Green Gallery, 18 November–12 December.
> G[rossberg], J[acob]. "In the Galleries." *Arts Magazine,* vol. 39, no. 4 (January 1965): 54.
> J[ohnson], J[ill]. "Reviews and Previews." *Art News,* vol. 63, no. 9 (January 1965): 13.
> Lippard, Lucy R. "New York Letter." *Art International,* vol. 9, no. 1 (February 1965): 37.

Robert Morris, Green Gallery, December.
> B[errigan], T[ed]. "Reviews and Previews." *Art News,* vol. 63, no. 10 (February 1965): 13.
> J[udd], D[onald]. "In the Galleries." *Arts Magazine,* vol. 39, no. 5 (February 1965): 54.
> Lippard, Lucy R. "New York Letter." *Art International,* vol. 9, no. 2 (March 1965): 46.
> Rose, Barbara. "Looking at American Sculpture." *Artforum,* vol. 3, no. 5 (February 1965): 35–36.

1965

Shape and Structure, Tibor de Nagy Gallery, 5–23 January.
> L[evin], K[im]. "Reviews and Previews." *Art News,* vol. 63, no. 10 (February 1965): 16.
> Lippard, Lucy R. "New York Letter." *Art International,* vol. 9, no. 2 (March 1965): 46.

Rose, Barbara. "Looking at American Sculpture." *Artforum*, vol. 3, no. 5 (February 1965): 34–35.

Kenneth Noland, Jewish Museum, 4 February–7 March (catalogue).

C[ampbell], L[awrence]. "Reviews and Previews." *Art News*, vol. 64, no. 1 (March 1965): 12.

J[udd], D[onald]. "In the Galleries." *Arts Magazine*, vol. 39, no. 6 (March 1965): 54–55.

Judd, Donald. "New York Letter." *Art International*, vol. 9, no. 3 (April 1965): 74.

The Responsive Eye, Museum of Modern Art, 25 February–25 April (catalogue).

Hess, Thomas B. "You Can Hang It in the Hall." *Art News*, vol. 64, no. 2 (April 1965): 41–43.

Krauss, Rosalind. "Afterthoughts on Op." *Art International*, vol. 9, no. 5 (June 1965): 75–76.

Rose, Barbara. "Beyond Vertigo: Optical Art at the Modern." *Artforum*, vol. 3, no. 7 (April 1965): 30–33.

Tillim, Sidney. "Optical Art: Pending or Ending?" *Arts Magazine*, vol. 39, no. 4 (January 1965): 16–25.

Carl Andre, Tibor de Nagy Gallery, 20 April–8 May.

B[errigan], T[ed]. "Reviews and Previews." *Art News*, vol. 64, no. 4 (Summer 1965): 21.

G[rossberg], J[acob]. "In the Galleries." *Arts Magazine*, vol. 39, no. 10 (September–October 1965): 72.

Lippard, Lucy R. "New York Letter." *Art International*, vol. 9, no. 6 (September 1965): 58–59.

Sol LeWitt, John Daniels Gallery, 4–29 May.

H[oene], A[nne]. "In the Galleries." *Arts Magazine*, vol. 39, no. 10 (September–October 1965): 63–64.

J[ohnson], J[ill]. "Reviews and Previews." *Art News*, vol. 64, no. 3 (May 1965): 18.

Lippard, Lucy R. "New York Letter." *Art International*, vol. 9, no. 6 (September 1965): 58.

John McCracken, Nicholas Wilder Gallery, Los Angeles, 1 June–2 July.

Coplans, John. "John McCracken." *Art News*, vol. 64, no. 8 (December 1965): 61–62.

Wurdeman, Helen. "A Stroll on La Cienega." *Art in America*, vol. 53, no. 5 (October–November 1965): 117.

VIII São Paulo Biennial, Brazil, 4 September–28 November (Washington, D.C., 27 January–6 March 1966) (catalogue).

Baker, Elizabeth C. "Brazilian Bouillabaisse." *Art News*, vol. 64, no. 8 (December 1965): 30–31.

Hopps, Walter. "United States Exhibit, São Paulo Bienal." *Art in America*, vol. 53, no. 5 (October–November 1965): 82.

Hudson, Andrew. "Letter from Washington." *Art International*, vol. 10, no. 6 (Summer 1966): 130–31.

Special Section. *Artforum*, vol. 3, no. 9 (June 1965): 19–38.

Robert Mangold, Fischbach Gallery, 12–30 October.

Benedikt, Michael. "New York Letter." *Art International*, vol. 9, nos. 9–10 (December 1965): 41.

B[erkson], W[illiam]. "In the Galleries." *Arts Magazine*, vol. 40, no. 2 (December 1965): 65–66.

Larry Bell, Pace Gallery, 6 November–6 December.

B[ochner], M[el]. "In the Galleries." *Arts Magazine*, vol. 40, no. 3 (January 1966): 54.

Glueck, Grace. "New York Gallery Notes." *Art in America*, vol. 53, no. 6 (December 1965–January 1966): 121.

Lippard, Lucy R. "New York Letter: Recent Sculpture as Escape." *Art International*, vol.

10, no. 2 (February 1966): 52.

"Reviews and Previews." *Art News,* vol. 64, no. 7 (November 1965): 12.

1966

Donald Judd, Castelli Gallery, 5 February–2 March.

Ashton, Dore. "The Artist as Dissenter." *Studio International,* vol. 171, no. 876 (April 1966): 165.

B[ochner], M[el]. "In the Galleries." *Arts Magazine,* vol. 40, no. 6 (April 1966): 57.

G[ollin], J[ane]. "Reviews and Previews." *Art News,* vol. 65, no. 2 (April 1965): 17.

Kramer, Hilton. "Constructed to Donald Judd's Specifications." *New York Times,* 19 February 1966, p. 23.

Krauss, Rosalind. "Allusion and Illusion in Donald Judd." *Artforum,* vol. 4, no. 9 (May 1966): 24–26.

Lippard, Lucy R. "New York Letter: Off Color." *Art International,* vol. 10, no. 4 (April 1966): 73.

Mellow, James R. "New York Letter." *Art International,* vol. 10, no. 4 (April 1966): 89.

Mellow, James R. "On Art: Hostage to the Gallery." *New Leader,* 14 March 1966, pp. 32–33.

Robert Morris, Dwan Gallery, Los Angeles, 15 March–1 April.

Antin, David. "Art & Information, 1: Grey Paint, Robert Morris." *Art News,* vol. 65, no. 2 (April 1966): 23–24.

F[actor], D[on]. "Los Angeles." *Artforum,* vol. 4, no. 9 (May 1966): 13.

von Meier, Kurt. "Los Angeles Letter." *Art International,* vol. 10, no. 5 (May 1966): 13.

Carl Andre, Tibor de Nagy Gallery, 29 March–16 April.

B[urton], S[cott]. "Reviews and Previews." *Art News,* vol. 65, no. 3 (May 1966): 14.

Lippard, Lucy R. "Rejective Art." *Art International,* vol. 10, no. 8 (October 1966): 35.

Sol LeWitt, Dwan Gallery, 1–29 April.

B[errigan], T[ed]. "Reviews and Previews." *Art News,* vol. 65, no. 4 (Summer 1966): 13.

B[ochner], M[el]. "In the Galleries." *Arts Magazine,* vol. 40, no. 9 (September–October 1966): 61.

Lippard, Lucy R. "Rejective Art." *Art International,* vol. 10, no. 8 (October 1966): 33–34.

Primary Structures, Jewish Museum, 27 April–12 June (catalogue).

A[shbery], J[ohn]. "Young Masters of Understatement." *Art News,* vol. 65, no. 3 (May 1966): 42.

Ashton, Dore. "The 'Anti-Compositional Attitude' in Sculpture." *Studio International,* vol. 172, no. 879 (July 1966): 44–45.

Bochner, M[el]. "Primary Structures." *Arts Magazine,* vol. 40, no. 8 (June 1966): 32–35.

Glueck, Grace. "ABC to Erotic." *Art in America,* vol. 54, no. 5 (September–October 1966): 105.

Glueck, Grace. "Anti-Collector, Anti-Museum." *New York Times,* 24 April 1966, sec. 2, p. 24.

Kramer, Hilton. "Art: Reshaping the Outermost Limits." *New York Times,* 28 April 1966, p. 48.

Kramer, Hilton. "'Primary Structures'—The New Anonymity." *New York Times,* 1 May 1966, sec. 2, p. 23.

Robins, Corinne. "Object, Structure or Sculpture: Where Are We?" *Arts Magazine,* vol. 40, no. 9 (September–October 1966): 33–37.

Art in Process, Finch College, 11 May–30 June (catalogue).

Bochner, M[el]. "Art in Process—Structures." *Arts Magazine,* vol. 40, no. 9 (September–October 1966): 38–39.

Kramer, Hilton. "An Art of Boredom?" *New York Times,* 5 June 1966, sec. 2, p. 23.

Lippard, Lucy R. "Rejective Art." *Art International,* vol. 10, no. 8 (October 1966): 33–36.

Systemic Painting, Solomon R. Guggenheim Museum, 21 September–27 November (catalogue).

Alloway, Lawrence. "Background to Systemic." *Art News,* vol. 65, no. 6 (October 1966): 30–33.

Ashton, Dore. "Marketing Techniques in the Promotion of Art." *Studio International,* vol. 172, no. 883 (November 1966): 270–72.

Bochner, M[el]. "Systemic." *Arts Magazine,* vol. 41, no. 1 (November 1966): 40.

Kramer, Hilton. "'Systemic Painting': An Art for Critics." *New York Times,* 18 September 1966, sec. 2, p. 33.

Mellow, James R. "New York Letter." *Art International,* vol. 10, no. 9 (November 1966): 58–59.

Pincus-Witten, Robert. "'Systemic' Painting." *Artforum,* vol. 5, no. 3 (November 1966): 42–45.

"10," Dwan Gallery, 4–29 October (catalogue).

Benedikt, Michael. "New York Letter." *Art International,* vol. 10, no. 10 (December 1966): 65.

Glueck, Grace. "ABC to Erotic." *Art in America,* vol. 54, no. 5 (September–October 1966): 105.

Michelson, Annette. "10 x 10: 'Concrete Reasonableness.'" *Artforum,* vol. 5, no. 5 (January 1967): 30–31.

Robert Smithson, Dwan Gallery, 1 December–31 January 1967.

Ashton, Dore. "The Symbol Lurking in the Wings." *Studio International,* vol. 173, no. 886 (February 1967): 100–101.

B[urton], S[cott]. "Reviews and Previews." *Art News,* vol. 65, no. 9 (January 1967): 18.

Mellow, James R. "New York Letter." *Art International,* vol. 11, no. 2 (February 1967): 66.

Pincus-Witten, Robert. "New York." *Artforum,* vol. 5, no. 6 (February 1967): 61.

S[iegel], J[eanne]. "In the Galleries." *Arts Magazine,* vol. 41, no. 3 (December 1966–January 1967): 61. See also "Letters." *Arts Magazine,* vol. 41, no. 4 (February 1967): 8.

Ad Reinhardt, Jewish Museum, 23 November–15 January 1967 (catalogue).

Ashton, Dore. "The Symbol Lurking in the Wings." *Studio International,* vol. 173, no. 886 (February 1967): 98–100.

Benedikt, Michael. "New York." *Art International,* vol. 11, no. 4 (April 1967): 64.

Kramer, Hilton. "Ad Reinhardt's Black Humor." *New York Times,* 27 November 1966, sec. 2, p. 17.

McShine, Kynaston. "More Than Black." *Arts Magazine,* vol. 41, no. 3 (December 1966–January 1967): 49–50.

Rosenstein, Harris. "Black Pastures." *Art News,* vol. 65, no. 7 (November 1966): 33–35.

Annual Exhibition 1966: Sculpture and Prints, Whitney Museum of American Art, 16 December–5 February 1967 (catalogue).

Adrian, Dennis. "New York." *Artforum,* vol. 5, no. 7 (March 1967): 55–56.

Benedikt, Michael. "New York: Notes on the Whitney Annual." *Art International,* vol. 11, no. 2 (February 1967): 56–60.

S[iple], M[olly]. "In the Galleries." *Arts Magazine,* vol. 41, no. 4 (February 1967): 54.

1967

Scale Models and Drawings, Dwan Gallery, 7 January–1 February.

Graham, Dan. "A Minimal Future? Models & Monuments." *Arts Magazine,* vol. 41, no. 5 (March 1967): 32–34.

S[loane], P[atricia]. "In the Galleries." *Arts Magazine,* vol. 41, no. 4 (February 1967): 57.
Carl Andre, Dwan Gallery, Los Angeles, 8 March–1 April.
 Livingston, Jane. "Los Angeles." *Artforum,* vol. 5, no. 9 (May 1967): 62–63.
 von Meier, Kurt. "Los Angeles." *Art International,* vol. 11, no. 4 (April 1967): 51–52.
American Sculpture of the Sixties, Los Angeles County Museum of Art, 28 April–25 June (catalogue).
 Danieli, Fidel A. "Los Angeles." *Studio International,* vol. 173, no. 890 (June 1967): 320–21.
 Kramer, Hilton. "A Nostalgia for the Future." *New York Times,* 7 May 1967, sec. 2, p. 25.
 Kramer, Hilton. "Sculpture: A Stunning Display of Radical Changes." *New York Times,* 28 April 1967, p. 38.
 Leider, Philip. "American Sculpture of the Sixties." *Artforum,* vol. 5, no. 10 (June 1967): 6–11.
 Tuten, Frederic. "'American Sculpture of the Sixties.'" *Arts Magazine,* vol. 41, no. 7 (May 1967): 40–41.
 von Meier, Kurt. "Los Angeles: American Sculpture of the Sixties." *Art International,* vol. 11, no. 6 (Summer 1967): 64–68.
 Weschler, Judith. "Why Scale?" *Art News,* vol. 66, no. 4 (Summer 1967): 32–35.
A New Aesthetic, Washington Gallery of Modern Art, Washington, D.C., 6 May–25 June (catalogue).
Sol LeWitt, Dwan Gallery, Los Angeles, 10 May–4 June.
Dan Flavin, Kornblee Gallery, 7 October–8 November.
 Mellow, James R. "New York Letter." *Art International,* vol. 11, no. 10 (Christmas 1967): 74.
 Wasserman, Emily. "New York." *Artforum,* vol. 6, no. 4 (December 1967): 59.
Scale as Content, Corcoran Gallery, Washington, D.C., 1–30 November.
 Hudson, Andrew. "Scale as Content." *Artforum,* vol. 6, no. 4 (December 1967): 40–47.
 Lippard, Lucy R. "Escalation in Washington." *Art International,* vol. 12, no. 1 (January 1968): 42–46.
Art in Series, Finch College, 21 November–6 January 1968.
 Lee, David. "Serial Rights." *Art News,* vol. 66, no. 8 (December 1967): 42–45.
 Mellow, James R. "New York Letter." *Art International,* vol. 12, no. 2 (February 1968): 73.

1968

Tony Smith, Fischbach Gallery, 27 January–22 February.
 B[urton], S[cott]. "Reviews and Previews." *Art News,* vol. 66, no. 10 (February 1968): 17.
 G[iuliano], C[harles]. "In the Galleries." *Arts Magazine,* vol. 42, no. 5 (March 1968): 56.
 Glueck, Grace. "Tony Smith Displays Some Departures." *New York Times,* 19 February 1968, p. 28.
 Mellow, James R. "New York Letter." *Art International,* vol. 12, no. 3 (March 1968): 60.
 Wasserman, Emily. "New York." *Artforum,* vol. 6, no. 8 (April 1968): 59–61.
Donald Judd, Whitney Museum of American Art, 27 February–14 April (catalogue).
 Baker, Elizabeth C. "Judd the Obscure." *Art News,* vol. 67, no. 2 (April 1968): 44–45.
 Cone, Jane Harrison. "Judd at the Whitney." *Artforum,* vol. 6, no. 9 (May 1968): 36–39.
 Glueck, Grace. "A Box Is a Box Is a Box." *New York Times,* 10 March 1968, sec. D, p. 23.
 Gold, Barbara. "Artist Seeks Validity in Boxes." *The Baltimore Sun,* 3 March 1968, sec. D, pp. 1–3.
 Mellow, James R. "'Everything Sculpture Has, My Work Doesn't.'" *New York Times,* 10 March 1968, sec. 2, pp. 21, 26.

Perreault, John. "Plastic Ambiguities." *Village Voice,* 7 March 1968, pp. 19–20.

Minimal Art, Gemeentemuseum, The Hague, 23 March–26 May (catalogue).

Blok, C. "Minimal Art at The Hague." *Art International,* vol. 12, no. 5 (May 1968): 18–24.

F[eldman], A[nita]. "In the Museums." *Arts Magazine,* vol. 42, no. 8 (June 1968): 57.

Piene, Nan R. "How to Stay Home and Help the Balance of Payments." *Art in America,* vol. 56, no. 3 (May–June 1968): 109.

The Art of the Real: USA 1948–1968, Museum of Modern Art, 3 July–8 September (catalogue).

Ashton, Dore. "New York Commentary." *Studio International,* vol. 175, no. 903 (September 1968): 92–93.

Battcock, Gregory. "The Art of the Real." *Arts Magazine,* vol. 42, no. 8 (June 1968): 44–47.

Leider, Philip. "New York." *Artforum,* vol. 7, no. 1 (September 1968): 65.

Mellow, James R. "New York Letter." *Art International,* vol. 12, no. 8 (October 1968): 60–61.

Melville, Robert. "Minimalism." *Architectural Review,* vol. 146, no. 870 (August 1969): 146–48.

Notes

Introduction

1. Peter Plagens, "Present-Day Styles and Ready-Made Criticism," *Artforum*, vol. 5, no. 4 (December 1966): 37.

2. D[onald] J[udd], "In the Galleries," *Arts Magazine*, vol. 37, no. 7 (April 1963): 61; and Michael Fried, "New York Letter," *Art International*, vol. 7, no. 4 (April 1963): 56.

3. For a history of the Green Gallery, see Amy Goldin, "Requiem for a Gallery," *Arts Magazine*, vol. 40, no. 3 (January 1966): 25–28.

4. This exhibition ran from 9 January to 9 February 1964, and included Morris, Truitt, James Byars, Ad Reinhardt, Barnett Newman, Dan Flavin, Stella, George Brecht, Jim Dine, Andy Warhol, Robert Indiana, Roy Lichtenstein, and Jasper Johns. Tony Smith's sculptures were seen here for the first time.

5. Interview with Sol LeWitt, New York City, 15 November 1980.

6. Alloway had originally planned to show two- and three-dimensional work, but after Primary Structures, the sculpture section was dropped. Lawrence Alloway, *Systemic Painting* (New York: Solomon R. Guggenheim Museum, 1966), p. 21n.8.

7. See Klauss Kertess's recollections of this period. He opened the Bykert Gallery with Marden's show the same night as Alloway's opened at the Guggenheim. P.S. 1, The Institute for Art and Urban Resources, "Openings," *Abstract Painting: 1960–69* (Long Island City: P.S. 1, 1983), n.p.

8. Rose and her husband, Frank Stella, had been invited to teach at the University of California, Irvine, in 1967. See Barbara Rose, "Remembering 1967," in Janet Kardon, *1967: At the Crossroads* (Philadelphia: Institute of Contemporary Art, University of Pennsylvania, 1987), pp. 32–33.

9. The most insightful article is C. Blok, "Minimal Art at The Hague," *Art International*, vol. 12, no. 5 (May 1968): 18–24. Andre, Ronald Bladen, Flavin, Robert Grosvenor, Judd, LeWitt, Morris, Tony Smith, Smithson, and Steiner participated.

10. In New York, The Art of the Real: USA 1948–1968 at the Museum of Modern Art, functioned similarly.

11. See Hal Foster, "The Crux of Minimalism," in Howard Singerman, ed., *Individuals: A Selected History of Contemporary Art 1945–1986* (Los Angeles: Museum of Contempo-

rary Art, 1986), pp. 162–83; and Hal Foster, "1967/1987," in Janet Kardon, *1967: At the Crossroads* (Philadelphia: Institute of Contemporary Art, University of Pennsylvania, 1987), pp. 14–21.

12. Kim Levin, "Farewell to Modernism," *Arts Magazine*, vol. 54, no. 2 (October 1979): 91.

13. Irving Sandler, "John D. Graham: The Painter as Esthetician and Connoisseur," *Artforum*, vol. 7, no. 2 (October 1968): 51–52.

14. Richard Wollheim, "Minimal Art," *Arts Magazine*, vol. 39, no. 4 (January 1965): 26–32. Reprinted in Gregory Battcock, ed., *Minimal Art: A Critical Anthology* (New York: E.P. Dutton, 1968), pp. 387–99. In conversation with the author, Wollheim mentioned that his essay was inspired by a lecture by Adrian Stokes.

15. D[onald] J[udd], "In the Galleries," *Arts*, vol. 34, no. 8 (May 1960): 60; Donald Judd, "Black, White and Gray," *Arts Magazine*, vol. 38, no. 6 (March 1964): 38; and D[onald] J[udd], "In the Galleries," *Arts Magazine*, vol. 39, no. 5 (February 1965): 54. Sidney Tillim referred to Stella's "pictorial parts" as minimal. Sidney Tillim, "The New Avant-Garde," *Arts Magazine*, vol. 38, no. 5 (February 1964): 21.

16. Hilton Kramer, "An Art of Boredom?" *New York Times*, 5 June 1966, sec. 2, p. 23; and Corinne Robins, "Object, Structure or Sculpture: Where Are We?" *Arts Magazine*, vol. 40, no. 9 (September-October 1966): 33.

17. John Perreault, "Plastic Ambiguities," *Village Voice*, 7 March 1968, p. 19.

18. Robert Morris, "Anti Form," *Artforum*, vol. 6, no. 8 (April 1968): 34.

19. John Perreault, "A Minimal Future? Union-Made," *Arts Magazine*, vol. 41, no. 5 (March 1967): 30.

20. Interview with Donald Judd, Marfa, Texas, 2–3 December 1980. Judd and Smithson organized meetings to protest the Guggenheim Museum's cancellation of Hans Haacke's controversial exhibition in 1971, and to encourage artists to be more responsible for the marketing of their work but, according to Judd, the meetings were somewhat of a failure.

21. David Novros, letter to the author, 21 January 1989.

22. Lil Picard, "Hung Up on Hang Outs," *Arts Magazine*, vol. 41, no. 3 (December 1966–January 1967): 17.

23. Bruce Kurtz, "Last Call at Max's," *Artforum*, vol. 19, no. 8 (April 1981): 27–28.

24. From discussions with the artists. Critic Craig Owens believes that the proliferation of the written discourse of Minimalism essentially usurped the works of art. Craig Owens, "Earthwords," *October* 10 (Fall 1979): 121–30.

25. Philip Leider, "Literalism and Abstraction: Frank Stella's Retrospective at the Modern," *Artforum*, vol. 8, no. 8 (April 1970): 47.

26. Barbara Rose, *American Painting: The Eighties* (New York: Vista Press, 1979), n.p.

27. Mel Bochner informed me of this last designation. The reference is, of course, to the deadpan Sergeant Friday of the popular television show "Dragnet."

28. See the process/product distinction as outlined by John Hospers, "The Concept of Artistic Expression," in John Hospers, ed., *Introductory Readings in Aesthetics* (New York: Free Press, 1969): pp. 142–66.

Chapter 1

1. Barbara Rose and Irving Sandler, "Sensibility of the Sixties," *Art in America*, vol. 55, no. 1 (January–February 1967): 54.

2. Jack Burnham, *Beyond Modern Sculpture* (New York: George Braziller, 1968), p. 96.

3. Interview with Anne Truitt, Washington, D.C., 21 November 1980.

4. Clement Greenberg, "After Abstract Expressionism," *Art International*, vol. 6, no. 8 (October 1962): 30.

5. Clement Greenberg, "Recentness of Sculpture," in Maurice Tuchman, ed., *American Sculpture of the Sixties* (Los Angeles: Los Angeles County Museum of Art, 1967), p. 25.

6. Interview with Clement Greenberg, New York City, 11 November 1980. Regardless of Greenberg's distinction, Minimal art remains highly conceptual. The implication is that ideation takes place over and above conception.

7. James K. Monte, *Mark di Suvero* (New York: Whitney Museum of American Art, 1975), p. 16.

8. Letter to the author, 3 March 1989.

9. Barbara Rose disagrees. "In place of the anonymity sought by the Constructivists, makers of specific objects emphasize the personal and the idiosyncratic element of their art." Barbara Rose, *A New Aesthetic* (Washington, D.C.: Washington Gallery of Modern Art, 1967), p. 14. She is fairly unsupported in this opinion.

10. Rosalind E. Krauss, *Passages in Modern Sculpture* (New York: Viking Press, 1977), p. 250.

11. John Coplans, "Don Judd: An Interview with John Coplans," *Don Judd* (Pasadena, Calif.: Pasadena Art Museum, 1971), pp. 15, 32–36. The dates in this interview are confused. According to the catalogue raisonné, Brydon Smith, *Donald Judd* (Ottawa: National Gallery of Canada, 1975), the first piece was made in 1964, not April of 1963. The Tibor de Nagy show, Shape and Structure, opened in January 1965, not 1964, although the work shown there was made in July of 1964. In Donald Judd, "Complaints: Part II," *Arts Magazine*, vol. 47, no. 5 (March 1973): 31, Judd noted that there were sixty-four mistakes in the Coplans catalogue.

12. Rosalind Krauss, "Allusion and Illusion in Donald Judd," *Artforum*, vol. 4, no. 9 (May 1966): 24–26; Elizabeth C. Baker, "Judd the Obscure," *Art News*, vol. 67, no. 2 (April 1968): 44; Jane Harrison Cone, "Judd at the Whitney," *Artforum*, vol. 6, no. 9 (May 1968): 36. These three are especially perceptive analyses of Judd in the 1960s.

13. Interview with Donald Judd, Marfa, Texas, 2–3 December 1980; and Roberta Smith, "Donald Judd," in Brydon Smith, *Donald Judd*, p. 27. Judd makes "editions" of the small progressions only for mercenary reasons. "Without money I can't make sculpture," he told John Coplans, "Don Judd: An Interview with John Coplans," in *Don Judd*, p. 37.

14. Donald Judd, "Specific Objects," *Arts Yearbook* 8 (New York: Art Digest, 1965), p. 80. The parallel to Brancusi, who also used different material in the same form, has been remarked upon by Agee in William C. Agee, *The Sculpture of Donald Judd* (Corpus Christi: Art Museum of South Texas, 1977), p. 18; and William C. Agee, "Unit, Series, Site: A Judd Lexicon," *Art in America*, vol. 63, no. 3 (May–June 1975): 47.

15. Interview with Truitt; and letter to the author, 24 March 1989.

16. Lucy R. Lippard, *Tony Smith* (New York: Abrams, 1972), pp. 9, 23.

17. Robert Rosenblum, "Notes on Sol LeWitt," in Alicia Legg, ed., *Sol LeWitt* (New York: Museum of Modern Art, 1978), p. 18.

18. Lucy R. Lippard, "New York Letter: April–June 1965," *Art International*, vol. 9, no. 6 (September 1965): 58.

19. Alicia Legg, ed., *Sol LeWitt*, p. 53. Notation by LeWitt.

20. Sol LeWitt, "Paragraphs on Conceptual Art," *Artforum*, vol. 5, no. 10 (June 1967): 83.

21. Krauss, "Allusion and Illusion in Donald Judd," p. 25.

22. Barbara Rose, "New York Letter," *Art International*, vol. 7, no. 9 (December 1963): 63; S[idney] T[illim], "New York Exhibitions: In the Galleries," *Arts Magazine*, vol. 38, no. 3 (December 1963): 62; Lucy R. Lippard, "New York Letter," *Art International*, vol. 9, no. 4 (May 1965): 57; and W[illiam] B[erkson], "In the Galleries," *Arts Magazine*, vol. 39, no. 9 (May–June 1965): 58.

23. William Wilson, "Hard Questions and Soft Answers," *Art News*, vol. 68, no. 7 (November 1969): 27.

24. Critics continue to attempt reconciliation of Morris's disparate objects and styles. "Death's concreteness was his art's implicit subject matter from the start," writes Donald Kuspit. "Morris's Minimalist objects are the simple material forms of death, preparing for the process works using waste and smoke." Donald B. Kuspit, "The *Ars Moriendi* according to Robert Morris," *Robert Morris: Works of the Eighties* (Newport Beach, Calif.: Newport Harbor Art Museum, 1985), p. 13.

25. Interview with Judd. The only reference Judd made in print to Morris's Dada interests was in Donald Judd, "Complaints: Part I," *Studio International*, vol. 177, no. 910 (April 1969): 184.

26. The use of "specific, sensuous material" disunifies the object. Robert Morris, "Notes on Sculpture, Part 2," *Artforum*, vol. 5, no. 2 (October 1966): 21. Reprinted in Gregory Battcock, ed., *Minimal Art: A Critical Anthology* (New York: E.P. Dutton, 1968), pp. 228–35.

27. Robert Morris, "Notes on Sculpture, Part 3: Notes and Nonsequiturs," *Artforum*, vol. 5, no. 10 (June 1967): 25–26. This seems in response to Judd's (and others') elegantly refined objects.

28. David Antin, "Art & Information, 1: Grey Paint, Robert Morris," *Art News*, vol. 65, no. 2 (April 1966): 24.

29. Martin Friedman, "The Theorists: Judd and Morris," in *14 Sculptors: The Industrial Edge* (Minneapolis: Walker Art Center, 1969), p. 13.

30. Robert Morris, "Notes on Sculpture [Part 1]," *Artforum*, vol. 4, no. 6 (February 1966): 42–44, reprinted in Gregory Battcock, ed., *Minimal Art: A Critical Anthology*, pp. 222–28.; Morris, "Notes on Sculpture, Part 2," pp. 20–23; Morris, "Notes on Sculpture, Part 3," pp. 24–29; and Robert Morris, "Notes on Sculpture, Part 4: Beyond Objects," *Artforum*, vol. 7, no. 8 (April 1969): 50–54.

31. Lucy R. Lippard, "New York," *Artforum*, vol. 2, no. 11 (May 1964): 54; Lucy R. Lippard, "New York Letter," *Art International*, vol. 9, no. 1 (February 1965): 37; and Lucy R. Lippard, "New York Letter: Off Color," *Art International*, vol. 10, no. 4 (April 1966): 74.

32. Philip Leider, "The Flavin Case," *New York Times,* 24 November 1968, sec. 2, p. 27.

33. Barbara Rose, "New York Letter," *Art International,* vol. 8, nos. 5–6 (Summer 1964): 80.

34. Elizabeth C. Baker, "The Light Brigade," *Art News,* vol. 66, no. 1 (March 1967): 54; and Dan Flavin, "Some Other Comments . . . More Pages from a Spleenish Journal," *Artforum,* vol. 6, no. 4 (December 1967): 21.

35. Dan Flavin, ". . . In Daylight or Cool White," *Artforum,* vol. 4, no. 4 (December 1965): 22.

36. Russian Constructivism, which exploited the demonstrational possibilities of materials, is equally significant. Flavin's early recognition of Russian avant-garde art, which was not widely known in the early sixties, impressed Judd (interview with Judd) and Stella. Maurice Tuchman, "The Russian Avant-Garde and the Contemporary Artist," in Stephanie Barron and Maurice Tuchman, eds., *The Avant-Garde in Russia, 1910–1930: New Perspectives* (Los Angeles: Los Angeles County Museum of Art, 1980), p. 120.

37. Judd, "Specific Objects," p. 80.

38. Lippard, "New York Letter: April–June 1965," p. 58; and Jane Livingston, "Los Angeles," *Artforum,* vol. 5, no. 9 (May 1967): 62.

39. Lippard, "New York Letter: April–June 1965," p. 58.

40. See David Bourdon, "The Razed Sites of Carl Andre," *Artforum,* vol. 5, no. 2 (October 1966): 17. Reprinted in Gregory Battcock, ed., *Minimal Art: A Critical Anthology,* pp. 103–8; and Andre's criticism in Phyllis Tuchman, "An Interview with Carl Andre," *Artforum,* vol. 8, no. 10 (June 1970): 61.

41. David Bourdon, *Carl Andre: Sculpture 1959–1977* (New York: Jaap Rietman, 1978), p. 27.

42. P. Tuchman, "Interview with Carl Andre," pp. 57–61.

43. Interview with Carl Andre, New York City, 4 November 1980; and letter to the author, 24 March 1989.

44. Kurt von Meier, "Los Angeles," *Art International,* vol. 11, no. 4 (April 1967): 51.

45. Clair Wolfe, "Notes on Craig Kauffman," *Artforum,* vol. 3, no. 5 (February 1965): 21; and Carol Lindsley, "Plastics into Art," *Art in America,* vol. 56, no. 3 (May–June 1968): 114.

46. Peter Plagens, *Sunshine Muse* (New York: Praeger Publishers, 1974), pp. 120–22.

47. Jane Livingston, "Los Angeles," *Artforum,* vol. 6, no. 4 (December 1967): 62.

48. John Coplans, "5 Los Angeles Sculptors at Irvine," *Artforum,* vol. 4, no. 6 (February 1966): 33. He is supported by Rose, in *A New Aesthetic,* p. 14.

49. Lindsley, "Plastics into Art," p. 115.

50. E. C. Goossen, "The Artist Speaks: Robert Morris," *Art in America,* vol. 58, no. 3 (May–June 1970): 108.

51. Albert Elsen, letter to Leo Steinberg, 21 August 1969, quoted in Leo Steinberg, "Rodin," in *Other Criteria: Confrontations with Twentieth-Century Art* (London: Oxford University Press, 1972), p. 330. On the issue of Rodin's originality, see Rosalind Krauss, "The Originality of the Avant-Garde," in *The Originality of the Avant-Garde and Other Modernist Myths* (Cambridge, Mass.: MIT Press, 1985), pp. 151–70.

52. Hilton Kramer, "Constructing the Absolute," *Arts,* vol. 34, no. 8 (May 1960): 42.

53. Samuel J. Wagstaff, Jr., "Paintings to Think About," *Art News,* vol. 62, no. 9 (January 1964): 62.

54. Kramer declared that anonymity was the result of fabrication in "'Primary Structures'— The New Anonymity," *New York Times,* 1 May 1966, sec. 2, p. 23. On the other hand, Amy Goldin, "Art in a Hairshirt," *Art News,* vol. 65, no. 10 (February 1967): 67, claimed Minimal artists embraced "technical professionalism" to avoid dealing with "public expectations of meaning and feeling." Kynaston McShine also felt that impersonality was a goal for the sculptors. Kynaston McShine, *Primary Structures* (New York: Jewish Museum, 1966), n.p. This may be the case for minor or semi-Minimalist sculptors, but does not apply to Judd, Morris, et al., though Judd claimed to intentionally downplay "the handicraft aspect." Coplans, "Don Judd: An Interview with John Coplans," in *Don Judd,* p. 37.

55. Coplans, "Don Judd: An Interview with John Coplans," in *Don Judd,* p. 37.

56. Interview with Robert Murray, New York City, 18 November 1980.

57. Barbara Rose, "An Interview with Robert Murray, " *Artforum,* vol. 5, no. 2 (October 1966): 45.

58. Letter to the author, 28 March 1989.

59. Interview with Truitt. See also Anne Truitt, *Daybook: The Journal of an Artist* (New York: Pantheon Books, 1982), pp. 150–53.

60. Coplans, "Don Judd: An Interview with John Coplans," in *Don Judd,* pp. 32–36.

61. See Barbara Rose, "Blowup—The Problem of Scale in Sculpture," *Art in America,* vol. 56, no. 4 (July–August 1968): 80–91.

62. Hugh Marlais Davies, "Interview with Donald Lippincott," *Artist & Fabricator* (Amherst: Fine Arts Gallery, University of Massachusetts, 1975), p. 40.

63. Rose, "An Interview with Robert Murray," p. 45.

64. Morris, "Notes on Sculpture, Part 3," p. 26.

65. Hilton Kramer, "Art: Reshaping the Outermost Limits," *New York Times,* 28 April 1966, p. 48.

66. Robert Pincus-Witten, "Sol LeWitt: Word Object," *Artforum,* vol. 11, no. 6 (February 1973): 72; Lucy R. Lippard, "The Structures, the Structures and the Wall Drawings, the Structures and the Wall Drawings and the Books," in Legg, ed., *Sol LeWitt,* p. 23.

67. Interview with Murray.

68. Donald Judd, "Statement," *Art Now: New York* (January 1969), reprinted in Donald Judd, *Complete Writings 1959–1975* (Halifax: Press of the Nova Scotia College of Art and Design, 1975), pp. 196–97.

69. Jack Burnham, "Robert Morris: Retrospective in Detroit," *Artforum,* vol. 8, no. 7 (March 1970): 69.

70. Morris, "Notes on Sculpture, Part 3," p. 26.

71. Interview with Sol LeWitt, New York City, 15 November 1980; Interviews with Truitt and Murray, and Murray's letter to the author, 28 March 1989.

72. Lucy R. Lippard, "New York Letter," *Art International*, vol. 10, no. 6 (Summer 1966): 114.

73. Corinne Robins, "Four Directions at Park Place," *Arts Magazine*, vol. 40, no. 8 (June 1966): 24.

74. Barbara Rose, "Shall We Have a Renaissance?" *Art in America*, vol. 55, no. 2 (March–April 1967): 32.

75. Frederic Tuten, "'American Sculpture of the Sixties,'" *Arts Magazine*, vol. 41, no. 7 (May 1967): 40–41.

76. Interview with John McCracken, Santa Barbara, Calif., 28 May 1980.

77. John Coplans, "The New Sculpture and Technology," in Maurice Tuchman, ed., *American Sculpture of the Sixties* (Los Angeles: Los Angeles County Museum of Art, 1967), p. 22. For a description of the mirroring process, see Fidel A. Danieli, "Bell's Progress," *Artforum*, vol. 5, no. 10 (June 1967): 69.

78. Max Kozloff, "The Further Adventures of American Sculpture," *Arts Magazine*, vol. 39, no. 5 (February 1965): 26.

79. Barbara Rose, "Looking at American Sculpture," *Artforum*, vol. 3, no. 5 (February 1965): 34.

80. Lippard, "New York Letter" (May 1965), p. 53.

81. Tuten, "American Sculpture of the Sixties," p. 43.

82. Hilton Kramer, "Sculpture: A Stunning Display of Radical Changes," *New York Times*, 28 April 1967, p. 38; and Hilton Kramer, "A Nostalgia for the Future," *New York Times*, 7 May 1967, sec. 2, p. 25.

83. Kramer, "Constructing the Absolute," p. 42.

84. Hilton Kramer, "Art: Constructed to Donald Judd's Specifications," *New York Times*, 19 February 1966, p. 23.

85. Dore Ashton, "The Artist as Dissenter," *Studio International*, vol. 171, no. 876 (April 1966): 165.

86. Dore Ashton, "The 'Anti-Compositional Attitude' in Sculpture," *Studio International*, vol. 172, no. 879 (July 1966): 45.

87. Dore Ashton, "Kant & Cant with Dore Ashton: The Language of Technics," *Arts Magazine*, vol. 41, no. 7 (May 1967): 11.

88. Davies, "Interview with Donald Lippincott," pp. 38–39; Coplans, "Don Judd: An Interview with John Coplans," in *Don Judd*, p. 37.

89. Judd, "Specific Objects," p. 80.

90. John McCracken, statement in Rose, *A New Aesthetic*, p. 57.

91. Corinne Robins, "Object, Structure or Sculpture: Where Are We?" *Arts Magazine*, vol. 40, no. 9 (September–October 1966): 35.

92. M[el] Bochner, "Primary Structures," *Arts Magazine*, vol. 40, no. 8 (June 1966): 33. According to Bochner, Richard Serra engaged in an argument with Morris concerning the identity of the L's. The dispute was settled by picking one of them up—there was

no plywood face on the side intended to rest on the floor. Morris himself has written, "A beam on its end is not the same as the same beam on its side." Morris, "Notes on Sculpture, Part 2," p. 23.

93. Lucy R. Lippard, "As Painting Is to Sculpture: A Changing Ratio," in Maurice Tuchman, ed., *American Sculpture of the Sixties* (Los Angeles: Los Angeles County Museum of Art, 1967), p. 34.

94. Harris Rosenstein, "Total and Complex," *Art News,* vol. 66, no. 3 (May 1967): 53–54. Subsequently, critics questioned Novros's use of any kind of cloth, suggesting in its place plastic and metal. James R. Mellow, "New York," *Art International,* vol. 11, no. 6 (Summer 1967): 52; and P[at] S[loane], "In the Galleries," *Arts Magazine,* vol. 41, no. 7 (May 1967): 57.

95. Lawrence Alloway, *Systemic Painting* (New York: Solomon R. Guggenheim Museum, 1966), p. 19. Nearly all writers who reviewed the show and the catalogue, with the exception of Bochner, were highly critical of the essay and Alloway's omnipotent curatorship. See Hilton Kramer, "'Systemic Painting': An Art for Critics," *New York Times,* 18 September 1966, sec. 2, p. 33; Dore Ashton, "Marketing Techniques in the Promotion of Art," *Studio International,* vol. 172, no. 883 (November 1966): 270–71; and James R. Mellow, "New York Letter," *Art International,* vol. 10, no. 9 (November 1966): 59.

96. Stella's prototypical Black Painting, *Delta* of 1958, originally a red and black painting, was reworked to eliminate "problematic areas," resulting in an all-black painting. This is an example of trial and error monochrome. See William S. Rubin, *Frank Stella* (New York: Museum of Modern Art, 1970), p. 16.

97. Ad Reinhardt, *Art as Art: The Selected Writings of Ad Reinhardt,* ed. Barbara Rose (New York: Viking Press, 1975), p. 205.

98. Lucy R. Lippard, "New York Letter," *Art International,* vol. 9, no. 2 (March 1965): 48.

99. Sidney Geist, "Color It Sculpture," *Arts Yearbook* 8 (New York: Art Digest, 1965), pp. 92–93.

100. Judd, "Specific Objects," p. 78.

101. Lucy R. Lippard, "As Painting Is to Sculpture," in M. Tuchman, ed., *American Sculpture of the Sixties,* pp. 33–34.

102. Lucy R. Lippard, "New York Letter: Recent Sculpture as Escape," *Art International,* vol. 10, no. 2 (February 1966): 49.

103. According to the artist, "I've only made two sculptures in tune properly between color and shape." Rosalind E. Krauss, *Terminal Iron Works: The Sculpture of David Smith* (Cambridge, Mass.: MIT Press, 1971), p. 170.

104. Coplans, "Don Judd: An Interview with John Coplans," in *Don Judd,* p. 32.

105. Krauss, *Terminal Iron Works,* p. 35. Neither Judd nor LeWitt thinks of himself as a sculptor.

106. Lippard, "New York" (May 1964), p. 54.

107. Interview with Truitt.

108. Lippard, "New York" (May 1964), p. 53.

109. Lippard, "New York Letter: Recent Sculpture as Escape," p. 52. American Minimalists could be described as adapting painting attitudes to an era of sculpture.

110. Irving Sandler, "Gesture and Non-Gesture in Recent Sculpture," in Maurice Tuchman, ed., *American Sculpture of the Sixties* (Los Angeles: Los Angeles County Museum of Art, 1967), p. 41.

111. See, for example, E. Baker, "Judd the Obscure," p. 62.

112. Amy Goldin, "The Anti-Hierarchical American," *Art News*, vol. 66, no. 5 (September 1967): 65.

113. Michael Fried, "Art and Objecthood," *Artforum*, vol. 5, no. 10 (June 1967): 20. Reprinted in Gregory Battcock, ed., *Minimal Art: A Critical Anthology* (New York: E.P. Dutton, 1968), pp. 116–47. Fried's criticisms of sculpture with respect to surface were first aired in Michael Fried, "Shape as Form: Frank Stella's New Paintings," *Artforum*, vol. 5, no. 3 (November 1966): 25–27. The argument in "Shape as Form" is intricate. Fried claims that opticality cannot be achieved in sculpture because of the emphasis on surface. What he seems to be saying is that sculpture does not partake of spatial illusionism because it is without a picture plane. See a more recent discussion of Fried's concerns in Rosalind Krauss, "Theories of Art after Minimalism and Pop," in Hal Foster, ed., *Discussions in Contemporary Culture* (Seattle: Bay Press, 1987), pp. 59–64.

114. This is true for most of Caro's work. An exception is *Month of May* (1963), which is painted red, yellow, and green. The result is strikingly disunified. See William Rubin, *Anthony Caro* (New York: Museum of Modern Art, 1975), p. 131 and n. 47. Greenberg wrote, in an article illustrating *Month of May*, that Caro's polychromy detracted from the quality of the whole work of art. Clement Greenberg, "Anthony Caro," *Arts Yearbook* 8 (New York: Arts Digest, 1965), p. 109.

115. Tim Scott, statement in "Colour in Sculpture," *Studio International*, vol. 177, no. 907 (January 1969): 22.

116. Interview with Judd; D[onald] J[udd], "In the Galleries," *Arts*, vol. 34, no. 5 (February 1960): 57; and Donald Judd, "Chamberlain: Another View," *Art International*, vol. 7, no. 10 (Christmas 1963–64): 38.

117. Robert Smithson, "Entropy and the New Monuments," *Artforum*, vol. 4, no. 10 (June 1966): 30.

118. Coplans, "Don Judd: An Interview with John Coplans," in *Don Judd*, p. 36.

119. Interview with Truitt. Truitt uses up to thirty coats of Liquitex on her sculptures.

120. See Frances Colpitt, "John McCracken at Flow Ace," *Art in America*, vol. 74, no. 1 (January 1986): 141.

121. Lippard, "As Painting Is to Sculpture," in M. Tuchman, ed., *American Sculpture of the Sixties*, p. 33; and Rose, *A New Aesthetic*, p. 56.

122. John McCracken, statement in McShine, *Primary Structures*, n.p.

123. Coplans, "Don Judd: An Interview with John Coplans," in *Don Judd*, p. 36. However, Judd also complained of the slipperiness and disagreeable quality of Plexiglas (p. 44).

124. Interview with Judd.

125. Coplans, "Don Judd: An Interview with John Coplans," in *Don Judd*, p. 25.

126. Interview with LeWitt.

127. Morris, "Notes on Sculpture [Part 1]," p. 43.

128. Coplans, "Don Judd: An Interview with John Coplans," in *Don Judd,* p. 36; Lippard, "As Painting Is to Sculpture," in M. Tuchman, ed., *American Sculpture of the Sixties,* pp. 33–34.

129. Coplans, "Don Judd: An Interview with John Coplans," in *Don Judd,* p. 44. Judd found a precedent, although it is not clear that he recognized it as such, in Bladen's early reliefs. "This scheme [of projecting shapes out from the back panel] and the colors, one to each panel and each projecting part, are Bladen's ideas." D[onald] J[udd], "In the Galleries," *Arts Magazine,* vol. 35, no. 5 (February 1963): 53.

130. D[onald] J[udd], "In the Galleries," *Arts Magazine,* vol. 37, no. 5 (April 1963): 61; Michael Fried, "New York Letter," *Art International,* vol. 7, no. 4 (April 1963): 56. For further comments, see Donald Judd, "Black, White and Gray," *Arts Magazine,* vol. 38, no. 6 (March 1964): 37.

131. Lucy R. Lippard, "Rejective Art," *Art International,* vol. 10, no. 8 (October 1966): 35.

132. Knute Stiles, "'Untitled '68': The San Francisco Annual Becomes an Invitational," *Artforum,* vol. 7, no. 5 (January 1969): 52.

133. D[onald] J[udd], "In the Galleries," *Arts Magazine,* vol. 39, no. 5 (February 1965): 54.

134. Samuel Wagstaff, Jr., "Talking with Tony Smith," *Artforum,* vol. 5, no. 4 (December 1966): 17.

135. Reinhardt, *Art as Art,* p. 97.

136. Stella heard with interest of Rauschenberg's black paintings, and saw Johns's monochrome paintings in 1958. Brenda Richardson, *Frank Stella: The Black Paintings* (Baltimore: Baltimore Museum of Art, 1976), p. 3; and W. Rubin, *Frank Stella,* p. 12.

137. Smithson, "Entropy and the New Monuments," p. 29.

138. Diane Waldman, *Robert Mangold* (New York: Solomon R. Guggenheim Museum, 1971), n.p.

139. Interview with Robert Mangold, New York City, 18 November 1980.

140. Michael Benedikt, "New York Letter," *Art International,* vol. 9, nos. 9–10 (December 1965): 41.

141. Richardson, *Frank Stella: The Black Paintings,* p. 3.

142. Lucy R. Lippard, "New York Letter: Off Color" (April 1966), p. 73; Naomi Spector, "Robert Ryman at the Whitechapel," in *Robert Ryman* (London: Whitechapel Art Gallery, 1977), p. 12.

143. Linda Shearer, *Brice Marden* (New York: Solomon R. Guggenheim Museum, 1975), p. 10.

144. Maurice Poirier, "Color-Coded Mysteries," *Art News,* vol. 84, no. 1 (January 1985): 55. See also Marden's discussion of his use of color in Carl Andre, "New in New York: Line Work," *Arts Magazine,* vol. 41, no. 7 (May 1967): 50.

145. Rosenstein, "Total and Complex," p. 67.

146. Telephone conversation with David Novros, 20 March 1989.

147. See Carter Ratcliff, "Mostly Monochrome," *Art in America,* vol. 69, no. 4 (April 1981): 111–12; and Benjamin H.D. Buchloh, "The Primary Colors for the Second Time: A Paradigm Repetition of the Neo-Avant-Garde," *October* 37 (Summer 1986): 41–52.

148. See D[onald] J[udd], "In the Galleries," *Arts Magazine,* vol. 37, no. 4 (January 1963): 48; and Judd, "Specific Objects," p. 76.

149. Alexander Watt, "Paris Letter: Nouveaux Réalistes," *Art in America* 2 (1961): 107.

150. Greenberg, "Recentness of Sculpture," in M. Tuchman, ed., *American Sculpture of the Sixties,* p. 24.

151. Calvin Tomkins, *The Bride and the Bachelors* (New York: Penguin Books, 1976), p. 203; Ratcliff, "Mostly Monochrome," p. 116.

152. Lucy R. Lippard, "The Silent Art," *Art in America,* vol. 55, no. 1 (January–February 1967): 61. This is the key article on monochromatic painting in the sixties.

153. As a young artist just out of Yale, Marden worked for Rauschenberg. One of his responsibilities was to repaint the white paintings as they yellowed with age. Joshua C. Taylor, Walter Hopps, and Lawrence Alloway, *Robert Rauschenberg* (Washington, D.C.: National Collection of Fine Arts, Smithsonian Institution, 1976), p. 66. See also Ratcliff, "Mostly Monochrome," p. 128.

154. Lucy R. Lippard, *Ad Reinhardt: Paintings* (New York: Jewish Museum, 1966), p. 14.

155. Reinhardt, *Art as Art,* p. 56.

156. See Greenberg's discussion in "After Abstract Expressionism," p. 29.

157. Lippard, "New York Letter: Recent Sculpture as Escape," p. 48.

158. Greenberg, "Recentness of Sculpture," in M. Tuchman, ed., *American Sculpture of the Sixties,* p. 24.

159. Lippard, "New York Letter: Recent Sculpture as Escape," p. 48.

160. Judd, "Specific Objects," pp. 75–78.

161. Rose, *A New Aesthetic,* p. 10. Elsewhere in "Specific Objects," Judd admits that the new three-dimensional work looks more like sculpture than painting. He was equally exasperated with both media. In 1967, when Rose's essay was written, there was more interesting sculpture than painting being done anyway.

162. Lippard, "The Silent Art," p. 62.

163. Robert Mangold, "Interview by Robin White," *View,* vol. 1, no. 7 (December 1978): 8.

164. He cites Zubarán, Velásquez, and Goya in his Master of Fine Arts thesis. Shearer, *Brice Marden,* p. 10.

165. Interview with Brice Marden, New York City, 13 November 1980.

166. Interview with David Novros, New York City, 17 November 1980.

167. Robert M. Murdock, "Public Passages: David Novros," *Art in America,* vol. 73, no. 1 (January 1985): 104–10.

168. Reinhardt, *Art as Art,* p. 49.

169. Grégoire Müller, "After the Ultimate," *Arts Magazine,* vol. 44, no. 5 (March 1970): 30.

170. There is disagreement about the "emptiness" of Baer's paintings of the sixties. See J[ohn] A[shbery], "Reviews and Previews," *Art News,* vol. 64, no. 10 (February 1966): 13; and Lippard, "New York Letter: Off Color," p. 73. Barbara Haskell, in *Jo Baer* (New York: Whitney Museum of American Art, 1975), n.p., agrees with Lippard that Baer's paintings are flat rather than empty.

171. Krauss, "Theories of Art after Minimalism and Pop," in Foster, ed., *Discussions in Contemporary Culture,* p. 61.

172. W. Rubin, *Frank Stella,* p. 37. Stella also recognized the sculptural implications of his shaped canvases (p. 68), but continues to maintain that his is an activity of painting.

173. D[onald] J[udd], "In the Galleries," *Arts Magazine,* vol. 36, no. 10 (September 1962): 51; and Fried, "Shape as Form," pp. 18–27. Fried's position was first outlined in his *Three American Painters* (Cambridge, Mass.: Fogg Art Museum, Harvard University, 1965), pp. 40–45.

174. Kurt von Meier, "Painting to Sculpture: One Tradition in a Radical Approach to the History of Twentieth-Century Art," *Art International,* vol. 12, no. 3 (March 1968): 39.

175. E. C. Goossen, *The Art of the Real: USA 1948–1968* (New York: Museum of Modern Art, 1968), p. 9; and Philip Leider, "New York," *Artforum,* vol. 7, no. 1 (September 1968): 65.

176. The importance of the rectangle for shaped canvases was recognized by Lippard in "The Silent Art," p. 63; and by Stella himself in W. Rubin, *Frank Stella,* p. 68.

177. Müller, "After the Ultimate," p. 28.

178. Frank Stella, from an unpublished transcript of a taped interview for National Educational Television "U.S.A. Artists" (1966), quoted in W. Rubin, *Frank Stella,* p. 32.

179. Mellow, "New York," p. 52.

180. Sheldon Nodelman, *Marden, Novros, Rothko: Painting in the Age of Actuality* (Houston: Institute for the Arts, Rice University, 1978), p. 61. Marden's signature line of drips at the bottom edge of the canvas is derived from Johns. Shearer, *Brice Marden,* p. 12.

181. Interview with Mangold.

182. Watt, "Paris Letter," p. 108.

183. Jack Wesley Burnham, "Sculpture's Vanishing Base," *Artforum,* vol. 6, no. 3 (November 1967): 47. Burnham's is the only contemporary article to deal with the functions and implications of the base (or lack of it) for modernist sculpture.

184. See Barbara Rose, "Sculpture, Intimacy and Perception," in Martin Friedman, *14 Sculptors: The Industrial Edge* (Minneapolis: Walker Art Center, 1969), p. 8.

185. Sheldon Nodelman, "Sixties Art: Some Philosophical Perspectives," *Perspecta: The Yale Architectural Journal* 11 (1967): 79.

186. Interview with Judd.

187. Burnham, "Sculpture's Vanishing Base," p. 48. Truitt suggested that the *absence* of a base was truer to the human situation: "There's no base under us, is there? We have our feet and our feet are on the ground. We don't have a base." Interview with Truitt.

188. Wagstaff, "Talking with Tony Smith," p. 19.

189. Interview with Truitt.

190. Lippard, "New York Letter: Recent Sculpture as Escape," p. 52.

191. Interview with LeWitt. As an example of the functional base, LeWitt gave his gray platforms with the superimposed grid. These inform the spectator of the operative system.

192. Coplans, "5 Los Angeles Sculptors at Irvine," p. 35.

193. Rose, "Sculpture, Intimacy and Perception," p. 8.

194. Burnham, "Sculpture's Vanishing Base," p. 49; Dore Ashton, "Assemblage and Beyond," in Maurice Tuchman, ed., *American Sculpture of the Sixties* (Los Angeles: Los Angeles County Museum of Art, 1967), p. 18.

195. William Tucker pointed this out with repsect to Smith; and Judd explained Chamberlain's work (speaking to the issue of the base) in this manner. Interviews with William Tucker, Brooklyn, N.Y., 10 November 1980, and Judd.

196. D[onald] J[udd], "In the Galleries," *Arts Magazine,* vol. 39, no. 3 (December 1964): 62.

197. Caro "took sculpture off the pedestal before any American did." Clement Greenberg, letter to the author, 28 January 1981. Caro traveled in the United States, meeting Noland, Smith, and Truitt in 1959.

198. David Annesley, Roelof Louw, Tim Scott, and William Tucker, "Anthony Caro's Work: A Symposium by Four Sculptors," *Studio International,* vol. 177, no. 907 (January 1969): 14.

199. See Robert Smithson, "Incidents of Mirror-Travel in the Yucatan," in Nancy Holt, ed., *The Writings of Robert Smithson* (New York: New York University Press, 1979), pp. 94–103.

200. Burnham, "Sculpture's Vanishing Base," p. 48. This can be demonstrated by imagining one of Judd's boxes *with* a base. It is practically impossible. The concept of subtracting the base is not relevant. It *is* making sculpture without a base; it is not through a conscious process of elimination. Note also that the incorporation of the base into the sculpture is different from incorporating the plane of the earth/ground into sculpture.

201. Burnham argues that sculpture is definitively "solid, palpable and *real.*" Burnham, "Sculpture's Vanishing Base," p. 54. This would depend on what one's notion of traditional sculpture was. Are these qualities applicable in description of Bernini's *Ecstasy of St. Theresa?* LeWitt confirmed the opinion that the absence of the base comes from painting as opposed to sculpture. Interview with LeWitt.

202. Lippard, "As Painting Is to Sculpture," in M. Tuchman, ed., *American Sculpture of the Sixties,* p. 31.

203. Coplans, "Don Judd: An Interview with John Coplans," in *Don Judd,* pp. 21–32. Caro did not exhibit in New York until December of 1964. Judd had, however, seen di Suvero's work and a piece by Lucas Samaras made of sculpmetal spread out on the floor of the Green Gallery.

204. Burnham, "Sculpture's Vanishing Base," p. 54.

205. Interview with Truitt.

206. See illustration in Marcia Tucker, *Robert Morris* (New York: Whitney Museum of American Art, 1970), p. 14.

207. Coplans, "Don Judd: An Interview with John Coplans," in *Don Judd*, p. 36.

208. Diane Waldman, *Carl Andre* (New York: Solomon R. Guggenheim Museum, 1970), p. 15. Bourdon stated that Andre's enlightening canoe trip ("his work should be as level as water") was responsible for *Lever*, exhibited in Primary Structures, following the Tibor de Nagy show. Bourdon, *Carl Andre: Sculpture 1959–1977*, p. 26.

209. Bourdon, "The Razed Sites of Carl Andre," p. 15.

Chapter 2

1. See the distinction as outlined by Monroe C. Beardsley, *Aesthetics: Problems in the Philosophy of Criticism* (New York: Harcourt, Brace & World, 1958), pp. 31–34.

2. William C. Agee, *The Sculpture of Donald Judd* (Corpus Christi: Art Museum of South Texas, 1977), p. 5.

3. Bruce Glaser, "Questions to Stella and Judd," ed. Lucy R. Lippard, *Art News*, vol. 65, no. 5 (September 1966): 55. Reprinted in Gregory Battcock, ed., *Minimal Art: A Critical Anthology* (New York: E.P. Dutton, 1968), pp. 148–64.

4. William S. Rubin, *Frank Stella* (New York: Museum of Modern Art, 1970), p. 24.

5. Donald W. Crawford, *Kant's Aesthetic Theory* (Madison: University of Wisconsin Press, 1974), p. 89.

6. Clement Greenberg, lecture at the University of Sydney, 1968, quoted in Charles Harrison, "Notes towards Art Work," *Studio International*, vol. 179, no. 919 (February 1970): 43n.5.

7. Hilton Kramer, "A Critic on the Side of History: Notes on Clement Greenberg," *Arts Magazine*, vol. 37, no. 1 (October 1962): 62.

8. Michael Fried, "Art and Objecthood," *Artforum*, vol. 5, no. 10 (June 1967): 20. Reprinted in Gregory Battcock, ed., *Minimal Art: A Critical Anthology* (New York: E.P. Dutton, 1968), pp. 116–47.

9. Rosalind E. Krauss, *Passages in Modern Sculpture* (New York: Viking Press, 1977), p. 86.

10. Jack Wesley Burnham, "Sculpture's Vanishing Base," *Artforum*, vol. 6, no. 3 (November 1967): 51; and Donald Judd, "Specific Objects," *Arts Yearbook* 8 (New York: Art Digest, 1965), p. 78.

11. Robert Morris, "Notes on Sculpture [Part 1]," *Artforum*, vol. 4, no. 6 (February 1966): 44. Reprinted in Gregory Battcock, ed., *Minimal Art: A Critical Anthology* (New York: E.P. Dutton, 1968), pp. 222–28.

12. Glaser, "Questions to Stella and Judd," p. 58.

13. Glaser, "Questions to Stella and Judd," p. 55.

14. Noland recalled that centering the image and symmetrical composition were "in the air," and were derived from Pollock's "all-over" manner of composing. Interview with Kenneth Noland, South Salem, N.Y., 14 November 1980.

15. Rudolf Arnheim, *Art and Visual Perception: The New Version* (Berkeley: University of California Press, 1974), p. 119. This was originally published in 1954 and widely read by artists.

16. W. Rubin, *Frank Stella*, p. 22.

17. Arnheim, *Art and Visual Perception*, p. 390.

18. Frank Stella, lecture at Pratt Institute, 1960, quoted in Barbara Rose, "ABC Art," *Art in America*, vol. 53, no. 5 (October–November 1965): 59. Reprinted in Gregory Battcock, ed., *Minimal Art: A Critical Anthology* (New York: E.P. Dutton, 1968), pp. 274–97.

19. Arnheim, *Art and Visual Perception*, p. 288.

20. Stella, lecture at Pratt Institute, in Rose, "ABC Art," p. 59.

21. Maurice Tuchman, "Introduction," in Maurice Tuchman, ed., *American Sculpture of the Sixties* (Los Angeles: Los Angeles County Museum of Art, 1967), p. 10.

22. David Bourdon, *Carl Andre: Sculpture 1959–1977* (New York: Jaap Rietman, 1978), p. 50.

23. Carl Andre, statement in Rose, "ABC Art," p. 67.

24. Glaser, "Questions to Stella and Judd," pp. 55–56; John Coplans, "Don Judd: An Interview with John Coplans," in *Don Judd* (Pasadena, Calif.: Pasadena Art Museum, 1971), p. 23.

25. Interview with Clement Greenberg, New York City, 11 November 1980.

26. Judd, "Specific Objects," p. 78.

27. Glaser, "Questions to Stella and Judd," p. 57.

28. Morris, "Notes on Sculpture [Part 1]," p. 44.

29. John Coplans, "Don Judd by John Coplans," *Don Judd* (Pasadena: Pasadena Art Museum, 1971), p. 12.

30. Arnheim, *Art and Visual Perception*, p. 29.

31. Don Judd, "Barnett Newman," *Studio International*, vol. 179, no. 919 (February 1970): 69; and Walter Hopps, "Barnett Newman," *United States of America: VIII São Paulo Biennial* (Pasadena, Calif.: Pasadena Art Museum, 1965), n.p.

32. Judd, "Specific Objects," p. 78.

33. Michael Fried, *Three American Painters* (Cambridge, Mass.: Fogg Art Museum, Harvard University, 1965), p. 43.

34. Michael Compton and David Sylvester, *Robert Morris* (London: Tate Gallery, 1971), p. 25.

35. Michael Fried, "Shape as Form: Frank Stella's New Paintings," *Artforum*, vol. 5, no. 3 (November 1966): 18; W. Rubin *Frank Stella*, p. 30.

36. David Sylvester and Robert Morris, "A Duologue," in Compton and Sylvester, *Robert Morris*, p. 17.

37. Don Judd, "Jackson Pollock," *Arts Magazine*, vol. 41, no. 6 (April 1967): 34.

38. Sylvester and Morris, "A Duologue," in Compton and Sylvester, *Robert Morris*, p. 16.

39. Edgar Rubin, *Visuell wahrgenommene Figuren* (Copenhagen, 1921). See Wolfgang Köhler, *Gestalt Psychology* (New York: New American Library, 1975), p. 120.

40. Arnheim, *Art and Visual Perception*, pp. 228–36.

41. Fried, *Three American Painters*, p. 14. Fried first described the nonfigurative character of Pollock's works in Michael Fried, "New York Letter," *Art International*, vol. 8, no. 3 (April 1964): 57–58.

42. Clement Greenberg, "Modernist Painting," *Arts Yearbook* 4 (New York: Art Digest, 1961), p. 104.

43. Fried, *Three American Painters*, pp. 14–15.

44. Greenberg, "Modernist Painting," p. 106. Much has been made of Greenberg's belief that flatness is the ultimate goal of painting in our century. Minimalists are often accused of merely buying into his proclamation, and acting it out by making paintings that are flat. Their decisions were much more complex than this.

45. Judd, "Specific Objects," p. 76.

46. Kurt von Meier, "Painting to Sculpture: One Tradition in a Radical Approach to the History of Twentieth-Century Art," *Art International*, vol. 12, no. 3 (March 1968): 38.

47. Robert Mangold, "Interview by Robin White," *View*, vol. 1, no. 7 (December 1978): 21. This distinguishes Mangold from Ryman and Marden who celebrate the *process* of painting.

48. Interview with Robert Mangold, New York City, 18 November 1980.

49. Lucy R. Lippard, "New York," *Artforum*, vol. 2, no. 9 (March 1964): 19; and Jane Harrison Cone, "In the Galleries," *Arts Magazine*, vol. 38, no. 6 (March 1964): 67.

50. Harris Rosenstein, "Total and Complex," *Art News*, vol. 66, no. 3 (May 1967): 54.

51. Interview with David Novros, New York City, 17 November 1980.

52. Sheldon Nodelman, "Sixties Art: Some Philosophical Perspectives," *Perspecta: The Yale Architectural Journal* 11 (1967): 75.

53. Jo Baer, "Letters," *Artforum*, vol. 6, no. 1 (September 1967): 6.

54. Clement Greenberg, "Collage," in *Art and Culture* (Boston: Beacon Press, 1961), pp. 71–72.

55. Fried, "Shape as Form," p. 18.

56. Donald Judd, "Local History," *Arts Yearbook* 7 (New York: Art Digest, 1964), p. 31.

57. Donald Judd, "Lee Bontecou," *Arts Magazine*, vol. 39, no. 7 (April 1965): 17.

58. Barbara Rose, "The Sculpture of Ellsworth Kelly," *Artforum*, vol. 5, no. 10 (June 1967): 51.

59. W. Rubin, *Frank Stella*, p. 50.

60. Clement Greenberg, "'American-Type' Painting," in *Art and Culture* (Boston: Beacon

Press, 1961), p. 219; and Clement Greenberg, "How Art Writing Earns Its Bad Name," *Encounter,* vol. 19, no. 6 (December 1962): 69.

61. Michael Fried, "Jules Olitski's New Paintings," *Artforum,* vol. 4, no. 3 (November 1965): 36.

62. Greenberg, "'American-Type' Painting," in *Art and Culture,* p. 226. Mondrian's black lines were seen by Greenberg to *echo* the shape of the picture. Greenberg, "Modernist Painting," p. 105.

63. Michael Fried, "New York Letter," *Art International,* vol. 7, no. 5 (May 1963): 69–70.

64. Fried, *Three American Painters,* p. 23.

65. Fried, "New York Letter" (May 1963), p. 69.

66. Fried, "Art and Objecthood," p. 15. By wholly literal, Fried means that no attention is paid to depicted shape or image. Minimal objects are shapes, literal shapes, and nothing more.

67. Fried, *Three American Painters,* pp. 28–31. This is a slightly revised version of Fried's essay in *Kenneth Noland* (New York: Jewish Museum, 1965), n.p.

68. Fried, "Shape as Form," pp. 18–23.

69. Carter Ratcliff, "Art Criticism: Other Minds, Other Eyes, Part VI (1961–73)," *Art International,* vol. 19, no. 1 (January 1975): 51.

70. Judd, "Local History," p. 32.

71. Nodelman, "Sixties Art," pp. 80–81.

72. Interview with Mangold.

73. Philip Leider, "Books," *Artforum,* vol. 4, no. 2 (October 1965): 45.

74. David Antin, "Differences—Sames: New York 1966–1967," *Metro,* no. 13 (February 1968): 79–82.

75. W. Rubin, *Frank Stella,* p. 65.

76. John Coplans, "Serial Imagery," *Artforum,* vol. 7, no. 2 (October 1968): 37.

77. W. Rubin, *Frank Stella,* p. 56.

78. Fried, *Three American Painters,* p. 40.

79. W. Rubin, *Frank Stella,* p. 58. The material elimination of the boxes "leftover" from the angled stripes in the corners, edges, or center was suggested to Stella by his friend Darby Bannard (p. 48).

80. Barbara Rose, *A New Aesthetic* (Washington, D.C.: Washington Gallery of Modern Art, 1967), p. 18n.6.

81. Fried, "New York Letter" (May 1963), p. 70; Michael Fried, "Frank Stella," in Ben Heller, *Toward a New Abstraction* (New York: Jewish Museum, 1963), p. 28; and Fried, *Three American Painters,* p. 40.

82. Interview with Noland.

83. Fried, "Shape as Form," p. 20.

84. Michael Fried, *Jules Olitski: Paintings 1963–1967* (Washington, D.C.: Corcoran Gallery of Art, 1967), pp. 21–22n.13.

85. Fried, *Three American Painters,* p. 23; and Fried, "Shape as Form," p. 18.

86. Interview with William Tucker, Brooklyn, N.Y., 10 November 1980.

87. Morris, "Notes on Sculpture [Part 1]," p. 44. According to Köhler, "Shape is probably the most important attribute of segregated things." Köhler, *Gestalt Psychology,* p. 120.

88. Glaser, "Questions to Stella and Judd," p. 58.

89. Judd, "Specific Objects," p. 78.

90. Fried, "Art and Objecthood," p. 12. Fried goes on to claim that this hollowness is "almost blatantly anthropomorphic" (p. 19).

91. Jack Burnham, *Beyond Modern Sculpture* (New York: George Braziller, 1968), p. 120.

92. D[onald] J[udd], "In the Galleries," *Arts Magazine,* vol. 39, no. 3 (December 1964): 62. One of the things Andre appreciated about Smith's pre-Cubi work was its solidity; the fact that this sculpture was not hollow. Phyllis Tuchman, "An Interview with Carl Andre," *Artforum,* vol. 8, no. 10 (June 1970): 61.

93. Glaser, "Questions to Stella and Judd," pp. 58–59.

94. John Coplans, "Don Judd: An Interview with John Coplans," in *Don Judd,* p. 36.

95. Fried, "Art and Objecthood," p. 19; and Lucy R. Lippard, "New York Letter," *Art International,* vol. 10, no. 6 (Summer 1966): 114.

96. Barbara Rose, "Post-Cubist Sculpture," in Maurice Tuchman, ed., *American Sculpture of the Sixties* (Los Angeles: Los Angeles County Museum of Art, 1967), p. 40.

97. Lucy R. Lippard, "Rejective Art," *Art International,* vol. 10, no. 8 (October 1966): 33.

98. Robert Morris, "Notes on Sculpture, Part 2," *Artforum,* vol. 5, no. 2 (October 1966): 21. Reprinted in Gregory Battcock, ed., *Minimal Art: A Critical Anthology* (New York: E.P. Dutton, 1968), pp. 228–35.

99. Compton and Sylvester, *Robert Morris,* p. 25.

100. Coplans, "Don Judd: An Interview with John Coplans," in *Don Judd,* p. 44.

101. Rose, *A New Aesthetic,* p. 20n.24.

102. Coplans, "Don Judd: An Interview with John Coplans," in *Don Judd,* p. 36.

103. P. Tuchman, "An Interview with Carl Andre," p. 61; and Coplans, "Don Judd: An Interview with John Coplans," in *Don Judd,* p. 37.

104. Krauss, *Passages in Modern Sculpture,* pp. 271–72; 298n.8.

105. Arnheim, *Art and Visual Perception,* p. 245.

106. Compton and Sylvester, *Robert Morris,* p. 25. Friedman seems to me to be mistaken when he claims that Judd's sculptures "are assertations about the displacement of space," although he does continue by discussing their hollowness. Martin Friedman, "The Nart-Art of Donald Judd," *Art and Artists,* vol. 1, no. 11 (February 1967): 60.

107. Glaser, "Questions to Stella and Judd," p. 57.

108. Mel Bochner, "Excerpts from Speculation (1967–1970)," *Artforum*, vol. 8, no. 9 (May 1970): 71.

109. Ludwig Wittgenstein, *Tractatus Logico-Philosophicus* (London: Kegan Paul, 1922), pp. 165–67.

110. Interview with Sol LeWitt, New York City, 15 November 1980.

111. Glaser, "Questions to Stella and Judd," p. 57.

112. Fried, "New York Letter" (May 1963), p. 69.

113. James R. Mellow, "New York Letter," *Art International*, vol. 10, no. 9 (November 1966): 58. This serves as the introduction for a review of Alloway's Systemic Painting at the Guggenheim Museum.

114. Mel Bochner, "Serial Art, Systems, Solipsism," in Gregory Battock, ed., *Minimal Art: A Critical Anthology* (New York: E.P. Dutton, 1968), p. 94. This is a revised version of an article published in *Arts Magazine*, vol. 41, no. 8 (Summer 1967).

115. Friedman, "The Nart-Art of Donald Judd," p. 60. Morris disagrees: "But appeals to binary mathematics, tensegrity techniques, mathematically derived modules, progressions, etc., within a work are only another application of the Cubist esthetic of having reasonableness or logic for the relating parts." Morris, "Notes on Sculpture, Part 2," p. 21.

116. Dan Flavin, "Some Remarks . . . Excerpts from a Spleenish Journal," *Artforum*, vol. 5, no. 4 (December 1966): 27.

117. John N. Chandler, "Tony Smith and Sol LeWitt: Mutations and Permutations," *Art International*, vol. 12, no. 7 (September 1968): 18.

118. Sam Hunter, *Tony Smith* (New York: Pace Gallery, 1979), p. 6.

119. Edward F. Fry, "Poons. A Clean and Balanced World?" *Art News*, vol. 65, no. 10 (February 1967): 34. See also Robert Pincus-Witten, "'Systemic' Painting," *Artforum*, vol. 5, no. 3 (November 1966): 45; and Lucy R. Lippard, "Perverse Perspectives," *Art International*, vol. 11, no. 3 (March 1967): 28.

120. Clement Greenberg, "The Crisis of the Easel Picture," in *Art and Culture* (Boston: Beacon Press, 1961), p. 155.

121. Sol LeWitt, "Paragraphs on Conceptual Art," *Artforum*, vol. 5, no. 10 (June 1967): 80.

122. During the Osaka '70 Exposition, the Container Corporation of America made up "thousands of flats" of Smith's tetrahedral modules, which his daughters constructed so that he had a supply of modules for his studies. Hunter, *Tony Smith*, p. 6.

123. Krauss, *Passages in Modern Sculpture*, p. 250.

124. E. C. Goossen, "The Artist Speaks: Robert Morris," *Art in America*, vol. 58, no. 3 (May–June 1970): 110.

125. See Rosalind Krauss, "Grids," in *The Originality of the Avant- Garde and Other Modernist Myths* (Cambridge, Mass.: MIT Press, 1985), pp. 9–22.

126. Interview with LeWitt.

127. See Naomi Spector, "Robert Ryman at the Whitechapel," in *Robert Ryman* (London: Whitechapel Art Gallery, 1977), p. 11.

128. Robert Smithson, "A Museum of Language in the Vicinity of Art," *Art International*, vol. 12, no. 3 (March 1968): 26.

129. C. Blok, "Minimal Art at The Hague," *Art International*, vol. 12, no. 5 (May 1968): 18. The idea of the space-lattice was popular in the mid to late sixties. Smithson presented it in "Donald Judd," *7 Sculptors* (Philadelphia: Philadelphia Institute of Contemporary Art, 1965), reprinted in Nancy Holt, ed., *The Writings of Robert Smithson* (New York: New York University Press, 1979), p. 25. Tony Smith referred to the space-lattice structure of his work in Samuel Wagstaff, Jr., "Talking with Tony Smith," *Artforum*, vol. 5, no. 4 (December 1966): 15, and in Lucy R. Lippard, "Tony Smith: 'The Ineluctable Modality of the Visible,'" *Art International*, vol. 11, no. 6 (Summer 1967): 25. Lippard also used it in her essay for the catalogue of Minimal Art.

130. Chandler, "Tony Smith and Sol LeWitt: Mutations and Permutations," p. 18.

131. Walter Hopps, "Frank Stella," in *United States of America: VIII São Paulo Biennial* (Pasadena, Calif.: Pasadena Art Museum, 1965), n.p.; and Coplans, "Serial Imagery," p. 37.

132. Mel Bochner, "The Serial Attitude," *Artforum*, vol. 6, no. 4 (December 1967): 28.

133. David Lee, "Serial Rights," *Art News*, vol. 66, no. 8 (December 1967): 44.

134. Bochner, "Serial Art, Systems, Solipsism," p. 100.

135. Coplans criticized Bochner's definition of seriality in this context, although they were actually talking about different things. Bochner refers to serial composition in a single work of art, while Coplans discusses groups of related works of art. Coplans, "Serial Imagery," p. 43n.3; and Bochner, "The Serial Attitude," p. 31.

136. Alicia Legg, ed., *Sol LeWitt* (New York: Museum of Modern Art, 1978), pp. 75–81. Notations by LeWitt.

137. See Compton and Sylvester, *Robert Morris*, p. 69.

138. Bourdon, *Carl Andre: Sculpture 1959–1977*, p. 56.

139. Coplans, "Don Judd: An Interview with John Coplans," in *Don Judd*, p. 41.

140. Interview with LeWitt. Bochner agrees. Bochner, "Serial Art, Systems, Solipsism," p. 101.

141. Donald B. Kuspit, "Sol LeWitt: The Look of Thought," *Art in America*, vol. 63, no. 5 (September–October 1975): 44.

142. Lippard, "Perverse Perspectives," p. 31.

143. Roger Fry, *Transformations* (London: Chatto & Windus, 1926), p. 6.

144. Joseph Masheck, "Kuspit's LeWitt: Has He Got Style?" *Art in America*, vol. 64, no. 6 (November–December 1976): 108.

145. Bochner, "The Serial Attitude," p. 31.

146. Bochner, "Serial Art, Systems, Solipsism," p. 99. "Flavin has employed [Ockham's] Razor in his choice of just three entities, the least number of entities necessary to establish a series." V[eda] S[emarne], "Dan Flavin," in Rainer F. Crone, *Numerals 1924–1977* (New Haven, Conn.: Yale University Art Gallery, 1978), n.p.

147. See M[el] Bochner, "Art in Process—Structures," *Arts Magazine*, vol. 40, no. 9 (September–October 1966): 38; and Lippard, "Rejective Art," p. 34. Bochner and Lippard discuss a work with the same form as the progression illustrated.

148. See Donald Judd, *Zeichnungen/Drawings 1956–1976* (Basel, Switzerland: Kunstmuseum, 1976), illus. no. 42, cat. no. 134.

149. Roberta Smith, "Donald Judd," in Brydon Smith, *Donald Judd* (Ottawa: National Gallery of Canada, 1975), pp. 24–25.

150. See illustration and text, D[avid] P[ark] C[urry], in Rainer F. Crone, *Numerals 1924–1977* (New Haven, Conn.: Yale University Art Gallery, 1978), n.p.

151. Coplans, "Don Judd: An Interview with John Coplans," in *Don Judd*, p. 41.

152. Barbara Haskell, *Donald Judd* (New York: Whitney Museum of American Art, 1988), p. 49.

153. R. Smith, "Donald Judd," in B. Smith, *Don Judd*, p. 25.

154. Interview with LeWitt.

155. Interview with Mel Bochner, New York City, 25 November 1980. Bochner's work is primarily visual and formal rather than literary, which distinguishes him from artists sponsored by Seth Siegelaub in 1968–69.

156. Bochner, "Serial Art, Systems, Solipsism," p. 94.

157. Lucy R. Lippard, "New York Letter: April–June 1965," *Art International*, vol. 9, no. 6 (September 1965): 58.

158. Goossen, "The Artist Speaks," p. 110.

159. Fried, *Three American Painters*, pp. 45–46. This position was also taken by Hopps ("Frank Stella," in *United States of America*, n.p.); Lawrence Alloway (*Systemic Painting* [New York: Solomon R. Guggenheim Museum, 1966], p. 19); and Coplans ("Serial Imagery," p. 35).

160. Alloway, *Systemic Painting*, p. 18.

161. Coplans, "Serial Imagery," p. 34.

162. James R. Mellow, "New York Letter," *Art International*, vol. 12, no. 2 (February 1968): 73.

163. Lawrence Alloway, "Serial Forms," in Maurice Tuchman, ed., *American Sculpture of the Sixties* (Los Angeles: Los Angeles County Museum of Art, 1967), p. 14.

164. Coplans, "Serial Imagery," pp. 35–44. See Calas's response. Nicolas Calas, "Art & Strategy," *Arts Magazine*, vol. 43, no. 5 (March 1969): 36–38.

165. Alloway, *Systemic Painting*, p. 19.

166. Lucy R. Lippard, "New York Letter: Off Color," *Art International*, vol. 10, no. 4 (April 1966): 73

Chapter 3

1. Michael Fried, "Art and Objecthood," *Artforum*, vol. 5, no. 10 (June 1967): 21. Reprinted in Gregory Battcock, ed., *Minimal Art: A Critical Anthology* (New York: E.P. Dutton, 1968), pp. 116–47.

2. Donald Judd, "Claes Oldenburg," in *Complete Writings 1959–1975* (Halifax: Press of the Nova Scotia College of Art and Design, 1975), p. 191. Previously unpublished essay written in July 1966.

3. Jack Burnham, "On Being Sculpture," *Artforum*, vol. 7, no. 9 (May 1969): 44.

4. Rosalind E. Krauss, *Passages in Modern Sculpture* (New York: Viking Press, 1977), p. 267.

5. Rudolf Arnheim, *Art and Visual Perception: The New Version* (Berkeley: University of California Press, 1974), pp. 242–43.

6. Robert Morris, "Notes on Sculpture, Part 3: Notes and Nonsequiturs," *Artforum*, vol. 5, no. 10 (June 1967): 29.

7. Lawrence Alloway, "Sculpture as Cliché," *Artforum*, vol. 2, no. 4 (October 1963): 26.

8. Hilton Kramer, "Art Centers: New York, the Season Surveyed," *Art in America*, 3 (1964): 112. The untitled red floor box of 1963 was typically referred to as "the record cabinet." Sidney Tillim, "The New Avant-Garde," *Arts Magazine*, vol. 38, no. 5 (February 1964): 20; and Irving Sandler, "The New Cool-Art," *Art in America*, vol. 53, no. 1 (February 1965): 98.

9. Donald Judd, "Specific Objects," *Arts Yearbook* 8 (New York: Art Digest, 1965), p. 80.

10. Interview with Donald Judd, Marfa, Tex., 2–3 December 1980.

11. Robert Smithson, "Interview with Robert Smithson for the Archives of American Art/ Smithsonian Institute," by Paul Cummings, in Nancy Holt, ed., *The Writings of Robert Smithson* (New York: New York University Press, 1979), p. 147.

12. Jack Wesley Burnham, "Sculpture's Vanishing Base," *Artforum*, vol. 6, no. 3 (November 1967): 48.

13. Fried, "Art and Objecthood," pp. 12–19. In a telephone conversation on 11 February 1981, Fried told me that he did not have a big stake in this claim, although he still believes it to be the case. Since his opinion was forceful in the widely read "Art and Objecthood," it deserves scrutiny here.

14. Fried, "Art and Objecthood," pp. 16–19. Smith's quote appeared in Morris, "Notes on Sculpture, Part 2," *Artforum*, vol. 5, no. 2 (October 1966): 21. Morris contends that this size is neither architectural nor figurative.

15. Interview with John McCracken, Santa Barbara, Calif., 28 May 1980.

16. Robert Morris, "Notes on Sculpture, Part 4: Beyond Objects," *Artforum*, vol. 7, no. 8 (April 1969): 51.

17. See the response in Kenneth Baker, "Donald Judd: Past Theory," *Artforum*, vol. 15, no. 10 (Summer 1977): 46.

18. Michael Fried, *Three American Painters* (Cambridge, Mass.: Fogg Art Museum, Harvard University, 1965), p. 44.

19. Barbara Rose, "New York Letter," *Art International*, vol. 7, no. 9 (December 1963): 63; and Judith Weschler, "Why Scale?" *Art News*, vol. 66, no. 4 (Summer 1967): 67.

20. William Rubin, *Frank Stella* (New York: Museum of Modern Art, 1970), p. 37; and Fried, "Art and Objecthood," p. 16.

21. Sheldon Nodelman, "Sixties Art: Some Philosophical Perspectives," *Perspecta: The Yale Architectural Journal* 11 (1967): 79.

22. Morris, "Notes on Sculpture, Part 4," p. 51.

23. Interview with Clement Greenberg, New York City, 11 November 1980.

24. Bruce Glaser, "Questions to Stella and Judd," ed. Lucy R. Lippard, *Art News*, vol. 65, no. 5 (September 1966): 60. Reprinted in Gregory Battcock, ed., *Minimal Art: A Critical Anthology* (New York: E.P. Dutton, 1968), pp. 148–64.

25. P[eter] P[lagens], "Los Angeles," *Artforum*, vol. 4, no. 7 (March 1966): 14. This is a review of sculpture by Judy Gerowitz [Chicago].

26. Diane Waldman, "Excerpts from a Conversation between Elizabeth C. Baker, John Chamberlain, Don Judd, and Diane Waldman," in *John Chamberlain: A Retrospective Exhibition* (New York: Solomon R. Guggenheim Museum, 1971), p. 15.

27. Samuel Wagstaff, Jr., "Talking with Tony Smith," *Artforum*, vol. 5, no. 4 (December 1966): 15; see also Grace Glueck, "No Place to Hide," *New York Times*, 27 November 1966, sec. 2, p. 19. Interview with McCracken.

28. Interview with Anne Truitt, Washington, D.C., 21 November 1980.

29. Fried, "Art and Objecthood," pp. 15–16. Greenberg had used the term in a 1959 reference to the work of Juan Gris. Clement Greenberg, "Collage," in *Art and Culture* (Boston: Beacon Press, 1961), p. 81. Clement Greenberg, "Recentness of Sculpture," in Maurice Tuchman, ed., *American Sculpture of the Sixties* (Los Angeles: Los Angeles County Museum of Art, 1967), pp. 24–26. In a telephone conversation in 1981, Fried later claimed that Minimal objects *were* indeed art, but were antimodernist.

30. Greenberg, "Recentness of Sculpture," in M. Tuchman, ed., *American Sculpture of the Sixties*, p. 26. Exactly what Greenberg meant by hiding behind presence is not clear. Truitt herself does not know what to make of his remark. Interview with Truitt.

31. Mel Bochner, "Serial Art Systems: Solipsism," *Arts Magazine*, vol. 41, no. 8 (Summer 1967): 40. Revised as "Serial Art, Systems, Solipsism," in Gregory Battcock, ed., *Minimal Art: A Critical Anthology* (New York: E.P. Dutton, 1968), pp. 92–102.

32. Samuel J. Wagstaff, Jr., "Paintings to Think About," *Art News*, vol. 62, no. 9 (January 1964): 62.

33. Carter Ratcliff, "Art Criticism: Other Minds, Other Eyes, Part VI (1961–73)," *Art International*, vol. 19, no. 1 (January 1975): 52.

34. Carter Ratcliff, "Art Criticism: Other Eyes, Other Minds (Part V)," *Art International*, vol. 18, no. 10 (December 1974): 56; and Ratcliff, "Art Criticism (Part VI)," pp. 51–52. See also Willis Domingo, "The Intuition of Form," *Arts Magazine*, vol. 47, no. 4 (February 1973): 43–44.

35. Michael Fried, "Shape as Form: Frank Stella's New Paintings," *Artforum*, vol. 5, no. 3 (November 1966): 21.

36. David Sylvester and Robert Morris, "A Duologue," in Michael Compton and David Sylvester, *Robert Morris* (London: Tate Gallery, 1971), p. 20.

37. Weschler, "Why Scale?" pp. 32–33.

38. Lucy R. Lippard, "Escalation in Washington," *Art International*, vol. 12, no. 1 (January 1968): 42. See note 20 for this chapter.

39. Barbara Hepworth, "Sculpture," in J. L. Martin, Ben Nicholson, N[aum] Gabo, eds., *Circle* (New York: Praeger Publishers, 1971), p. 113.

40. Lippard, "Escalation in Washington," p. 42.

41. See Phyllis Tuchman, "An Interview with Carl Andre," *Artforum,* vol. 8, no. 10 (June 1970): 57; and Robert Smithson, "The Spiral Jetty," in Nancy Holt, ed., *The Writings of Robert Smithson* (New York: New York University Press, 1979), p. 112.

42. Sylvester and Morris, "A Duologue," in Compton and Sylvester, *Robert Morris,* p. 14. On p. 20, Morris could not recall discarding any specific sculpture on account of incorrect scale.

43. Interview with Robert Mangold, New York City, 18 November 1980.

44. Rose noted that large-scale sculpture comes from the "'environmental' scale of American painting." Barbara Rose, "Blowup—The Problem of Scale in Sculpture," *Art in America,* vol. 56, no. 4 (July–August 1968): 83. Blok also remarked upon the scale of American art: "In Europe I think there lingers a tendency to regard scale as more or less of an accident." C. Blok, "Minimal Art at The Hague," *Art International,* vol. 12, no. 5 (May 1968): 20.

45. Barbara Reise, "The Stance of Barnett Newman," *Studio International,* vol. 179, no. 919 (February 1970): 49n.1. See her comments on scale on p. 51.

46. Walter Hopps, "Barnett Newman," *United States of America: VIII São Paulo Biennial* (Pasadena, Calif.: Pasadena Art Museum, 1965), n.p.

47. Interview with Robert Murray, New York City, 18 November 1980.

48. Interview with Mangold. Judd now has his own designs for furniture fabricated and marketed.

49. W. Rubin, *Frank Stella,* p. 39.

50. Rose, "Blowup—The Problem of Scale in Sculpture," p. 86.

51. Lippard, "Escalation in Washington," p. 42. See also Andrew Hudson, "Scale as Content: Bladen, Newman, Smith at the Corcoran," *Artforum,* vol. 6, no. 4 (December 1967): 47.

52. Lippard, "Escalation in Washington," p. 42.

53. W. Rubin, *Frank Stella,* p. 39.

54. Lippard, "Escalation in Washington," p. 42.

55. Reise, "The Stance of Barnett Newman," p. 51. This is the sort of relational quality that Fried denied to human beings.

56. Robert Morris, "Notes on Sculpture, Part 2," *Artforum,* vol. 5, no. 2 (October 1966): 21. Reprinted in Gregory Battcock, ed., *Minimal Art: A Critical Anthology* (New York: E.P. Dutton, 1968), pp. 228–35.

57. P. Tuchman, "An Interview with Carl Andre," p. 57.

58. Interview with Judd; Interview with Sol LeWitt, New York City, 15 November 1980. McCracken and I came to opposing conclusions about two of his planks. The artist is very tall and preferred the scale of the larger plank, while I appreciated the shorter of the two.

59. Robert Mangold, "Interview by Robin White," *View,* vol. 1, no. 7 (December 1978): 5. See also Hepworth, "Sculpture," in Martin, et al., *Circle,* p. 114; Lippard, "Escalation in Washington," p. 42; and W. Rubin, *Frank Stella,* p. 39.

60. Rose, "Blowup—The Problem of Scale in Sculpture," p. 86.

61. Morris, "Notes on Sculpture, Part 2," p. 21. Lippard cautioned that his remark "shouldn't be taken too generally," considering Smith's other pieces that vary greatly in size. Lippard, "Escalation in Washington," p. 42.

62. Sol LeWitt, "Paragraphs on Conceptual Art," *Artforum,* vol. 5, no. 10 (June 1967): 83.

63. Kurt von Meier, "Los Angeles," *Art International,* vol. 11, no. 4 (April 1967): 51.

64. Donald Judd, "Lee Bontecou," *Arts Magazine,* vol. 39, no. 7 (April 1965): 17.

65. Blok, "Minimal Art at The Hague," p. 20.

66. Interview with LeWitt; Morris, "Notes on Sculpture, Part 2," p. 21.

67. Linda Shearer, *Brice Marden* (New York: Solomon R. Guggenheim Museum, 1975), p. 16.

68. This aspect distinguishes Judd's 1965 (1966, according to the catalogue raisonné by Brydon Smith) progression, owned by the Whitney Museum, from his more typical work. Not only is it incapable of being physically embraced, its tremendous length (253 inches) prohibits immediate perceptual comprehension. The scale is further impeded by the many relatively small units suspended below the horizontal bar.

69. J[ill] J[ohnston], "Reviews and Previews: New Names This Month," *Art News,* vol. 62, no. 1 (March 1963): 16, on Truitt; L[awrence] C[ampbell], "Reviews and Previews," *Art News,* vol. 65, no. 3 (May 1966): 22, on Stella; and T[ed] B[errigan], "Reviews and Previews: New Names This Month," *Art News,* vol. 64, no. 4 (Summer 1965): 21, on Andre. *Art News,* and especially Ted Berrigan, were most prone to this characterization. There is nothing new in equating artists with children. The analogy is loaded with sociological implications.

70. Weschler, "Why Scale?," p. 33.

71. Lippard, "Escalation in Washington," p. 43.

72. Alloway, "Sculpture as Cliché," p. 26.

73. LeWitt, "Paragraphs on Conceptual Art," p. 83.

74. Lippard, "Escalation in Washington," p. 43. According to Tony Smith, "Architecture has to do with space and light, not with form; that's sculpture." Wagstaff, "Talking with Tony Smith," p. 16.

75. E.C. Goossen, "The Artist Speaks: Robert Morris," *Art in America,* vol. 58, no. 3 (May–June 1970): 107.

76. J[ohn] A[shbery], "Young Masters of Understatement," *Art News,* vol. 65, no. 3 (May 1966): 62.

77. Robert Morris, "Notes on Sculpture [Part 1]," *Artforum,* vol. 4, no. 6 (February 1966): 43. Reprinted in Gregory Battcock, ed., *Minimal Art: A Critical Anthology* (New York: E.P. Dutton, 1968), pp. 222–28.

78. Lucy R. Lippard, "10 Strukturisten in 20 Absätzen," *Minimal Art,* by Enno Develing and Lucy R. Lippard (Düsseldorf: Städtische Kunsthalle, 1969), p. 16 [translation in Richard Kostelanetz, ed., *Esthetics Contemporary* (Buffalo: Prometheus Books, 1978), p. 236]; and Lippard, "Escalation in Washington," p. 44.

79. Donald B. Kuspit, *Clement Greenberg: Art Critic* (Madison: University of Wisconsin Press, 1979), pp. 20–29.

80. John Perreault, "A Minimal Future? Union-Made," *Arts Magazine,* vol. 41, no. 5 (March 1967): 30.

81. E. C. Goossen, *Ellsworth Kelly* (New York: Museum of Modern Art, 1972), pp. 50–59.

82. Mangold, "Interview by Robin White," p. 17.

83. Michael Fried, "New York Letter," *Art International,* vol. 8, nos. 5–6 (Summer 1964): 82. Fried treated the quality of "doorness" as the most significant aspect of Caro's *Deep Body Blue* in Michael Fried, "Two Sculptures by Anthony Caro," *Artforum,* vol. 6, no. 6 (February 1968): 24–25.

84. Interview with David Novros, New York City, 17 November 1980; and Los Angeles, 24 September 1981.

85. Brice Marden, "Interview by Robin White," *View,* vol. 3, no. 3 (June 1980): 13.

86. Martin Friedman, "Robert Morris: Polemics and Cubes," *Art International,* vol. 10, no. 10 (December 1966): 23.

87. Dennis Adrian, "New York," *Artforum,* vol. 5, no. 7 (March 1967): 55.

88. Rosalind Krauss, "Allusion and Illusion in Donald Judd," *Artforum,* vol. 4, no. 9 (May 1966): 25.

89. David Bourdon, *Carl Andre: Sculpture 1959–1977* (New York: Jaap Rietman, 1978), p. 24.

90. Lucy R. Lippard, "New York Letter: April–June 1965," *Art International,* vol. 9, no. 6 (September 1965): 58.

91. Lucy R. Lippard, *Tony Smith* (New York: Harry N. Abrams, 1972), p. 20; and Wagstaff, "Talking with Tony Smith," p. 19.

92. Interview with LeWitt.

93. David Bourdon, "The Cantilevered Rainbow," *Art News,* vol. 66, no. 4 (Summer 1967): 30.

94. Corinne Robins, "The Artist Speaks: Ronald Bladen," *Art in America,* vol. 57, no. 5 (September–October 1969): 78.

95. Lucy R. Lippard, "New York Letter," *Art International,* vol. 9, no. 5 (June 1965): 52.

96. See Hilton Kramer, "Art: Reshaping the Outermost Limits," *New York Times,* 28 April 1966, p. 48.

97. W. Rubin, *Frank Stella,* p. 46.

98. Kurt von Meier, "Los Angeles Letter," *Art International,* vol. 10, no. 5 (May 1966): 59.

99. See Lucy R. Lippard, "New York Letter: Off Color," *Art International,* vol. 10, no. 4 (April 1966): 74.

100. Robert Rauschenberg, statement in Dorothy C. Miller, ed., *Sixteen Americans* (New York: Museum of Modern Art, 1959), p. 58; Robert Grosvenor, statement in Kynaston McShine, *Primary Structures* (New York: Jewish Museum, 1966), n.p.; Interview with Mel Bochner, New York City, 25 November 1980.

101. Lippard, "10 Strukturisten in 20 Absätzen," p. 14.

102. Lucy R. Lippard, "New York," *Artforum*, vol. 2, no. 9 (March 1964): 18.

103. Nan R. Piene, "New York: Gallery Notes," *Art in America*, vol. 54, no. 2 (March–April 1966): 128.

104. See Fidel A. Danieli, "Los Angeles," *Artforum*, vol. 5, no. 6 (February 1967): 62. The very different use to which Gabo put the corner, in a work such as *Head of a Woman* (1916–17) was pointed out by Annette Michelson, "Robert Morris—An Aesthetics of Transgression," *Robert Morris* (Washington, D.C.: Corcoran Gallery of Art, 1969), p. 71.

105. A[shbery], "Young Masters of Understatement," p. 62.

106. Lippard, "New York" (March 1964), p. 18.

107. Lawrence Alloway, "Venezorama," *Art International*, vol. 6, no. 8 (October 1962): 35.

108. D[on] F[actor], "Los Angeles," *Artforum*, vol. 4, no. 9 (May 1966): 13.

109. Friedman, "Robert Morris: Polemics and Cubes," p. 23.

110. Morris, "Notes on Sculpture, Part 2," p. 21; Morris, "Notes on Sculpture, Part 3," p. 26.

111. D[onald] J[udd], "In the Galleries," *Arts Magazine*, vol. 39, no. 5 (February 1965): 54.

112. Judd, "Specific Objects," p. 78; and Sylvester and Morris, "A Duologue," in Compton and Sylvester, *Robert Morris*, p. 16.

113. Hal Foster, "The Crux of Minimalism," *Individuals: A Selected History of Contemporary Art, 1945–1986*, ed. Howard Singerman (Los Angeles: Museum of Contemporary Art, 1986), pp. 172–73.

114. Bochner, "Serial Art Systems: Solipsism," p. 40.

115. Like Morris's, Flavin's work elicited disagreements as to its environmental nature. Danieli ("Los Angeles," p. 62) thought it "easily situational or environmental." John Perreault ("New York," *Art International*, vol. 11, no. 3 [March 1967]: 66) denied environmental considerations.

116. Dan Flavin, "Some Other Comments . . . More Pages from a Spleenish Journal," *Artforum*, vol. 6, no. 4 (December 1967): 23.

117. Jack Burnham, "A Dan Flavin Retrospective in Ottawa," *Artforum*, vol. 8, no. 4 (December 1969): 55.

118. Corinne Robins, "Four Directions at Park Place," *Arts Magazine*, vol. 40, no. 8 (June 1966): 22.

119. Interview with Novros.

120. Michael Benedikt, "New York Letter," *Art International*, vol. 10, no. 10 (December 1966): 65.

121. Marcia Tucker, *Robert Morris* (New York: Whitney Museum of American Art, 1970), p. 25.

122. Jane Harrison Cone, "Judd at the Whitney," *Artforum*, vol. 6, no. 9 (May 1968): 36. Although she refers to both the wall boxes and the floor boxes here, she prefers the former's "consistency and plausibility," since the floor boxes exhibit a kind of "flimsiness."

123. Barbara Rose, "New York Letter," *Art International*, vol. 8, no. 1 (February 1964): 41. Contains reviews of Black and White at the Jewish Museum and Black, White and Gray at the Wadsworth Atheneum.

124. Morris, "Notes on Sculpture, Part 2," p. 23. "In fact, Morris says, it is placement which particularizes the most anonymous seeming object." Friedman, "Robert Morris: Polemics and Cubes," p. 23.

125. David Bourdon, "The Razed Sites of Carl Andre," *Artforum*, vol. 5, no. 2 (October 1966): 15.

126. P. Tuchman, "An Interview with Carl Andre," p. 55.

127. Donald Judd, statement in "Artists on Museums," *Arts Yearbook* 9 (New York: Art Digest, 1967), reprinted in Donald Judd, *Complete Writings 1959–1975* (Halifax: Press of the Nova Scotia College of Art and Design, 1975), p. 195; and see his defense of permanent installations in "On Installation," *Journal: A Contemporary Art Magazine* (Los Angeles Institute of Contemporary Art), vol. 4, no. 32 (Spring 1982): 18–21. Reprinted in Donald Judd, *Complete Writings: 1975–1986* (Eindhoven, Netherlands: Van Abbemuseum, 1987), pp. 19–24.

128. Interview with Robert Murray, New York City, 18 November 1980. Bochner confirmed the difference between Judd's exhibitions as arranged by gallery directors and those arranged by the artist. Interview with Bochner.

129. D[onald] J[udd], "In the Galleries," *Arts Magazine*, vol. 37, no. 7 (April 1963): 61.

130. A[nne] H[oene], "In the Galleries," *Arts Magazine*, vol. 39, no. 10 (September–October 1965): 64.

131. Lippard, "New York Letter: Off Color," pp. 73–74.

132. Lucy R. Lippard, "Rejective Art," *Art International*, vol. 10, no. 8 (October 1966): 34. LeWitt himself was aware of the significance of the shadows in the early pieces. See his commentary in Alicia Legg, ed., *Sol LeWitt* (New York: Museum of Modern Art, 1978), p. 65.

133. Coplans, "Don Judd: An Interview with John Coplans," in *Don Judd*, p. 41.

134. Friedman, "Robert Morris: Polemics and Cubes," p. 23.

135. William C. Agee, *The Sculpture of Donald Judd* (Corpus Christi: Art Museum of South Texas, 1977), p. 17.

136. Barbara Rose, "ABC Art," *Art in America*, vol. 53, no. 5 (October–November 1965): 62. Revised version in Gregory Battcock, ed., *Minimal Art: A Critical Anthology* (New York: E.P. Dutton, 1968), pp. 274–97.

137. Reproduced in Jay Belloli and Emily S. Rauh, *Dan Flavin: Drawings, Diagrams and Prints 1972–1975* (Fort Worth: Fort Worth Art Museum, 1977), p. 23.

138. Dan Flavin, "' . . . In Daylight or Cool White,'" *Artforum*, vol. 4, no. 4 (December 1965): 24. One reviewer was not so sure about this. "The situation of the tilted light rods does

not seem to affect actual space very radically.... There is not much spatial interest generated." Emily Wasserman, "New York," *Artforum*, vol. 6, no. 4 (December 1967): 59.

139. F[actor], "Los Angeles," p. 13.

140. John Coplans, "Serial Imagery," *Artforum*, vol. 7, no. 2 (October 1968): 40. See also John Coplans, "The New Sculpture and Technology," in Maurice Tuchman, ed., *American Sculpture of the Sixties* (Los Angeles: Los Angeles County Museum of Art, 1967), p. 23.

141. Morris, "Notes on Sculpture, Part 2," p. 21.

142. Friedman, "Robert Morris: Polemics and Cubes," p. 23. See the discussion of real versus virtual space in Michelson, "Robert Morris—An Aesthetics of Transgression," pp. 35–43.

143. Lippard, "New York" (March 1964), p. 19.

144. James R. Mellow, "'Everything Sculpture Has, My Work Doesn't,'" *New York Times*, 10 March 1968, sec. 2, p. 26.

145. Morris, "Notes on Sculpture, Part 3," p. 26; Morris, "Notes on Sculpture, Part 2," p. 21.

146. Krauss, *Passages in Modern Sculpture*, p. 266.

147. W. Rubin, *Frank Stella*, pp. 40–41.

148. Barbara Rose, "Looking at American Sculpture," *Artforum*, vol. 3, no. 5 (February 1965): 35.

149. Morris, "Notes on Sculpture, Part 2," p. 21.

150. Max Kozloff, "A Letter to the Editor," *Art International*, vol. 7, no. 6 (June 1963): 90. Kozloff's critique maintains that "the difficulty of inert art [Minimalism] is that it refuses to motivate the spectator." Max Kozloff, "The Inert and the Frenetic," *Artforum*, vol. 4, no. 7 (March 1966): 43.

151. David Annesley, Roelof Louw, Tim Scott, and William Tucker, "Anthony Caro's Work: A Symposium by Four Sculptors," *Studio International*, vol. 177, no. 907 (January 1969): 19.

152. The extent of its effect can be seen, for example, in Douglas Crimp's 1979 discussion of contemporary representational art, based on Fried's notion of Minimalist theatricality. Douglas Crimp, "Pictures," *Art after Modernism*, ed. Brian Wallis (New York: The New Museum of Contemporary Art, 1984), pp. 175–87.

153. Fried has since claimed that he "was precisely not attacking earlier art that might be considered overtly theatrical." Michael Fried, "Theories of Art after Minimalism and Pop," in Hal Foster, ed., *Discussions in Contemporary Culture* (Seattle: Day Press, 1987), p. 57

154. Lippard, "New York" (March 1964), p. 19.

155. Corinne Robins, "Object, Structure or Sculpture: Where Are We?" *Arts Magazine*, vol. 40, no. 9 (September–October 1966): 34.

156. Krauss, *Passages in Modern Sculpture*, p. 236.

157. Telephone conversation with Fried, 1981.

158. Fried, "Art and Objecthood," p. 21.

159. Judd, "Specific Objects," p. 77.

160. "Theatre is now the negation of art." Fried, "Art and Objecthood," p. 15.

161. Michael Fried, "New York Letter," *Art International,* vol. 8, no. 1 (February 1964): 26. He continued by praising Judd's work over Varujan Boghusian's (the subject here) because of its intelligence rather than poetry.

162. Andrew Forge, "Anthony Caro Interviewed by Andrew Forge," *Studio International,* vol. 171, no. 873 (January 1966): 6.

163. Fried, "Art and Objecthood," p. 21.

164. Barbara Reise, "'Untitled 1969': A Footnote on Art and Minimal-Stylehood," *Studio International,* vol. 177, no. 910 (April 1969): 168.

165. Fried, "Art and Objecthood," pp. 15–19.

166. Forge, "Anthony Caro Interviewed by Andrew Forge," p. 6.

167. Michael Fried, *Absorption and Theatricality: Painting and Beholder in the Age of Diderot* (Berkeley: University of California Press, 1980), p. 5. See Krauss's discussion of the illusion that the viewer is not there in Rosalind Krauss, "Theories of Art after Minimalism and Pop," in Foster, ed., *Discussions in Contemporary Culture,* p. 61.

168. Fried, "Art and Objecthood," p. 22.

169. Krauss, *Passages in Modern Sculpture,* p. 200. Temporality is a central thesis in this book: "Space and time cannot be separated for purposes of analysis. . . . The history of modern sculpture is incomplete without discussion of the temporal consequences of a particular arrangement of form," p. 4.

170. Barbara Reise, "Greenberg and the Group: A Retrospective View, Part 2," *Studio International,* vol. 175, no. 901 (June 1968): 314–15.

171. John N. Chandler, "Tony Smith and Sol LeWitt: Mutations and Permutations," *Art International,* vol. 12, no. 7 (September 1968): 17.

172. Lucy R. Lippard, *Tony Smith* (New York: Harry N. Abrams, 1972), p. 20.

173. Fried, "Art and Objecthood," p. 21.

174. Clement Greenberg, "The New Sculpture," in *Art and Culture* (Boston: Beacon Press, 1961), p. 143.

175. Fried, *Three American Painters,* pp. 43–44.

176. Fried, "Shape as Form," p. 22.

177. Fried, "Art and Objecthood," p. 15.

178. Barbara Rose, *A New Aesthetic* (Washington, D.C.: Washington Gallery of Modern Art, 1967), p. 8.

179. Fried, "Art and Objecthood," p. 15.

180. On the traditional concept of aesthetic distance, see Edward Bullough, "'Psychical Distance' as a Factor in Art and an Aesthetic Principle" (1912), in George Dickie and Richard J. Sclafani, eds., *Aesthetics: A Critical Anthology* (New York: St. Martin's Press, 1977), pp. 758–82. On p. 766, specific mention is made of the loss of distance in theatre.

Although Bullough notes the distancing function of pedestals (p. 771), Minimal objects are actually more distanced than figurative sculpture with a base, because of their complete rejection of anthropomorphism.

181. Fried, *Three American Painters*, p. 35.

182. Fried, "Art and Objecthood," p. 22.

183. Fried, "Two Sculptures by Anthony Caro," p. 25.

184. Fried, "Art and Objecthood," p. 22. This particular reference to Judd appears only in the reprinted essay in Battcock's *Minimal Art*, p. 18.

185. Judd, "Specific Objects," p. 78. See also Glaser, "Questions to Stella and Judd," pp. 55–57.

186. Interview with Mangold.

187. Nodelman, "Sixties Art," p. 82.

188. Glaser, "Questions to Stella and Judd," p. 59.

189. Lucy R. Lippard, "The Silent Art," *Art in America*, vol. 55, no. 1 (January–February 1967): 63.

190. Michelson, "Robert Morris—An Aesthetics of Transgression," p. 23. Michelson notes, on p. 19, that Fried's advocacy of the nontemporal has a moral or religious ring to it, with instantaneousness or "absolute presentness" being the attribute of Divinity." This theme is later pursued in Hal Foster, "1967/1987," in Janet Kardon, *1967: At the Crossroads* (Philadelphia: Institute of Contemporary Art, University of Pennsylvania, 1987), p. 17.

191. Flavin, "Some Other Comments ... More Pages from a Spleenish Journal," p. 23.

192. Interview with LeWitt.

193. Morris, "Notes on Sculpture, Part 2," p. 23.

194. P. Tuchman, "An Interview with Carl Andre," p. 57.

195. Sylvester and Morris, "A Duologue," in Compton and Sylvester, *Robert Morris*, p. 18.

196. P. Tuchman, "An Interview with Carl Andre," p. 57.

197. Interview with Judd.

198. Interview with William Tucker, Brooklyn, N.Y., 10 November 1980.

199. James Smith Pierce, "Contemplating Parallax," *Art International*, vol. 12, no. 7 (September 1968): 21–22. Pierce meant this literally, in the sense that unlike environmental sculpture, Moore's work cannot be physically passed through.

200. Rosalind E. Krauss, *Terminal Iron Works: The Sculpture of David Smith* (Cambridge, Mass.: MIT Press, 1971), pp. 26, 181 and n. 7.

201. Krauss, *Passages in Modern Sculpture*, pp. 158–61.

202. John Coplans, "Don Judd by John Coplans," in *Don Judd* (Pasadena, Calif.: Pasadena Art Museum, 1971), p. 5.

203. John Coplans, *Five Los Angeles Sculptors* (Irvine: University of California, Art Gallery, 1966), p. 5; Rose, *A New Aesthetic*, p. 20n.24.

204. Morris, "Notes on Sculpture [Part 1]," p. 44.

205. Friedman, "Robert Morris: Polemics and Cubes," p. 23. The French critic Otto Hahn described a similar experience. A curious reversal, he explained, takes place, with a multitude of perspectives replacing the original totality of the object. Otto Hahn, "Après le Pop, Ennui," *L'Express*, 4–10 March 1968, p. 102.

206. Rudolf Arnheim, *Art and Visual Perception: The New Version* (Berkeley: University of California Press, 1974), p. 45.

207. F[actor], "Los Angeles," p. 13.

208. Arnheim, *Art and Visual Perception*, p. 5.

209. Morris, "Notes on Sculpture [Part 1]," p. 44.

210. Interview with LeWitt.

211. Sylvester and Morris, "A Duologue," in Compton and Sylvester, *Robert Morris*, p. 18.

212. Lawrence Alloway, "Serial Forms," in Maurice Tuchman, ed., *American Sculpture of the Sixties* (Los Angeles: Los Angeles County Museum of Art, 1967), p. 14.

213. Morris, "Notes on Sculpture, Part 2," p. 22; Sylvester and Morris, "A Duologue," in Compton and Sylvester, *Robert Morris*, p. 18.

214. Arnheim, *Art and Visual Perception*, p. 104.

215. M[aurice] Merleau-Ponty, *Phenomenology of Perception*, trans. Colin Smith (London: Routledge & Kegan Paul, 1962), pp. 67–69.

216. Merleau-Ponty, *Phenomenology*, p. 203. On Merleau-Ponty and Donald Judd, see Krauss, "Allusion and Illusion in Donald Judd," p. 26.

Chapter 4

1. See the author's discussion of this terminology in Frances Colpitt, "Abstraction at Eighty: Theory and Experience of Painting," in Phyllis Plous and Frances Colpitt, *Abstract Options* (Santa Barbara: University Art Museum, University of California, Santa Barbara, 1989), pp. 11–12.

2. Clement Greenberg, *Post Painterly Abstraction* (Los Angeles: Los Angeles County Museum of Art, 1964), n.p.

3. Robert Morris, "Notes on Sculpture [Part 1]," *Artforum*, vol. 4, no. 6 (February 1966): 43. Reprinted in Gregory Battcock, ed., *Minimal Art: A Critical Anthology* (New York: E.P. Dutton, 1968), pp. 222–28.

4. Naum Gabo, "Sculpture: Carving and Construction in Space," in J.L. Martin, Ben Nicholson, N[aum] Gabo, eds., *Circle* (New York: Praeger Publishers, 1971), p. 109.

5. Annette Michelson, "Robert Morris—An Aesthetics of Transgression," *Robert Morris* (Washington, D.C.: Corcoran Gallery of Art, 1969), p. 9. Increased spectator involvement is the result of the new work's being what Morris has called "less *self*-important."

Robert Morris, "Notes on Sculpture, Part 2," *Artforum*, vol. 5, no. 2 (October 1966): 23. Reprinted in Gregory Battcock, ed., *Minimal Art: A Critical Anthology* (New York: E.P. Dutton, 1968), pp. 228–35.

6. Mel Bochner, "Serial Art, Systems, Solipsism," *Minimal Art: A Critical Anthology*, ed. Gregory Battcock (New York: E.P. Dutton, 1968), p. 100. This does not appear in the original article in *Arts Magazine* (Summer 1967).

7. Sheldon Nodelman, "Sixties Art: Some Philosophical Perspectives," *Perspecta: Yale Architectural Journal* 11 (1967): 74.

8. Donald Judd, "Specific Objects," *Arts Yearbook* 8 (New York: Art Digest, 1965), pp. 76–77.

9. Diane Waldman, *Robert Mangold* (New York: Solomon R. Guggenheim Museum, 1971), n.p.

10. Barbara Rose, "Abstract Illusionism," *Artforum*, vol. 6, no. 2 (October 1967): 33; and Grégoire Müller, "Donald Judd: Ten Years," *Arts Magazine*, vol. 47, no. 4 (February 1973): 35.

11. Michael Fried, "Art and Objecthood," *Artforum*, vol. 5, no. 10 (June 1967): 12–23. Reprinted in Gregory Battcock, ed., *Minimal Art: A Critical Anthology* (New York: E.P. Dutton, 1968), pp. 116–47.

12. Michael Fried, "Shape as Form: Frank Stella's New Paintings," *Artforum*, vol. 5, no. 3 (November 1966): 18–22. Some of Fried's italics are deleted here.

13. Willis Domingo, "The Intuition of Form," *Arts Magazine*, vol. 47, no. 4 (February 1973): 44–45.

14. Rose, "Abstract Illusionism," pp. 33–37.

15. Nodelman, "Sixties Art," p. 77.

16. Fried, "Shape as Form," p. 22.

17. Clement Greenberg, "The New Sculpture," in *Art and Culture* (Boston: Beacon Press, 1961), pp. 142–43.

18. See Dan Flavin, "'... In Daylight or Cool White,'" *Artforum*, vol. 4, no. 4 (December 1965): 24; and Emily Wasserman, "New York," *Artforum*, vol. 6, no. 4 (December 1967): 59.

19. Lucy R. Lippard, "As Painting Is to Sculpture: A Changing Ratio," in Maurice Tuchman, ed., *American Sculpture of the Sixties* (Los Angeles: Los Angeles County Museum of Art, 1967), p. 32.

20. Morris, "Notes on Sculpture [Part 1]," p. 43.

21. Judd, "Specific Objects," p. 78.

22. Rosalind Krauss, "Allusion and Illusion in Donald Judd," *Artforum*, vol. 4, no. 9 (May 1966): 24–26. According to Nicolas Calas, however, "What she is saying, without perhaps realizing it, is that she had at first made a mistake." Nicolas Calas, "The Illusion of Non Illusion," *Arts Magazine*, vol. 43, no. 8 (Summer 1969): 29. See p. 229n.68.

23. Barbara Rose, *A New Aesthetic* (Washington, D.C.: Washington Gallery of Modern Art, 1967), p. 43.

24. Robert Pincus-Witten, "Fining It Down: Don Judd at Castelli," *Artforum*, vol. 8, no. 10 (June 1970): 48.

25. Robert Morris, *Robert Morris: Mirror Works 1961–78* (New York: Leo Castelli Gallery, 1979), n.p.

26. Phil Patton, "Robert Morris and the Fire Next Time," *Art News*, vol. 82, no. 10 (December 1983): 88.

27. Rose, *A New Aesthetic*, p. 43; Barbara Rose, "Sculpture, Intimacy and Perception," in Martin Friedman, *14 Sculptors: The Industrial Edge* (Minneapolis: Walker Art Center, 1969), p. 8.

28. Rudolf Arnheim, *Art and Visual Perception: The New Version* (Berkeley: University of California Press, 1974), p. 271.

29. Robert Morris, "Notes on Sculpture, Part 3: Notes and Nonsequiturs," *Artforum*, vol. 5, no. 10 (June 1967): 25.

30. Krauss, "Allusion and Illusion in Donald Judd," p. 26. Pincus-Witten, on the other hand, refers specifically to Judd's "pictorial illusionism." Pincus-Witten, "Fining It Down: Don Judd at Castelli," p. 48.

31. William C. Agee, "Unit, Series, Site: A Judd Lexicon," *Art in America*, vol. 63, no. 3 (May–June 1975): 46; Rose, *A New Aesthetic*, p. 43; and Müller, "Donald Judd: Ten Years," pp. 35–36. See also Waldman, *Robert Mangold*, n.p.

32. Quoted in Rose, *A New Aesthetic*, p. 43.

33. John Coplans, "Don Judd by John Coplans," in *Don Judd* (Pasadena, Calif.: Pasadena Art Museum, 1971), 17.

34. Müller, "Donald Judd: Ten Years," p. 36.

35. Richard Wollheim, "Minimal Art," *Arts Magazine*, vol. 39, no. 4 (January 1965): 28 (reprinted in Gregory Battcock, ed., *Minimal Art: A Critical Anthology* [New York: E.P. Dutton, 1968], pp. 387–99); and Richard Wollheim, "The Work of Art as Object," *Studio International*, vol. 180, no. 928 (December 1970): 232.

36. Sonya Rudikoff, "Language and Actuality: A Letter to Irving Sandler," *Arts*, vol. 34, no. 6 (March 1960): 25.

37. Nodelman, "Sixties Art," p. 78.

38. Tatlin's demand for "Real materials in real space" is central to Constructivist ideology, which is outlined by the Pevsner brothers in "The Realist Manifesto" of 1920. See Naum Gabo, "The Realist Manifesto," reprinted in Herschel B. Chipp, *Theories of Modern Art* (Berkeley: University of California Press, 1968) p. 328. The French *Nouveaux Réalistes*, Klein, Arman, Jean Tinguely, and César, explored an ultra- or supra-reality, closer to Hans Hofmann's "Search for the Real," in contrast to Minimalism's emphasis on the equation of real (life) objects and art objects.

39. Dore Ashton, "New York Commentary," *Studio International*, vol. 175, no. 903 (September 1968): 92.

40. R. C. Kenedy, "London Letter," *Art International,* vol. 13, no. 6 (Summer 1969): 47.

41. E. C. Goossen, *The Art of the Real: USA 1948–1968* (New York: Museum of Modern Art, 1968), p. 7. This exhibition included Andre, Judd, LeWitt, McCracken, Morris, Noland, Tony Smith, Smithson, and Stella, accompanied by, among others, Johns, Louis, Newman, Georgia O'Keeffe, Pollock, Reinhardt, Rothko, David Smith, and Still. See especially Philip Leider, "New York," *Artforum,* vol. 7, no. 1 (September 1968): 65. Leider uses Fried's argument in "Art and Objecthood" against Goossen.

42. Lawrence Alloway, "Sculpture as Cliché," *Artforum,* vol. 2, no. 4 (October 1963): 26. Kozloff uses Alloway's article to criticize Minimal sculpture. "A sculpture trying to be object-like lacks the fascinating interference of the translation process from metaphysical to literal, for it is literal to start with." Max Kozloff, "The Further Adventures of American Sculpture," *Arts Magazine,* vol. 39, no. 5 (February 1965): 26.

43. Arthur Danto, "The Artistic Enfranchisement of Real Objects: The Artworld," *Journal of Philosophy* (1964) and "The Last Work of Art: Artworks and Real Things," *Theoria* (1973), reprinted in George Dickie and Richard J. Sclafani, eds., *Aesthetics: A Critical Anthology* (New York: St. Martin's Press, 1977), pp. 24–26 and 553–54. The problem is discussed at length in the final section of this chapter.

44. Bruce Glaser, "Questions to Stella and Judd," ed. Lucy R. Lippard, *Art News,* vol. 65, no. 5 (September 1966): 58–60. Reprinted in Gregory Battcock, ed., *Minimal Art: A Critical Anthology* (New York: E.P. Dutton, 1968), pp. 148–64.

45. Robert Mangold, "Interview by Robin White," *View,* vol. 1, no. 7 (December 1978): 7.

46. Interview with Robert Mangold, New York City, 18 November 1980.

47. For example, see D[onald] J[udd], "In the Galleries," *Arts Magazine,* vol. 38, no. 7 (April 1964): 31 (a review of Flavin's exhibition); and Knute Stiles, "Thing, Act, Place: Davis, Fulton, Carrigg," *Artforum,* vol. 3, no. 4 (January 1965): 37.

48. Interview with William Tucker, Brooklyn, N.Y., 10 November 1980.

49. Müller, "Donald Judd: Ten Years," p. 36.

50. Barbara Rose, "ABC Art," *Art in America,* vol. 53, no. 5 (October–November 1965): 58. Revised version in Gregory Battcock, ed., *Minimal Art: A Critical Anthology* (New York: E.P. Dutton, 1968), pp. 274–97.

51. George Kubler, *The Shape of Time* (New Haven, Conn.: Yale University Press, 1963), pp. 39–53. Kubler distinguishes the "prime object" from the ordinary object. The former is something like a "type." Examples of prime objects are the Parthenon, the Reims portal sculptures and Raphael's Vatican frescoes.

52. See, for example, John Cage, "Jasper Johns: Stories and Ideas," reprinted in Ellen H. Johnson, *American Artists on Art from 1940 to 1980* (New York: Harper and Row, 1982), pp. 72–78.

53. S[idney] T[illim], "In the Galleries," *Arts,* vol. 34, no. 3 (December 1959): 59.

54. Judd, "Specific Objects," p. 78.

55. D[onald] J[udd], "In the Galleries," *Arts Magazine,* vol. 36, no. 10 (September 1962): 49 (Noland); "In the Galleries," *Arts Magazine,* vol. 37, no. 4 (January 1963): 44–48 (Bontecou and Klein); and "In the Galleries," *Arts Magazine,* vol. 37, no. 10 (September 1963): 55 (Stella).

56. Donald Judd, "Introduction," in *Complete Writings 1959–1975* (Halifax: Press of the Nova Scotia College of Art and Design, 1975), p. vii.

57. Judd, "Specific Objects," pp. 74–82.

58. Clair Wolfe, "Notes on Craig Kauffman," *Artforum,* vol. 3, no. 5 (February 1965): 21; and Rose, "ABC Art," p. 58.

59. Fried, "Art and Objecthood," p. 12. Fried consistently equated shape and objecthood. See his examination of Noland's work in Fried, "Shape as Form," p. 20.

60. Donald Judd, "Local History," *Arts Yearbook* 7 (New York: Art Digest, 1964), pp. 30–31.

61. E. C. Goossen, "The Artist Speaks: Robert Morris," *Art in America,* vol. 58, no. 3 (May–June 1970): 111.

62. Morris, "Notes on Sculpture [Part 1]," p. 44.

63. See, for example, Barbara Rose, "New York Letter," *Art International,* vol. 8, no. 1 (February 1964): 41; and S[idney] T[illim], "In the Galleries," *Arts Magazine,* vol. 38, no. 10 (September 1964): 63.

64. Barbara Rose, "Looking at American Sculpture," *Artforum,* vol. 3, no. 5 (February 1965): 34.

65. Jack Wesley Burnham, "Sculpture's Vanishing Base," *Artforum,* vol. 6, no. 3 (November 1967): 54. To differentiate the concerns of painters and sculptors, Nodelman called the former's work "picture-objects." Nodelman, "Sixties Art," p. 79.

66. Lucy R. Lippard, "10 Strukturisten in 20 Absätzen," *Minimal Art,* by Enno Develing and Lucy R. Lippard (Düsseldorf: Städtische Kunsthalle, 1969), p. 10. Translation in Richard Kostelanetz, ed., *Esthetics Contemporary* (Buffalo: Prometheus Books, 1978), p. 229.

67. Kynaston McShine, *Primary Structures* (New York: Jewish Museum, 1966), n.p.

68. Lucy R. Lippard, "Rejective Art," *Art International,* vol. 10, no. 8 (October 1966): 33–36. An earlier group, including Charles Biederman and Eli Bornstein, was also known as the "Structurists." See John Ernest, "Constructivism and Content," *Studio International,* vol. 171, no. 876 (April 1966): 154.

69. Interview with Sol LeWitt, New York City, 15 November 1980.

70. Lippard, "As Painting Is to Sculpture," in M. Tuchman, ed., *American Sculpture of the Sixties,* p. 31.

71. Morris, "Notes on Sculpture, Part 2," p. 21; and Morris, "Notes on Sculpture, Part 3," p. 25.

72. Robert Morris, "Anti Form," *Artforum,* vol. 6, no. 8 (April 1968): 35; Fried, "Art and Objecthood," p. 12.

73. William Tucker, "An Essay on Sculpture," *Studio International,* vol. 177, no. 907 (January 1969): 12; Garth Evans, "Sculpture and Reality," *Studio International,* vol. 177, no. 908 (February 1969): 62.

74. Clement Greenberg, "'American-Type' Painting," in *Art and Culture* (Boston: Beacon Press, 1961), pp. 208–9. Reduction, as a teleological process of modernism, was first proposed in 1940. See Clement Greenberg, "Towards a Newer Laocoon," in *The Collected Essays and Criticism, Volume I: Perceptions and Judgments, 1939–1944,* ed. John O'Brian (Chicago: University of Chicago Press, 1986), pp. 23–38.

75. Clement Greenberg, "After Abstract Expressionism," *Art International,* vol. 6, no. 8 (October 1962): 30. Greenberg subsequently clarified his position. Although he has implied "that there was such a thing as the intrinsic nature of each art ... what I meant was that this was assumed by Modernist artists themselves, & that it was a useful illusion & maybe still is, but not one I myself believed in." Letter to the author, 28 January 1981.

76. In a telephone conversation with the author, Fried said that "[Darby] Bannard, Stella and I found only one critic worth reading and that was Greenberg." He met Greenberg while a junior at college in 1957–58.

77. Michael Fried, "Theories of Art after Minimalism and Pop," in Hal Foster, ed., *Discussions in Contemporary Culture* (Seattle: Bay Press, 1987), pp. 56–57.

78. Fried, "Shape as Form," p. 27n.11.

79. Fried, "Art and Objecthood," p. 23n.4. In 1980, Greenberg too claimed that modernist painting definitively strives to maintain the quality level of past art. Clement Greenberg, "Modern and Post-Modern," *Arts Magazine,* vol. 54, no. 6 (February 1980): 66. No mention is made of reduction.

80. Lucy R. Lippard, *Ad Reinhardt: Paintings* (New York: Jewish Museum, 1966), p. 10.

81. Lippard, "As Painting Is to Sculpture," in M. Tuchman, ed., *American Sculpture of the Sixties,* p. 31.

82. C. Blok, "Minimal Art at The Hague," *Art International,* vol. 12, no. 5 (May 1968): 22.

83. David Bourdon, *Carl Andre: Sculpture 1959–1977* (New York: Jaap Rietman, 1978), p. 39.

84. John Perreault, "A Minimal Future? Union-Made," *Arts Magazine,* vol. 41, no. 5 (March 1967): 29–30. Perreault felt that this essence was a "mythological" concept.

85. Rose, "Looking at American Sculpture," p. 35. In 1979, Rose claimed that *"illusion, not flatness, is the essence of painting."* Barbara Rose, *American Painting: The Eighties* (New York: Vista Press, 1979), n.p.

86. Glaser, "Questions to Stella and Judd," p. 55.

87. Phyllis Tuchman, "An Interview with Carl Andre," *Artforum,* vol. 8, no. 10 (June 1970): 57.

88. Morris, "Notes on Sculpture [Part 1]," p. 44.

89. Max Kozloff, "Abstract Attrition," *Arts Magazine,* vol. 39, no. 4 (January 1965): 47.

90. John Coplans, "Don Judd: An Interview with John Coplans," in *Don Judd* (Pasadena, Calif.: Pasadena Art Museum, 1971), p. 44.

91. Glaser, "Questions to Stella and Judd," p. 58.

92. Enno Develing, *Carl Andre* (The Hague: Gemeentemuseum, 1969), p. 39.

93. Thomas B. Hess, *Barnett Newman* (New York: Walker and Co., 1969), p. 31.

94. Wollheim, "Minimal Art," pp. 30–32.

95. Donald Judd, unpublished transcript of symposium (Jewish Museum, 1966), reprinted in Rose, *A New Aesthetic,* p. 18n.2. See also Judd, "Specific Objects," p. 82.

96. Judd, statement in McShine, *Primary Structures,* n.p.

97. Interview with John McCracken, Santa Barbara, Calif., 28 May 1980.

98. Interview with Robert Murray, New York City, 18 November 1980.

99. Interview with LeWitt.

100. Interview with Kenneth Noland, South Salem, N.Y., 14 November 1980.

101. Glaser, "Questions to Stella and Judd," pp. 59–60.

102. Barbara Rose, "Post-Cubist Sculpture," in Maurice Tuchman, ed., *American Sculpture of the Sixties* (Los Angeles: Los Angeles County Museum of Art, 1967), p. 39.

103. P. Tuchman, "An Interview with Carl Andre," p. 59. "What I was describing was a kind of catharsis *I* had to undergo in order to make art of any worth; not to get rid of culture, but the dross in *me*." Letter to the author, 24 March 1989.

104. Interview with Carl Andre, New York City, 4 November 1980.

105. A revised version of this and the following section was published by the author as "The Issue of Boredom: Is It Interesting?" *Journal of Aesthetics and Art Criticism,* vol. 43, no. 4 (Summer 1985): 359–65.

106. Judd, "Specific Objects," p. 78; and Rose, "ABC Art," p. 65. This and other references to boredom were eliminated in the essay in Battcock's *Minimal Art* anthology.

107. James R. Mellow, "'Everything Sculpture Has, My Work Doesn't,'" *New York Times,* 10 March 1968, sec. 2, p. 21.

108. Blok, "Minimal Art at The Hague," p. 22.

109. Amy Goldin, "McLuhan's Message: Participate, Enjoy!," *Arts Magazine,* vol. 40, no. 7 (May 1966): 30.

110. Clement Greenberg, "Recentness of Sculpture," in Maurice Tuchman, ed., *American Sculpture of the Sixties* (Los Angeles: Los Angeles County Museum of Art, 1967), p. 24.

111. Max Kozloff, "New York Letter," *Art International,* vol. 8, no. 3 (April 1964): 64.

112. Brian O'Doherty, "Frank Stella and a Crisis of Nothingness," *New York Times,* 19 January 1964, sec. 2, p. 21.

113. William Rubin, *Frank Stella* (New York: Museum of Modern Art, 1970), p. 31.

114. Barbara Cavaliere, "Drawings," *Arts Magazine,* vol. 55, no. 6 (February 1981): 32. Morris's drawing was classified "Most Careless."

115. Goldin, "McLuhan's Message: Participate, Enjoy!," p. 30.

116. Rose, "ABC Art," p. 65.

117. Interview with LeWitt, who is here paraphrasing Stella's famous "What you see is what you see."

118. Morris, "Notes on Sculpture, Part 3," p. 29.

119. John Perreault, "Art: Pulling Out the Rug," *Village Voice,* 16 May 1968, p. 15.

120. Michael Benedikt, "New York Letter," *Art International,* vol. 9, nos. 9–10 (December 1965): 41.

121. Irving Sandler, "The New Cool-Art," *Art in America*, vol. 53, no. 1 (February 1965): 101.

122. Morris, "Notes on Sculpture, Part 2," p. 23.

123. Susan Sontag, *Against Interpretation and Other Essays* (New York: Noonday Press, 1966), p. 303.

124. Perreault, "A Minimal Future? Union-Made," p. 30.

125. Blok, "Minimal Art at The Hague," p. 22.

126. Rose, "ABC Art," p. 62.

127. Rolf-Gunter Dienst, "A propos Primary Structures," *Arts Magazine*, vol. 40, no. 8 (June 1966): 13.

128. Hilton Kramer, "'Primary Structures'—The New Anonymity," *New York Times*, 1 May 1966, sec. 2, p. 23.

129. Ed Sommer, "Prospect 68 and Kunstmarkt 68," *Art International*, vol. 13, no. 2 (February 1969): 35.

130. Lucy R. Lippard, "Excerpts," from "After a Fashion—The Group Show," in *Changing: Essays in Art Criticism* (New York: E.P. Dutton, 1971), p. 205.

131. Hilton Kramer, "An Art of Boredom?" *New York Times*, 5 June 1966, sec. 2, p. 23.

132. Hilton Kramer, "The New Line: Minimalism Is Americanism," *New York Times*, 26 March 1978, sec. D, p. 29.

133. Ad Reinhardt, *Art as Art: The Selected Writings of Ad Reinhardt*, ed. Barbara Rose (New York: Viking Press, 1975), p. 24.

134. Mel Bochner, "Parenthetical Reflections on Five Earlier Statements," *Arts Magazine*, vol. 46, no. 8 (Summer 1972): 38. Bochner has emphasized, in conversation with the author, the respect he has for both Judd's criticism and sculpture. Interview with Mel Bochner, New York City, 25 November 1980.

135. Lucy R. Lippard, "New York Letter: Recent Sculpture as Escape," *Art International*, vol. 10, no. 2 (February 1966): 50.

136. McShine, *Primary Structures*, n.p.

137. Lucy R. Lippard, "The Silent Art," *Art in America*, vol. 55, no. 1 (January–February 1967): 63.

138. Kramer, "An Art of Boredom?," p. 23.

139. Benedikt, "New York Letter" (December 1965), p. 41.

140. Sandler, "The New Cool-Art," p. 97.

141. Interview with Donald Judd, Marfa, Tex., 2–3 December 1980.

142. Interviews with the artists.

143. Michael Fried, "New York Letter," *Art International*, vol. 8, no. 1 (February 1964): 26.

144. Fried, "Shape as Form," p. 27n.8.

145. Fried, "Art and Objecthood," p. 21.

146. "A Symposium of the Rose Institute of Fine Arts," *Art Criticism in the Sixties* (New York: October House, 1967), n.p. Participants included Rose, Fried, Kozloff, and Sidney Tillim.

147. Bruce Boice, "The Quality Problem," *Artforum*, vol. 11, no. 2 (October 1972): 68–70.

148. Don Judd, "Jackson Pollock," *Arts Magazine*, vol. 41, no. 6 (April 1967): 34.

149. Interview with Judd. See, for example, Donald Judd, "A Long Discussion Not about Master-Pieces but Why There Are So Few of Them," *Art in America*, vol. 72, no. 8 (September 1984): 9–19.

150. Fried, "Art and Objecthood," p. 21.

151. Donald Judd, "Complaints: Part I," *Studio International*, vol. 177, no. 910 (April 1969): 184.

152. Fried, "Shape as Form," p. 27n.8. Fried rarely failed to acknowledge his debt to Cavell in footnotes.

153. Interview with Noland.

154. Fried, "Shape as Form," p. 27n.8.

155. Interview with Clement Greenberg, New York City, 11 November 1980.

156. Fried, "Art and Objecthood," p. 21.

157. Boice, "The Quality Problem," p. 70.

158. Judd, "Complaints: Part I," p. 184.

159. Interview with Judd.

160. Ralph Barton Perry, "Value as Any Object of Any Interest," (1926), reprinted in Wilfrid Sellars and John Hospers, eds., *Readings in Ethical Theory* (New York: Meredith Corp., 1970), p. 138.

161. Perry, "Value as Any Object," in Sellars and Hospers, eds., *Readings in Ethical Theory*, p. 138.

162. Ralph Barton Perry, *Realms of Value* (New York: Greenwood Press, 1968), p. 7.

163. Perry, "Value as Any Object," in Sellars and Hospers, eds., *Readings in Ethical Theory*, pp. 139–43.

164. Donald W. Crawford, *Kant's Aesthetic Theory* (Madison: University of Wisconsin Press, 1974), pp. 38–39. Of course, disinterested does not mean bored. There are at least two senses of "interest" operative in this context. I only bring up disinterestedness, in contrast to Judd's notion of interesting, to emphasize the nonjudgmental nature of the Kant/Stolnitz axis.

165. Jerome Stolnitz, "The Aesthetic Attitude," in John Hospers, ed., *Introductory Readings in Aesthetics* (New York: Free Press, 1969), p. 19.

166. See especially George Dickie, "The Myth of the Aesthetic Attitude," in John Hospers, ed., *Introductory Readings in Aesthetics* (New York: Free Press, 1969), pp. 28–44.

167. Timothy Binkley, "Piece: Contra Aesthetics," in Joseph Margolis, ed., *Philosophy Looks at the Arts* (Philadelphia: Temple University Press, 1978), p. 39. Binkley is referring to the valuing of art, rather than simply, like Stolnitz, to the experiencing of art.

168. Richard W. Lind, "Attention and the Aesthetic Attitude," *Journal of Aesthetics and Art Criticism*, vol. 39, no. 2 (Winter 1980): 132. Lind maintains that the experiencing of an aesthetic object is one of "motive attraction" (p. 134). This recalls Perry's "motor-affective attitude" (from D. W. Prall) as characteristic of an act of interest. Perry, "Value as Any Object," in Sellars and Hospers, eds., *Readings in Ethical Theory*, p. 139.

169. Lind's response is to the author's original argument. Richard Lind, "Why Isn't Minimal Art Boring?" *Journal of Aesthetics and Art Criticism*, vol. 45, no. 2 (Winter 1986): 196.

170. Lind, "Attention and the Aesthetic Attitude," pp. 136–39.

171. Roger Fry, *Vision and Design* (Cleveland: World Publishing Co., 1920), p. 237.

172. Greenberg, "After Abstract Expressionism," p. 30.

173. Wollheim, "Minimal Art," pp. 31–32.

174. Judd, "Specific Objects," p. 78.

175. Dan Flavin, "Some Remarks . . . Excerpts from a Spleenish Journal," *Artforum*, vol. 5, no. 4 (December 1966): 27.

176. Fried, "Art and Objecthood," p. 21.

177. Allan Kaprow, "Letters," *Artforum*, vol. 6, no. 1 (September 1967): 4.

178. David Sylvester and Robert Morris, "A Duologue," in Michael Compton and David Sylvester, *Robert Morris* (London: Tate Gallery, 1971), p. 16.

179. Glaser, "Questions to Stella and Judd," p. 61.

180. D[onald] J[udd], "In the Galleries," *Arts Magazine*, vol. 37, nos. 8–9 (May–June 1963): 110.

181. Donald Judd, "Black, White and Gray," *Arts Magazine*, vol. 38, no. 6 (March 1964): 37.

182. Judd, "Specific Objects," p. 78.

183. Interview with McCracken.

184. Lucy R. Lippard, "The Structures, the Structures and the Wall Drawings, the Structures and the Wall Drawings and the Books," in Alicia Legg, ed., *Sol LeWitt* (New York: Museum of Modern Art, 1978), p. 28.

185. Morris, "Notes on Sculpture, Part 3," p. 29.

186. Sylvester and Morris, "A Duologue," in Compton and Sylvester, *Robert Morris*, p. 16.

187. Rosalind E. Krauss, *Passages in Modern Sculpture* (New York: Viking Press, 1977), p. 254.

188. John Canaday, "Art: 'Images of Praise,' in 3 Themes," *New York Times*, 21 December 1963, p. 20.

189. Hilton Kramer, "The Emperor's New Bikini," *Art in America*, vol. 57, no. 1 (January–February 1969): 50.

190. Greenberg, "Recentness of Sculpture," pp. 24–25.

191. Fried, "Art and Objecthood," pp. 15–21.

192. Telephone conversation with Fried, 1981.

193. Fried, "Art and Objecthood," p. 23n.4. See Greenberg, "After Abstract Expressionism," p. 30.

194. Rose, "Looking at American Sculpture," p. 35.

195. Hilton Kramer, "Art: Constructed to Donald Judd's Specifications," *New York Times,* 19 February 1966, p. 23; James R. Mellow, "On Art: Hostage to the Gallery," *New Leader,* 14 March 1966, pp. 32–33.

196. Dore Ashton, "The Artist as Dissenter," *Studio International,* vol. 171, no. 876 (April 1966): 165.

197. Bochner, "Serial Art, Systems, Solipsism," p. 94. This was not the case a decade later. Kuspit claimed that in LeWitt's work "it is a purely philosophical order—the concept of order and its intellectual use or value—which makes his objects 'art.'" Donald B. Kuspit, "Sol LeWitt: The Look of Thought," *Art in America,* vol. 63, no. 5 (September–October 1975): 44.

198. D[onald] J[udd], "In the Galleries," *Arts Magazine,* vol. 39, no. 5 (February 1965): 54.

199. M[el] Bochner, "Systemic," *Arts Magazine,* vol. 41, no. 1 (November 1966): 40.

200. Michael Fried, "New York Letter," *Art International,* vol. 8, no. 3 (April 1964): 59.

201. Greenberg, "Recentness of Sculpture," p. 24.

202. L[awrence] C[ampbell], "Reviews and Previews," *Art News,* vol. 63, no. 4 (Summer 1964): 16.

203. Kramer, "The Emperor's New Bikini," p. 52.

204. Danto, "The Last Work of Art: Artworks and Real Things," p. 553.

205. Kramer, "The Emperor's New Bikini," pp. 49–50.

206. Danto, "The Last Work of Art: Artworks and Real Things," p. 560.

207. Kramer, "The Emperor's New Bikini," p. 50.

208. Mellow, "On Art: Hostage to the Gallery," p. 33.

209. Donald Judd, "Complaints: Part II," *Arts Magazine,* vol. 47, no. 5 (March 1973): 31.

210. Judd, "Black, White and Gray," p. 38.

211. Rose, "New York Letter" (February 1964), p. 41.

212. George Dickie, *Art and the Aesthetic: An Institutional Analysis* (Ithaca, N.Y.: Cornell University Press, 1974), pp. 29–35.

213. Danto, "The Artistic Enfranchisement of Real Objects: The Artworld," pp. 23–29.

214. Danto, "The Last Work of Art: Artworks and Real Things," p. 561.

Conclusion

1. M[el] Bochner, "Primary Structures," *Arts Magazine,* vol. 40, no. 8 (June 1966): 34.

2. Now, artists as diverse as Richard Artschwager and Richard Serra have been critically subsumed by the label of Minimalism, and others, like Truitt, Novros, Mogensen, and Murray, who were instrumental in sixties' abstraction, are overlooked because—one can only assume—they are no longer popular.

3. Lucy Lippard, *Six Years: The Dematerialization of the Art Object from 1966 to 1972* (New York: Praeger Publishers, 1973).

4. *January 5–31, 1969* (New York: Seth Siegelaub, 1969), n.p. The exhibition existed only in the form of the catalogue. The catalogue *is* the exhibition.

5. Eric Gibson, "Was Minimalist Art a Political Movement?" *The New Criterion,* vol. 5, no. 9 (May 1987): 60.

6. Hal Foster, "1967/1987," in Janet Kardon, *1967: At the Crossroads* (Philadelphia: Institute of Contemporary Art, University of Pennsylvania, 1987), p. 20; and Hal Foster, "The Future of an Illusion, or The Contemporary Artist as Cargo Cultist," *Endgame: Reference and Simulation in Recent Painting and Sculpture* (Boston: Massachusetts Institute of Technology and the Institute of Contemporary Art, 1986), p. 92.

7. Brian Wallis, "Notes on (Re)Viewing Donald Judd's Work," *Donald Judd: Eight Works in Three Dimensions* (Charlotte, N.C.: Knight Gallery, 1983), n.p.

8. Hal Foster, "The Crux of Minimalism," *Individuals: A Selected History of Contemporary Art 1945–1986,* ed. Howard Singerman (Los Angeles: Museum of Contemporary Art, 1986), p. 173. Krauss's notion of the decentering of modern sculpture, in which the spectator's body is the sculpture's subject, is similar. Rosalind E. Krauss, *Passages in Modern Sculpture* (New York: Viking Press, 1977), p. 279.

9. Hilton Kramer, "The New Line: Minimalism Is Americanism," *New York Times,* 26 March 1978, sec. D, p. 29.

10. Craig Owens, "Earthwords," *October* 10 (Fall 1979): 126.

11. Foster, "1967/1987," in Kardon, *1967,* p. 20.

12. Peter Schjeldahl, "Minimalism," *Art of Our Time: The Saatchi Collection, Volume 1* (New York: Rizzoli, 1985), p. 13.

13. Darby Bannard, "Present-Day Art and Ready-Made Styles," *Artforum,* vol. 5, no. 4 (December 1966): 33.

14. Barbara Rose, "Americans 1963," *Art International,* vol. 7, no. 7 (September 1963): 79.

15. J[ames] M[onte], "Reviews," *Artforum,* vol. 2, no. 5 (November 1963): 44.

Bibliography

Books, Catalogues, Articles, and Reviews

Agee, William C. *Don Judd*. New York: Whitney Museum of American Art, 1968.
_____ . *The Sculpture of Donald Judd*. Corpus Christi: Art Museum of South Texas, 1977.
_____ . "Unit, Series, Site: A Judd Lexicon." *Art in America*, vol. 63, no. 3 (May-June 1975):
40–49.
Aldrich, Larry. *Cool Art—1967*. Ridgefield, Conn.: The Aldrich Museum of Contemporary Art,
1968.
Alloway, Lawrence. "Sculpture as Cliché." *Artforum*, vol. 2, no. 4 (October 1963): 26.
_____ . *Systemic Painting*. New York: Solomon R. Guggenheim Museum, 1966. Reprinted in
Gregory Battcock, ed. *Minimal Art: A Critical Anthology*. New York: E.P. Dutton, 1968, pp.
37–60.
_____ . "Venezorama." *Art International*, vol. 6, no. 8 (October 1962): 35–36.
Andre, Carl. *Carl Andre: Sculpture 1958–1974*. Bern: Kunsthalle, 1975.
_____ . "Frank Stella: Preface to Stripe Painting." *Sixteen Americans*, ed. Dorothy C. Miller.
New York: Museum of Modern Art, 1959, p. 76.
_____ . "New in New York: Line Work." *Arts Magazine*, vol. 41, no. 7 (May 1967): 49–50.
Andre, Carl, and Frampton, Hollis. *12 Dialogues 1962–1963*. Halifax: Press of the Nova Scotia
College of Art and Design, 1981.
Annesley, Davis; Louw, Roelof; Scott, Tim; and Tucker, William. "Anthony Caro's Work: A
Symposium by Four Sculptors." *Studio International*, vol. 177, no. 907 (January 1969):
14–20.
Antin, David. "Art & Information, 1: Grey Paint, Robert Morris." *Art News*, vol. 65, no. 2 (April
1966): 22–24.
_____ . "Differences—Sames: New York 1966–1967." *Metro*, no. 13 (February 1968): 78–104.
Arnheim, Rudolf. *Art and Visual Perception: The New Version*. Berkeley: University of Califor-
nia Press, 1974.
A[shbery], J[ohn]. "Young Masters of Understatement." *Art News*, vol. 65, no. 3 (May 1966):
42, 62.
Ashton, Dore. "The 'Anti-Compositional Attitude' in Sculpture." *Studio International*, vol.
172, no. 879 (July 1966): 44–47.
_____ . "The Artist as Dissenter." *Studio International*, vol. 171, no. 876 (April 1966): 165–
67.
_____ . "Kant & Cant with Dore Ashton: The Language of Technics." *Arts Magazine*, vol. 41,
no. 7 (May 1967): 11.

————. "Marketing Techniques in the Promotion of Art." *Studio International*, vol. 172, no. 883 (November 1966): 270–73.

————. "New York Commentary." *Studio International*, vol. 175, no. 903 (September 1968): 92–93.

Baer, Jo. "Letters." *Artforum*, vol. 6, no. 1 (September 1967): 5–6.

Baker, Elizabeth C. "Judd the Obscure." *Art News*, vol. 67, no. 2 (April 1968): 44–45, 60–63.

————. "The Light Brigade." *Art News*, vol. 66, no. 1 (March 1967): 52–55.

Baker, Kenneth. "Andre in Retrospect." *Art in America*, vol. 68, no. 4 (April 1980): 88–94.

————. "Donald Judd: Past Theory." *Artforum*, vol. 15, no. 10 (Summer 1977): 46–47.

————. *Minimalism: Art of Circumstance*. New York: Abbeville Press, 1988.

Bann, Stephan. *Brice Marden: Paintings Drawings Etchings 1975–1980*. Amsterdam: Stedelijk Museum, 1981.

Bannard, Darby. "Present-Day Art and Ready-Made Styles." *Artforum*, vol. 5, no. 4 (December 1966): 30–35.

Baro, Gene. "American Sculpture: A New Scene." *Studio International*, vol. 175, no. 896 (January 1968): 10–18.

————. "British Sculpture: The Developing Scene." *Studio International*, vol. 172, no. 882 (October 1966): 171–81.

Batchelor, David. "A Small Kind of Order: Donald Judd Interviewed by David Batchelor." *Artscribe* 78 (November–December 1989): 62–67.

Battcock, Gregory. "The Art of the Real." *Arts Magazine*, vol. 42, no. 8 (June 1968): 44–47.

————, ed. *Minimal Art: A Critical Anthology*. New York: E.P. Dutton, 1968.

Beardsley, Monroe C. *Aesthetics: Problems in the Philosophy of Criticism*. New York: Harcourt, Brace & World, 1958.

Belloli, Jay, and Rauh, Emily S. *Dan Flavin: Drawings, Diagrams and Prints 1972–1975*. Fort Worth: Fort Worth Art Museum, 1977.

Benedikt, Michael. "New York Letter." *Art International*, vol. 9, nos. 9–10 (December 1965): 41.

————. "New York Letter." *Art International*, vol. 10, no. 10 (December 1966): 65.

Berger, Maurice. *Labyrinths: Robert Morris, Minimalism, and the 1960s*. New York: Harper and Row, 1989.

Blok, C. "Minimal Art at The Hague." *Art International*, vol. 12, no. 5 (May 1968): 18–24.

Bochner, Mel. "Art in Process—Structures." *Arts Magazine*, vol. 40, no. 9 (September–October 1966): 38–39.

————. "Excerpts from Speculation (1967–1970)." *Artforum*, vol. 8, no. 9 (May 1970): 70–73.

————. "Parenthetical Reflections on Five Earlier Statements." *Arts Magazine*, vol. 46, no. 8 (Summer 1972): 38.

————. "Primary Structures." *Arts Magazine*, vol. 40, no. 8 (June 1966): 32–35.

————. "Serial Art Systems: Solipsism." *Arts Magazine*, vol. 41, no. 8 (Summer 1967): 39–43. Revised as "Serial Art, Systems, Solipsism," in Gregory Battcock, ed. *Minimal Art: A Critical Anthology*. New York: E.P. Dutton, 1968, pp. 92–102.

————. "The Serial Attitude." *Artforum*, vol. 6, no. 4 (December 1967): 28–33.

————. "Systemic." *Arts Magazine*, vol. 41, no. 1 (November 1966): 40.

Boice, Bruce. "The Quality Problem." *Artforum*, vol. 11, no. 2 (October 1972): 68–70.

Bourdon, David. "The Cantilevered Rainbow." *Art News*, vol. 66, no. 4 (Summer 1967): 28–31.

————. *Carl Andre: Sculpture 1959–1977*. New York: Jaap Rietman, 1978.

————. "$E = mc^2$ à Go-Go." *Art News*, vol. 64, no. 9 (January 1966): 22–25.

————. "The Razed Sites of Carl Andre." *Artforum*, vol. 5, no. 2 (October 1966): 14–17. Reprinted in Gregory Battcock, ed. *Minimal Art, A Critical Anthology*. New York: E.P. Dutton, 1968, pp. 103–8.

Buchloh, Benjamin H. D. "The Primary Colors for the Second Time: A Paradigm Repetition of the Neo-Avant-Garde." *October* 37 (Summer 1986): 41–52.

Burnham, Jack. *Beyond Modern Sculpture*. New York: George Braziller, 1968.

_____. "A Dan Flavin Retrospective in Ottawa." *Artforum*, vol. 8, no. 4 (December 1969): 48–55.

_____. "On Being Sculpture." *Artforum*, vol. 7, no. 9 (May 1969): 44–49.

_____. "Robert Morris: Retrospective in Detroit." *Artforum*, vol. 8, no. 7 (March 1970): 67–75.

_____. "Sculpture's Vanishing Base." *Artforum*, vol. 6, no. 3 (November 1967): 47–55. Reprinted in *Beyond Modern Sculpture*. New York: George Braziller, 1968.

Calas, Nicolas. "Art & Strategy." *Arts Magazine*, vol. 43, no. 5 (March 1969): 36–38.

_____. "The Illusion of Non Illusion." *Arts Magazine*, vol. 43, no. 8 (Summer 1969): 28–31.

Carlson, Prudence. "Donald Judd's Equivocal Objects." *Art in America*, vol. 72, no. 1 (January 1984): 114–18.

Carmean, E. A., Jr. *The Great Decade of American Abstraction: Modernist Art 1960 to 1970.* Houston: Museum of Fine Arts, 1974.

Castle, Fredrick. "What's That, the '68 Stella? Wow!" *Art News*, vol. 66, no. 9 (January 1968): 46–47.

Cavaliere, Barbara. "Drawings." *Arts Magazine*, vol. 55, no. 6 (February 1981): 32.

Celant, Germano. *Das Bild einer Geschichte 1956/1976: Die Sammlung Panza di Biumo.* Milan, Italy: Gruppo Editoriale Electa, 1980.

Chandler, John N. "Tony Smith and Sol LeWitt: Mutations and Permutations." *Art International*, vol. 12, no. 7 (September 1968): 16–19.

Chipp, Herschel B. *Theories of Modern Art.* Berkeley: University of California Press, 1968.

Colpitt, Frances. "Abstraction at Eighty: Theory and Experience of Painting." In *Abstract Options*, by Phyllis Plous and Frances Colpitt. Santa Barbara: University Art Museum, University of California, Santa Barbara, 1989.

_____. "The Issue of Boredom: Is It Interesting?" *Journal of Aesthetics and Art Criticism*, vol. 43, no. 4 (Summer 1985): 359–65.

_____. "John McCracken at Flow Ace." *Art in America*, vol. 74, no. 1 (January 1986): 141.

Compton, Michael, and Sylvester, David. *Robert Morris.* London: Tate Gallery, 1971.

Cone, Jane Harrison. "In the Galleries." *Arts Magazine*, vol. 38, no. 6 (March 1964): 67.

_____. "Judd at the Whitney." *Artforum*, vol. 6, no. 9 (May 1968): 36–39.

Coplans, John. *Don Judd.* Pasadena, Calif.: Pasadena Art Museum, 1971.

_____. "5 Los Angeles Sculptors at Irvine." *Artforum*, vol. 4, no. 6 (February 1966): 33–36. Revised version of catalogue essay, *Five Los Angeles Sculptors.* Irvine: University of California, Art Gallery, 1966.

_____. "Post-Painterly Abstraction." *Artforum*, vol. 2, no. 12 (Summer 1964): 4–9.

_____. "Serial Imagery." *Artforum*, vol. 7, no. 2 (October 1968): 34–43. Reprinted from *Serial Imagery.* Pasadena, Calif.: Pasadena Art Museum, 1968.

Craig-Martin, Michael. *Minimalism.* Liverpool: Tate Gallery, 1989.

Crawford, Donald W. *Kant's Aesthetic Theory.* Madison: University of Wisconsin Press, 1974.

Crimp, Douglas. "Pictures." *Art after Modernism*, ed. Brian Wallis. New York: The New Museum of Contemporary Art, 1984.

Crone, Rainer F. *Numerals 1924–1977.* New Haven, Conn.: Yale University Art Gallery, 1978.

Dabrowski, Magdalena. *Contrasts of Form: Geometric Abstract Art 1910–1980.* New York: Museum of Modern Art, 1985.

Danieli, Fidel A. "Bell's Progress." *Artforum*, vol. 5, no. 10 (June 1967): 68–71.

Danoff, I. Michael. *Emergence and Progression: Six Contemporary American Artists.* Milwaukee: New Milwaukee Art Center, 1979.

Davies, Hugh Marlais. "Interview with Donald Lippincott." *Artist & Fabricator*. Amherst: Fine Arts Gallery, University of Massachusetts, 1975.

Davis, Douglas. "The Dimensions of the Miniarts." *Art in America*, vol. 55, no. 6 (November-December 1967): 84–91.

Detroit. Archives of American Art. Leo Castelli Gallery, New York, Papers: 1958–1968.

Develing, Enno. *Carl Andre*. The Hague: Gemeentemeuseum, 1969.

Develing, Enno, and Lippard, Lucy R. *Minimal Art*. Dusseldorf: Städtische Kunsthalle, 1969.

Dickie, George. *Art and the Aesthetic: An Institutional Analysis*. Ithaca, New York: Cornell University Press, 1974.

Dickie, George, and Sclafani, Richard J., eds. *Aesthetics: A Critical Anthology*. New York: St. Martin's Press, 1977.

Dienst, Rolf-Gunter. "Absolut Malerei: Zu Einer Kunst der Reduction und Differenzierung." *Kunstwerk*, vol 34, no. 4 (1981): 3–48.

————. "A propos Primary Structures." *Arts Magazine*, vol. 40, no. 8 (June 1966): 13.

Domingo, Willis. "The Intuition of Form." *Arts Magazine*, vol. 47, no. 4 (February 1973): 43–47.

Dwan Gallery. *10*. New York: Dwan Gallery, 1966.

Ernest, John. "Constructivism and Content." *Studio International*, vol. 171, no. 876 (April 1966): 148–56.

Evans, Garth. "Sculpture and Reality." *Studio International*, vol. 177, no. 908 (February 1969): 61–62.

Fineberg, Jonathan. "Robert Morris Looking Back." *Arts Magazine*, vol. 55, no. 1 (September 1980): 110–15.

Flavin, Dan. "' . . . In Daylight or Cool White.'" *Artforum*, vol. 4, no. 4 (December 1965): 21–24.

————. "Several More Remarks . . . " *Studio International*, vol. 177, no. 910 (April 1969): 173–75.

————. "Some Other Comments . . . More Pages from a Spleenish Journal." *Artforum*, vol. 6, no. 4 (December 1967): 20–25.

————. "Some Remarks . . . Excerpts from a Spleenish Journal." *Artforum*, vol. 5, no. 4 (December 1966): 27–29.

Foley, Suzanne. *Unitary Forms*. San Francisco: San Francisco Museum of Art, 1970.

Forge, Andrew. "Anthony Caro Interviewed by Andrew Forge." *Studio International*, vol. 171, no. 873 (January 1966): 6–9.

Foster, Hal. "The Crux of Minimalism." *Individuals: A Selected History of Contemporary Art 1945–1986*, ed. Howard Singerman. Los Angeles: Museum of Contemporary Art, 1986, pp. 162–83.

————, ed. *Discussions in Contemporary Culture*. Seattle: Bay Press, 1987.

————. "The Future of an Illusion, or The Contemporary Artist as Cargo Cultist." *Endgame: Reference and Simulation in Recent Painting and Sculpture*. Boston: Massachusetts Institute of Technology and the Institute of Contemporary Art, 1986.

Fried, Michael. *Absorption and Theatricality: Painting and Beholder in the Age of Diderot*. Berkeley: University of California Press, 1980.

————. "Art and Objecthood." *Artforum*, vol. 5, no. 10 (June 1967): 12–23. Revised version in Gregory Battcock, ed. *Minimal Art: A Critical Anthology*. New York: E.P. Dutton, 1968, pp. 116–47.

————. *Jules Olitski: Paintings 1963–1967*. Washington, D.C.: Corcoran Gallery of Art, 1967.

————. "Jules Olitski's New Paintings." *Artforum*, vol. 4, no. 3 (November 1965): 36–40.

————. *Kenneth Noland*. New York: Jewish Museum, 1965.

_____ . "Modernist Painting and Formal Criticism." *American Scholar*, vol. 33, no. 4 (Autumn 1964): 642–48.

_____ . "New York Letter." *Art International*, vol. 7, no. 4 (April 1963): 56.

_____ . "New York Letter." *Art International*, vol. 7, no. 5 (May 1963): 69–70.

_____ . "New York Letter." *Art International*, vol. 8, no. 1 (February 1964): 26.

_____ . "New York Letter." *Art International*, vol. 8, no. 3 (April 1964): 57–59.

_____ . "New York Letter." *Art International*, vol. 8, nos. 5–6 (Summer 1964): 82.

_____ . "Shape as Form: Frank Stella's New Paintings." *Artforum*, vol. 5, no. 3 (November 1966): 18–27. Reprinted from *Frank Stella*. Pasadena, Calif.: Pasadena Art Museum, 1966.

_____ . *Three American Painters*. Cambridge, Mass.: Fogg Art Museum, Harvard University, 1965.

_____ . "Two Sculptures by Anthony Caro." *Artforum*, vol. 6, no. 6 (February 1968): 24–25.

Friedman, Martin. *Eight Sculptors: The Ambiguous Image*. Minneapolis: Walker Art Center, 1966.

_____ . *14 Sculptors: The Industrial Edge*. Minneapolis: Walker Art Center, 1969.

_____ . "The Nart-Art of Donald Judd." *Art and Artists*, vol. 1, no. 11 (February 1967): 59–61. Reprinted from *Eight Sculptors: The Ambiguous Image*. Minneapolis: Walker Art Center, 1969.

_____ . "Robert Morris: Polemics and Cubes." *Art International*, vol. 10, no. 10 (December 1966): 23–24. Revised version in *Eight Sculptors: The Ambiguous Image*. Minneapolis: Walker Art Center, 1969.

Fry, Edward F. "Poons: A Clean and Balanced World?" *Art News*, vol. 65, no. 10 (February 1967): 34–35.

_____ . "Sculpture of the Sixties." *Art in America*, vol. 55, no. 5 (September-October 1967): 26–43.

Fry, Roger. *Transformations*. London: Chatto & Windus, 1926.

_____ . *Vision and Design*. Cleveland: World Publishing Co., 1920.

Gablik, Suzi. "Don Judd: Drawings 1956–1976." *Studio International*, vol. 193, no. 985 (January–February 1977): 64–65.

_____ . "Minimalism." *Concepts of Modern Art*, ed. Nikos Stangos. New York: Harper and Row, 1981, pp. 244–55.

Geist, Sidney. "Color It Sculpture." *Arts Yearbook* 8 (New York: Art Digest, 1965): 91–98.

Geldzahler, Henry. *New York Paintings and Sculpture: 1940–1970*. New York: E.P. Dutton, 1969.

Gibson, Eric. "Was Minimalist Art a Political Movement?" *The New Criterion*, vol. 5, no. 9 (May 1987): 59–64.

Glaser, Bruce. "Questions to Stella and Judd," ed. Lucy R. Lippard, *Art News*, vol. 65, no. 5 (September 1966): 55–61. Reprinted in Gregory Battcock, ed. *Minimal Art: A Critical Anthology*. New York: E.P. Dutton, 1968, pp. 148–64.

Glueck, Grace. "No Place to Hide." *New York Times*, 27 November 1966, sec. 2, p. 19.

_____ . "Thinking Pink with a Plankster." *New York Times*, 23 April 1967, p. 32.

Goldin, Amy. "The Anti-Hierarchical American." *Art News*, vol. 66, no. 5 (September 1967): 48–50, 64–65.

_____ . "Art in a Hairshirt." *Art News*, vol. 65, no. 10 (February 1967): 26, 65–68.

_____ . "McLuhan's Message: Participate, Enjoy!" *Arts Magazine*, vol. 40, no. 7 (May 1966): 27–31.

_____ . "A Note on Opticality." *Arts Magazine*, vol. 40, no. 7 (May 1966): 53–54.

_____ . "Requiem for a Gallery." *Arts Magazine*, vol. 40, no. 3 (January 1966): 25–29.

Goldwater, Robert. "Problems of Criticism, I." *Artforum*, vol. 6, no. 1 (September 1967): 40–41.

Goossen, E. C. *The Art of the Real: USA 1948–1968*. New York: Museum of Modern Art, 1968.

———. "The Artist Speaks: Robert Morris." *Art in America*, vol. 58, no. 3 (May–June 1970): 104–11.

———. *Ellsworth Kelly*. New York: Museum of Modern Art, 1972.

Graham, Dan. "A Minimal Future? Models and Monuments." *Arts Magazine*, vol. 41, no. 5 (March 1967): 32–34.

Greenberg, Clement. "After Abstract Expressionism." *Art International*, vol. 6, no. 8 (October 1962): 24–32.

———. "Anthony Caro." *Arts Yearbook* 8 (New York: Art Digest, 1965): 106–9.

———. *Art and Culture*. Boston: Beacon Press, 1961.

———. "Changee." *Vogue*, vol. 151, no. 9 (May 1968): 212–13.

———. *The Collected Essays and Criticism Volume I: Perceptions and Judgments, 1939–1944*, ed. John O'Brian. Chicago: University of Chicago Press, 1986.

———. "How Art Writing Earns Its Bad Name." *Encounter*, vol. 19, no. 6 (December 1962): 67–71.

———. "Modernist Painting." *Arts Yearbook* 4 (New York: Art Digest, 1961): 100–108.

———. "Modern and Post-Modern." *Arts Magazine*, vol. 54, no. 6 (February 1980): 64–66.

———. *Post Painterly Abstraction*. Los Angeles: Los Angeles County Museum of Art, 1964.

———. "Problems of Criticism, II: Complaints of an Art Critic." *Artforum*, vol. 6, no. 2 (October 1967): 38–39.

Hahn, Otto. "Après le Pop, Ennui." *L'Express*, 4–10 March 1968, p. 102.

———. "Ingres and Primary Structure." *Arts Magazine*, vol. 42, no. 4 (February 1968): 24–26.

Harrison, Charles. "Notes towards Art Work." *Studio International*, vol. 179, no. 919 (February 1970): 42–43.

Haskell, Barbara. *BLAM! The Explosion of Pop, Minimalism, and Performance, 1958–1964*. New York: Whitney Museum of American Art, 1984.

———. *Donald Judd*. New York: Whitney Museum of American Art, 1988.

———. *Jo Baer*. New York: Whitney Museum of American Art, 1975.

Heller, Ben. *Toward a New Abstraction*. New York: Jewish Museum, 1963.

Hess, Thomas B. *Barnett Newman*. New York: Walker and Co., 1969.

Hobbs, Robert. *Robert Smithson: Sculpture*. Ithaca, N.Y.: Cornell University Press, 1981.

Hopps, Walter. *Anne Truitt: Sculpture and Drawings 1961–1973*. Washington, D.C.: Corcoran Gallery of Art, 1974.

———. *United States of America: VIII São Paulo Biennial*. Pasadena, Calif.: Pasadena Art Museum, 1965.

Hospers, John, ed. *Introductory Readings in Aesthetics*. New York: Free Press, 1969.

Hudson, Andrew. "Scale as Content: Bladen, Newman, Smith at the Corcoran." *Artforum*, vol. 6, no. 4 (December 1967): 46–47.

Hunter, Sam. *Tony Smith*. New York: Pace Gallery, 1979.

Hutchinson, Peter. "The Critics' Art of Labeling: A Minimal Future." *Arts Magazine*, vol. 41, no. 7 (May 1967): 19–20.

———. "Science-Fiction: An Aesthetic for Science." *Art International*, vol. 12, no. 8 (20 October 1968): 32–34.

Johnson, Ellen H. *American Artists on Art from 1940 to 1980*. New York: Harper and Row, 1982.

Judd, Donald. "Barnett Newman." *Studio International*, vol. 179, no. 919 (February 1970): 66–69.

———. "Black, White and Gray." *Arts Magazine*, vol. 38, no. 6 (March 1964): 36–38.

———. "Chamberlain: Another View." *Art International*, vol. 7, no. 10 (Christmas 1963–64): 38–39.

_____ . "Complaints: Part I." *Studio International*, vol. 177, no. 910 (April 1969): 182–85.

_____ . "Complaints: Part II." *Arts Magazine*, vol. 47, no. 5 (March 1973): 30–32.

_____ . *Complete Writings 1959–1975*. Halifax: Press of the Nova Scotia College of Art and Design, 1975.

_____ . *Complete Writings: 1975–1986*. Eindhoven, Netherlands: Van Abbemuseum, 1987.

_____ . "Jackson Pollock." *Arts Magazine*, vol. 41, no. 6 (April 1967): 32–35.

_____ . "Lee Bontecou." *Arts Magazine*, vol. 39, no. 7 (April 1965): 16–21.

_____ . "Local History." *Arts Yearbook* 7 (New York: Art Digest, 1964): 23–35.

_____ . "A Long Discussion Not about Master-Pieces but Why There Are So Few of Them." *Art in America*, vol. 72, no. 8 (September 1984): 9–19.

_____ . *Donald Judd: Skulpturen*. Bern, Switzerland: Kunsthalle, 1976.

_____ . "Specific Objects." *Arts Yearbook* 8 (New York: Art Digest, 1965): 74–82.

_____ . *Zeichnungen/Drawings 1956–1976*. Basel, Switzerland: Kunstmuseum, 1976.

Kaprow, Allan. "Letters." *Artforum*, vol. 6, no. 1 (September 1967): 4.

Kardon, Janet. *1967: At the Crossroads*. Philadelphia: Institute of Contemporary Art, University of Pennsylvania, 1987.

Kenedy, R. C. "London Letter." *Art International*, vol. 13, no. 6 (Summer 1969): 47.

King, Philip; Scott, Tim; Annesley, David; Turnbull, William. "Colour in Sculpture." *Studio International*, vol. 177, no. 907 (January 1969): 21–24.

Knight, Christopher. *Art of the Sixties and Seventies: The Panza Collection*. New York: Rizzoli, 1987.

Köhler, Wolfgang. *Gestalt Psychology*. New York: New American Library, 1975.

Kozloff, Max. "Abstract Attrition." *Arts Magazine*, vol. 39, no. 4 (January 1965): 47–50.

_____ . "The Further Adventures of American Sculpture." *Arts Magazine*, vol. 39, no. 5 (February 1965): 24–31.

_____ . "The Inert and the Frenetic." *Artforum*, vol. 4, no. 7 (March 1966): 40–44.

_____ . "A Letter to the Editor." *Art International*, vol. 7, no. 6 (June 1963): 88–92.

_____ . "New York Letter." *Art International*, vol. 8, no. 3 (April 1964): 64.

_____ . "Problems of Criticism, III." *Artforum*, vol. 6, no. 4 (December 1967): 42–45.

Kramer, Hilton. "Art: Constructed to Donald Judd's Specifications." *New York Times*, 19 February 1966, p. 23.

_____ . "Art: Reshaping the Outermost Limits." *New York Times*, 28 April 1966, p. 48.

_____ . "Art Centers: New York, the Season Surveyed." *Art in America*, 3 (1964): 112.

_____ . "An Art of Boredom?" *New York Times*, 5 June 1966, sec. 2, p. 23.

_____ . "Constructing the Absolute." *Arts*, vol. 34, no. 8 (May 1960): 36–42.

_____ . "A Critic on the Side of History: Notes on Clement Greenberg." *Arts Magazine*, vol. 37, no. 1 (October 1962): 60–63.

_____ . "The Emperor's New Bikini." *Art in America*, vol. 57, no. 1 (January–February 1969): 49–55.

_____ . "The New Line: Minimalism Is Americanism." *New York Times*, 26 March 1978, sec. D, p. 29.

_____ . "A Nostalgia for the Future." *New York Times*, 7 May 1967, sec. 2, p. 25.

_____ . "'Primary Structures'—The New Anonymity." *New York Times*, 1 May 1966, sec. 2, p. 23.

_____ . "Sculpture: A Stunning Display of Radical Changes." *New York Times*, 28 April 1967, p. 38.

_____ . "'Systemic Painting': An Art for Critics." *New York Times*, 18 September 1966, sec. 2, p. 33.

Krauss, Rosalind. "Allusion and Illusion in Donald Judd." *Artforum*, vol. 4, no. 9 (May 1966): 24–26.

_____ . "On Frontality." *Artforum*, vol. 6, no. 9 (May 1968): 40–46.

_____ . *The Originality of the Avant-Garde and Other Modernist Myths*. Cambridge, Mass.: MIT Press, 1985.

_____ . *Passages in Modern Sculpture*. New York: Viking Press, 1977.

_____ . "Robert Mangold: An Interview." *Artforum*, vol. 12, no. 6 (March 1974): 36–38.

_____ . "Sense and Sensibility: Reflections on Post 60's Sculpture." *Artforum*, vol. 12, no. 3 (November 1973): 43–53.

_____ . *Terminal Iron Works: The Sculpture of David Smith*. Cambridge, Mass.: MIT Press, 1971.

Kubler, George. *The Shape of Time*. New Haven, Conn.: Yale University Press, 1963.

Kurtz, Bruce. "Last Call at Max's." *Artforum*, vol. 19, no. 8 (April 1981): 26–29.

Kuspit, Donald B. "The Ars Moriendi according to Robert Morris." *Robert Morris: Works of the Eighties*. Newport Beach, Calif.: Newport Harbor Art Museum, 1985.

_____ . "The Artist (Neo-Dandy) Stripped Bare by His Critic (Neo-Careerist), Almost." *Arts Magazine*, vol. 54, no. 9 (May 1980): 134–37.

_____ . *Clement Greenberg: Art Critic*. Madison: University of Wisconsin Press, 1979.

_____ . "Donald Judd." *Artforum*, vol. 23, no. 5 (February 1985): 92–93.

_____ . "Red Desert & Arctic Dreams." *Art in America*, vol. 77, no. 3 (March 1989): 120–25.

_____ . "Sol LeWitt: The Look of Thought." *Art in America*, vol. 63, no. 5 (September–October 1975): 43–49.

Lebeer, Paul. "Le Minimal Art ou le Rasoir d'Occam." *XXe Siècle*, vol. 35, no. 41 (December 1973): 141–45.

Lee, David. "Serial Rights." *Art News*, vol. 66, no. 8 (December 1967): 42–45.

Leering, J[ean]. *Don Judd*. Eindhoven, Netherlands: Van Abbemuseum, 1970.

_____ . *Robert Morris*. Eindhoven, Netherlands: Van Abbemuseum, 1968.

Leffingwell, Edward. *Heroic Stance: The Sculpture of John McCracken*. Long Island City: P.S. 1, 1987.

Legg, Alicia, ed. *Sol LeWitt*. New York: Museum of Modern Art, 1978.

Leider, Philip. "American Sculpture at the Los Angeles County Museum of Art." *Artforum*, vol. 5, no. 10 (June 1966): 6–11.

_____ . "Books." *Artforum*, vol. 4, no. 2 (October 1965): 44–45.

_____ . "The Flavin Case." *New York Times*, 24 November 1968, sec. 2, p. 27.

_____ . "Literalism and Abstraction: Frank Stella's Retrospective at the Modern." *Artforum*, vol. 8, no. 8 (April 1970): 44–51.

_____ . "New York." *Artforum*, vol. 7, no. 1 (September 1968): 65.

_____ . *Stella since 1970*. Fort Worth, Tex.: Fort Worth Art Museum, 1978.

Levin, Kim. "Farewell to Modernism." *Arts Magazine*, vol. 54, no. 2 (October 1979): 90–92.

LeWitt, Sol. "Paragraphs on Conceptual Art." *Artforum*, vol. 5, no. 10 (June 1967): 79–83.

Lind, Richard W. "Attention and the Aesthetic Attitude." *Journal of Aesthetics and Art Criticism*, vol. 39, no. 2 (Winter 1980): 131–42.

_____ . "Why Isn't Minimal Art Boring?" *Journal of Aesthetics and Art Criticism*, vol. 45, no. 2 (Winter 1986): 195–97.

Lindsley, Carol. "Plastics into Art." *Art in America*, vol. 56, no. 3 (May–June 1968): 114–15.

Lippard, Lucy R. *Ad Reinhardt: Paintings*. New York: Jewish Museum, 1966.

_____ . "Change and Criticism: Consistency and Small Minds." *Art International*, vol. 11, no. 9 (November 1967): 18–20.

_____ . *Changing: Essays in Art Criticism*. New York: E.P. Dutton, 1971.

_____ . "10 Strukturisten in 20 Absätzen." *Minimal Art*, by Enno Develing and Lucy R. Lippard. Düsseldorf: Städtische Kunsthalle, 1969. Translation in Richard Kostelanetz, ed. *Esthetics Contemporary*. Buffalo: Prometheus Books, 1978, pp. 229–37.

_____ . "Escalation in Washington." *Art International*, vol. 12, no. 1 (January 1968): 42–46.

_____ . *Grids*. Philadelphia: Institute of Contemporary Art, University of Pennsylvania, 1972.

_____ . "Homage to the Square." *Art in America*, vol. 55, no. 4 (July–August 1967): 50–57.

_____. "New York." *Artforum*, vol. 2, no. 9 (March 1964): 18–19.

_____. "New York." *Artforum*, vol. 2, no. 11 (May 1964): 52–54.

_____. "New York Letter." *Art International*, vol. 9, no. 1 (February 1965): 34–37.

_____. "New York Letter." *Art International*, vol. 9, no. 2 (March 1965): 46–48.

_____. "New York Letter." *Art International*, vol. 9, no. 4 (May 1965): 52–59.

_____. "New York Letter." *Art International*, vol. 9, no. 5 (June 1965): 51–52.

_____. "New York Letter." *Art International*, vol. 10, no. 6 (Summer 1966): 108–15.

_____. "New York Letter: April–June 1965." *Art International*, vol. 9, no. 6 (September 1965): 58–60.

_____. "New York Letter: Off Color." *Art International*, vol. 10, no. 4 (April 1966): 73–79.

_____. New York Letter: Recent Sculpture as Escape." *Art International*, vol. 10, no. 2 (February 1966): 48–58.

_____. "Perverse Perspectives." *Art International*, vol. 11, no. 3 (March 1967): 28–33.

_____. "Rejective Art." *Art International*, vol. 10, no. 8 (October 1966): 33–37.

_____. "The Silent Art." *Art in America*, vol. 55, no. 1 (January–February 1967): 58–63.

_____. *Six Years: The Dematerialization of the Art Object from 1966 to 1972*. New York: Praeger Publishers, 1973.

_____. *Tony Smith*. New York: Harry N. Abrams, 1972.

_____. "Tony Smith: 'The Ineluctable Modality of the Visible.'" *Art International*, vol. 11, no. 6 (Summer 1967): 24–27.

Livingston, Jane. "Los Angeles." *Artforum*, vol. 5, no. 9 (May 1967): 62.

_____. "Los Angeles." *Artforum*, vol. 6, no. 4 (December 1967): 62–63.

Lynton, Norbert. *Minimal Art: Druckgraphik*. Hannover: Kestner-Gesellschaft, 1977.

McDonald, Robert. *Craig Kauffman: A Comprehensive Survey 1957–1980*. La Jolla, Calif.: La Jolla Museum of Contemporary Art, 1981.

McQuillan, Melissa. "The Art Criticism of Michael Fried." *Marsyas: Studies in the History of Art*, vol. 15 (1970–71): 86–102.

McShine, Kynaston. *Primary Structures*. New York: Jewish Museum, 1966.

Mangold, Robert. "Interview by Robin White." *View*, vol. 1, no. 7 (December 1978).

Marden, Brice. "Interview by Robin White." *View*, vol. 3, no. 3 (June 1980).

Margolis, Joseph, ed. *Philosophy Looks at the Arts*. Philadelphia: Temple University Press, 1978.

Marshall, Neil. *Robert Murray*. Dayton: The Dayton Art Institute, 1979.

Martin, J.L.; Nicholson, Ben; and Gabo, N[aum], eds. *Circle*. New York: Praeger Publishers, 1971.

Masheck, Joseph. "Kuspit's LeWitt: Has He Got Style?" *Art in America*, vol. 64, no. 6 (November–December 1976): 107–11.

Mayhall, Dorothy. *The Minimal Tradition*. Ridgefield, Conn.: The Aldrich Museum of Contemporary Art, 1979.

Mellow, James R. "'Everything Sculpture Has, My Work Doesn't.'" *New York Times*, 10 March 1968, sec. 2, pp. 21, 26.

_____. "New York." *Art International*, vol. 11, no. 6 (Summer 1967): 49–57.

_____. "New York Letter." *Art International*, vol. 10, no. 9 (November 1966): 58–59.

_____. "New York Letter." *Art International*, vol. 12, no. 2 (February 1968): 73–74.

_____. "On Art: Hostage to the Gallery." *New Leader*, 14 March 1966, pp. 32–33.

Merleau-Ponty, M[aurice]. *Phenomenology of Perception*, trans. Colin Smith. London: Routledge & Kegan Paul, 1962.

Michelson, Annette. "Robert Morris—An Aesthetics of Transgression." *Robert Morris*. Washington, D.C.: Corcoran Gallery of Art, 1969.

_____. "10 X 10: Concrete Reasonableness." *Artforum*, vol. 5, no. 5 (January 1967): 30–31.

Miller, Dorothy C., ed. *Sixteen Americans*. New York: Museum of Modern Art, 1959.

Monte, James K. *Mark di Suvero*. New York: Whitney Museum of American Art, 1975.

Morris, Robert. "Anti Form." *Artforum*, vol. 6, no. 8 (April 1968): 33–35.

————. "Notes on Sculpture [Part 1]." *Artforum*, vol. 4, no. 6 (February 1966): 42–44. Reprinted in Gregory Battcock, ed. *Minimal Art: A Critical Anthology*. New York: E.P. Dutton, 1968, pp. 222–28.

————. "Notes on Sculpture, Part 2." *Artforum*, vol. 5, no. 2 (October 1966): 20–23. Reprinted in Gregory Battcock, ed. *Minimal Art: A Critical Anthology*. New York: E.P. Dutton, 1968, pp. 228–35.

————. "Notes on Sculpture, Part 3: Notes and Nonsequiturs." *Artforum*, vol. 5, no. 10 (June 1967): 24–29.

————. "Notes on Sculpture, Part 4: Beyond Objects." *Artforum*, vol. 7, no. 8 (April 1969): 50–54.

————. *Robert Morris: Mirror Works 1961–78*. New York: Leo Castelli Gallery, 1979.

————. "Three Folds in the Fabric and Four Autobiographical Asides as Allegories (Or Interruptions)." *Art in America*, vol. 77, no. 11 (November 1989): 142–51.

Müller, Grégoire. "After the Ultimate." *Arts Magazine*, vol. 44, no. 5 (March 1970): 28–31.

————. "Donald Judd: Ten Years." *Arts Magazine*, vol. 47, no. 4 (February 1973): 35–42.

Murdock, Robert M. "Public Passages: David Novros." *Art in America*, vol. 73, no. 1 (January 1985): 104–10.

Newman, Barnett. "For Impassioned Criticism." *Art News*, vol. 67, no. 4 (Summer 1968): 26–27.

Nodelman, Sheldon. *Marden, Novros, Rothko: Painting in the Age of Actuality*. Houston: Institute for the Arts, Rice University, 1978.

————. "Sixties Art: Some Philosophical Perspectives." *Perspecta: The Yale Architectural Journal* 11 (1967): 73–90.

O'Doherty, Brian. "Frank Stella and a Crisis of Nothingness." *New York Times*, 19 January 1964, sec. 2, p. 21.

Owens, Craig. "Earthwords." *October* 10 (Fall 1979): 121–30.

P.S. 1, The Institute for Art and Urban Resources. *Abstract Painting: 1960–69*. Long Island City: P.S. 1, 1983.

Patton, Phil. "Robert Morris and the Fire Next Time." *Art News*, vol. 82, no. 10 (December 1983): 84–91.

Perreault, John. "Art: Pulling Out the Rug." *Village Voice*, 16 May 1968, p. 15.

————. "A Minimal Future? Union-Made." *Arts Magazine*, vol. 41, no. 5 (March 1967): 26–31.

————. "Plastic Ambiguities." *Village Voice*, 7 March 1968, p. 19.

Perrone, Jeff. "Seeing through the Boxes." *Artforum*, vol. 15, no. 3 (November 1976): 45–47.

Perry, Ralph Barton. *Realms of Value*. New York: Greenwood Press, 1968.

Picard, Lil. "Hung Up on Hang Outs." *Arts Magazine*, vol. 41, no. 3 (December 1966–January 1967): 17.

Pierce, James Smith. "Contemplating Parallax." *Art International*, vol. 12, no. 7 (September 1968): 20–24.

————. "Design and Expression in Minimal Art." *Art International*, vol. 12, no. 5 (May 1968): 25–27.

Pincus-Witten, Robert. "Fining It Down: Don Judd at Castelli." *Artforum*, vol. 8, no. 10 (June 1970): 47–49.

————. "Sol LeWitt: Word Object." *Artforum*, vol. 11, no. 6 (February 1973): 69–72.

————. "'Systemic' Painting." *Artforum*, vol. 5, no. 3 (November 1966): 42–45.

Plagens, Peter. "Present-Day Styles and Ready-Made Criticism." *Artforum*, vol. 5, no. 4 (December 1966): 36–39.

———. *Sunshine Muse*. New York: Praeger Publishers, 1974.

Poirier, Maurice. "Color-Coded Mysteries." *Art News*, vol. 84, no. 1 (January 1985): 52–61.

Poirier, Maurice, and Necol, Jane. "The '60s in Abstract: 13 Statements and an Essay." *Art in America*, vol. 71, no. 9 (October 1983): 122–37.

"Portfolio: 4 Sculptors." *Perspecta: Yale Architectural Journal* 11 (1967): 44–53.

Prokopoff, Stephen. *A Romantic Minimalism*. Philadelphia: Institute of Contemporary Art, 1967.

Rainer, Yvonne. "Don't Give the Game Away." *Arts Magazine*, vol. 41, no. 6 (April 1967): 44–47.

Ratcliff, Carter. "Art Criticism: Other Eyes, Other Minds (Part V)." *Art International*, vol. 18, no. 10 (December 1974): 53–57.

———. "Art Criticism: Other Minds, Other Eyes, Part VI (1961–73)." *Art International*, vol. 19, no. 1 (January 1975): 50–60.

———. "Frank Stella: Portrait of the Artist as an Image Administrator." *Art in America*, vol. 73, no. 2 (February 1985): 94–107.

———. *In the Realm of the Monochrome*. Chicago: Renaissance Society, University of Chicago, 1979.

———. "Mostly Monochrome." *Art in America*, vol. 69, no. 4 (April 1981): 111–31.

———. "Robert Morris: Prisoner of Modernism." *Art in America*, vol. 67, no. 6 (October 1979): 96–109.

Reinhardt, Ad. *Art as Art: The Selected Writings of Ad Reinhardt*, ed. Barbara Rose. New York: Viking Press, 1975.

Reise, Barbara. "Greenberg and the Group: A Retrospective View." *Studio International*, vol. 175, no. 900 (May 1968): 254–57.

———. "Greenberg and the Group: A Retrospective View, Part 2." *Studio International*, vol. 175, no. 901 (June 1968): 314–16.

———. "The Stance of Barnett Newman." *Studio International*, vol. 179, no. 919 (February 1970): 49–63.

———. "'Untitled 1969': A Footnote on Art and Minimal Stylehood." *Studio International*, vol. 177, no. 910 (April 1969): 166–72.

Richardson, Brenda. *Frank Stella: The Black Paintings*. Baltimore: Baltimore Museum of Art, 1976.

Robins, Corinne. "The Artist Speaks: Ronald Bladen." *Art in America*, vol. 57, no. 5 (September–October 1969): 76–81.

———. "Four Directions at Park Place." *Arts Magazine*, vol. 40, no. 8 (June 1966): 20–24.

———. "Object, Structure or Sculpture: Where Are We?" *Arts Magazine*, vol. 40, no. 9 (September–October 1966): 33–37.

Rose, Barbara. "ABC Art." *Art in America*, vol. 53, no. 5 (October–November 1965): 57–69. Revised version in Gregory Battcock, ed. *Minimal Art: A Critical Anthology* New York: E. P. Dutton, 1968, pp. 274–97.

———. "Abstract Illusionism." *Artforum*, vol. 6, no. 2 (October 1967): 33–37.

———. *American Painting: The Eighties*. New York: Vista Press, 1979.

———. "Americans 1963." *Art International*, vol. 7, no. 7 (September 1963): 77–79.

———. "Blowup—The Problem of Scale in Sculpture." *Art in America*, vol. 56, no. 4 (July–August 1968): 80–91.

———. "An Interview with Robert Murray." *Artforum*, vol. 5, no. 2 (October 1966): 45–47.

———. "Looking at American Sculpture." *Artforum*, vol. 3, no. 5 (February 1965): 29–38.

———. *A New Aesthetic*. Washington, D.C.: Washington Gallery of Modern Art, 1967.

———. "New York Letter." *Art International*, vol. 7, no. 9 (December 1963): 62–64.

———. "New York Letter." *Art International*, vol. 8, no. 1 (February 1964): 41.

———. "New York Letter." *Art International*, vol. 8, nos. 5–6 (Summer 1964): 80.

———. "Problems of Criticism, IV." *Artforum*, vol. 6, no. 6 (February 1968): 31–32.

———. "Problems of Criticism, V." *Artforum*, vol. 7, no. 5 (January 1969): 44–49.

———. "The Sculpture of Ellsworth Kelly." *Artforum*, vol. 5, no. 10 (June 1967): 51–55.

———. "Shall We Have a Renaissance?" *Art in America*, vol. 55, no. 2 (March–April 1967): 30–39.

———. "The Value of Didactic Art." *Artforum*, vol. 5, no. 8 (April 1967): 32–36.

Rose, Barbara, and Sandler, Irving. "Sensibility of the Sixties." *Art in America*, vol. 55, no. 1 (January–February 1967): 44–57.

Rose Institute of Fine Arts, Brandeis University. *Art Criticism in the Sixties*. New York: October House, 1967.

Rosenblum, Robert. "Frank Stella: Five Years of Variations on an Irreducible Theme." *Artforum*, vol. 3, no. 6 (March 1965): 21–25.

Rosenstein, Harris. "Total and Complex." *Art News*, vol. 66, no. 3 (May 1967): 52–54, 67–68.

Rubin, Edgar. *Visuell wahrgenommene Figuren*. Copenhagen, 1921.

Rubin, Lawrence. *Frank Stella, Paintings 1958 to 1965: A Catalogue Raisonné*. New York: Stewart, Tabori & Chang, 1986.

Rubin, William. *Anthony Caro*. New York: Museum of Modern Art, 1975.

———. *Frank Stella*. New York: Museum of Modern Art, 1970.

Ruda, Ed. "Park Place: 1963–1967." *Arts Magazine*, vol. 42, no. 2 (November 1967): 30–33.

Rudikoff, Sonya. "Language and Actuality: A Letter to Irving Sandler." *Arts*, vol. 34, no. 6 (March 1960): 23–25.

Sandler, Irving. *American Art of the 1960s*. New York: Harper and Row, 1988.

———. "John D. Graham: The Painter as Esthetician and Connoisseur." *Artforum*, vol. 7, no. 2 (October 1968): 50–53.

———. "The New Cool-Art." *Art in America*, vol. 53, no. 1 (February 1965): 96–101.

Schjeldahl, Peter. "Minimalism." *Art of Our Time: The Saatchi Collection, Volume 1*. New York: Rizzoli, 1985.

Scott, Tim, et al. "Colour in Sculpture." *Studio International*, vol. 177, no. 907 (January 1969): 21–24.

Seitz, William. *The Responsive Eye*. New York: Museum of Modern Art, 1965.

Sellars, Wilfrid, and Hospers, John, eds. *Readings in Ethical Theory*. New York: Meredith Corp., 1970.

Shearer, Linda. *Brice Marden*. New York: Solomon R. Guggenheim Museum, 1975.

Siegelaub, Seth. *January 5–31, 1969*. New York: Seth Siegelaub, 1969.

Skoggard, Ross. "Flavin 'According to His Lights.'" *Artforum*, vol. 15, no. 8 (April 1977): 52–54.

Smith, Brydon. *Donald Judd*. Ottawa: National Gallery of Canada, 1975.

———. *Fluorescent Light, etc. from Dan Flavin*. Ottawa: National Gallery of Canada, 1969.

Smith, Roberta. "Multiple Returns." *Art in America*, vol. 70, no. 3 (March 1982): 112–14.

Smithson, Robert. "Entropy and the New Monuments." *Artforum*, vol. 4, no. 10 (June 1966): 26–31.

———. "A Museum of Language in the Vicinity of Art." *Art International*, vol. 12, no. 3 (March 1968): 21–27.

———. *The Writings of Robert Smithson*, ed. Nancy Holt. New York: New York University Press, 1979.

Sommer, Ed. "Prospect 68 and Kunstmarkt 68." *Art International*, vol. 13, no. 2 (February 1969): 32–36.

Sontag, Susan. *Against Interpretation and Other Essays*. New York: Noonday Press, 1966.

Spector, Naomi. *Robert Ryman*. London: Whitechapel Art Gallery, 1977.

Steinberg, Leo. *Other Criteria: Confrontations with Twentieth Century Art*. London: Oxford University Press, 1972.

Stella, Frank. *Working Space*. Cambridge, Mass.: Harvard University Press, 1986.

Stiles, Knute. "Thing, Act, Place: Davis, Fulton, Carrigg." *Artforum*, vol. 3, no. 4 (January 1965): 37–40.

_____. "'Untitled '68': The San Francisco Annual Becomes an Invitational." *Artforum*, vol. 7, no. 5 (January 1969): 50–52.

Taylor, Joshua C.; Hopps, Walter; Alloway, Lawrence. *Robert Rauschenberg*. Washington, D.C.: National Collection of Fine Arts, Smithsonian Institution, 1976.

Taylor, Paul. "Interview with Donald Judd." *Flash Art* 134 (May 1987): 35–37.

Tillim, Sidney. "Art au Go-Go or, The Spirit of '65." *Arts Magazine*, vol. 39, no. 10 (September–October 1965): 38–40.

_____. "The New Avant-Garde." *Arts Magazine*, vol. 38, no. 5 (February 1964): 20–21.

_____. "New York Exhibitions: In the Galleries." *Arts Magazine*, vol. 38, no. 3 (December 1963): 62.

Tomkins, Calvin. *The Bride and the Bachelors*. New York: Penguin Books, 1976.

Truitt, Anne. *Daybook: The Journal of an Artist*. New York: Pantheon Books, 1982.

Tuchman, Maurice, ed. *American Sculpture of the Sixties*. Los Angeles: Los Angeles County Museum of Art, 1967.

_____. "The Russian Avant-Garde and the Contemporary Artist." *The Avant-Garde in Russia, 1910–1930: New Perspectives*, ed. Stephanie Barron and Maurice Tuchman. Los Angeles: Los Angeles County Museum of Art, 1980.

Tuchman, Phyllis. Forthcoming Ph.D. dissertation. Institute of Fine Arts, New York University.

_____. "Background of a Minimalist: Carl Andre." *Artforum*, vol. 16, no. 7 (March 1978): 29–33.

_____. "An Interview with Carl Andre." *Artforum*, vol. 8, no. 10 (June 1970): 55–61.

_____. "An Interview with Robert Ryman." *Artforum*, vol. 9, no. 9 (May 1971): 46–53.

_____. "Minimalism." *Three Decades: The Oliver-Hoffmann Collection*. Chicago: Museum of Contemporary Art, 1988.

_____. "Minimalism and Critical Response." *Artforum*, vol. 15, no. 9 (May 1977): 26–31.

_____. "Reflections on Minimalism." *Dokumentation 6*. Zurich, Switzerland: InK. Halle für internationale neue Kunst, n.d.

_____. "The Shapes of Prose." *Newsday*, 28 October 1988, p. 15.

_____. "Twenty Years of Purification." *The Maximal Implications of the Minimalist Line*, by Linda Weintraub. Annandale-on-Hudson, New York: Edith C. Blum Art Institute, 1985.

Tucker, Marcia. *Robert Morris*. New York: Whitney Museum of American Art, 1970.

Tucker, William. "An Essay on Sculpture." *Studio International*, vol. 177, no. 907 (January 1969): 12–13.

Tuten, Frederic. "American Sculpture of the Sixties." *Arts Magazine*, vol. 41, no. 7 (May 1967): 40–44.

Von Kageneck, C. "Minimal und Conceptual Art aus der Sammlung Panza." *Kunstwerk*, vol. 34, no. 1 (1981): 59.

von Meier, Kurt. "Los Angeles." *Art International*, vol. 11, no. 4 (April 1967): 51–54.

_____. "Los Angeles Letter." *Art International*, vol. 10, no. 5 (May 1966): 57–60.

_____. "Painting to Sculpture: One Tradition in a Radical Approach to the History of Twentieth-Century Art." *Art International*, vol. 12, no. 3 (March 1968): 37–39.

Wagstaff, Samuel J., Jr. "Paintings to Think About." *Art News*, vol. 62, no. 9 (January 1964): 33, 62.

_____. "Talking with Tony Smith." *Artforum*, vol. 5, no. 4 (December 1966): 14–19.

Waldman, Diane. *Carl Andre*. New York: Solomon R. Guggenheim Museum, 1970.

———.*John Chamberlain: A Retrospective Exhibition*. New York: Solomon R. Guggenheim Museum, 1971.

———. *Robert Mangold*. New York: Solomon R. Guggenheim Museum, 1971.

Wallis, Brian. "Notes on (Re)Viewing Donald Judd's Work." *Donald Judd: Eight Works in Three Dimensions*. Charlotte, N.C.: Knight Gallery, 1983.

Wasserman, Emily. "New York." *Artforum*, vol. 6, no. 4 (December 1967): 59.

Watt, Alexander. "Paris Letter: Nouveaux Réalistes." *Art in America* 2 (1961): 106–12.

Weschler, Judith. "Why Scale?" *Art News*, vol. 66, no. 4 (Summer 1967): 32–35, 67–68.

Whitney, David, ed. *Leo Castelli: Ten Years*. New York: Leo Castelli, 1967.

Wilson, William. "Hard Questions and Soft Answers." *Art News*, vol. 68, no. 7 (November 1969): 26–29.

Wittgenstein, Ludwig. *Tractatus Logico-Philosophicus*. London: Kegan Paul, 1922.

Wolfe, Clair. "Notes on Craig Kauffman." *Artforum*, vol. 3, no. 5 (February 1965): 20–21.

Wollheim, Richard. "Minimal Art." *Arts Magazine*, vol. 39, no. 4 (January 1965): 26–32. Reprinted in Gregory Battcock, ed. *Minimal Art: A Critical Anthology*. New York: E.P. Dutton, 1968, pp. 387–99.

———. "The Work of Art as Object." *Studio International*, vol. 180, no. 928 (December 1970): 231–35.

Wooster, Ann Sargent. "Sol LeWitt's Expanding Grid." *Art in America*, vol. 68, no. 5 (May 1980): 143–47.

Wortz, Melinda. *Larry Bell: New Work*. Yonkers, N.Y.: The Hudson River Museum, 1980.

Interviews

Carl Andre, New York City, 4 November 1980.

Mel Bochner, New York City, 25 November 1980.

Clement Greenberg, New York City, 11 November 1980.

Donald Judd, Marfa, Tex., 2–3 December 1980.

Sol LeWitt, New York City, 15 November 1980.

John McCracken, Santa Barbara, Calif., 28 May 1980.

Robert Mangold, New York City, 18 November 1980.

Brice Marden, New York City, 13 November 1980.

Robert Murray, New York City, 18 November 1980.

Kenneth Noland, South Salem, N.Y., 14 November 1980.

David Novros, New York City, 17 November 1980, and Los Angeles, 24 September 1981.

Anne Truitt, Washington, D.C., 21 November 1980.

William Tucker, Brooklyn, N.Y., 10 November 1980.

Correspondence

Carl Andre, 3 March 1989.

———, 24 March 1989.

Clement Greenberg, 28 January 1981.

Robert Murray, 28 March 1989.

David Novros, 21 January 1989.

Anne Truitt, 24 March 1989.

Index

Printed in the United States
200022BV00004B/199-249/A

9 780295 972367